WE MAKE EACH OTHER BEAUTIFUL

A volume in the series
Publicly Engaged Scholars: Identities, Purposes, Practices
Edited by Anna Sims Bartel, Debra Ann Castillo, and Scott Peters

A list of titles in this series is available at cornellpress.cornell.edu.

WE MAKE EACH OTHER BEAUTIFUL

Art, Activism, and the Law

Yxta Maya Murray

CORNELL UNIVERSITY PRESS ITHACA AND LONDON

Publication of this book has been aided by a grant from the Wyeth Foundation for American Art Publication Fund of CAA.

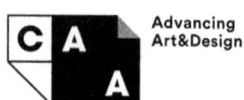

The chapter on Carrie Mae Weems draws on Yxta Maya Murray, "From Here I saw What Happened and I Cried: Carrie Mae Weems's Challenge to the Harvard Archive," *Unbound: Harvard Journal of the Legal Left* 8, no. 1 (Winter 2012–2013).

The chapter on Imani Jacqueline Brown draws on Yxta Maya Murray, "Blights out and Property Rights in New Orleans Post-Katrina," *Buffalo Law Review* 68, no. 1 (January 2020).

Copyright © 2024 by Yxta Maya Murray

All rights reserved. Except for brief quotations in a review, this book, or parts thereof, must not be reproduced in any form without permission in writing from the publisher. For information, address Cornell University Press, Sage House, 512 East State Street, Ithaca, New York 14850. Visit our website at cornellpress.cornell.edu.

First published 2024 by Cornell University Press

Library of Congress Cataloging-in-Publication Data

Names: Murray, Yxta Maya, author.
Title: We make each other beautiful : art, activism, and the law / Yxta Maya Murray.
Description: Ithaca : Cornell University Press, 2024. | Series: Publicly engaged scholars : identities, purposes, practices | Includes bibliographical references and index.
Identifiers: LCCN 2023051154 (print) | LCCN 2023051155 (ebook) | ISBN 9781501775581 (hardcover) | ISBN 9781501775598 (paperback) | ISBN 9781501775604 (pdf) | ISBN 9781501775611 (epub)
Subjects: LCSH: Political art—United States. | Law and art—United States. | Art—Political aspects—United States. | Art and social action—United States. | Art and society—United States. | Social problems in art. | Minority women artists—Political activity—United States. | Minority artists—Political activity—United States. | Gay artists—Political activity—United States. | Homosexuality and the arts—Political aspects—United States.
Classification: LCC N72.P6 M88 2024 (print) | LCC N72.P6 (ebook) | DDC 701/.03—dc23/eng/20231117
LC record available at https://lccn.loc.gov/2023051154
LC ebook record available at https://lccn.loc.gov/2023051155

To Gerald Torres
"only do the work"

Contents

Acknowledgments	ix
Introduction: A Tradition Born of Women of Color and Queer of Color Arts-Activism	1
1. Artivism Avant la lettre	11
2. From Here I Saw What Happened and I Cried: Carrie Mae Weems's Challenge to Copyright and Property Law	38
3. "I Just Didn't Feel Safe": Young Joon Kwak's Mutant Salon and the Queer Need for Safer, Thriving Spaces	65
4. "How Did We Get Here?": Tanya Aguiñiga's Art about the Border and Disability Law	89
5. "So Many Stories Like That": Imani Jacqueline Brown, Blights Out, and *Live Action Painting* (2015)	109
6. "We Wanted to Open Up": *Drawn Together* and Fair Artists' Contracts	139
Conclusion: An Art Dedicated to Survival: Law, Hope, and the Way Ahead	173
Notes	179
Index	223

Acknowledgments

Yxta thanks and remembers Fred MacMurray, Thelma Diaz Quinn, Maggie MacMurray, María Adastik, Walter Adastik, John Quinn, Gerald Torres, Debra Ann Castillo, Mahinder S. Kingra, Lauren Willis, Soua Nia Moua, Colin Goward, Deborah Weissman, Stephen Lee, Serena Mayeri, Katherine Macfarlane, Elizabeth Ferrer, Pilar Tompkins Rivas, Theodore Seto, Tulsa Kinney, Christopher Michno, Shirley Lin, Alex Jonavovich, David Velasco, *Artforum*, the Yaddo Corporation, Diane Mehta, Samira Abbassy, Helen Benedict, Anthony Cheung, Ashon Crawley, Blane De St. Croix, Max Duncan, Barbara Friedman, Danielle Ganek, Dean Haspiel, Adam Hurwitz, Jessica Kingdon, Wang Lu, Sarah Mantell, Sharon Mashihi, Laetitia Mikles, T. D. Mitchell, Patrick Palermo, Lynn Sachs, Coral Saucedo Lomeli, Anna Sperber, Lisa Gail Collins, Nafis White, Xinyan Yu, The Lighthouse Works, Nate Malinowski, Tryn Collins, Jocelyn Saidenberg, Dennis Delgado, Emily Harter, Darryl DeAngelo Terrell, Claudia DeSimone, Arlene Dávila, Sarah Preisler, the Women's International Study Center, Allan Ides, Young Chung, Commonwealth and Council, Liz Sepper, Mary B. Burnham, Heather Ferguson Burnham, Arthur Kuijpers, Ella Foshay, Margaret O'Neil Frank, Marnie Franklin, Jan Geniesse, Meredith James, Susan Lawrence, Elizabeth Miller, Tom Parker, Sarah Stack, Danielle Kie Hart, Christabel Vartanian, Douglas NeJaime, Victor Gold, Adam Zimmerman, Loyola Law School, Justin Levitt, Jonathan Harris, Michael Waterstone, Steven Willborn, The Huntington Library Fellowship Program, David E. Pozen, Mark Weber, Raquel Aldana, Daria Roithmayr, Laura E. Gómez, Sarah Elizabeth Lewis, Julie Goldscheid, Janette Rodriguez, Jennifer Savran Kelly, Trent Hancock, the New York Foundation for the Arts, the Arts Writers Grant and the Andy Warhol Foundation for the Visual Arts, and my dearest Andrew Brown, Kiki Brown, and Babs Brown. This book could not have been written without the work and words of Tamara Lanier, Young Joon Kwak, Imani Jacqueline Brown, Tanya Aguiñiga, Carrie Mae Weems, Mira Dayal, Maia Chao, An Duplan, Simon Wu, and Jodi Waynberg.

WE MAKE EACH OTHER BEAUTIFUL

Introduction

A TRADITION BORN OF WOMEN OF COLOR AND QUEER OF COLOR ARTS-ACTIVISM

In August of 2020, immigrants hoping to cross from Tijuana into San Diego from the San Ysidro border had to queue in la línea ("the line") for up to ten hours.[1] The temperatures in San Ysidro that month reached the mid-nineties and, according to local news stations, people became "desperate" for bathrooms. On the twenty-third of August, an eighty-nine-year-old woman died, evidently of cardiac arrest, as she endured the wait in her car.[2] While reports of the woman's death didn't become national news, Tanya Aguiñiga, a Los Angeles–based artist born in Tijuana, Mexico, read of the tragedy.

The woman's demise struck Aguiñiga as one of the many avoidable calamities caused by the US government's violent and xenophobic immigration policy. Aguiñiga's anger and sadness inspired her to continue readying her part in a group show at the Los Angeles Contemporary Exhibitions gallery (LACE), which would exhibit relics of an immigration-rights performance that she had premiered earlier, in January of 2020. *Metabolizing the Border* (2020) had seen Aguiñiga undertaking a multiplicity of gestures. She asked children in Los Angeles to write notes on ribbons for kids in Tijuana and tied these to the metal prongs of the San Ysidro wall. She then painted portions of the wall and hacked off some of its corroded pieces. With the aid of Latinos in the area, she pulverized these pieces in a mortar. To create a ritual that would "expel" the "heavy things" and "scars" that she acquired at San Ysidro, she hand-blew a glass space suit or suit of armor, whose elaborate and bulbous headpiece found inspiration in Mesoamerican art. Aguiñiga embedded parts of the border wall into this helmet's

earpieces, goggles, and an attachment that operated as a respirator so that she could see, hear, and breathe in the barrier. She also inserted border fragments into a glass belt that expanded into a womb-piece (a female-identified version of a codpiece) to experience the generative parts of her body in relationship to the border. In addition, Aguiñiga blew glass huaraches that were "designed to fail." With a group of attendants, she drove to the San Ysidro Port of Entry from her home in Los Angeles and conducted a purification ritual with incense and meditation. Her friends helped her put on a protective scuba suit and, over it, the glass elements. She walked back and forth in front of the crossing while carrying a flashlight topped with a hand-blown ball, which looked like a miter or a torch. She did this until the huaraches broke on her feet.³

Metabolizing the Border was Aguiñiga's cathartic response to American border policies. But even as she readied to present the scuba suit, broken glass shoes, and other fragments retained from the performance at her upcoming show at LACE, the artist couldn't forget about the woman dying while waiting to cross over. Aguiñiga is a veteran of the San Ysidro border crossing, and based on her own experience, as well as the observations that she'd made of other people's suffering there, she conceived a second project, titled *Línea Pak* ("pack for the line"). The paks consisted of five hundred vibrantly decorated plastic packages that each contained a port-a-potty, purified water, a granola bar, saladitos (salted prunes), a map of the line, and also a "petition against the US government . . . for violating the Americans with Disabilities Act [as] . . . currently, there is no accessibility for disabled or elderly people at any of the border crossings."⁴ Aguiñiga, with the aid of assistants, assembled the paks and displayed them alongside her *Metabolizing* residua at the group show titled *Intergalactix: against isolation/contra el aislamiento*, which ran at LACE from May 14 to August 15, 2021. After the exhibit, Aguiñiga planned to distribute the paks to people at the San Ysidro line with the help of other artists and activists.⁵ She also uploaded her governmental petition on the *¡Somos Presente!* website, a Latinx-forward campaign platform that encourages members of the community to post petitions that seek positive change.⁶

I first encountered *Línea Pak* in May of 2021 after my editor at *Artforum*, Alex Jovanovich, emailed me with an invitation to write about *Intergalactix*: "Looks like an incredible show—five years in the making, I think?!?!"⁷ he enthused. I had the honor of being invited to write about the exhibit because I'd been reporting for the magazine for two years and had otherwise penned arts essays since 2012. I did this work during my free nights and weekends and whenever I was not busy pursuing my three-decades-long career as a law professor who writes about the state's role in policing race, gender, disability, queerness, and immigration. I'd begun to write about the art scenes in LA, New Orleans, New York, and

other American cities because of my long-standing passion for visual, conceptual, and performance art. As I'd deepened my involvement with the art world over the years, I'd discovered that the pieces I gravitated toward often tackled the same problems that progressive lawyers do—the various forms of racial and gendered injustice that this country has been trafficking in since its "discovery" and founding.

The more I'd investigated this resonance, the more I realized that there existed a relationship between the political art I studied and progressive lawyering because the artists often behaved like key players in social movements that had inspired major US legal reforms. When, as a reporter, I'd taken part in Young Joon Kwak's 2016 creation of music-filled queer and trans safe spaces (see chapter 3), or when I'd studied the 2015 conceptual-art housing and racial justice protests of Imani Jacqueline Brown (see chapter 5), I saw that these artists' engagements resembled the expressive demonstrations and acts of mutual aid made by members of the civil rights, feminist, disability, and queer rights movements of the 1960s to 1980s as well as activists in Black Lives Matter, transgender rights, tenants' rights, and other modern human rights movements. I largely focused on the art of women of color and queer people of color (and their intersections), observing that actions such as Marsha P. Johnson's '70s-era mixture of Black trans cabaret and political protest (see chapter 1) and Faith Ringgold's '70 staging of a dance exhibition-cum-free speech rally (see chapter 1) linked to the most magnetic moments of, say, the 1966 Meredith March Against Fear, where activist Fannie Lou Hamer danced and led the singing of gospel songs in an effort to obtain legally recognized voting rights.[8] And Ringgold's 1970 production of an art show dedicated to flag burning (see chapter 1), Charlene Teters's spectacular 1998 burning of racist Native caricatures (see chapter 1), and rafa esparza's 2017 burning of colonial art textbooks[9] recalled the theatrical aspects of the New York Radical Women's '68 anti–Miss America "bra-burning" protest,[10] which would help propel the Equal Rights Amendment struggle and the transformation of the US Constitution's Equal Protection Clause.[11] Since I'd initially started to think about the tether between art and law, I'd grown to realize that conversations between the two disciplines could enhance the project of justice and legal reform, similar to the way social movements have driven law's evolution. And so, I had no problem agreeing with Alex that *Artforum*'s readers should learn about *Intergalactix*. During that first Saturday in May, I traveled to LACE to experience these artists' interpretations of border policy and see whether they might offer legal insights.

LACE is a forty-six-year-old artist-run storefront gallery situated on Hollywood's Sunset Boulevard and exists as a beacon of art and political dissent sandwiched between coffee shops and souvenir stores.[12] Once I entered the gallery, I saw that *Intergalactix* featured metal sculptures by Beatriz Cortez and

the Kaqjay Moloj collective, as well as searing videos about isolation and detention by Ernesto Bautista. Even amid this scintillating art, I found myself moving toward a far wall from which hung dozens of Aguiñiga's brightly ornamented food baggies and informal legal complaints. I didn't understand the meaning of the installation, but I experienced a trembling and uncanny moment where I was flooded with memories of my grandmother, María Aldrete Adastik, a Mexican immigrant who had resisted the workings of racism and patriarchy by doing mutual aid; cooking; making crafts; and performing other, private protests in our family home. The línea paks' slim and, at this point, inchoate connection to my own biography spurred my interest and made me linger. LACE's gallerist, Daniela Lieja Quintanar, noticed my fixation and approached me. Soon, she was telling me stories about the eighty-nine-year-old woman's death and Aguiñiga's anguished, art-filled response to that catastrophe. "These are saladitos," Lieja Quintanar said, inviting me to look closer at the paks so I could see the wrinkled, dark prunes they carried. "People in Tijuana eat these in order to withstand dehydration, and these are escusado portátils, so that people can relieve themselves," she continued, pointing at folded-up squares of plastic attached to the paks.

I nodded, photographing the necessities, as well as Aguiñiga's petition alleging the Department of Customs and Border Protection's violation of the ADA, objects that bore little relation to the customary relics of high art that one might expect to find in an arts space. These were not paintings, or sculptures, and might seem less like the artifacts of an art performance than supplies stockpiled in the basement of the Mexican American Legal Defense and Educational Fund or The Coalition for Humane Immigrant Rights. Still, I knew that incidents of artist-activists' actions had been displayed in gallery and museum spaces at least since Joseph Beuys held events for his Office of the Organization for Direct Democracy by Referendum at documenta 5 (1972) in Kassel,[13] and, five years later, Suzanne Lacy orchestrated a woman-only consciousness-raising session at LA's Studio Watts Workshop Garage Gallery.[14] But I also discerned that, in examining the photos of *Metabolizing the Border*, or the packaged granola bars and saladitos in the línea paks, I wasn't just hearing an echo of my grandmother's aesthetic acts of resistance, nor was I only looking at the accessories of a sweeping phenomenon of "arts-activism," a phrase that I understand to denote a wide body of art practices bearing political significance. Rather, Aguiñiga's actions and artifacts presented high watermarks of a political arts tradition that is obviously related to the umbrella category of arts-activism but has its own specific lineage rooted in the culture of women of color and possesses its own burgeoning community and theory. Since 2008, this practice has been known as artivism.[15]

Decolonial theorist Chela Sandoval and art historian Guisela Latorre first coined the term in their 2008 article "Chicana/o Artivism: Judy Baca's Digital

Work with Youth of Color," which studied the art and community outreach of Judy Baca.[16] Artivism emerged as a new and identity-focused category of activist art, which had seen a plethora of writings dedicated to the general concept of arts activism since the 1984 publication of Lucy Lippard's *Get the Message? A Decade of Art for Social Change.* Criticism like Lippard's had studied the synthesis of arts, community engagement, and political action that formed part of a heritage extending back to the political art that surfaced in the 1930s and '40s.[17] Her essays detailed how politically engaged artists in the '60s and '70s developed novel public actions reflecting on warfare, labor union politics, voting rights, anti-Black and anti–Puerto Rican violence, and the related arrival of community-based arts practices, such New York's downtown "streetworks" and the Guerrilla Art Action Group's 1969 protest calling for the immediate resignation of war financiers from the Board of the Museum of Modern Art.[18] Other hallmarks of these early arts efforts include the Artist Protest Committee's 1966 construction of an anti–Vietnam War "peace tower" in Los Angeles, the Black Emergency Cultural Coalition's (BECC) 1969 protest of the Metropolitan Museum of Art's exclusion of Black artists in the show "Harlem on My Mind," and the 1970 New York Art Strike Against War, Racism, Fascism, Sexism, and Repression.[19]

As the years pressed forward, activist art experienced a flowering and its authors invented manifold strategies of engagement. Emory Douglas's political posters created in the '60s and '70s for the Black Panther Party continued the activist-artist project as did Keith Haring's queer activist and anti-apartheid posters in the 1980s.[20] The 1990s through the early 2000s witnessed the arts-inflected protests of international activist movements and collectives such as the Zapatista revolution in Chiapas, Italy's pro-immigrants' rights and antiglobalization Tute Bianche movement, and Britain's anticapitalist Reclaim the Streets movement, as well as the controversial innovations of Santiago Sierra, who secreted Chechen asylum-seekers in a German gallery.[21] A new wave of critics published responses to these moves at the start of the millennium: Thinkers such Nicolas Bourriaud and Claire Bishop limned the connections between activist, relational, or social practice art (wherein the artist engages with people and places) and democracy.[22] Chantal Mouffe's 2007 critique of art-activism that challenged the "existing consensus"[23] proved especially challenging to the genre, as she observed that participatory art could not subvert neoliberalism on its own and would need to work with traditional political groups such as parties and unions.[24]

While these theorists were naming artist-activist practices, scholars of color were also recognizing that this valence had special meaning for female and minority artists. Bridget R. Cooks, Lisa Gail Collins, and Renée Ater are just some of the intellectuals who formed language for the phenomenon in the mid-2000s, observing that Black women such as Faith Ringgold, Adrian Piper, and

Howardena Pindell were merging political action with art gestures.²⁵ In 2008, Sandoval and Latorre joined this movement by coining the term "artivism" and rooting its practice in the engagement of women of color artists. Sandoval and Latorre homed in on the art of Latinx women working in the United States, observing that the muralist and educator Judy Baca had been developing a hybrid practice that merged direct action and aesthetics since the 1970s, when she painted murals with at-risk youth.²⁶ The scholars found Baca's artivism related to Gloria Anzaldúa's concept of la conciencia de la mestiza (the consciousness of the mixed race woman), in that it "expresses a consciousness aware of conflicting and meshing identities." Artivism, Sandoval and Latorre wrote, "confront[s] adversity, thus arriving at more democratic and egalitarian conclusions."²⁷

In this book, I elaborate on Sandoval and Latorre's nomenclature and the vision they share with Cooks, Collins, and Ater by studying the practices not only of women of color artists but also queer Black, Brown, Asian, and Indigenous artists, reflecting on the ways in which these creatives relate to contemporary social movements and their legal challenges. In the penultimate chapter, I also very briefly engage the work of the Black disabled musician Brigardo Groves and his overlapping exercises in the fields of art, law, and disability justice. My framing issues from two commitments. First, I expand Sandoval and Latorre's emphasis on Chicana and other women of color artivism to queer and disabled of color engagements out of the understanding that these artists may also experience "conflicting and meshing identities" on account of their intersectional status, as scholars such as Chon Noriega and Robb Hernández have documented.²⁸ While I don't maintain that only women, queer, or disabled people of color may practice artivism, Cooks, Collins, Ater, and Sandoval and Latorre's emphasis on woman of color projects indicates that artivism will always coexist with artistic practices that seek liberation for racial minorities and those with intersectional identities.²⁹ To that end, my focus marks the foundations of this undertaking and introduces these artists' insights during a political moment that is bombarded by racial and gendered violence.³⁰

This brings me to my second point. As I've noted, at the beginning of my career as an arts writer, I reacted strongly when the art I saw displayed and performed in art spaces aligned with the missions and tactics of social movements that moved the legal needle. Perhaps because of my day job, I'm drawn to the work of intersectional artivists because I'm convinced their revelations offer a necessary resource in an increasingly inequitable US society whose asymmetrical opportunities and risks are induced by law. For this reason, I not only study the history of artivism but also concern myself with the *critiques of law* that emanate from these artists' practices. Thus, in these pages, I'll engage my experience as an art critic and an artist and also draw on my career as a legal scholar to study how

artivism offers important confrontations with, and even new interpretations of, law. Artivists' legal critiques deserve attention as we absorb the shocks distributed by the post-Trump Supreme Court, confront fresh cascades of public health crises and ecological collapse, and continue the battles against police brutality, environmental racism, xenophobic immigration policies, and other emergencies that are generated and cemented by law.

The connections I make between artivism and law haven't emerged fully formed like Athena from the head of Zeus. For one, my work is an extension of Mouffe's interest in art-activism's democracy-enhancing potential. It also takes part in scholarship that studies associations between social movements and law:[31] Theorists such as Jack Balkin, Reva Siegel, Robert Post, Douglas NeJaime, and Serena Mayeri have demonstrated how civic activism, including that of twentieth-century ERA activists and other mobilized citizens, helped create new interpretations of the US Constitution's Equal Protection clause that were later promoted by young lawyers like Pauli Murray, Mary Eastwood, and Ruth Bader Ginsburg and eventually enshrined by the Supreme Court.[32] Lani Guinier and Gerald Torres's coterminous studies of Demosprudence, an expression that describes how social mobilizations can "contribute to the meaning of law," revolutionized our understandings of how activists of color—such as members of the Montgomery Bus Boycott and Fannie Lou Hamer and participants in the Freedom Summer—reshaped the law of segregation and voting by carefully framing their claims for racial justice, staging public actions, and affiliating with and sometimes combating movement lawyers such as Fred Gray and Joseph Rauh.[33]

Social movement scholarship bears important connections with other seedbeds for artivism and the law studies, which involve scholars who study the humanities and narratives to introduce excluded perspectives to jurisprudence. The mid-1990s saw the emergence of a "law and literature" school of thought whose leaders, such as the classicist Martha Nussbaum, Judge Richard Posner, and law professor Robin West, seek to reform law and advance its critiques by unveiling human experiences and emotions that go undetected in legal culture but are limned in fiction.[34] Related to this work also are the writings of Critical Race Theorists, a school of intellectuals including the law professors Derrick Bell, Patricia Williams, Richard Delgado, Mari Matsuda, and Dorothy E. Roberts, who incorporate people of colors' stories into legal thought.[35] In the 2010s, theorists began examining the visual and performing arts in connection with law to promote similarly progressive legal aims or to obtain a greater understanding of art's meaning by reflecting on its position in the legal landscape. Highlights in this field include work by the lawyer and art historian Joan Kee, art historian Sarah Elizabeth Lewis, and the law professors Sonia Katyal, Adrienne Davis, and Amy Adler; I have also contributed to this field.[36]

Inspired by this foundational work, I examine not only how artivism has developed as an art movement but also how it takes up the mantle of its social movement forbears and contemporaries by critiquing the law in numerous essential ways, and so hews new pathways toward legal change.[37] One of the first questions I had to face in this journey was the type of artivism that I would study in this book. As my brief reference to my grandmother's use of craft and cooking to resist oppression indicates, the concept is large enough to cover nearly every single form of art and every type of artistic gesture that contains intersectional political content. I have determined to focus on artivism that commits to *direct action*, as that style of engagement has proved such a powerful agent of legal disruption since the time of Mohandas Gandhi, Dr. Martin Luther King Jr., Rosa Parks, and James Farmer.[38] Direct action is often associated with illegal acts of civil disobedience, but here it will also be connected to protesting, rule-breaking, contract-breaching, providing mutual aid, performing public outreach, fomenting rebellion, and researching, identifying, and monitoring governmental and institutional abuse.[39] In four cases, I also mark the artivist act of appearing in public without shame, an expression of a baseline human capability that queer and trans artivists have transformed into both art and protest.[40] These gestures generate rich criticisms and reconceptualizations of law, either by forcing legal institutions to recognize artivists' aims or to offer alternative readings of human rights that legal actors should, on their own initiative, seek out and study.

This last point deserves emphasis. I am often asked by my colleagues, "How exactly does this work?" when I advance a claim that artivism has a relationship to law. How *do* artivists and lawyers interact? As the reader will see, several artivists whose work is studied here engage in direct contacts with law. Some risk arrest through their protests and performances, while others post petitions against the US government, invite and inspire lawsuits, meddle in corporate governance, and conduct investigations of racist abuses in preparation for litigation or other kinds of legal pushback. Through these agons, artivists create opportunities for the birth of new legal understandings, just as members of the civil rights movement, the feminist movement, and the agents of the Chicano Blowouts, ACT UP, and Black Lives Matter have pushed for new readings of Equal Protection and other core legal concepts relevant to the liberation of oppressed peoples. Sometimes, however, artivists conduct themselves at a distance from the legal sphere, even while manifesting legal critiques and new readings of civil and human rights. In these cases, they generate art that bears legal meaning but without any legal audience.

I write this book with the purpose of encouraging members of both the art world and the legal profession to examine the relationship between artivism and the law. As we'll see, artivists often lack legal training; and while some, like Tanya

Aguiñiga, directly court legal change, others express beliefs that their work does not connect to law in any recognizable way even as they foment against a social order that is made possible by legal structures.[41] I'm working to highlight for these artists (as well as their gallerists, curators, commentators, and audiences) the many ways in which artivist acts *do* confront and reinterpret US law, as well as to affirm the intelligibility and cogency of their critiques of how legal power is being visited on the ground.

To that end, I maintain that members of the legal profession should study artivism because it provides such a deep well of jurisprudential insight, particularly relating to issues faced by intersectional people. In this way, I'm encouraging lawyers and artivists to associate and collaborate, much in the manner that social movement protagonists form relationships with legal actors.[42] Energizing social justice developments and legal reform could well flow from these exchanges and relationships. At a base level, we'll see that artivists often alert to human rights issues well before the legal community, and so can serve as important bellwethers for lawyers and law professors. Further, lawyers who pay attention to the critiques of artivists will find that those artists' work provides legal "analyses" and "cases" that challenge law's racist, queerphobic, ableist, and sexist underpinnings.

It's also worth noting that artivists' work possesses beauty, as well as the ability to trigger emotional responses that might help us commit to the fight for human rights in ways that legal arguments and philosophy typically can't. Legal actors who rally for oppressed people often bemoan the inability of courts or antagonists to be able to "see" their clients as human.[43] But, at least since Aristotle first noted that art can evoke cathartic responses in viewers, artists have endeavored to generate exactly that—a new and cathartic way of seeing that which is human, a way of seeing that is rooted in the emotions.[44]

Artivism is a force for intersectional justice, and it's also a global phenomenon that possesses potent legal significance. In Mexico's Ciudad Juárez, the arts collective Hijas de su Maquilera Madre (Daughters of the Maquiladora Mothers) protests the largely uncharged crimes of femicide with installations, marches, signs and broadsides, and graffiti.[45] The German-Senegalese rapper Sister Fa speaks out against female genital cutting (which violates national law and contravenes the United Nations' 2010 Commission on the Status of Women) by giving talks to villages and schools in Senegal and Guinea.[46] The Shanghai-based photographer Shawn Zhang organized the now-banned Shanghai Pride parade, China's longest-running celebration of queer identity in a nation that neglects constitutional or other legal protections for queer people.[47] This list of names conveys just a tiny sampling of exciting transnational practices that see intersectional artivists engaged in direct action that connects with laws or related instruments.

In this book, I largely focus on US-based artivism. I do so not out of a sense of exceptionalism and North American solipsism, but because I'm the most versed in the artwork of these creatives and the most familiar with the US laws and policies that they critique. I also look to these artists' counsel in the hopes of bettering a US polis that can't divest itself of its long habit of subordinating "the other"—a practice that has crescendoed during the writing of this book, which took place during the long tails of the pandemic and Trumpism. In this battered period of history, some progressives wonder whether the Constitution or even law itself can afford marginalized classes any succor or even hope. "Struggling over the Constitution has proved a dead end," as Ryan D. Doerfler and Samuel Moyn wrote in the *New York Times* in the summer of 2022.[48] "US law is fundamentally structured to establish and uphold settler colonialism, white supremacy, capitalism—the legal system will not undo these things," Seattle Law Professor Dean Spade counsels aspiring law students.[49] "People on the streets, people who are organizing, are going to put certain things on the table that will rarely leave a lawyer's mouth," abolition advocate Derecka Purnell observed in 2017.[50]

My project doesn't turn away from the Constitution or other law, however. Instead, just as social movement actors ranging from Fannie Lou Hamer to the Defund the Police initiative rethink what the law is and what it can do, artists offer a new library of insights about the Constitution, statutes, case law, and legal theory that can help critique, reconstitute, and transform the law in the name of the marginalized and the underclass.[51] As Reva Siegel wrote in the wake of *Dobbs v. Jackson Women's Health Organization* (which reversed *Roe v. Wade* in 2022), we must "remember the many ways that the Constitution emanates from the people themselves" to "tak[e] back the Constitution from the Court."[52] And as Dorothy E. Roberts has written, "alternative public meaning[s]" of law can penetrate the legal system.[53] Even where artists recognize that the law does not uplift or sometimes even touch the lives of vulnerable populations and express anxiety or hostility about its reach, their work offers inspirations for legal reforms that harmonize with and precede radical legal theory. The products of these women of color and queer of color artivists has much to say about human rights in the United States, and in such precarious times, we should take heed of this rich and insightful tradition.[54]

1

ARTIVISM AVANT LA LETTRE

In *Chicana/o Artivism*, Chela Sandoval and Guisela Latorre signaled that artivist practices long existed avant la lettre when they identified Baca's 1970s work with young muralists as an early occurrence.[1] Once we see that activism and art practice can shade into each other, it becomes difficult *not* to descry examples of their merging in US history, particularly where women of color or nonbinary peoples' political strategy or activism is at stake. In the following profiles of early artivists, I am highlighting a selection of creatives that is based on my still-progressing study of this phenomenon as women of color and queer people of color practice it. I am not creating a "canon," as I do not believe in canon-building on account of its roots in male dominance, colonialism, ableism, and white supremacy, and instead regard this collecting of artivist stories as part of a growing archive.[2] Further, the study of artivism will have to be broadened to include many more disabled artists of color. As such, this review can be seen as shaped by my own background as a bisexual Latinx cis woman from California who has been driven to study the work of artists who challenge political, social, and legal systems.

In most cases, I've selected artivists whose direct action flows unswervingly from their art practice; but there will be instances, particularly in the earlier part of this history, where I study artists whose activism and art jostle together in less consolidated ways, which offers opportunities to consider the qualifications and definitions of artivism. Moreover, in some instances the artivists I study create art that makes claims that map on brightly to legal issues. In other cases, artivists' products manifest as complex and even baffling engagements that require

FIGURE 1.1. Gladys Bentley, taken 1946–1949, collection of the Smithsonian National Museum of African American History and Culture

the observer to embark on close studies to glean meanings that can enrich legal doctrine, an obliquity that may initially seem at odds with artivism's links with social movements and their reputedly accessible demands. Nevertheless, "classic" social movement actors can produce polysemous actions,[3] and, moreover, if sifting some artivists' oracular gestures requires patience and attention, that complexity is of a piece with art's capacity to limn problems far in advance of mainstream society's ability to recognize or develop language to describe them. In all the cases I study, artivists are bound together by their participation in art and craft, their use of direct action, and the eloquent manners in which their actions push against legal doctrines and practices that harm intersectional people. For the moment, seeking to narrow down the narrative for the sake of space and comprehension, I'll start off by observing that in the 1930s and the 1940s, Gladys Bentley and Elizabeth Catlett provided two powerful and incipient examples of intersectional artists who, in the service of their creative labors, engaged direct action to critique existing laws and policies.[4]

In the 1930s, the Black cabaret performer Bentley shocked New York audiences with her performances, wherein the large-bodied singer would express, to borrow from Jack Halberstam, "black female masculinity" by wearing men's attire.[5] Appearing in public without shame, she would flirt with women in the audience and croon bawdy songs with the aid of male backup singers who wore makeup and other forms of feminine plumage.[6] Bentley did this in contravention of New York's Wales Padlock Law, which made it illegal to depict "sex degeneracy or perversion,"[7] and her violation of that statute appears to have motivated the police to barricade the doors of the King's Terrace Theater.[8] Bentley also flouted US marriage and anti-miscegenation laws and norms by either in fact marrying a white woman or pretending to do so in a "highly publicized ceremony" that served simultaneously as civil disobedience and political theater.[9]

A few years after Bentley employed performance to resist New York's homophobic and racist statutes, Black sculptor and educator Catlett mounted what might, today, be described as an untitled collective action protesting racial segregation in New Orleans. Catlett had obtained an MFA from the University of Iowa in 1940 and soon after become chair of the Art Department at New Orleans' historically Black Dillard University.[10] As an artist and an arts educator, Catlett worked to gain access to inspiring artworks for her students, but she found that Louisiana segregation laws stymied these ambitions: New Orleans' City Park surrounded the Delgado Art Museum (today the esteemed New Orleans Museum of Art), whose galleries hosted a Picasso exhibit in 1941. Catlett, a newly minted professor, knew her students should see these canvases, but museum officials told her that, while she and her pupils were welcome inside the institution, they could

FIGURE 1.2. Elizabeth Catlett, © Ben Hider 2010

not enter it, as Louisiana statutes forbade racial mixing on its surrounding park grounds. Incensed, Catlett hired a bus to drive over the grass and deposit her pilgrims at the museum's front steps, in a move that both committed trespass and worked to evade arrest. "You know," she told an interviewer in 2009 when recollecting this adventure, "these were second-year university students and none of them had been in an art museum before."[11]

While Bentley expressed her political defiance in direct action that is indistinguishable from her art (since her stage persona and personal identity proved inextricable from her lawbreaking performance), I can find no evidence that Catlett envisioned her synthesis of art viewing, art teaching, illegal trespass, and civil disobedience as an activist artwork. It's quite possible that Catlett would

have been nonplussed at any labeling of her defiance as a form of art, but regardless of intention, both her and Bentley's violations (or performative violations) of censorship, marriage, and Jim Crow laws, and their mingling of protest with art practice, art teaching, and criticism of arts institutions foretold many later trends. These include conceptualism, the participatory countercultural art of the 1960s and 1970s, the activist art of that same era, the social justice–forward art practice of crime commission, institutional critique, social practice art, pedagogy-as-art practice,[12] and the woman of color, disabled, queer and trans artivism that Bridget R. Cooks, Lisa Gail Collins, Renée Ater, Chela Sandoval, and Guisela Latorre began to name in the 2000s.

In the period following Bentley's and Catlett's actions, intersectional artists continued to engage in direct action that combated structural racism, homophobia, and sexism and critiqued the laws and norms that supported these ills. In the 1940s, the Black painter Lois Mailou Jones broke the rules of the Corcoran Gallery of Art when she had a white friend submit a painting to its show to evade its color bar and had it accepted;[13] with this act of resistance, Jones became a promoter of equal employment opportunity in the arts. Another stalwart is Eskew "Esquerita" Reeder Jr., a Black R&B singer and songwriter who both expressed his identity as a musical star and protested the anti-sodomy and Jim Crow laws of Greenville, South Carolina by wearing fashionable, queer-coded attire without shame in the 1950s.[14] The queer Latinx writer John Rechy also figures in this history, as he protested police brutality against gay men in the Cooper Do-Nuts Riot in Los Angeles in 1959 and in succeeding years became an oral storyteller about this episode of civil disobedience.[15] These episodes of artistic and insurrectionist interplay further laid the ground for the 1960s and 1970s, decades that saw the Civil Rights, antiwar, and feminist political movements traversing the careers of an increasing number of intersectional artists who began to intentionally and visibly use direct action as integral parts of artworks that critiqued the state, its institutions, and its laws.

Performance, Painting, and Dissent in the 1960s and '70s: Yoko Ono, Faith Ringgold, Judy Baca, and Marsha P. Johnson

American women of color and queer of color creatives who took up the artivist tradition begun by artists such as Bentley, Catlett, Jones, Reeder, and Rechy did so during an incendiary period in US history and art. The early '60s saw the United States begin the buildup that would soon become the Vietnam War.[16] Civil rights crusaders engaged in unprecedented actions against Jim Crow and

voting rights deprivations, but even when the nation saw progress in the form of the 1964 Civil Rights Act and the 1965 Voting Rights Act, these laws did not do enough alleviate people of colors' on-the-ground experiences with poverty, police brutality, and lack of education and opportunity.[17] With respect to gender and sexuality rights, New York Radical Women sparked the second wave feminist movement in its 1968 protest against the Miss America beauty pageant, held in Atlantic City.[18] A year later would come the Stonewall riots, where queer and trans people rejected the segregation, threat of incarceration, and law enforcement violence imposed upon them by the state.[19] The history of early artivism's responses to these emergencies proves varied and deep, and here I focus on only a few artists who helped create the artivist lineage in the 1960s with their notable works and outrages.[20]

Yoko Ono and *Cut Piece*

Yoko Ono's 1961–64 tour of *Cut Piece* offers an early, breakthrough example of a work that mingled performance with public outreach and protest.[21] In the

FIGURE 1.3. Yoko Ono, courtesy of Arctic-Images

1964 version of the action, Ono sat on a bare wood stage at Carnegie Hall, wearing a chic and simple outfit consisting of dark stockings, a black dress, and a black cardigan. White male and female members of the audience approached her individually and cut off a piece of her clothing with a pair of scissors. They did so with her permission: In her directing notes, Ono had specified that audience members should, "one at a time . . . come on stage and cut a small piece of the performer's clothing to take with them," while the "performer remains motionless."[22]

In *Cut Piece*, Ono's performance consisted of her endurance of the shredding of her clothes, which some of the audience members did shyly and others performed with relish. Her face, which initially appeared blank, eventually revealed expressions of distress and defiance. Moreover, she remained silent throughout the exercise. This remained true when a man leapt to the stage, announced that he was going to "take his time," or that this process would "take some time," and proceeded to remove all of Ono's cardigan before slicing and ripping off her bra while the women in the audience grew agitated.[23] This antagonist is now known in Ono literature as "The Creep."

Cut Piece has long been regarded as something of an enigma in art history. It appeared to be an incendiary feminist and antiwar work, but Ono, at first, denied that she intended the performance to harbor any such meanings. Instead, she made gnomic statements indicating that the work critiqued artists, rather than illustrated the exploitation of vulnerable people.[24] In the first days of *Cut Piece*, Ono refused to commit to any coherent position and the action's political content seemed to have been supplied by the bad acts of audience members and the critical response of feminist and other onlookers.

Nevertheless, the ambiguous identity of *Cut Piece* as an intentionally artivist act was later clarified when Ono affirmed that the work participated in the politics of nonviolence as well as feminism, telling the Museum of Modern Art curators in an undated interview that, "Hey, you're doing this to women, you know? We're all in it. But also, at the time, it's much better to just go with it. And that thought of letting women know that, you know, we're all going through this, but don't fight, let it happen. By not fighting, we show them that there's a whole world, which could exist by being peaceful."[25] This avowal indicates that *Cut Piece* existed as a purposeful nonviolent protest, or a satyagraha akin to those practiced by Mohandas Gandhi. Years after the performance, Ono announced an affinity for Gandhi's practices of political resistance, lending support to this resonance.[26] Further, four years before the Carnegie engagement, civil rights activists who sat at segregated lunch counters in the South—such as Ezell Blair Jr., David Richmond, Franklin McCain, and Joseph McNeil, known as

the "Greensboro Four" —met racists' physical violence and humiliating assaults with stalwart nonviolence as well as silence.[27] We cannot know whether Ono intended to orchestrate a project wherein she would find herself engaging some of the same tactics as the Greensboro activists, and certainly the problems and contexts in Greensboro and Carnegie Hall issued from different racist and gendered histories. Yet, as *Cut Piece* unfolded, the artist weathered abuse without physically fighting back or verbally objecting, and so some parallels manifested with distressing lucidity.

Moreover, like Gandhi's and the desegregation activist' protests, *Cut Piece* bore significant liberationist and legal meaning. In its evocation of white men's sexual predations on women of color, *Cut Piece* was part of a heritage of revelatory engagements such as Harriet Jacobs's writings on slavery, assault, and harassment in her 1861 *Incidents in the Life of a Slave Girl*, Northern Paiute educator Sarah Winnemucca's 1880s lectures and writings on the rape of Native American women, and Rosa Parks's (and others') 1944 formation of the Committee for Equal Justice for the Rights of Mrs. Recy Taylor, which sought the prosecution of Taylor's rapists.[28] Further, with respect to asking questions about how apparent consent and sexual assault can coexist in the minds of victims but not in the law ("you're doing this to women, you know?"), *Cut Piece* proved well ahead of its time and remains so;[29] national anti-rape politics became increasingly audible starting in the early 1970s, when speak-outs occurred in New York and activists established the first rape crisis centers on both coasts.[30] From the date of *Cut Piece*'s initial performance, it would take more than two decades until prominent lawyers broadcast critiques of rape law that reflected the questions Ono pioneered, and the law's analysis of sexual assault remains woefully inadequate in light of her revelations.[31]

Cut Piece also cannot be assessed as a work of artivism without also considering the political traumas of the time. Ono's experience of the physical invasion of her person proved especially telling during the Vietnam War, which arguably violated the provisions of the Geneva Accords of 1954 prohibiting foreign military occupation of Vietnam.[32] *Cut Piece* also spoke to the tide of anti-Asian violence triggered by the war,[33] as well as limned the catastrophic and violent aftermath of *Korematsu v. United States*, the 1944 Supreme Court decision that upheld the US internment of Japanese citizens and signaled that people of Japanese or other Asian descent could be subjected to atrocities on US soil without hope of intervention.[34] While Ono's statements have not shown that she was expressly critiquing violations of the Accords or Supreme Court decisions, her intersectional status and the richness of her artistry made *Cut Piece* a multivalent work that continues to dazzle with its political, social, and even legal insights.

Faith Ringgold's Intersectional Arts Activism and the *People's Flag Show*

Six years after Ono appeared at Carnegie Hall, the New York–based Black graphics and fabric artist Faith Ringgold meshed political activism with her artwork when she organized a series of protests of arts institutions, the Vietnam War, and speech-chilling laws. In 1970, Ringgold founded Women Students and Artists for Black Art Liberation (WSABAL) with her daughters Michele and Barbara Wallace and Tom Lloyd.[35] This mission of protest, outreach, and

FIGURE 1.4. Faith Ringgold, Rabbani and Solimene Photography, © 2011

mutual aid involved the writing of a manifesto lambasting the exclusion of Black women artists from shows like the Venice Biennale, engaging in correspondence with WSABAL members, and maintaining a Black female voice in the December sit-in protesting the Whitney's exclusion of women artists.[36] Ringgold's and Michele and Barbara Wallace's womanist efforts to create professional opportunities for female artists of color followed upon lawyer Pauli Murray's 1960s' labors to create workplace protections for Black women and unfolded years before the '73 establishment of the National Black Feminist Organization (NBFO), which was one of the first institutions dedicated to protecting the rights of women of color.[37] Emerging at the same time as actions by the Third World Women's Alliance to protest the prosecution of Angela Davis, WSABAL gave early expression to intersectional politics and simultaneously offered a radical argument about museums' obligations to maintain diverse collections.[38] This latter claim resonates not only with the ideals of inclusivity found in public accommodations and anti-discrimination laws but also modern critiques of arts institutions that call for collection practices to cohere with ethical, civil rights, and public trust principles.[39]

Ringgold, as well as Michele Wallace, also organized, or helped organize, the now-famous *People's Flag Show* in 1970, an art exhibition that opened on November 9 at the Judson Memorial Church on Washington Square Park.[40] The *People's Flag Show* grew from dual motives: it waged against state violence, both domestic and in Southeast Asia, and excoriated the New York state law criminalizing flag desecration. As Ringgold knew, antiwar activist Stephen Radich had been recently arrested for flag burning under that law, and she may have also been aware of Sidney Street's 1967 conviction for burning the flag upon hearing of the shooting of civil rights activist James Meredith.[41]

In the service of these messages, the *Show* delivered a political protest through performance and the presentation of art objects, as it involved nude dance, an anarchic curation of over 150 flag-related works, and a flag burning ritual.[42] Ringgold designed the exhibit's poster, an 18 × 24" offset lithograph in red and black, displaying text by Michele Wallace that read: "A flag which does not belong to the people to do with as they see fit should be burned and forgotten. Artists, workers, students, women, third world people, you are oppressed. What does the flag mean to you?"[43] On November 13, Ringgold, along with artists Jean Toche and Jon Hendricks, were arrested for flag desecration and fined $100 each, a penalty they paid to avoid incarceration, even while issuing a statement asserting "We have been convicted, but in fact it is this nation and these courts who are guilty . . . [because the United States has been] mutilating human beings," a reference that many understood to refer to the Vietnam War and police brutality inflicted on people of color.[44] The trio later became known as "The Judson Three" and their prosecution became a cause célèbre.[45]

Ringgold's assertion that the United States was "guilty" for the crime of the Vietnam War would never penetrate the courts.[46] Still, her "prosecution" of the US government for domestic violence against racial minorities would coincide with similar arguments by social movement leaders, such as the Black Panthers, and also presage the activism of Black Lives Matter.[47] Further, her framing of flag burning laws as impermissible constraints on expression would be validated in 1989 and 1990, when the Supreme Court recognized finally that flag burning constituted protected "symbolic speech" in *Texas v. Johnson* and *United States v. Eichman*.[48]

Marsha P. Johnson and Queer and Trans Rights

Around the time that Ringgold picketed the Whitney, the Black trans activist, spoken word poet, and performer Marsha P. Johnson could be found holding court in New York City's Sheridan Square.[49] Wearing a series of rasquache (a term I am borrowing from Chicanx art criticism) outfits and headpieces crafted out of flowers, castoffs, and detritus, the New Jersey–born Johnson would model liberty for other queer people by expressing her joie de vivre and insisting on being visible.[50] This act of appearing in public without shame linked to the actions of Gladys Bentley and Eskew Reeder Jr. while making a contemporary protest against cisheteronormativity and queer people's lack of human rights: no state law explicitly protecting queer people against discrimination would be enacted until 1982, police brutality was endemic for queer and trans people regardless of extant civil rights protections, and "lewd conduct" laws were enforced selectively.[51] As a consequence, Johnson's mere presence in public could lead to her arrest.[52] Despite these dangers, Johnson performed political actions where she deployed voice and gesture in charismatic ways, such as can be seen in an undated clip where she tells a reporter, "Darling, I want my gay rights now. I think it's time the gay brothers and sisters got their rights, and especially the women."[53] Moreover, Johnson integrated her politics into a recognized arts practice, as she performed spoken-word poetry about transgender identity in multiple venues, often appearing as a member of the Angels of Light drag ensemble, as well as the Hot Peaches musical troupe, whose acts have been described as "radical" and "genderfuck" drag."[54]

Johnson is today most famous as one of the instigators of the '69 Stonewall Riots, a role she downplayed during her life: Johnson once explained that when she first arrived at Greenwich's Stonewall Inn in the early hours of June 28, 1969, the riots had "already started" and the Inn was "on fire."[55] Johnson described how she immediately participated by throwing "over cars [and] screaming in the middle of the street. . . . We were just saying no more police brutality, oh, we had enough of police harassment in the Village and other places."[56] In the years after

FIGURE 1.5. Marsha P. Johnson, courtesy of Barbara Alper

Stonewall, Johnson became a storyteller about this chapter of queer rights history; reminiscent of John Rechy's storytelling about the Cooper Do-Nuts riot in the previous decade, she sat for interviews wherein she described how Stonewall unfolded and shaped her as an activist.[57]

Johnson proved so inspired by the rebellion that in '71 she teamed up with Sylvia Rivera, another trans woman and Stonewall veteran, as well as a change-making activist.[58] Together, Johnson and Rivera founded the Street Transvestite Action Revolutionaries (STAR) caucus in 1970, which liaised with the Gay Liberation Front and the Young Lords, a Puerto Rican rights party.[59] STAR became the first known shelter for trans youth and the organization developed chapters in Chicago, England, and California before folding a few years after its founding.[60] STAR proved a remarkable accomplishment that intersected with existing social movements, such as the Black Panthers' 1966 call for "decent housing" for Black people.[61] STAR also resisted the political forces that would lead the Supreme Court, in 1972, to reject the claim that housing is a fundamental right.[62]

Johnson's contributions to the culture were many, and like in the case of Yoko Ono, Elizabeth Catlett, and perhaps John Rechy, questions about her status as an artivist arise from a study of her biography: Was her participation in Stonewall and formation of STAR examples of artivist acts, or were they simply other parts of her life? And when determining whether her protest and philanthropy were mingled forms of art, do we look to Johnson's own subjective intentions or find some other way of categorizing her work? With respect to Johnson's own perspective, it's unclear how she regarded her activism as opposed to her artwork since she operated relatively independently of the art world and merged art, craft, and direct action in ways that appear both intuitive and as an expression of her boundary-shattering genius. Unlike an artivist such as, say, Faith Ringgold, she didn't hold marked art shows that contained the elements of direct action or even possess a strong public identity as a fine artist. It's possible that Johnson didn't regard her dress or rebellion or public service as artworks but rather as expressions of her immanent gender identity and ethics. Maybe she never thought about it and maybe the distinction wouldn't have had relevance for her.[63]

Still, a review of Johnson's statements shows that she approached these things in a seamless way. To an interviewer, she once said, "I never come out of drag to go anywhere. Everywhere I go I get all dressed up."[64] To another, she reflected, "I know people think I'm a stupid little street queen out there begging for change cause there's nothing else she knows how to do. . . . I'll always be reaching out to young people who have no one to help them out, so I help them out with a place to stay or some food to eat or some change for their pocket."[65] In these statements,

Johnson disclosed that she lived in a state of near-constant creativity, social stress, protest, and outreach, and indicated that her craft and direct actions were indivisible. This would make sense, as, without a formal gallery or residency, Johnson had learned to do her art not only on stage but also in the street and appears to have carried her practice everywhere she went as a political commitment. This makes Johnson resemble a "life artist," that is, an artist who does not distinguish between living, aesthetic, and political practices. There exists before and after Johnson an impressive lineage of life artists, including Joseph Beuys, Lee Lozano, Stephen Kaltenbach, Linda Montano, David Hammons, and Jennifer Moon.[66] Johnson's dress assemblages, outreach, safehousing, performance, protests and storytelling may all be contained by the concept of artivism when considered in this light.

Reading Johnson as a life artivist, we see that she qualified as one of the most magnetic and formidable members of this guild. Her incandescent activism and personal example helped create the LGBTQI movement, whose protests and advocacy changed the legal landscape. Building on the work of the Society of Human Rights, The Daughters of Bilitis, the Reminder Day picketers, The Mattachine Society, other Stonewall protesters such as Stormé DeLarverie, the organizers of and participants in the 1970 Christopher Street Gay Liberation Day March (which paved the way for Pride Parades), Kathy Kozachenko, Harvey Milk, Audre Lorde, ACT UP,[67] and many, many others, Johnson helped create the world wherein Justice Kennedy acknowledged the humanity of queer people in 2003's *Lawrence v. Texas* (striking down anti-sodomy statutes) and 2015's *Obergefell v. Hodges* (announcing a right to same-sex marriage);[68] in 2020, Justice Gorsuch held that queer and trans people were entitled to civil rights in *Bostock v. Clayton County*.[69] As Carolyn Simon of the Human Rights Campaign has written, Johnson was the "Rosa Parks of the LGBTQ Movement."[70]

Judy Baca's Anti-incarceration and Chicanx Education-Rights Artivism

At this same point in history, Judy Baca's marriage of art and activism began to make itself felt on the West Coast. In 1970, trained painter Baca taught art in Boyle Heights as an employee of the city's Parks and Recreation Department.[71] She witnessed there the violence between rival gang members and, to broker peace between them, conceived an informal program where they would paint murals together. Sometimes, gang members would also serve as "lookouts" to protect the painters from neighborhood rivals or police officers, who could arrest them and Baca for vandalism.[72] Eventually, Baca and her allies developed

FIGURE 1.6. Judy Baca standing before *The Great Wall of Los Angeles*, courtesy of Brian Vander Brug, © 1990

a nonprofit called the Social and Public Art Research Center (SPARC) and did their work under its auspices.[73]

In 1976, Baca directed four hundred young people in the painting of *The Great Wall of Los Angeles*, which theorists Sandoval and Latorre would later depend on in their development of the artivist concept. This mural, depicting scenes from the Spanish arrival in California, the Holocaust, the community exclusion that occurred at Chavez Ravine, and many other episodes from local and world history, was painted on a half-mile concrete retaining wall installed in San Fernando Valley's Tujunga Wash for the purposes of flood abatement.[74] Baca intended the mural to symbolize "interracial harmony" and it also created community healing as well as constituted a new kind of educational programming.[75] By including important chapters of Chicanx history, Baca's Wall offered a new Latino-centered pedagogy for those who worked on, and read, the murals. Baca's direct action—her outreach, teaching, "vandalism," and protest—aligned with the activism of The Brown Berets, a contemporary radical Chicano-rights collective that called for, among other things, the right to bilingual education and a change in public schools that would lead to lessons in the "true history of the Mexican American."[76] Her objectives also converged with those of the Chicano activists who had recently led the '68 "blowouts," that is, walkouts, of East LA schools to protest unequal educational opportunities for Latinos.[77] In addition, her work with

youth offenders represented an early call to replace systems of mass incarceration with public programs aimed at education and public health.[78] Baca's activism was thus prescient and much needed, particularly as it came during the era when prison populations began to see extraordinary increases and the Supreme Court decided in 1973 that education is not a fundamental federal constitutional right.[79] We can still hear the echoes of her message in the modern movements to defund the police and obtain the equality in public education that is mandated by some state constitutions.[80]

The Legacy of Artivism in the '60s and '70s

The work of Ono, Ringgold, Johnson, and Baca in the '60s and '70s demonstrates that this first named generation of artivists invented a constellation of moves that merged art and direct action. Women of color and queer and trans of color artists embarked upon street protests of racism and homophobia that contained aesthetic or performative elements, as in the case of Johnson and Ringgold. Other actions, such as Ono's and Baca's, engaged theater performances that were also protests, or mural painting that was also vandalism, to wage a protest against rape culture, colonialism, unequal educational opportunities, and mass incarceration.

Regardless of the way these creatives' artivism manifested, Ono, Ringgold, Baca, and Johnson offered critiques of law that mirrored and enhanced the claims of contemporary social movements and expressed altogether new visions of legal rights. Ono's *Cut Piece* obliquely studied the force and consent elements of rape law and simultaneously looked to the future of intersectional feminism.[81] In addition, just as lawyers and activists argued that the Vietnam War constituted an illegal aggression and invasion, Ono's performance offered scathing insights on the history of Western imperialism generally and the US occupation of Vietnam. Similarly, Ringgold's WSABAL organization helped lay the groundwork for the social and legal recognition of race and gender intersectionality and the need for art world and workplace inclusion. Her co-curation of the *People's Flag Show*, and her graphics work on its poster, also synchronized with the civil rights and antiwar protests that ushered in new legal arguments about the invalidity of the Vietnam War and the reach of the First Amendment.

Johnson's work as a poet, performer, housing activist, and protester formed an early, intersectional call for trans recognition by the queer community, trans rights,[82] and an end to police brutality by paving the path for the modern understanding that Black Trans Lives Matter and Supreme Court decisions that created protections for queer and trans people. Baca's direction of historical mural-making

resisted educational discrimination, which was the constitutional order of the day. As in the case of Ringgold, her opposition to law enforcement looked back to the lawbreaking of Bentley and Catlett. It also helped create strategies that would resonate with future social movements that demand the end of the carceral state and the diversion of resources from prisons to community programs.

These leaps forward came about during a period when women of color, queer of color people, and their intersections, found themselves inspired by the new forms of protest ushered in by the civil rights and antiwar movements. The 1980s and 1990s would see the revolutionary work of Ono, Ringgold, Baca, and Johnson built upon by a new generation of artists who continued to reckon with state and private violence and inequality.

Artivism from the 1980s to '90s: Howardena Pindell, Assotto Saint, and Charlene Teters

Artivists operating from the 1980s to the turn of the century confronted a vast array of political and legal shocks that would inspire a deepening of the practices inaugurated in earlier decades. After his election in 1980, Ronald Reagan slashed the funds of social programs, which helped bring on the "post-Civil Rights Era," wherein "any gains... were reversed and African Americans and others... were worse off as a group in the 1990s and 2000s."[83] The early '80s saw the beginnings of the HIV/AIDS crisis, which the US government responded to initially with silence and inaction, and later panic, scapegoating, and violations of human rights. Further, Native Americans in the United States took part in protests that not only battled against the taking of tribal lands and the strangling of self-determination but also fought against racist characterizations. Poets, theorists, and activists resisting these oppressions included Audre Lorde, bell hooks, Barbara Smith, Cherríe Moraga, and Gloria E. Anzaldúa. As in the '60s and '70s, women of color and queer of color artivists also shaped the social as well as legal debates of the time.[84] In this section, I focus on the art-activism of Howardena Pindell, Assotto Saint, and Charlene Teters and examine how they extended the tradition of artivism begun by the likes of Bentley, Catlett, Ono, Ringgold, Johnson, and Baca.

Howardena Pindell's Monitoring of Art World Racism

From the 1960s to the present day, the African American artist, curator, and educator Howardena Pindell has executed a broad body of work, including video and other forms of visual art that combine her training as a painter with a talent for mixed media and photography as well as acute racial and political

critique.⁸⁵ Born in Philadelphia in 1943 and raised in the South, Pindell experienced firsthand the pain of racial segregation and was twenty-one years old when the Civil Rights Act passed.⁸⁶ A Yale MFA now represented by New York's Garth Greenan Gallery, Pindell's reputation arises from such powerful pieces as the 1980 video *Free, White and 21*, where she describes and enacts the destructive effects of white supremacy, as well as *Art Crow/Jim Crow* (1988), an artist's book that juxtaposes the "whites only" signs of the Jim Crow era with the contemporary whites-only lineups of thirty-five major art galleries in New York.⁸⁷

Pindell's most famous gestures of direct action relate directly to the concerns evinced in those artworks. In 1987, a year before she created *Art Crow/Jim Crow*, Pindell confronted the difficult emotions that were inspired by the art world's racial segregation, which she had witnessed for the past twelve years as the first Black female curator at the Museum of Modern Art.⁸⁸ Pindell became active in MoMA's union (which was the first union of its kind) and picketed but found herself in an intractable political situation: "Everyone was mad at me: the artists on the outside who wanted me to help them get into the museum, and the people on the inside who were mistrustful of artists and me in particular," as she later told an interviewer about that time.⁸⁹ Through the '70s, Pindell had protested art

FIGURE 1.7. Howardena Pindell, taken in 1989 or 1990, courtesy of the artist and Garth Greenan Gallery, New York

world racism, sometimes sending anonymous letters to arts institutions signed "The Black Hornet."[90] A watershed political moment had arrived in 1979, when the venue Artists Space held a Donald Newman show titled *The N----- Drawings*. Pindell and her colleagues protested outside of the gallery and she and colleagues such as Lucy Lippard and Faith Ringgold sent a letter of complaint, but were dismayed when critics and historians like Rosalind Krauss, Douglas Crimp, Roberta Smith, and Craig Owens came to the defense of Artists Space and Newman.[91] Pindell quit MoMA soon after and began teaching at Stony Brook University and cofounded the woman-identified artists' gallery A.I.R.[92] while deliberating the extent and meanings of racial exclusion in the art world.

In the 1980s, Pindell brought together her arts and activists practices in a new formulation, which saw her writing a testimony about the art world's racism and pairing it with a statistical analysis of "[art] exhibition patterns in both the private and public sector for 1986–87."[93] Pindell's report, titled "Art World Surveys," came at a time when government and civilian statisticians monitored a host of racial injustices in the United States, from the failures of Black farms to the rise of anti-Asian violence to discrimination against Black students in education.[94] Her observational approach also reflects the 1960s innovations of the Black Panthers, who surveilled the actions of California police officers to guard against police brutality, and the protesting aspect of her work looks back to actions such as the '69 Black Emergency Cultural Coalition (BECC) "Harlem on My Mind" demonstration and Faith Ringgold's WSABAL labors.[95] Pindell's scrutiny of museum and gallery representation practices uncovered the widescale effects of white supremacy in the arts, revealing that thirty-nine major New York galleries—including Leo Castelli, Mary Boone, Pace/MacGill, and Paula Cooper—were "100% white" and that museums like the Guggenheim and the Metropolitan Museum of Art also overwhelmingly represented the work of white artists.[96] In the "Testimony" section of her report, she wrote:

> The art world will state that 'all white' exhibitions, year after year with few and far between occasional tokens in both the public and private sectors and ghettoized, segregated art communities tangent to the so called 'mainstream' are not a reflection of racism. The lie or denial is cloaked in phrases such as 'artistic choice' or 'artistic quality' when the pattern reveals a different intent. . . .
>
> When I called Volunteer Lawyers for the Arts concerning racial discrimination in galleries, public institutions and relative omission from the art magazines I was told that artists are independent contractors and have no rights under Title 7 [of the Civil Rights Act]. "You cannot

prove racism when it comes to 'artistic choice.' And if you can prove it is racism, 'So what!' There is nothing you can do about it." This individual used the same argument when referring to women trying to prove discrimination.⁹⁷

Pindell's revelations were profound. The *Boston Globe* and the *Philadelphia Inquirer* wrote about the study soon after it was completed and Maurice Berger's foundational 1990 essay *Are Art Museums Racist?* depended on her research.⁹⁸ Artists and scholars such as Adrian Piper and Kirsten Pai Buick have since reflected on how Pindell's study changed the arts ecosystem and raised their consciousness on matters of racism and sexism in the art world.⁹⁹ Pindell's report continues to have such traction that it is available on the website of Chicago's Museum of Contemporary Art and featured in the catalog of the Brooklyn Museum's 2017 show "We Wanted a Revolution: Black Radical Women, 1965–86."¹⁰⁰

Pindell's monitoring also had legal significance that reached both back in time as well as forward. Her report built on the artivism of Lois Mailou Jones, who broke the Corcoran Gallery of Art's rules by submitting to one of its shows despite a color bar, as well as the BECC's and Ringgold's prior actions concerning museums' lack of Black and intersectional representation. This line of protest insisted that artists of color be hired on equal terms as white people and placed a responsibility on arts institutions to administer their holdings in ways that are consistent with justice. Today, the Civil Rights Act of 1964 has not been held to require parity in arts institutional collections as a matter of either employment law or equal accommodations and devising a right of gallery and museum inclusion based on public trust principles persists as a theoretical undertaking.¹⁰¹ It remains conceivable, but not wholly probable, that anti-discrimination statutes can interfere with white-centered gallery and museum collection missions.¹⁰² Still, Pindell's report contains "law talk"—which is just what it sounds like, talk about law that can build into legal reform and social change¹⁰³—that helped to lay the foundation for minority artists' current attempts to resist their limited legal and institutional options by calling out art world abuse in language and gestures that echo the equitable goals of civil, human rights, and labor laws. This work involves protests around museum and gallery norms, such as found in Black women artists' recent critiques of the 2022 Wisconsin Triennial's contracting and inclusivity practices, Decolonize This Place's demands that the Brooklyn Museum renounce bias, Strike MoMA's lambasting of the Museum of Modern Art's canon-making and anti-Blackness,¹⁰⁴ and the escalating trend toward museum and gallery unionization.¹⁰⁵

Assotto Saint's Poetic Resistance on the Part of Haitians Detained in Guantanamo Bay

The queer Haitian American artist Assotto Saint possessed a diverse and energetic practice. Born Yves François Lubin in Les Cayes, Haiti, in 1957, Saint moved to New York in 1970, and, in 1980, took the name Assotto Saint in homage to his hero, Toussaint L'Ouverture.[106] Saint worked as a poet, essayist, organizer of writing collectives, publisher, rock singer, and, from 1973–1980, as a dancer with the Martha Graham Dance Company.[107] Testing positive for HIV in 1987, Saint became a part of the HIV/AIDS activist organization ACT UP in the early 1990s.[108] Saint's life, activism, and body of work covered a large territory. In this profile, I focus on how his poetry, essays, performance, and activism, which addressed queer identity, HIV plus status, Haitian politics, and the culture of the Haitian diaspora, coalesced in a remarkable speech that he gave at the Superior Court of the District of Columbia on April 28, 1993.

In 1993, the thirty-six-year-old Saint had already honed a passionate style of performance and writing. Photographs reveal a man with a magnetic stance and a flair for assembling elegant and eye-catching outfits, including items such as robes, scarves, silver jewelry, veils, dresses, and bright shirts.[109] Moreover, the rare available films of Saint's poetry performances reveal his eloquent, choreographed speaking style.[110] Saint's texts proved just as riveting. In poems such as "Heart and Soul," Saint addressed his intersectional identity by musing on the two pins—one of the Haitian tricolor, the other of the queer rainbow flag—that he had attached to his backpack: "One unfurls the future of the queer nation/the other salutes african ancestors," he wrote.[111]

FIGURE 1.8. Assotto Saint in New York in 1987, photo by Robert Giard, © The Estate of Robert Giard

Saint's commitments to his Haitian roots coexisted with his criticism of his homeland's culture and politics. In his early work, he wrote of homophobia in Haiti and his fears of its tyrannical president, François Duvalier. In the essay "A Memory Journey," Saint describes the pain of being branded a "masisi" (a slur for a queer person), noting that "the word to this day sends shivers down my spine."[112] Saint soon directed his critical eye at his adopted nation, excoriating the Supreme Court's *Bowers v. Hardwick* (1986) decision, which upheld the criminalization of same-sex intimacy, and President Bill Clinton's "Don't Ask, Don't Tell" Defense Directive, which required queer military members to remain closeted.[113]

But it was Saint's work with ACT UP that allowed him to pour his creative energies into direct actions against a US government that compounded its crimes against queer people by neglecting and ignoring the HIV/AIDS crisis.[114] His efforts with that organization reached an apex in the early 1990s, the period when the United States ran Camp Bulkeley, a detention center at Guantanamo that held 310 Haitian women, men, and children, many of whom were HIV positive.[115] The history of Camp Bulkeley and its ultimate closing is a tale of activist lawyers and social movement agents working in tandem to shock the conscience of the nation and its courts.[116] By 1992, ACT UP became part of that project, protesting the detentions by staging an action in front of the INS's Varick Street Center in Manhattan.[117] It is not clear from the historical record whether Saint was present at that protest, but he did get arrested for a similar act of civil disobedience shortly afterwards. On April 28, 1993, Saint appeared at the Superior Court of the District of Columbia, where he answered for a charge, which I cannot discover, that issued from his agitations against the detainees' treatment. At that hearing, Saint made a speech that merged with his talents as a creative writer and poet. Just as Saint's lyrics resound with anger and grief, his courtroom address reveals his ability to elicit emotion by his evocation of the departed, even as he delivered a galvanizing vision of equal protection law, immigration law, and universal health care. It is too bad that we do not have footage of his allocution, so we might see whether and how he wove his performative talents into his pronouncement. We are lucky, however, that after Saint made his declarations to the court, he wrote down his statement and offered it as a work of literature:

> Your Honor, my life-partner & I. . . . both strongly believe[] that every individual in this country, no matter what socioeconomic background he or she belonged to, deserves access to the best health care.
>
> My illegal yet constitutional action this past Monday morning, to which I unashamedly plead guilty, was done on behalf of all the HIV-positive Haitians who have been granted political asylum in the United

States, but are being detained unlawfully & immorally at Guantanamo Bay. It was done on behalf of my late activist friend Ortez Alderson. It was done on behalf of my life-partner, Jan Urban Holmgren.

May the memory of their suffering, due to the inadequacy, greed & stupidity of bureaucrats, finally bring much needed transformation to our health care system.[118]

Saint lived long enough to see his protest bear fruit: On June 8, 1993, Camp Bulkeley was ordered to be closed by Judge Sterling Johnson Jr. on the grounds that the statutory and constitutional rights of the detainees had been violated. The Haitian refugees imprisoned there were released.[119] Though I haven't found Saint mentioned in modern histories of this legal and human rights battle, his artivist act in 1993 was a part of that victory.

Charlene Teters's Artivism against a Native American Sports Mascot

In 1988, Charlene Teters, an artist and a member of the Spokane tribe in Washington State, matriculated in the University of Illinois at Urbana-Champaign's art and design program. Only a few weeks into the term, Teters noticed that sororities and fraternities held events that revolved around a grotesque caricature of Native Americans called "Chief Illiniwek," the university's mascot. Sorority members would wear feather headdresses when drinking in bars decorated with posters showing Chief Illiniwek's "big belly and an exaggerated sized nose" and neon signs showing a Native person "falling down drunk."[120] Soon after, Teters took her two children to a university basketball game, where they were surrounded by white people wearing "war paint" and holding tomahawks. The breaking point came when a white student appeared in the guise of Chief Illiniwek and did a mock Native American dance, the eagle feathers of his headdress blasphemously touching the ground as he clowned around.[121]

Troubled by the pained reactions of her children, Teters arrived at the next game holding a hand-painted sign that read "American Indians are human beings, not mascots." From this protest bloomed Teters's new life as an artivist who would fight the prevalence of racist mascot culture out of the conviction that its tropes led to physical and psychic harm. Her activism was of a piece with other contemporary social and legal movements that sought to regain Native territory, resources, and self-rule and eliminate sexist and racist iconography and hate speech.[122] Her efforts came at a great cost, as she received "hateful" phone calls, vandalism of her mail, drive-by harassment at her home, and debris left on her lawn.[123] Teters nevertheless continued her fight. In the

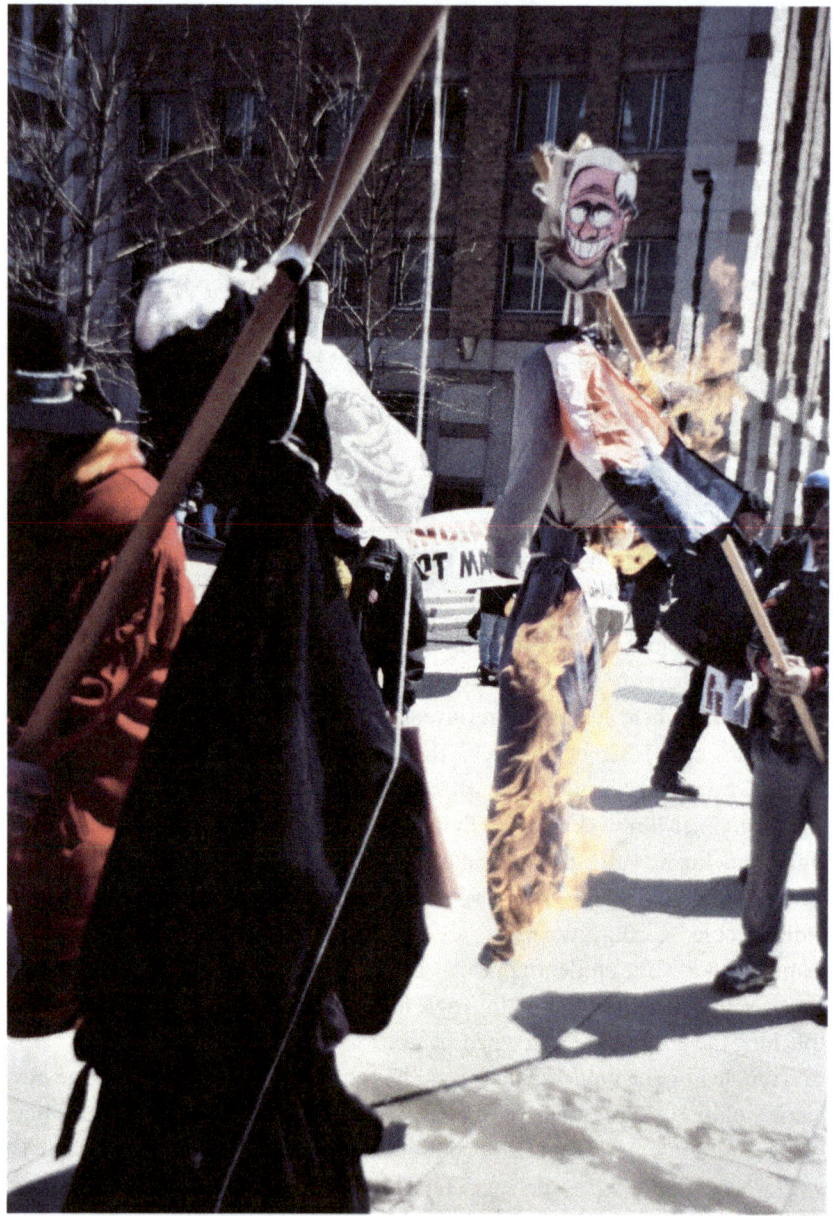

FIGURE 1.9. One of the Chief Wahoo Protests, © James Fenelon 1998

1990s, she began teaching at the Institute of American Indian Arts in Santa Fe and formed The National Coalition on Racism in Sports and the Media (NCRSM).[124] All the while, she continued agitating against the Chief Illiniwek caricature and brought her protests to major sports stadiums that hosted the

Cleveland Indians, the Washington Redskins, the Kansas City Chiefs, and the Atlanta Braves.[125]

The next year saw Teters engaging in direct action that brought together her activism and her work as a maker of art objects. It also announced her as a legal change-agent. In a protest that recalled Faith Ringgold's orchestration of flag burning at the *People's Flag Show*, Teters organized a protest-performance outside of Ohio's Jacobs Field sports arena (today known as Progressive Field). Occupying a cordoned-off area, and flanked by police officers, she and other activists burned a scarecrow-effigy that they had built of the Cleveland Indians' "Chief Wahoo" mascot.[126] The effigy—or sculpture—was crafted out of a shirt and trousers, stuffed with newspaper, had a "head" upon which was affixed the ugly visage of "Chief Wahoo," and bore a small cape made out of the American flag on its shoulders.[127] The protesters also burned an image of "Sambo," the reviled Black caricature, to express "outrage" over the widespread use of racist iconography.[128] Police arrested Teters and her fellow protesters but then released them without other incident. The activists responded by filing a complaint against the arresting officers, the police chief, and the city of Cleveland for deprivation of their First Amendment freedoms under the color of law.[129] *Bellecourt v. City of Cleveland* made its way up to the Ohio Supreme Court, which found that the burning of effigies qualified as constitutionally protected speech but that the arrests remained valid because they furthered the important government objective of maintaining public safety under the four-part test announced in *United States v. O'Brien*.[130] While Teters did not win her case, her activism, arrest, and appeal shed light on how constitutional law's penchant for complex tests appears to guarantee certainty and equality but may only create a facade that hides sloppy and racist rulings, since the protest had occurred in a controlled environment.[131]

Teters spent the remainder of the 1990s merging her activism with her arts practice, exhibiting installations that criticized Native appropriations and slurs in various galleries and museums.[132] She would have to wait decades before seeing the fruits of her labors. The University of Illinois retired Chief Illiniwek in 2007 and the Cleveland Indians retired their name, mascot, and regalia between 2018 and 2021.[133] Nevertheless, despite these triumphs, Teters's activism continues to exert a gadfly influence on jurisprudence, as *Bellecourt v. City of Cleveland* remains good law.

The Legacy of '80s–'90s Artivism

The work of creatives like Pindell, Saint, and Teters helped artivism evolve during the first concussions of the Reagan presidency, the rise of neoliberalism, and the decades that followed. Saint's and Teters's practices demonstrated that rule

and lawbreaking remained a part of the toolkit of artists seeking social change, and they formed a lineage with artist-activist outrages such as Faith Ringgold's solicitation of illegal flag burning, Marsha Johnson's participation at Stonewall, Elizabeth Catlett's drive to the museum, and Gladys Bentley's "obscene" show and queer wedding. Pindell's criticism of arts institutions grew from Ringgold's WSA-BAL actions and connected to Yoko Ono's *Cut Piece* and Judy Baca's *The Great Wall* in its race-justice revelations. Like Johnson, Saint employed both personal presentation and the spoken word to create queer visibility in an age when state violence threatened the group's survival and manifested how race and queerness created exigent vulnerabilities that have constitutional dimensions. And Teters's use of handcrafted items in her protests also recalls the handicraft and handwork seen in Johnson's outfits and Ringgold's *People's Flag Show* poster.

Like the artists that came before them, Pindell, Teters, and Saint created work that saw them interacting with communities, institutions, and courts while creating critical readings of law. Pindell's art world survey contained law talk about illegal discrimination and helped build the path for modern assaults on racist and colonial museum and gallery practices. Saint marshaled his poetic gifts to take a stand against queerphobia and the HIV detention centers for Haitians in the DC Superior Court and extended a radical vision of equal protection and health care rights. Teters waged against racist speech in protests that would take forty years to create change and helped develop First Amendment law that revealed how constitutional protections can sometimes amount more to illusion than reality.

Artivism from the 2000s to the Present Day

As the new century crested, women of color and queer artists faced a plethora of crises, old and new. Starting in the early 2000s, such artists confronted the long-term impacts of chattel slavery, global warming, housing and economic inequality, and queer- and transphobia. They also faced the problems and gains of the Obama administration and Donald Trump's depredations in the regions of immigrant rights, the environment, and voting rights.

The artivist tradition, now firmly grounded in the earthworks laid by women of color and queer of color artists working from the 1930s onward, gained an upswell of energy and participants who would go on to change not only the history of art but also challenge the fundaments of law itself. In the following chapters, I limn the stories and work of five twenty-first-century artivists and artivist groups who create radical critiques of law with their work and direct action. My first profile will be of Carrie Mae Weems, who took photographs of the infamous "slave daguerreotypes" at Harvard's Peabody Museum, broke a

contract with the university, and thereafter initiated a legal crisis that called in to question the essentials of copyright and property law. Following that, reflections on Young Jook Kwak's leadership of the queer arts collective Mutant Salon will reveal that "safe spaces" can be understood as a queer fundamental right if we are to maintain the survival of LGBTQI people but also show how the law deploys a multiplicity of weapons to defeat access to these havens. Next, I delve into the work and life of Tanya Aguiñiga in a profile that studies her performances of the trauma created by immigration law and her readings of the border as a place that today sees violations of US disability antidiscrimination law. Following that, I examine the actions and art of Imani Jacqueline Brown, whose work with the anti-gentrification arts collective Blights Out indicates a new reading of Fifth Amendment law that maps directly onto a federal appeals court decision declining constitutional property rights to Black and other people in New Orleans. Finally, I recount my own participation in a woman and queer-of-color collective that has dedicated itself to tackling the problem of inequitable artists' contracts.

2

FROM HERE I SAW WHAT HAPPENED AND I CRIED

Carrie Mae Weems's Challenge to Copyright and Property Law

In the early 1990s, New York artist Carrie Mae Weems traveled to Harvard University's Peabody Museum of Archaeology and Ethnology to see some storied photographs. Entering the archives, she signed a contract promising not to use any Peabody images without permission. She next found herself staring down at the daguerreotypes of a miserable, dignified, and stripped-naked man and woman named "Renty" and "Delia," who had been enslaved in 1800s South Carolina. These two pictures, as well as the images of fifteen other enslaved people, had been commissioned from photographer J. T. Zealy by Harvard ethnologist and Harvard zoology museum founder Louis Agassiz in the nineteenth century.[1]

As Weems already knew from previous study, Agassiz's suite of pictures had been undertaken to prove his very own "son of Ham" theory of "separate creation."[2] In an era beguiled by the claims of racist science, which saw the US anthropologist Samuel George Morton collect and measure human skulls and the Swiss-American geologist Arnold Guyot pontificate about the effects of climate on the moral faculties of people of color, Agassiz promoted "polygenesis," a philosophy maintaining that God had created the races as entirely separate species, endowing some with masterful gifts and others with only servile capacities. Agassiz attempted to prove his theory with the aid of Dr. Robert W. Gibbes, a paleontologist who enjoyed close friendships with South Carolina slaveowners.[3] Together, the two men hired Zealy to document enslaved people handpicked by Agassiz off a plantation—beyond Renty and Delia (who were father and daughter), this group also included a man named Jack and a woman named Drana.[4]

FIGURE 2.1. Carrie Mae Weems, courtesy of Lars Niki, © 2017

Zealy took one set of images showing the subjects full length and nude and a second set that focused on their heads and torsos.[5] The daguerreotypes revealed outrage and fear in Renty, Delia, Jack, and Drana's faces, and their clothing, pulled down over their chests, was in disarray. Yet, for all of Agassiz's machinations, he never publicized the pictures. After Charles Darwin's *On the Origin of Species* invalidated his polygenesist fantasies in 1859, he stored the trove away. Years later, Agassiz or his son Alexander donated the images to the museum.[6] The daguerreotypes remained in an attic of the Peabody until Harvard researcher Elinor Reichlin rediscovered them in 1976.[7]

Weems realized that in Agassiz she had discovered the Ivy League equivalent of Josef Mengele or Harry Laughlin. She also knew that Harvard's ownership of these images was problematic. Harvard didn't do much to distance itself from Agassiz and his crimes but instead named at least one building after him, the Louis Agassiz Museum of Comparative Zoology.[8] Further, Harvard hadn't made a sufficient effort to atone for its participation in slavery by educating and hiring Black people: in the mid-1990s, Harvard's Black student population was only around 7.2 percent and Black professors comprised 2 percent of the Harvard faculty.[9] Even as Weems studied the daguerreotypes at the Peabody, the university continued to benefit from slavery and its defenders. Not only had Agassiz founded the university's zoology museum; it was common knowledge during this time that Harvard's law school had been founded by the slaveowner Isaac Royall Jr., and the Royall crest served as the law school's symbol.[10] Eventually, the injustice of the daguerreotypes' creation and Harvard's dominion over them

appear to have persuaded Weems to break the university's rules as well as the law of contracts. Though the artist had signed Harvard's restrictive agreement, she violated it by unilaterally photographing the daguerreotypes and, without seeking the school's permission, including these copies in her 1995–96 photo series *From Here I Saw What Happened and I Cried*. In this work, Weems displayed the images of Renty and Delia as well those of Jack and Drana. She enlarged the images, shaped them in tondo portraits (which are oval), and tinted them red. She emblazoned Renty's profile image with text that read "A Negroid Type," and Delia's with the phrase "& A Photographic Subject." She accented Drana's profile image with the white boldface words "You Became a Scientific Profile." On Jack's, she scrawled over "An Anthropological Debate." Weems then combined this quartet with twenty-nine other appropriated pictures, such as a famous albumen silver carte de visite showing the scourged back of an enslaved man named Gordon and a snapshot revealing expatriate chanteuse Josephine Baker in a pensive mood.[11]

In short order, Harvard threatened to sue Weems. Its administrators argued that Weems had violated their copyright to the Agassiz daguerreotypes and that she broke her contractual promise not to use images taken in the Peabody without Harvard's permission.[12] Weems later spoke about the imbroglio in the 2009 documentary series *Art in the 21st Century* (*Art 21*), confessing that she felt flabbergasted by Harvard's response: "I thought, *Harvard's* going to sue me for using these images of Black people in their collection. The richest university in the world." Weems spent considerable time "worrying about it and thinking about it" and then issued a remarkable response. "I think that I don't have really a legal case, but maybe I have a moral case that should be carried out in public," she told university representatives. "I think that your suing me would be a really good thing. You should. And we should have this conversation in court. . . . I think it would be instructive for any number of reasons, and certainly for artists who are engaged in the act of appropriation, and who think that there is a larger story to tell." Weems won this staring contest when Harvard blinked. It backed down from its litigation threat and only demanded payment whenever Weems sold a cell. Harvard administrators also, as it happens, purchased the images for its art museum. In the 2009 documentary, Weems called this result "confusing."[13]

Harvard's oblique way of handling Weems seemed half a concession and half an arrogation. But Weems's provocation presented Harvard's ownership of the daguerreotypes in a startling new light. Her rebellion inspired an important question: Despite the evident limitations of copyright law, do Black appropriations artists own claims over the daguerreotypes because those artists are entitled to "tell" the "larger story" behind the images? Weems's rejection of the contractual terms also raised a second set of inquiries: Viewed either from a legal

or moral angle, did Harvard even own the daguerreotypes, which would help clinch their (lapsed) copyright and contract claims? Or should we regard these photos as property belonging to the descendants of Renty and Delia, or maybe all African Americans?

In time, Weems's evolving interactions with Harvard, as well as her personal choices and statements, indicated that she was mostly concerned with the first question: Though Weems's relationship with Harvard reached its nadir when the university threatened to sue her, it eventually defrosted, and the artist and the school even developed a partnership of sorts. In 2019, twenty-five years after Weems first visited the daguerreotypes at the Peabody, Harvard embraced Weems's appropriations art by giving her star status at a high-profile conference and commissioning her to publish a sixty-one-page photography spread in a controversial book that portrays the university as not only the rightful, but also the ethical, owner and steward of the daguerreotypes. At the same time, Weems appeared to drop any position that cast the institution's ownership of the images as illegitimate, since she refrained from criticizing Harvard's continuing custody of the daguerreotypes and participated in both the conference and the book publication.

Nevertheless, Weems's breach of her contract and unflappable reaction to Harvard's litigation threats grew into a magnetic chapter in the history of woman of color artivism, since it employed rule-breaking, civil disobedience, litigation courtship, and protest. Like artivists who came before her, Weems's joining of her art practice with direct action possessed legal meaning: her confrontation with Harvard created new readings of US copyright and property law. Further, Weems's 1990s gesture unexpectedly (and, it appears, unintentionally) gave rise to another signature of artivist practice: collaboration. While Weems eventually developed a rapprochement with Harvard, other observers of Weems's disobedience continued to fight with the university. In the latter half of the 2010s, Tamara Lanier, a direct descendant of Renty and Delia, first learned of Weems's transgression when she read a 2012 article that I published in *Unbound: The Harvard Journal of the Legal Left*, wherein I described the artist's confrontation with Harvard and argued that the daguerreotypes were the fruits of robbery.[14] Contemplating Weems's decision to break her contract and her mid-1990s readiness to ventilate the issues of race, property, and injustice in court, Lanier wondered whether Harvard actually owned the daguerreotypes that had been obtained through Agassiz's and Zealy's violence. Lanier, who had been unsuccessfully lobbying Harvard to recognize her as Renty and Delia's descendant since 2011, sued the university for the return of the daguerreotypes.[15] Lanier's challenge drew international attention and eventually found its way before the Massachusetts Supreme Judicial Court.

In this chapter, I sketch Carrie Mae Weems's life, art, engagement with the Descendant/Lanier daguerreotypes, and the legal implications of her direct action. The artist's insubordination in the 1990s evolved into a unique collaboration that cast artivism and its practice in a new light. It also raised radical insights about the Copyright Act and initiated a dialogue about US property law in the wake of slavery that reached the highest court in Massachusetts and continues to be felt to this day.

The Life and Art of Carrie Mae Weems

Weems is an Oregon baby, but before her family landed on the West Coast they worked as sharecroppers in Mississippi.[16] As a young artist, she first studied modern dance in San Francisco, learning the body-morphing forms first styled by Merce Cunningham and Paul Taylor and set to the blendered cacophonies of John Cage. Her dance practice showcased a stalwart work ethic that supported her financially as she took jobs in restaurants, offices, and factories while she studied choreography.[17] Her experience working with socialist and feminist organizations also garlands her CV during her early years. Yet her attraction to the referential, disassembled movements of modern dance may have proved just as foundational for her adult work practices, which combine political consciousness with appropriations so transfigurative that they qualify as alchemy.

Weems's vision of her life changed at the age of eighteen. That year she first encountered the periodical *Black Photographers Annual* and work by photographers Anthony Barboza, Roy DeCarava, and Adger Cowans.[18] At the age of twenty-one, her first boyfriend gave her a camera; and at twenty-nine, she entered the BFA program at CalArts.[19] After spending the early '80s taking photographs, she seemed to switch gears again by studying folklore at the University of California, Berkeley in 1984. She returned to the visual arts full time, however, and has continued taking photographs until the present day.

Before *From Here I Saw What Happened and I Cried*, Weems was probably best known for her allusive *Kitchen Table Series* (1990), which examines Black subjectivity, emotion, and domesticity through a series of black-and-white images set at a kitchen table. In retrospect, though, Weems's appropriation of what I will hereafter call the Descendant/Lanier daguerreotypes relates the most to other art she made around the time of her fateful visit to the Peabody Museum. Some of Weems's most piquant critical race sampling, for example, may be found in her watershed 1989–90 series *Colored People*. This sequence consists of variously tinted portraits of African American boys, girls, men, and women.[20] In its presentation of headshots of people of color, it borrows from photography innovators

such as Francis Galton, the nineteenth-century eugenicist and mugshot inventor who produced composite photographs of criminals, Jews, sufferers of tuberculosis, and the mentally ill to establish their physiognomic "types."[21]

Weems's *Colored People* takes out a loan from Galton in its play with front and side profile close-up shots. The series consists of monochrome triptychs of repeated headshots of her subjects, some of which she titled *Burnt Orange Girl*, *Magenta Colored Girl*, *Blue Black Boy*, *Golden Yella Girl*, and *Violet Colored Girl*. The images are beautifully tinted repurposings of Galton's grim forensic traditions. Their soft coloring and resolution quote daguerreotypes like Galton's but rebut his brutal schemes by showing boys, girls, men, and women in attitudes of contemplation, happiness, and melancholy.[22]

As far as I can tell, Weems made her first direct appropriations of existing images when she encountered Agassiz's daguerreotypes. The Getty Museum commissioned *From Here I Saw What Happened and I Cried* from Weems, asking her to react to its 1995 show *Hidden Witness: African Americans in Early Photography*. *Hidden Witness* displayed photographs of African Americans from the 1840s through the 1860s owned by the Getty itself as well as the Detroit collector Jackie Napoleon Wilson.[23] Weems assembled a presentation based on thirty prints, which she tinted red and blue and emblazoned with her texts. *From Here I Saw What Happened and I Cried* issued from this show.

From Here I Saw begins with the archival, rectangular photo of a Nubian woman in profile. Cast in a cobalt shade, she gazes on thirty-one crimson-dyed pictures of African Americans from the 1850s through the 1950s or '60s, which include additional appropriated pictures that portray other enslaved people such as Gordon (the man with the whipped back), folks living under segregation, and the meditative specter of Josephine Baker. The series ends with a flipped image of the Nubian observer. As I've already stated, the Descendant/Lanier daguerreotypes inhabit the first four stations of the series.

Weems's decision to appropriate the four daguerreotypes in *From Here I Saw* by photographing them at the Peabody and then violating her contract with Harvard participated in two artistic traditions. The first is appropriations art, which consists of artists making work out of existing images or other records. Marcel Duchamp is perhaps the first and most famous of this group of artists, as he appropriated a urinal and transformed it into a work of art in *Fountain* (1917). Andy Warhol's 1960s-era-appropriated images of Marilyn Monroe and his doctored portraits of Campbell Soup cans are other widely known predecessors. In the 1970s and 1980s, feminist artists commandeered appropriations as gender and class critiques of the state and the art world. In 1979, Sherrie Levine used tear-outs from magazines in her *President Collage 1*, which showed a woman inhabiting George Washington's mind.[24] In 1988, Louise Lawler took

a photo of Andy Warhol's *Gold Marilyn Monroe* on the auction block, creating a work that reflected on gender, genius, authorship, and the art market.[25] Some critics, while not dismissive of these audacious acts, described them as "steal[ing]."[26] Appropriations were becoming a recognized arts practice, but their legal risks grew evident at least in 1992, when the rap group 2 Live Crew was sued for copyright infringement after sampling the Roy Orbison song "Oh, Pretty Woman" and the Sixth Circuit Court of Appeals held that the infringement wasn't defended under the doctrine known as fair use.[27] That decision was reversed by the Supreme Court in 1994, in an opinion that nevertheless emphasized that copyright infringement depended on how much an appropriator sampled of an original work.[28]

When Weems waded into these perilous waters to study the legacy of US slavery and racism, she announced that she had not only joined the ranks of appropriations artists but had also entered artivist territory. By appropriating the entirety of the daguerreotypes she risked being taken as a "thief" by the art world or, perhaps worse, as an infringer under the Copyright Act.[29] As a feat of rule-breaking, Weems's gesture recalls the rebellion of Lois Mailou Jones, who, in the 1940s, had broken the rules of the Corcoran Gallery of Art by having a white friend submit a painting to its show to evade its color bar. Like Jones, Weems broke the rules of the art and museum worlds for the purposes of social and racial critique, as well as to gesture toward racial reparations, a concept that many considered impossible-to-shocking in the mid-1990s.[30] But of even greater danger to herself than mere rule-breaking was Weems's breach of her contract with Harvard, "the richest university in the world." I am framing Weems's contract breach as an act of civil disobedience that resides within the larger category of direct action, though her gesture bears some dissimilarities from classic acts of civil disobedience. Unlike traditional examples of civil disobedience—for example, Rosa Parks's decision to break the law of Montgomery, Alabama, by refusing to yield her seat to a white man—Weems does not appear to have set out to violate her contract with Harvard from the beginning of her engagement with the university. From all available facts, she decided to commit a breach once she had emotionally processed Harvard's jealous possession of the daguerreotypes and considered the school's role in Renty and Delia's abuse and enslavement.[31] Regardless, when Weems broke her contract, she acted from her conscience, broke the law, and faced down threats of punishment, which are all signatures of civil disobedience according to Dr. King.[32] As such, Weems finds herself in the company of artivist ancestors such as Gladys Bentley, Elizabeth Catlett, Marsha P. Johnson, Faith Ringgold, and Assotto Saint, who committed acts of civil disobedience that were integral to their art. Weems's stoicism in the face of Harvard's lawsuit threat and hope to "have this conversation in court" also aligns her with Charlene Teters,

who insisted on conducting such a conversation about race justice in *Bellecourt v. City of Cleveland*.

Like other artivists, Weems's direct action created legal meaning. But what, exactly, were her critiques of the law? When Weems invited Harvard to sue her, was she claiming that she possessed a right under copyright law to use the images because the crime of slavery and the concept of reparations entitled her to do that? Or was she making a case that is even more unsettling, as it has the potential to unravel the current system of property ownership in this country—that the physical objects themselves did not belong to formerly slave-holding Harvard and its slave-abusing professor, and so, in the absence of an identified "true" owner, she could do what she pleased with them?[33]

Weems, Copyright's "Fair Use" Doctrine, Power Dynamics, and Race

As we recall, when *Art 21* interviewed Weems, she remembered her own shock at being threatened with a lawsuit by Harvard. "I thought, *Harvard's* going to sue me for using these images of Black people in their collection. The richest university in the world." Weems went on to say that she thought she might not have a legal case but did have a moral one, and so the university *should* sue her because "I think it would be instructive for any number of reasons. And certainly for artists who are engaged in the act of appropriation, and who think that there is a larger story to tell."[34]

In this statement, Weems suggested that her privilege to use the images was based on Harvard's tricky ownership of them, her status as an appropriations artist, and her mission and privilege to tell a "larger story." Weems's own racial identity and lifelong mission to eradicate or at least limn the dynamics of racism went unspoken but not unheard. As it turns out, her argument and example connected powerfully with legal theories and rights that were being born at the very same point in history that she was appropriating the Descendant/Lanier daguerreotypes—that is, legal theories and rights concerning US copyright's "fair use" doctrine, which permits a certain degree of appropriation of copyrighted works "for purposes such as criticism and comment."[35] One year before Weems began work on *From Here I Saw What Happened*, the US Supreme Court announced that artists had a right to appropriate copyrighted works when making fun of, or even attacking, those works, in a highly contested case that involved Black defendants. As noted above, in *Campbell v. Acuff-Rose Music* (1994), the Supreme Court cast a beneficent eye on the band 2 Live Crew's jocular and vulgar send up of Roy Orbison's song "Oh, Pretty Woman,"[36] noting that such parodies

don't necessarily steal prior work but can "transform" it, thereby creating the "social benefit" of shedding new light on the prior art's meanings.[37] *Campbell*, nevertheless, didn't create a clear-cut path through the Copyright Act's fair use morass, as the Court remarked that cases would be decided on a "case by case" basis and that the amount of borrowing would influence the analysis.[38]

Seven years later, the Eleventh Circuit, in *Suntrust Bank v. Houghton Mifflin*, upheld African-American author Alice Randall's extensive borrowing from Margaret Mitchell's *Gone with the Wind* in her own novel, *The Wind Done Gone*.[39] There, the court acknowledged that Randall's absorption and transformation of Mitchell's racist saga brought "social benefit" in part because of the later book's excoriation of the former's racism and homophobia.[40] Still, while both *Campbell* and *Suntrust* addressed the rights of Black artists to appropriate art in the service of social and political criticism, neither case conferred upon those artists privileges to take entire works based on the confiscatory and violent ramifications of slavery and modern racial power dynamics or the reparative significance of a Black artist's taking back power, property, and voice through appropriations. Yet Weems, as is indicated in her *Art 21* documentary, was conscious of all those issues when appropriating the Descendant/Lanier daguerreotypes supposedly owned by Harvard University.

This put Weems, in 1995, not only beyond the ken of the high and circuit courts but also ahead of the pace of the most audacious contemporary intellectual property (IP) theorists working in the country. Starting in the early to mid-'90s, scholars began to recognize IP's colonial heritage and Eurocentrism but hadn't yet dreamed of an intellectual property landscape that would privilege takings based on the heritage of slavery and its resulting power imbalances.[41] Scholars who began to recognize how race and class subordination might change the dynamics of IP law in the 2000s include Margaret Chon, Ruth L. Okediji, Madhavi Sunder, Eduardo Moisés Peñalver and Sonia K. Katyal, Anjali Vats and Deidré A. Keller, and Lateef Mtima.[42] By 2018, Anjali Vat and Deidré A. Keller documented the recent tradition of legal theory that wages against the "racial investments and implications of the laws of copyright" as well as other fields of intellectual property law.[43] But, even today, few scholars have rooted the Copyright Act's fair use analysis in the same fertile soil as Weems, who thirty years ago advocated for an expanded right to sample, take, and republish images and other products made of and by enslaved or segregated people as a specific rejoinder to the crime of the enslavement of Black people in the United States.[44]

Yet we might wonder what other terrain Weems sought to claim in her adaptation of the daguerreotypes. Was she seeking to tear the whole system down? Was she convinced that she could use the images because Harvard owned them,

because *she* partly owned them, because Black people generally owned them, or because no one owned them? That is the exciting and troubling question to which I now attend.

Weems and the Nature of Property Ownership in the United States

In 1991, three years before she initiated *From Here I Saw*, Weems created a series titled *And 22 Million Very Tired and Very Angry People*.[45] In this installation, she interspersed images of a globe, an African icon, a book, a rolling pin, an armed man, and a veiled woman with banners bearing direct block quotes from speeches delivered by various leaders, including the following 1964 statement by Malcolm X: "It was our labor that built this house. You sat beneath the old cotton tree telling us how long to work or how hard to work, but it was our labor, our sweat, and our blood that made this country what it is, and we're the ones who haven't benefited from it. And all we're saying today is, it's payday—retroactive."[46]

Weems's inclusion of X's theory of property rights in *And 22 Million* relates intriguingly with her own later decision to unilaterally publish the embellished Descendant/Lanier daguerreotypes in *From Here I Saw*. It indicates that Weems is partial to a view that all US property entitlements, including not only intellectual property, but also chattels (which are forms of property apart from real estate), as well as real property, should be redistributed in keeping with the ethics of Black reparations for slavery, or what X describes as a "retroactive" "payday." Weems's 1990s encouragement of this conception of property law brings us back to the 1805 Supreme Court case of *Pierson v. Post*,[47] which announced a rule that negated X's argument 159 years before it was made by confirming the defining role that capture and dominion play in property rights. In a terse opinion dealing with an anarchic fox hunting expedition, the Court found that these forces drive the designation of property ownership. Specifically, it determined that rights are achieved through physical occupancy and that labor alone does not entitle anyone to any right. The labor theory fell on hard times upon the decision in *Pierson* and has never recovered, despite exhortations such as X's.

Can *And 22 Million People*, *From Here I Saw*, and Weems's decision to violate her Harvard contract together support a reading that advances a radical vision of property rights in the United States? And if so, would this vision help anchor the conclusion that Weems was entitled to appropriate the Descendant/Lanier images because Harvard does not own them? That is, does Weems's artivism "argue" that the daguerreotypes either belong to no one, or that they belong to

artists like Weems, or that they belong to some other Black person because it was Black labor and suffering that "built" them?

Teasing out Weems's artivist legacy on the increasingly pressing question of Harvard's ownership of the daguerreotypes becomes complicated once we consider the relationship that she developed with the university in the years following the administration's threats to sue her. My efforts to contact Weems through her gallery did not result in an interview, and so I cannot offer her own words on this subject. However, the first signs of a thaw in Weems's relationship with Harvard came in 2001, when Harvard introduced Weems's versions of the daguerreotypes into its collection.[48] As Weems noted in her 2009 *Art 21* interview, she found this resolution "confusing," and in that same conversation, she said that thinking back on her struggle with Harvard was like "opening up a can of worms."[49] But fast forward ten years from the *Art 21* documentary, and we find Weems taking star turns in Harvard artistic and intellectual programs, while seemingly withholding criticism of the university: During April 25–27 of 2019, Harvard's Radcliffe Institute for Advanced Study produced a conference titled Vision and Justice, which explored "the role of the arts in understanding the nexus of art, race, and justice."[50] Organized by the scholar Sarah Elizabeth Lewis (who has included my own early scholarship on Weems and the Descendant/Lanier daguerreotypes in a 2021 MIT book on the artist), Vision and Justice featured Weems on a panel with Lewis and architect David Adjaye, where she described her motivations for her work.

During the trio's discussion, Weems remembered that, as a young child, her father had told her to "never forget you have a right to be" and that, as a result, she is "comfortable in the world and . . . in this complex game,"[51] which conceivably could relate to the complexities of her presence at the conference. She also allowed that much of her work has focused on challenging institutions, alluding to her *Museums*, *American Monuments*, and *Roaming* series, which contain suites of pictures showing her standing in front of various important buildings and witnessing them. She said:

> I use my skin, my body, as a way of marking what [these institutions] have historically been—what was inside of them, outside of them, what needed to change in relationship to them, what needed to change inside of them. Institution building were early thoughts, so I've struggled hard and worked hard to get inside of them, to critique them, to understand them, to understand my body in relationship to them, but also to understand the power of these institutions and what they exude by their architecture.[52]

When it came to critiquing Harvard for its history of enriching itself with the proceeds of enslavement or keeping such a tight hold on items such as the Descendant/Lanier daguerreotypes, however, Weems was more muted than she

had been previously, when she had analogized her dealings with the university to opening a can of worms. On the panel, she did seem to, once, venture into that territory in an exchange with Lewis, wherein she said, "we're here critiquing the thing that we're also critiquing," but this offhand partial sentence drifted and was never resolved.[53]

At this same point in time, however, Tamara Lanier, the descendant of "Papa Renty," had already made herself heard on the question of the true ownership of the Renty and Delia daguerreotypes. Lanier had informed Harvard of her direct descent from Renty and Delia as of 2011, and, more than a month prior to the Vision and Justice conference, Lanier had brought an action in Middlesex County demanding the replevin (that is, recovery) of the Renty and Delia images, along with damages, based on the theory that Harvard had unclean hands and Lanier was the rightful owner of the objects.[54] Lanier also sued for the negligent infliction of emotional distress, citing the nausea and insomnia she had endured as a result of Harvard's continual rejection of her claims.[55] As of March 20, the lawsuit had been written about in publications such as the *Washington Post* online, *Reuters*, the *New York Daily News*, and the *New York Times*.[56] If Weems had sought to advance a theory of redistributive property ownership in line with Malcolm X and Lanier, the April Vision and Justice conference would have been the moment. But no such public critiques were forthcoming.[57]

Moreover, in 2020, Weems took part in a publishing project on the "Zealy daguerreotypes" that Harvard jointly embarked upon with the Aperture Foundation (an organization with which I have also worked).[58] *To Make Their Own Way in the World: The Enduring Legacy of the Zealy Daguerreotypes* is a 485-page book on the images and their history, containing nineteen essays by arts, writers, and scholars. The book is beautifully produced and contains many fine works of art criticism, art history, and social inquiry. But at least two of its contributors either directly or obliquely called into question Lanier's claim. Henry Louis Gates Jr., Harvard's esteemed Alphonse Fletcher University Professor and Director of the Hutchins Center for African & African American Research, wrote a piece that acknowledged Lanier's lawsuit but added, "in a larger sense, can any one person be the heir of these photographs, or does the responsibility for them fall to all of us to protect them as archival relics of history, to be studied, pondered, and reckoned with?"[59] Molly Rogers, the author of *Delia's Tears*, the 2010 landmark study of the daguerreotypes, and an editor of *To Make Their Own Way*, asked "Are they the Zealy, Agassiz, or Peabody daguerreotypes?" She also briefly wondered if the images might belong to the "subjects." Without resolving these questions, she suggested that appending the names of the subjects to the images offered an inadequate solution "because names were typically assigned by enslavers."[60]

From personal correspondence with Molly Rogers, I understand that, except for the essay by Gates, most of the writings in *To Make Their Own Way in the*

World had been finalized by 2018, a year before Lanier filed suit in Middlesex.[61] Yet Lanier's claims of ancestry were well known to Harvard as well as to Rogers (who had once met with Lanier in 2010 or 2011) by that time.[62] Further, since 2012, or at the latest 2014, Weems had probably been aware of arguments that her work could be read as supporting a case that Harvard did or should not own the daguerreotypes: In 2012, the artist gave me permission to reproduce images from *Here I Saw* for the article I wrote on just that topic for the *Harvard Journal of the Legal Left*, titled "From Here I Saw What Happened and I Cried: Carrie Mae Weems' Challenge to the Harvard Archive."[63]

Seen in this light, and when juxtaposed to her muffled or nonexistent critiques of the university during her Vision and Justice panel, Weems's contribution to *Make Their Own Way in the World* does not continue her artivist challenge to Harvard's dominion over the daguerreotypes, though she does confront the history of slavery, dispossession, and South Carolina in powerful ways. For the book, Weems created and collected images for a sixty-one-page spread titled *While Sitting upon the Ruins of Your Remains, I Pondered the Course of History*. This virtuosic series focuses on Weems's interventions in and witnessing of plantations and gathers impressions of the Zealy studio, private homes, images of enslaved people in the fields, staged silhouetted shots depicting the female-slave-and-white-mistress dynamic, and found images of Black women holding white children, who were presumably in their care.

While Sitting upon the Ruins doesn't tackle the legal problem of property ownership in ways highlighted by Weems's 1990s decision to break her contract with Harvard and invitation to sue her. The artist's decision to focus on Southern plantations, for example, rather than digging into Harvard's own archives and displaying any found evidence of its aid and comfort of Agassiz, is a meaningful choice. Weems's framing *does* allow her to create a work that is devastating in its remembrance and emotional recovery of the US crime of enslavement, as well as, as per the 13th Amendment, the "badges and incidents of slavery."[64] Her "witnessing" images, wherein she regards plantations and physically enters their manors—in one case, capturing herself dancing in an antebellum home—constitutes a reclaiming of history, one that is deeply conscious of the catastrophic legacy of the "peculiar institution."[65] So, too, are her engagements with found images of women holding white children and her silhouetted mummeries of female slaves tending to their mistresses. Weems here brings in the intersectional story, showing how enslaved women were subjected to oppressions that implicated both their race and their gender, questioned their beauty, and conscripted their mothering.

But Weems doesn't manifest any stated desire to use her art these days to get into a particular argument about who owns what with respect to the daguerreotypes. Her work and methods today are more subtle than that. In an interview

with Deborah Willis, which is included as a chapter in *To Make Their Own Way in the World*, Weems discusses her motivations, which are to deploy her artwork to uncover what she once called "the larger story":

> I've never been able to unblinkingly stare at tragedy—to see people hurt, suffering, in pain—I can't do it. My immediate response is to help or, at the very least, to figure out ways of lifting the subject or altering the circumstances. This doesn't mean that I'm interested in creating "positive" images of black people but, rather, nuanced images of blackness. This to me, is the imperative and a path to deeper truth. Social justice stems from examining the complexity of lived lives.[66]

Weems, in this passage, presents as an artist of "nuance," not an artivist of yes-or-no property law battles. Her art investigates large, indeed, spiritual and existential themes of remembering and of searching out the truth hidden behind the veils of racism and colonialism.

Nevertheless, Harvard deployed Weems's participation in *To Make Their Way* to assist its own ends, insofar as the university remains interested in exhibiting itself to the world as the rightful, ethical, and responsible owner of the Descendant/Lanier daguerreotypes. The book, in an essay by Ilisa Barbash, takes care to announce the university as the daguerreotypes' "steward[]."[67] Further, in his essay, Professor Gates is plain in his negative assessment of Lanier's claim, and Molly Rogers also casts an indirect critique of Lanier's challenge—though, it must be said, in my personal correspondence with Rogers, she may be in the process of rethinking that position.[68]

There are moments in Weems's conversation with Willis where the artist breaks out of this dynamic. At one point, she observes that Harvard once threatened to sue her, though she allows that is "a wild story for another time."[69] And, at the end of the conversation, she bursts forth with a description of the rage and stress that she feels about doing her work:

> These images have been around for a long time, and often we've been the ones to redress this particular history . . . [which is to say,] black artists. We've been tasked with cleaning up the mess, a mess often left behind by white people. And I'm tired of it. I'll admit, some of this has been fine with me. Like okay, let me see what I can make of this mess. But much of it is bullshit; it keeps us locked in a futile struggle for power and ultimately has serious implications—the burden is a hindrance to a broader practice. So here we are in the twenty-first century, cleaning up a mess that whites willingly or otherwise refuse to even accept as possible.[70]

One might here sense Weems's frustration not only with the corrosive effects that white supremacy has on a Black artist's life, vision, work, and jeu d'esprit, but also with the position that she finds herself in because of Harvard's power and aggression. "Some of it is fine" with her, and some of it is "bullshit." But there she is, cleaning up the mess of whites and of white supremacist institutions, who refuse to recognize what they have created. Nevertheless, Weems avoids leveling direct critiques at Harvard. By my lights, her words do not lead to a strong indication that she may be regarded, in the last few years, as creating artivist work that specifically targets Harvard or any particular legal code in an effort to guarantee Black people's reparations and the return of their stolen property. While, in the 1990s, Weems's artivism cast Harvard's legal title to the daguerreotypes into doubt, her later statements at the Vision and Justice conference, and her contributions in *To Make Their Own Way*, do not together read as a mandate that, in Malcolm X's words, slavery-enriched institutions like Harvard must cough up a "payday" that is "retroactive."

So, how should we regard Weems and interpret the legal meanings of her photographs and actions? Is she an artivist who teaches us new lessons not only about intellectual property law but also the law of real and tangible property? Or is hers a case of missed opportunities and a cautionary tale about the responsibility that artivists take on when they begin moving beyond the image and the object and begin to interact with the social and political world?

In an effort to understand these matters, I turn to the testimony of a person whose readings and responses to Weems's work and life sheds critical light on these questions. This interpreter is not so much interested in the question of intellectual property rights or contract law. Rather, she sees Weems's breaking the Harvard contract and invitation to Harvard to sue her as teaching lessons in civil disobedience that can help birth new human and property rights in the United States in the wake of American slavery. She also, it must be said, is deeply troubled by Weems's later rapprochement with the university.

This person is Tamara K. Lanier, and it is to her story that I now turn.

Tamara K. Lanier, the Career of Carrie Mae Weems, and the "Moral Responsibility to Disobey Unjust Laws"

"As a child I learned about Renty, his was an important story that my mom would always talk about," Tamara K. Lanier told me on a Zoom call on the morning of

FIGURE 2.2. Tamara Lanier, Papa Renty, and Lanier's mother, Mattye Pearl Thompson Lanier, courtesy of Tamara Lanier

February 2, 2022. A clear-eyed and decisive woman, Lanier is a retired NAACP official and Connecticut probation officer with a long career in working with, in her words, "justice-impacted people" who have "substance abuse issues, addiction issues and get involved in a justice system that fails to treat those needs, a system with racial disparities." Lanier is also a direct descendant of Renty and Delia, as has been certified and verified by the genealogists Toni Carrier and Chris Childs.[71] She grew up hearing of her familial connection with Renty at her mother's knee, when Lanier mère "would tell me about how Papa Renty—that's what he's known as in my family—was a religious man, a self-taught man, a man who taught others to read, a good person."

As noted above, in March 2019, Lanier sued Harvard for conversion and replevin (the wrongful taking of property and its restoration) of the Renty and Delia daguerreotypes and negligent infliction of emotional distress and other counts in the Middlesex County Superior Court. The Middlesex Court dismissed Lanier's complaint for failing to state a claim in March 2021. In the words of Associate Justice Camille F. Sarrouf, "Renty and Delia did not possess an interest in the photographs, and as a result, Lanier has no such interest."[72] Lanier's lack of a property interest, Justice Sarrouf maintained, destroyed her emotional distress claims.[73] At the time of our conversation, Lanier had appealed to the Massachusetts Supreme Judicial Court and she—as well as the rest of the world—awaited its decision. For years, Lanier had struggled to be recognized by Harvard as Renty and Delia's descendant and to persuade the university to acknowledge the evil that Agassiz committed and how it had been enriched by his unclean deeds. Despite Harvard's polite but firm refusals to engage with her about these matters, she told me, she would not be stopped from telling this "larger story."

"Years ago, my mom, she had renal failure and she knew that she was dying," Lanier said in a firm tone as I took notes. "It became important to her that I document in a book our family legacy and our family story about Papa Renty. I did promise to do that, though I did it to pacify her in that moment when she passed. But then, I started on this journey to learn about my genealogy. Anyway, I was out walking one day, and I stopped in a small ice cream shop that sold salads and ice cream, and the owner, this man named Richard Morrison, he and I started talking. I told him about my mom's passing and my promise to her, and he said, 'I love doing that research, give me the information and I'll help you.' So, I told him all the things I knew about Papa Renty at that point, and then came back in the store some weeks later. He threw his hands up and said, 'Where have you been? I found your Papa Renty!' We exchanged names and he sent me an email with Renty's image [that is, a picture of the daguerreotype in Harvard's possession]. Oh, I had a feeling in my gut! When I looked at that picture, I felt like our eyes connected, and I saw family in his face. I remember thinking, 'This is the

photo of the man that I've heard so many stories about.' I called my girls to come look at the picture, and my oldest made the comment that she had created an image in her mind that Renty was like a giant, so seeing the real Renty was kind of a surprise.

"By then, Rich had put together a document about Louis Agassiz. I read that, and for a long time, I didn't know what I was looking at. I'm like, 'this is dark stuff. This is about scientific racism. This is about doing experiments on people. And how they used people.' But I didn't know that I was reading about things that had happened to my ancestors, to Renty, until I finally put it together. I was just learning as I went, about how horrific this experiment was, and that my enslaved ancestor, whom we revered and respected, was abused in that way. I read until I was well informed, and I was just numb from the highs and the lows. I was just paralyzed."

"Why were you paralyzed?" I asked.

"Well, I thought about how this image came to be. And I thought how my mom would have been so excited to see it, finally. But then, how would she have felt if she had known about how this image was created? So, I had a bundle of mixed emotions. But eventually, I knew that she would have wanted me to correct the narrative."

Lanier told me that she was motivated to tell the full story in large part because she believed Harvard was unforthcoming about Agassiz's crime against her ancestor. As evidence, she cited a 2012 conflict that Harvard had with a Swiss museum that sought to publish the daguerreotypes in order to expose the history of racism in Switzerland (where Agassiz was born), a request that Harvard refused. The fracas was written up in the *Boston Globe* that year in an article written by the journalist Mary Carmichael, who reported that while the university maintained that they had a policy against distributing "exploitative images," the Swiss group asserted that Harvard was "protecting one of its own."[74] "I read that article when it came out," Lanier said, "and I don't know how things get scrubbed off the internet, but you can't find it now. Luckily, I saved a physical copy, and you can read it if you want." Seeking to reframe Agassiz's reputation despite Harvard's defensiveness, and to broadcast Renty's true history, Lanier strove to inform people about her predecessor's personality, legacy, and humanity.

"Papa Renty was an educator," she told me. "I have a recording of my mom talking about how he taught himself to read, and then taught others. And he'd read from the Bible, teaching younger people with Bible stories. I remember thinking about the irony of this scientific racism, and what it tried to say about Black people—when Renty would teach whoever was interested in learning to read, even when it was illegal to do so, and would have cost him his life. And my mom, that was important to her. She'd say, 'if you don't know how to read it's not

easy to teach yourself." And then, here's Harvard, celebrating and glorifying Louis Agassiz and bullying anyone who would talk or write about anything different. And pretending like Renty's invisible.

"So, I reached out to Harvard. I'm calling Henry Gates's office, I'm calling the Charles Hamilton Institute,[75] I even reached out to [Harvard Law professor] Charles Ogletree, I got some responses from him, but I'm a persistent person, I never give up and I hounded people, I even called you."

Here, Lanier informed me briskly that I was one of the people that she reached out to in the 2010s in order to push her case forward, as at this point in the timeline, she had read my *Harvard Journal of the Legal Left* law review article on Weems and the daguerreotypes. She allowed that I, like so many others, was unresponsive to this initial contact. For a few minutes we talked about this failure of mine, and then she continued:

"Eventually, I wrote a letter to Drew Faust [president of the Harvard at the time], and her response was very cordial. It was something along the lines of 'thank you for your interest but go away, if you get more information we'll share it, but just go away.' So, it was nice, but dismissive.

"But I'd seen your brief," Lanier went on, meaning my 2012 article. "A few years after you wrote it. Your brief introduced me to Carrie Mae Weems. After I read it, I googled *From Here I Saw What Happened and I Cried*, and the artwork opened up for me, kind of—it didn't open, it *widened* a wound that I had about cultural appropriation. Because my ancestors' dignity was appropriated, their heritage, their legacy, everything of theirs was appropriated by Harvard, who was telling me, 'You can't tell this story, only we can tell that story. And Carrie Mae Weems' art reinforced that for me."

I nodded, rapidly typing everything down. "How did her work reinforce that idea for you?"

"There's a defiance about it, in my mind. When I finally went into the Peabody to see the daguerreotypes, it was like going to jail. The experience was so structured and controlled, like it is for offenders, when you're in a facility, and you're vulnerable there. The indignity. It was like that, and I thought about her defiance of all of those security restrictions, and how she somehow managed to get a copy of the daguerreotypes and put on this public display, putting it out for the world to see. For her to put on this public display of oppositional defiance, this 'I'm taking control' kind of thing, her saying, 'no Harvard, you're not going to be the only keeper and teller of this story, I'm going to take some control back.' It reminded me of that quote of Martin Luther King's, the one where he talks about how we have a moral responsibility to disobey an unjust law, and I think that we have a moral responsibility to expose what Harvard did. And I saw Weems as doing that. I saw her as going against the grain, doing an act of civil disobedience. And that meant a lot to me."

"What did you think of the images themselves, the ones in *From Here I Saw What Happened and I Cried*? The tinting of the daguerreotypes red, the script scrawled over."

At first, Lanier was uninterested in engaging in an analysis of Weems's aesthetics. Eventually, though, she said, "The way I see it is, she was saying, 'How do I restore dignity to these people in a way that I give them a voice'? That appeared to me what the intention was. I see the image of Renty as the original mugshot, the devaluing of Black life—that's the purpose of the racist science. And when she referred to the 'negroid type' in Renty's profile picture, it was an act of defiance and disobedience."

"Did you ever speak to her about it, personally?"

Lanier paused. "I emailed her about it. But . . ."

"What did you talk about?"

"Well, she was very excited, at first. She gave me her cell phone number, and she said, 'I always knew we could find a descendant of Renty.' But then, I think, people at Harvard . . . were shutting everything down. And that was the end of the conversation."

Lanier described her worry that Weems went to Harvard with the information that she'd been contacted by one of the daguerreotypes' subjects' descendants and that Harvard dissuaded Weems from engaging with Lanier further. "Because, once we were on the phone, I didn't hear the excitement. But I also know that she's under some contract with them. But now I think she is conflicted in ways that she can't talk about."

"What do you think about that?"

"I was disappointed. I'd seen her as this rebel, as this oppositional sister going against the grain and, granted her role in it was selective, but I felt like when she ended her discussions with me it was a betrayal to the cause. I'd felt like, 'Okay, here is someone who is down for the cause, who knows that this is an injustice that they're not going to stand for it.' And she knows, I sent her everything, she had all the information. And then, where is this oppositional sister now? To say this is wrong here? That we have these enslaved people who have been victimized, who have been exploited for years? Here is a way to right that wrong and now you're just compounding that injury by publishing a book that perpetuates false narratives about Renty and Delia, when you know better?"

"You're talking about her participation in *To Make Their Own Way in the World*," I said.

"Yes. So I was disappointed. I felt that, okay, maybe this is not the kind of social justice activist work you do, I get what the legal terms are, and how it works, that you enter into these kinds of agreements, you now have this obligation to Harvard. But for me, [her contributing to *To Make Their Own Way in the World*] was a disappointment. It was deceit, the book was unethical. It creates false narratives."

"Tamara, what do you mean?"
Lanier nodded.
"She participated in a deceit."

Weems, Lanier, Their Legacies, and Their Critiques of Law

Lanier's interaction with Weems gives us at least two important insights into the workings of artivism. First, Lanier's story reveals that artivism's legal meaning can extend to its inspiration of legal action by other parties. Weems's civil disobedience attracted Lanier, who became a kind of collaborator. Lanier contacted Weems when she discovered that the artist was an "oppositional sister" who had breached her contract with Harvard and independently compiled the daguerreotypes into *From Here I Saw What Happened and I Cried*. Later, still inspired by Weems though increasingly anxious that the artist was no longer on her side, Lanier sued the university with the aid of her attorneys Ben Crump and Josh Koskoff.[76] By bringing a lawsuit inspired by Weems's work and civil disobedience, Lanier participated in Weems's defiance in a way that resembles artivist collaboration through the decades. As I described in this book's introduction, collaboration is a part of the tool kit of artivists, forming an important facet of the practices of Marsha P. Johnson, Faith Ringgold, Judy Baca, and, in ways particularly germane to Lanier, Charlene Teters, who protested racist mascots with four fellow activists at Jacobs Field and sued the City of Cleveland with that group.[77] That Weems's civil disobedience would attract collaborators is not surprising because, as the philosopher Hannah Arendt and the legal scholar David E. Pozen have observed, the civil disobedient "never exists as an individual; he can function and survive only as a member of a group."[78] Lanier is certainly not a classic collaborator, though, as she didn't work directly with Weems or receive anything in the way of support from the artist; this distinguishes her collaboration from that of the other artivists I've mentioned here, who all possessed voluntary and enthusiastic relationships with their partners.

Still, Weems's acts and art created legal meaning by galvanizing Lanier's pursuit of justice in the courts. This feature of Weems's artivism further binds it to the history of social movements, since those movements have similarly led to litigation, as scholars such as Reva Siegel, Jack Balkin, Robert Post, Serena Mayeri, Lani Guinier, and Gerald Torres have demonstrated. Many of the lawsuits or other legal moves inspired by protests and activism were instigated by lawyers,

such as in the case of the Black, nonbinary poet, priest, and lawyer Pauli Murray, who labored alongside anti-racist and feminist activists and in 1962 authored a report for President Kennedy's Commission on the Status of Women, recommending that gender equality be pursued under 14th Amendment litigation.[79] Similarly, the Black Montgomery lawyer Fred Gray learned from the Montgomery Bus Boycott activists, collaborated with Dr. King and the Montgomery Improvement Association, and then co-filed a lawsuit against bus segregation in 1956.[80] Lanier doesn't fit perfectly into this model of collaboration, either, since she's not a lawyer but rather a plaintiff. Nevertheless, Lanier has been a legal actor, as she's a retired probation officer for the State of Connecticut and well-versed in the workings, limitations, and possibilities of the law. She's an exemplar of what Lani Guinier has deemed a "role-literate participant" in social movements, who moves the legal needle.[81] And her legal moves were triggered by Weems's art and civil disobedience.

But the relationship between these two agents of social change was not an easy one. Lanier's disappointment in Weems contributes a second, and far more difficult, element in an analysis of woman of color and queer of color artivism. Lanier grounds her criticism of Weems in her concern that the artist is "under some contract" with Harvard and is thus "conflicted." This characterization of Weems's decisions highlights some of the complexities of being a female or queer of color artivist who challenges existing systems' racism, classism, homophobia, and other biases but also works within capitalism and, indeed, may be ambitious to succeed in a world that has historically barricaded their entry. (In my own case, that of a scholar and a researcher, Lanier's critiques are a caution for writers to *pick up the phone.*)

For Weems to break her contract with Harvard, invite Harvard to sue her, publicize her disobedience in the *Art 21* documentary, and publish the daguerreotypes in large-format forms and send these images on a tour around the world in her *From Here I Saw* show—these were the acts of a social justice warrior whose artivism dared the law to reconsider the roots of property. Yet, when she appeared to have distanced herself from Lanier in a phone call, participated in a Harvard symposium on race and justice without talking much about Harvard's specious behavior, and said that her fight with the university is a story "for another time" in *To Make Their Own Way in the World* (without mentioning Lanier at all), then it seemed that she had backed off the issue.

"Where is this oppositional sister now?" as Lanier said, in response to Weems's choices. "To say this is wrong here? . . . And now you're just compounding that injury by publishing a book that perpetrates false narratives about Renty and Delia, when you know better?"

How do we approach this quandary? It's worth mentioning that activists, artist-activists, and artivists have long been accused of betraying the role that they first inhabited when fighting for the underclass. Gladys Bentley, whose artivist queer stage acts and marriage to a white woman flouted New York laws, later was profiled in *Ebony Magazine* as having undergone a personal conversion to heterosexuality: In the 1952 photo-essay *I Am a Woman Again*, Bentley was pictured tending to her second husband, Charles Roberts (she had just been widowed by her first husband shortly before), while wearing dresses, makeup, and curled hair. "While I earned large sums of money and thrilled to recognition [as a performer,] still, in my secret heart, I was weeping and wounded because I was traveling the wrong road to real love and true happiness," she wrote in a confessional that queer people are still struggling to understand.[82] Yoko Ono, too, was accused of betraying her fidelity to the avant garde when she married John Lennon, a decision that also earned her widespread public derision and even hatred by a Beatles-loving public.[83] Shulamith Firestone, the 1960s writer, radical feminist, cofounder of New York Radical Women, and an artist who was trained at the Art Institute of Chicago, was denounced by sister feminists for getting a book deal and appearing on "The David Susskind Show."[84] In addition, revered civil rights leaders have been branded as traitors or hypocrites, such as when Malcolm X intimated that Martin Luther King Jr. was a "sellout" for participating in the March on Washington and Gloria Steinem suffered what she later deemed "'looks' attacks" after she wrote up her 1963 undercover experience as a Bunny in a New York Playboy club.[85]

These criticisms of Bentley, Ono, Firestone, King, and Steinem have not dampened the power of their artivism or their other political gestures. Artivists, like other political activists, hopefully can lead long and full lives that defy only one interpretation and can move in and out of their roles in ways that clarify and complicate their actions' political significance. Ono, for one, is an artivist who initially refused to claim feminist meaning for *Cut Piece* and yet her work retains high feminist significance. Firestone railed against male dominance while still trying to work within its structures, but she remains a force to contend with in feminist history. King was a man of many parts, not a magical superhero or angel who rose above negotiation, compromise, or cost-benefit analyses. Steinem remains a formidable feminist who has always had to contend with responses to her physical beauty and white privilege. And Bentley continues to inspire us with her incendiary stage acts and public wedding, even as we fear that homophobia, racism, and sexism marred her later life.

And so, too, Weems's 1990s "defiance" of Harvard created a chance to reconsider the law of intellectual and real property, as well as custom, convention, power dynamics, and race in the United States. She proved one of the first to

claim copyright law as a field of race rights and reparations, preceding the theories of even the most adventurous scholars by several years. She also created a space wherein Lanier could imagine demanding Malcolm X's "payday" through the courts. Weems's later partnership with Harvard does not diminish this. As the foregoing history shows, civil rights leaders have made indelible and necessary changes to the laws in the United States even though their life stories did not always hew to an idealized tale of political perfection. But Weems's choices also demonstrate the double binds that artivists may face as they work within a structurally racist art world that operates in strict keeping with demands of the market and buffets artists with the vagaries and seductions of money and fame.

The story of Weems's artivism cannot be told successfully without also exploring the story of Lanier, for Lanier accepted the challenge thrown down by Weems on the day that Weems broke her contract with the university. Lanier's perceptions of Weems's participation in a "deceit" must sit uneasily alongside Weems's bold invitation to Harvard to sue her, creating conflict and tension in this chapter of artivism. In the end, Weems's artivism evolved into a collaboration with Lanier. Weems's disobedience inspired Lanier to research the depredations of racist scientists like Agassiz and his ilk and then push the issue of the daguerreotypes' true ownership into courtrooms and the public consciousness.

The aftereffects of Weems's 1990s rebellion and Lanier's resulting litigation have been seismic. In November 2021, the Massachusetts high court heard oral argument on Lanier's appeal from the Middlesex Superior Court's dismissal of her complaint. The tenor of the Justices' questions to Harvard's counsel Anton Metlitsky communicated their hostility to the university's possession of the daguerreotypes. When Metlitsky opened his argument with the assurance that "I want to make clear at the outset, that no one here disputes the grave evils of slavery, or that Louis Agassiz's scientific theories of white supremacy were abhorrent," Justice Dalila Argaez Wendlandt cut in with the question: "What is Harvard's possessory interest in these daguerreotypes and where does it stem from?" Metlitsky stammered slightly in response, before asserting that Harvard's possessory interest "doesn't matter" because a plaintiff may not bring a replevin action seeking restoration of "someone else's property." Justice Elspeth B. Cypher aimed this salvo at Metlitsky: "Are you disagreeing that human beings have an inherent property right in their body?" "Of course not," Metlitsky answered.[86]

The interest in the disposition of *Lanier v. Harvard* proved intense. The arts magazine *Hyperallergic* embarked on a #freeRenty campaign and invited thought leaders such as Aliyyah I. Abdur-Rahman, Kimberly Juanita Brown, and Eunsong Kim to write "endorsements" of an amicus brief for *Lanier v. Harvard*.[87]

Director and screenwriter David Grubin's film about the case, *Free Renty: Lanier v. Harvard* was chosen to screen at the Brooklyn Film Festival, the Omaha Film Festival, and the Sedona International Film Festival, among other places.[88] The *Washington Post* quoted Lanier attorney Josh Koskoff, who associated Harvard with the possessors of revenge or child pornography.[89]

While the world awaited a decision, Lanier's case found itself again in the news cycle that April when Harvard announced that it was dedicating $100 million to an endowed "Legacy of Slavery Fund," which was commissioned in remembrance of more than seventy known people who were enslaved by the university in the seventeenth and eighteenth centuries.[90] Harvard's report accompanying the fund did "not mention ... Tamara Lanier," the *New York Times*' Anemona Hartocollis wrote. That June, Lanier's name was once again found in newspapers when the *Harvard Crimson* leaked a report that Harvard held the remains of nearly seven thousand Indigenous people, which had been collected to further the aims of the kinds of racist science that Agassiz and others had practiced. The *Crimson* also disclosed that Harvard had stored the bodies of nineteen Black people who had "probably" been enslaved.[91]

For some, anticipation was high that Harvard would lose the legal battle over the daguerreotypes, and these scandals kept the public interest fixated on the litigation's resolution. But on June 23, 2022, the Massachusetts high court decided in the negative on the property question. Lanier's property claims were foreclosed for two reasons, the court said: They were barred by the applicable three-year statute of limitations, which had begun to run in 2011, when Lanier first contacted President Drew Gilpin Faust about her relationship to Renty and Delia. At the very latest, the court said, Lanier had notice of her connection to the daguerreotypes by 2014, when her story was published in an article in the *Norwich Bulletin*.[92] The court also determined that Lanier simply did not own the daguerreotypes. It held that photographers own photographs, not subjects, and even in egregious cases such as this, "property transfers to private parties have not been ordered."[93] While those convicted of criminal offenses could have ill-gotten gains removed from their possession through the doctrine of forfeiture, forfeited property goes to the state, not to private persons. And here, the court said, "we have neither a criminal conviction nor a specific statute providing for forfeiture or transfer of property under the factual circumstances alleged."[94] Justice Cypher, who had asked Harvard's counsel whether it disagreed with the maxim that people own property interests in their bodies, advocated in a concurrence for the creation of a new common law property right that would permit redistribution of the artifacts of enslaved people to their descendants.[95] But the majority refused to go that route, writing that such an allocation could only arise from an act of the legislature and

that the judicial branch would be overextending its role if it created this "new" remedy.[96]

Yet the court did give Lanier something. It determined that Harvard owed Lanier a duty because the actions surrounding the creation of the daguerreotypes were "horrific" and it had answered Lanier's letters with assurances that it would keep her apprised of new information about the images.[97] The court noted President Faust's 2011 brush-off of Lanier, which had been accompanied by a promise to "be in touch with you directly if [Harvard researchers] discover any new relevant information."[98] The court also cited a 2014 statement the university made to the press, where it called into question Lanier's ancestral connection to Renty and Delia, causing Lanier to suffer from nausea and insomnia.[99] Based on these facts, the Justices held that Lanier could sue Harvard for both negligent *and* reckless infliction of emotional distress:

> In these circumstances, basic community standards of decency dictate that the institution complicit in the extreme and outrageous actions by which the degrading daguerreotypes of Lanier's ancestors were produced should, in the words of her complaint, "willingly make amends" for its past actions or at least "stop perpetuating the wrenching pain of its past" by engaging in good faith with her, both about her ancestral connection to the individuals depicted in the daguerreotypes, and about how these degrading and dehumanizing images would be used going forward, particularly in public displays.[100]

The decision made headlines, with outlets like *CNN*, *Hyperallergic*, and the *Washington Post* emphasizing that Lanier was now permitted to go forward on her emotional distress claims.[101] These reports were celebratory, framing the results of the litigation as a kind of victory.

Still, when I spoke to Lanier a few weeks after the opinion had been issued, I found her as forthright as always but also saddened and exhausted.

"I'm not happy at all," she said.

"How come?"

"Oh, sure, when I meet with my attorneys, I try to be excited about the fact that we can sue for distress. But I also have to fight back tears, and even now I get emotional. We weren't asking for anything that we weren't entitled to, and I'm disappointed in the injustice of the decision. Most of all, I'm having all this guilt and remorse about my mother. Would she be pleased with where we are today? The decision leaves the daguerreotypes in the hands of the wrongdoers. And emotional distress . . . ?" Lanier took a moment to collect herself. "Emotional *distress*—little does the court know that this decision has compounded my pain and suffering in ways that they can't imagine."

Lanier and I continued talking about the psychological fallout of her yearslong battle to be recognized as Renty and Delia's relative and to take back the property she believed had been wrongfully taken from them. We moved onto an analysis of the intricacies of the decision, as well as Cypher's concurrence, and eventually our discussion tracked back to the art of Carrie Mae Weems.

"Has she contacted you?" I asked.

"No," Lanier said.

"What are your thoughts about her art, which helped get this litigation started?"

Lanier took her time contemplating this question. "When I first saw her work with the daguerreotypes," she finally said, "I was excited about her tenacity. I was excited about her courage to not only go in and capture the images of the daguerreotypes, but to also to exhibit them. To take a firm stance with Harvard and say, 'Harvard, this is our story. We're taking it back.' Hers was almost like a defiant protest against Harvard, to say 'No, you're not controlling this narrative.' But then, I think after the legal case, she joined and partnered with them."

Lanier and I talked a little more about how much Weems's direct action had inspired her to take her claims to the courts and how Lanier had picked up the baton that the artivist had unintentionally handed her. Privately, I thought about the two women's shared history with the daguerreotypes, which struck me as particularly moving in light of the achievements Weems had made in such dynamic works as *Colored People* and *From Here I Saw What Happened and I Cried*. In those beautiful and harrowing pieces, Weems had brought to light the brutal history of racist science, which still underpinned many of today's technological mainstays. And with her violation of her contract, Weems had also cast a glaring light on the long reach of slavery, that theft of property, families, and bodies that continues to propel economic and cultural inequality more than a century and a half after Lincoln's Emancipation Proclamation.

Lanier interrupted my revery when she cleared her throat and laughed ruefully. "Yeah, I liked her better when she was defiant and taking it to Harvard," she said softly. "When she was saying, 'You're not going to appropriate *this* story, Harvard.'"[102]

3

"I JUST DIDN'T FEEL SAFE"
Young Joon Kwak's Mutant Salon and the Queer Need for Safer, Thriving Spaces

In June of 2016, Los Angeles's *Artillery Magazine* assigned me to cover a "Non-Object(ive) Happening" taking place at the Broad Museum, an impressive exhibition space in downtown LA that houses part of philanthropists Eli and Edythe Broad's $2.2 billion art collection.[1] The Happening was being promoted as a Dionysian bacchanal of art, dance, music, food, and revelry, and, with a mixture of eagerness and trepidation, I prepared to attend the event. My qualified enthusiasm stemmed from my study of the early incarnations of happenings, since I knew they had a complex history. After all, the lore of early happenings was replete with stories of artists gathering in the spirit of freedom and anarchy but sometimes failing to guard against the emergence of power plays within this site of supposed aesthetic liberation.

One of the first and most famous happenings was 1963's storied *Tree, a Happening*, where Allan Kaprow hosted an orphic assembly at fellow artist George Segal's eleven-and-a-half-acre farm in New Jersey.[2] At Kaprow's mandate, people acted like trees, danced to jazz, and "abolished the artist-audience divide" within the unfolding of what he called "natural time"—a concept that rejects the capitalist clock and conforms temporal measures to the needs of the moment.[3] This all sounds good, until we learn that Kaprow's "forest people" were also compelled to follow a "physically strong" male leader who embarked on an antic game of wrestling, yelling, and joining combat with other participants and objects.[4] As such, Kaprow's *Tree, a Happening* was a missed opportunity. It appeared poised

FIGURE 3.1. Young Joon Kwak playing a Xina Xurner show at Human Resources (LA), in 2018, © KT Stenberg 2018.

to dismantle the neoliberal trappings of art in its creation of momentary and noncommodifiable experiences, but Kaprow and his followers' blind adherence to patriarchal norms emptied the form of its most heartening possibilities.

Happenings' tendencies to produce spaces for temporary freedom, creation, and anarchy while simultaneously duplicating unhappy power dynamics could also manifest where women steered them. Carolee Schneemann's *Round House* (1967) offers one piquant example. Executed at the Camden Roundhouse theater venue in London, *Round House* occurred during the Congress of the Dialects of Liberation, a legendary metaphysical gathering whose organizers set out to "demystify human violence in all its forms."[5] Schneemann, a white female multimedia artist, orchestrated *Round House*'s "kinetic theater" as a group engagement involving players slathering themselves in grease, painting each other's faces, wrapping themselves in tin foil and cloth, and dancing to music in an effort to forge "'personal and inter-racial equalities.'"[6] Schneemann's efforts were stymied, however, when she announced her intention to conclude *Round House* with a feedback session and found herself obstructed by a male associate who shouted her down and questioned her invitation to the venue.[7] Other speakers expressed hostility to her performance, and their resentment created communication blockages, which Schneemann reacted to by writing acerbic vernacular poems.[8]

Nevertheless, in the ensuing years, artists from marginalized and subordinated communities continued to take up the happening modus operandi and improve upon it. In 1977, Kaprow's student Suzanne Lacy organized a feminist consciousness-raising group as an artistic act: at LA's Studio Watts Workshop Garage Gallery, women sat in a circle and talked about their experiences with sexual assault, an experiment that art historian Vivien Green Fryd ties to Kaprow's blurring of the life-art divide as well as to the pedagogical circles of Judy Chicago and the famous consciousness-raising sessions of the women's movement.[9] Queer people had also unlocked happenings, such as when Ray Johnson, in the 1960s and 1970s, created a Kaprovian antipode that he called "nothings." These nonevents saw Johnson engaging in acts both mundane and meaningful, including stuffing his mouth with Reese's Peanut Butter Cups and then reading the musings of Walt Whitman or pushing a piano across a room before leaving the space.[10] When considering happenings' (or nothings') graduation into a queer form, it's also worth noting that their play with time intersects the concept with queer temporality, which, among other virtues, challenges characterizations of identity as immutable.[11]

I felt both suspicious and excited, then, at the prospect of attending the Broad's Happening and secretly hoped that it would induct me into a charmed circle where time was suspended, art merged with life, revelations might be forthcoming, and maybe even queer nothings could occur. When I first showed up, though, I was disappointed. I wandered into the Broad's slick, $140 million[12] campus and witnessed the awesome achievements of the art industrial complex: Hundreds of patrons who had already paid the $35.00 entrance fee queued around the Broad's Death Star–looking museum so that red-lanyarded employees could tick their names off a list and, upon a carding ritual, give them drinks bracelets. Burly security guards scowled at points of entry; members of downtown LA's unhoused and lower-income population who wandered by on South Grand Avenue would see these sentries staffing the velvet ropes and know not to try to sneak in. Once I was inside, I shouldered up to the Broad's sparkling bar, ordered a Chardonnay, and observed how the Broad's martinet culture shaped patrons' behavior: Except for one outlier named "Ariel" who cavorted in a pink bodysuit with anatomically correct nipples and a merkin (they got it at Goodwill, they told me), everyone behaved according to the unwritten code governing this luxury fastness—we all stood around, drinking and quietly chatting, instead of dashing about naked, screaming, or acting like trees. Apart from Ariel, we supernumeraries also wore some version of the mostly black, minimalist, casual-rebellious chic one can find advertised in the most predictable and conformist of fashion magazines.

At 8:30 sharp—which I clocked as a unit of unnatural time—the shows began. An intriguing gender-fluid masked acrobat named Narcissister performed a mystery play about sexuality and death by inserting and extracting items from their pudendum while the crowd massed on a manicured lawn and watched silently. Afterwards, audience members trundled into the Broad's museum and made their way to its hospital-bright second floor, which held expensive paintings by Takashi Murakami. Here, a cool electronic musician named Lotic spun tunes that sounded like aliens arguing, but the atmosphere was so policed and surveilled that no one did much in the way of dancing.

This is a failure, I thought, while snapping photos and wondering whether I should get another drink. The artist-audience divide was in perfect health here at the Broad, and its culture was so authoritarian that it resembled the endgame of Foucault's *Discipline and Punish*. Within the Broad's system of hierarchical observation and normalizing judgment, we were being trained to mutely watch Narcissister remove a rubber mask of an old lady's face from their genitals and then slip it on their head and to motionlessly listen to Lotic's crazy beats. I was nearly ready to sign off on the Happening and write a savage review, until I realized there was one more act I'd not yet seen.

I wandered up through the museum until I reached its second floor, which was taken up by a small conference room/performance space called the Oculus Hall. At its entrance stood a pink neon sign that read "Mutant Salon" and an accompanying placard that warned spectators about nudity. When I looked inside, I saw a vibrant and chaotic beauty salon that was part of the happenings heritage and sui generis, as it was filled with unclothed, twinkling people busying themselves with mysterious rituals.

The room pullulated with tables heaped with makeup sets, cans of hair spray, scissors, phials of glitter, and bright, biomorphic-looking handcrafted mirrors and brushes. Scattered here and there were stations where people could get their hair braided or cut. Nail polish and liquid blush oozed onto the floor. Clothes and wigs heaped in little islands—dresses, blouses, bikinis, high-heeled shoes, pink and blue polyurethane hairpieces. A small gathering of mostly nude nonbinary people of color undulated among these talismans. Wearing neon pageboys and struggling into sheer body stockings, or spackling their torsos with unguents, the performers worked intently on crafting themselves into astonishing monsters. For all the activity, the mood was subdued: These "mutants" of Mutant Salon seemed unnerved by the museum patrons gawking at them from the doorway but still encouraged each other to slather on more beauty products or applauded the manufacture of outfits cobbled out of detritus in styles recalling Marsha P. Johnson's flower headdresses and handmade couture. At the room's nucleus, three people sat in a goddess circle. I remained on the outskirts, looking in with

the other bystanders. From my research into Kaprow, Schneemann, and Lacy's group work, though, I suspected that the audience-artist divide was vulnerable to rupture.

I treaded into the inner sanctum and sat on the ground next to a blue-skinned person who wore a giant papier-mâché nose ring and no pants or underwear. Having tucked their genitals neatly between their thighs, the mutant held a hunk of Play-Doh and a spill of paper, which they fashioned into a crown. Next to them rested a woman wearing a splashy printed shirt and Birkenstocks. Both mutants gave me minimal greetings.

"What's the process here?" I asked the person with the nose ring.

"What?" they replied, and upon my asking several more times they shook their heads and gestured vaguely at the room.

Exactly! I thought.

The next few hours went by in something of a blur, but later that night the mutants broke into a riot. Mutant Salon, as I would soon learn from the web, was a queer and anti-capitalist venture that sought to create healing, community, selfhood, and liberation by practicing a species of playful "objectification" that didn't involve oppression but rather affirmation and self-creation. This project required a horizontal approach to class status and the development of safe spaces where mutants—queer, poc, often femme-identified people who experienced economic precarity—could feel free to be beautiful. At the Happening, however, the mutants decided that the Broad's imperious atmosphere hamstrung their mission: In ways reminiscent of Schneemann's poeticized frustration at the Congress of the Dialectics of Liberation and Ray Johnson's antipodal stance-taking to Kaprovian enterprise, they objected to the $35 price of admission because it excluded lower-income people from entering the Salon. Relatedly, the performers also dissented from the Broad's limited dispensation of "comps," which would allow mutant community members free entry to the goings-on. In a sudden access of emotion, the mutants staged a mutiny by running out from the basement-level Oculus, stampeding up the Broad's escalators and staircases, and rushing out onto South Grand Avenue. Here, they whirligigged and yawped in the hopes that other mutants or mutants-to-be might see them and join along.

"Who on earth is behind all of this?" I thought, later at home, as I researched the phantasmagoria I'd just seen.

The mind behind Mutant Salon, I eventually discovered, was an artist named Young Joon Kwak.

"I was the first person in my extended Korean family to be born in the US," Kwak told me on a bright spring morning in April of 2022 as we sat in a back

room of Commonwealth and Council, an independent gallery run by the exceptionally talented curator Young Chung in Los Angeles's Koreatown. Dressed in a mauve-and-black pants ensemble, and wearing a color coordinated black and pink ombré wig, this thirty-eight-year-old nonbinary and transfeminine creative gently smiled at my questions about their background. "Let's say I was born in Queens and grew up in a Christian Korean community in Jersey, as I think it's totally relevant that I was raised in the church."

Nearly six years had passed since the night the mutants ran madly through the Broad and rushed out onto the street so they could share their art with people who couldn't afford the Happening's price of admission. In the interim, Kwak had continued cultivating Mutant Salon as a cultural force and become known as a ceramicist, rock star, videographer, maker of monoprints, and sculptor. I'd followed Kwak's career with great interest, writing a second profile of them for *Artillery* and studying their performances and engagements at a host of venues, including the Hammer Museum and the Museum of Art of the National University of Colombia. The recipient of many prizes and grants (the Rema Hort Mann, the Korea Arts Foundation of America Artist Award), Kwak had grown into a global talent to be reckoned with. Their success can be attributed to their tenacious work ethic and carefully thought-out art products, the latter of which mark the artist's ambition to reimagine and reinterpret bodies. But Kwak, speaking softly while making riveting eye contact, wanted me to know that the road they had to travel to their present success was a hard one.

"I went to several Jesus camps when I was a kid, and when I was there, I had my first recognition of the idea of otherness or queerness. I knew that my gender and sexuality and identity didn't line up with the moral values of my community, and I think that for a long time I genuinely wanted to be saved. But that never worked out in the church. I was stuck in a rut of being lost and depressed and not having a community or feeling accepted. When it comes to my aesthetics, there were several instances that I think were pretty formative. At the Jesus camps, on multiple occasions, I had to deal with literal shit. Like, shit, feces. There was this one camp that for some reason was on a Navajo reservation in New Mexico, and we were supposed to evangelize to Native Americans, which is just. . . ." Kwak rolled their eyes. "Anyway, there was no plumbing, there were just these ditches filled with shit, and they didn't have showers. And, one late night, when I needed to go to the bathroom, I fell into a pile of this shit! I was covered with shit! I tried to clean myself off, but then I couldn't. It was like, I couldn't help but be abject. I felt like I couldn't clean myself up after the fact. You know what I mean? I just couldn't get clean."

Kwak's struggles with finding their way as a young person didn't end with the church but continued at school and even at home. "When I was in junior high and high school, I was going through emotional issues, like this whole process of grappling with my own otherness. And it didn't help that several teachers

dismissed me as a bad student. My dad, too. He had a conservative Korean view and he told me I was a failure. And I knew they all thought I was stupid. I was confronted with the notion that I was failure within the context or the demands of a larger structure that I didn't choose. Various institutions and my family told me that." Kwak's face took on a melancholy cast while they remembered this part of their youth, but then they looked at me with a punkish expression. "Art was always my outlet, though. I was good at drawing. I said, 'I suck at school, I can't really read good. But art, that'll be my life.' And it's been that way for me as long as I can remember."

For all their exposure to academic and familial insults, after graduating from New Jersey's Fort Lee High School in 2002, Kwak made their way to The Art Institute of Chicago, which administers one of the best programs in the world. Kwak found the transition a difficult one, as, they told me, "I'd always done bad at school and I was hiding a lot. It wasn't until my junior year and I took a queer lit course that I realized—oh my God, if I'd had this, I wouldn't have been so lost and felt alone when I was younger." Kwak's introduction to queer studies coincided with their entrance into a Chicago "queer POC DIY artists' community, and it was feminist too, with different art spaces. A few friends of mine had a collective called No Coast. We had a little storefront with books, zines, records, we had screen printing. I met a lot of musicians and artists. And then, around 2007, 2008, I started performing at queer nightlife venues."

Kwak found that they loved enacting drag. As they once explained to artist and journalist Charles Long in 2019, "In my teens, I was fat, femme, and Asian. And that's not always celebrated in the gay community. I went through waves of hating my body and trying to make it something else. Then I encountered drag performance."[13] At Commonwealth and Council, Kwak told me that, even though they cherished the dress and presentation aspects of drag, they weren't "really good at lip synching. I wanted to sing my own songs that were informed by the queer theory I'd learned in school, rather than singing these hits that were about a woman's longing for the love of a man, this whole heteronormative attachment thing." At the same time, Kwak was deep in a relationship with their current partner, the Latinx electronic musician and brown futurist Marvin Astorga, who was raised in the Ciudad Juárez-El Paso region.[14] "Marvin, he's just like a weirdo, and with him I was able to be myself without shame," Kwak said. Out of Kwak's burgeoning interest in writing their own material, and their collaboration and relationship with Astorga, grew the "sadical" (radically sad) and "sexperimental" musical duo Xina Xurner. Kwak's creative awakening would lead to such songs as "We are One," where Kwak sings:

> I'm losing my voice, I cannot see, I'm losing all sense of my OMG.
> OMG she's falling apart, OMG I'm falling apart. I am not one.

> Suddenly we grow into something new
> Becoming something new, being something new
> We are one.[15]

Kwak and Astorga performed in queer underground Chicago venues, where they donned body-conscious dresses and Kwak became known for wearing signature glamorous wigs with long and undulating locks. Kwak accented their face with makeup styling that showed a special flair, and deeper undercurrents of meaning, as they adorned their eyes with thick black eyeliner that dripped down their face like tears. Kwak also developed a remarkable signing style, as they crooned their lyrics about queer love and pain into a microphone fitted with a vocal transformer. In their 2019 conversation, Kwak told Long that

> I . . . shift my pitch from little girl to deep-voiced man, monster, and cyborg, singing over layers of unintelligible noise combined with beats by Marvin that get people dancing. I want to bring together people from different backgrounds, so they can collectively experience and process the messy swirl of feelings through dancing and establish connections between different bodies and know that we can see and affect each other.[16]

Xina Xurner spurred at least two connected revelations that became central to Kwak's practice: Kwak discovered that developing a community proved central to their art and discerned something life-sustaining and ethically virtuous in human relations found on the dance floor. While Kwak had been harmed by other people's treatment of them as less than fully human (as "stupid;" as a "failure"), they observed that, in dance parties, "we can treat each other like objects, but in profound admiration. We can say 'yes, this is what we do on the dance floor, in a space that allows us to do so without the risk of dehumanization. We can show our bodies without shame, and we might look monstrous, but we're still beautiful, because we make each other beautiful.'"

These insights grew in reach and intensity when, in 2010, Kwak received a master's degree from the University of Chicago. Kwak attended this program because "I didn't know how to speak about my work, and I was interested in being part of a larger discourse. That year, I read more than I'd ever done in my life, and after that, I decided, that, yeah, I have something to say." This encouragement propelled Kwak and Astorga to move to Los Angeles, where Kwak entered the graduate division at USC's Roski School of Fine Arts. There, they deepened their work with Xina Xurner and connected with the LA community, a development made easier by the fact that some Chicago friends, like the Indigenous artist Elisa Harkins, had also transplanted in the city.

Starting in 2011, Xina Xurner played in LA venues like Mustache Mondays and Club sCum, which were episodic parties held in hotels and bars, and are now recognized as historic safe spaces that incubated an inclusive and working class queer community.[17] These events were organized by impresarios such as Rudy "Bleu" Garcia, Ray Sanchez, and Nacho Nava, and Kwak told me they drew "queer POC and other performers, audience members, creative producers, and artists who weren't involved in the contemporary art world or didn't aspire to be involved in a way that my peers in grad school did, because these were underground performance spaces." This contact inspired Kwak, because "I simply wanted to collaborate with these artists, but I realized that a lot of them didn't have studios. And that's a real issue in LA—space, which is so expensive here. And here I was at an institution where I had all this space for free. I had a lot of freedom in that old graduate building, which was the Roski Studios Building at 3001 South Flower Street."

The Roski Studios sat a half mile away from the main USC campus and were individual "white cubes" where students had the room to create and display many different forms of art, from photography to built environments.[18] Kwak invited people they met during Xina Xurner performances to their USC atelier, which quickly became a safe space for dressing and makeup and hair application. "I made it into a beauty space because I was not feeling comfortable dressing in my apartment," Kwak allowed.

"Why didn't you feel comfortable?" I asked.

Kwak contemplated their answer for a moment. "Well, it was a safety issue. In Koreatown, the parking sucks, and after Xina Xurner shows I'd have to do the walk of shame for five or six blocks away from my apartment, when it was late at night, and it could be crazy sometimes."

"Crazy how?"

"I just didn't feel safe, though I have to say I don't feel safe a lot of times, in a lot of different places. And I think that maybe even some women can relate to that." Kwak gestured at me, indicating that I could empathize with the predicament. "The problem is just *violence*, whether it's verbal or physical or the threat of that. Having experienced that overt racism, homophobia, sexism, and transphobia, I know it's so pervasive. There are both overt aspects of toxic white supremacy and masculinity and also subtle, nuanced ways by which it rears its ugly head in public spaces every day. The overt ways that you experience it are people getting beat up. Less so are the verbal things, like people catcalling racist and homophobic statements if you're not a straight white guy. I mean, everyone I know has experienced it, it's innumerable."

Eventually, the scene at Kwak's Roski studio developed into Mutant Salon, a name that Kwak chose because "mutant" had already become "a descriptor for

my practice in school, and then what was happening in my studio was not just a beauty salon situation, but also reminded me of the historical salons women would gather in France. So, 'Mutant Salon.' It became a space for weirdos, and also, on a base level, we are all mutating. And I felt like there were all of these historically elitist and white supremacist heteronormative conceptions of beauty and desire, but that, as an artist making new forms of beauty, I'd align myself with a mutant sensibility."

As I listened to Kwak talking about hosting mutants at USC, I wondered about how easy it had been to bring nonstudents onto policed and highly regulated school property for antic beauty sessions.

"Oh, well, you know . . ." Kwak said, growing slightly uncomfortable at my question.

As my later research showed, Kwak's invitation to nonstudents to participate in Roski Studio Mutant Salons wasn't necessarily sanctioned by the university, as it created a legal and bureaucratic gray area. USC's official policy requires that events produced by "non-USC affiliated organizations" gain certificates of liability insurance.[19] Further, USC's website cautions that the "first step" anyone on campus should take before organizing an "event" is to fill out an event permit application; "event" is not defined.[20] Was Mutant Salon a "non-USC-affiliated organization"? Was it an event that needed a permit? In an apparent observance of the "it's better to ask for forgiveness than permission" adage, Kwak put on their Salons without checking to see whether any of these limitations applied to them.

Years after the fact, in a July 2019 Instagram post, Kwak wrote about these first incarnations of the Salon and hinted at their sub rosa quality:

> I started Mutant Salon initially bc I needed a safe space to get made up and dressed up and to share that space with other mutants; I wanted to build a community around collaboration and caring for each other; where we could let go of the shame and feel valued and respected and embrace our differences; where we could hear each other and help ourselves be heard, and throw free parties & art & performance shows inviting our communities, all-the-while using the institution's resources and space from underneath their noses, which I knew was temporary.[21]

When I asked Kwak why Mutant Salon had to organize "under the noses" of USC officials, they noted that it was a good thing that the Roski Studios were "apart from campus and the administrative offices weren't there," though they blanched at the idea that they should have sought special permission when other art students invited curators and parents to their studios. Kwak also allowed that

they were encouraged by multimedia artist A. L. Steiner, the-then head of USC's MFA program, who was terminated by the university under contentious circumstances that allegedly included gender and sexuality discrimination, as well as queer-shaming, two years after Kwak graduated.[22]

As a consequence of Steiner's evidently contingent protection and Kwak's evasive approach to bureaucratic hurdles, Mutant Salon was able to develop a core group of performers, including Astorga, Elisa Harkins, the collaborative think tank Black@TED, the life-artist Jennifer Moon, the musician San Cha, and a larger, shifting assembly of about forty other members. The troupe soon moved from the Roski Studios to meet in spaces such as downtown LA's edgy REDCAT theater, where they found themselves free to perform and do makeup, makeovers, nails, body work, and tarot readings with each other and audience members without worrying about constraints like USC's red tape.[23] This liberty granted the mutants social and political gifts: gesticulating animatedly, Kwak explained to me that Salons conducted in an atmosphere of license and latitude allow mutants to have experiences akin to when "somebody has this fling with queerness that blows their mind and makes them evacuate their basic-ass heteronormative inadequate relationships and forms of intimacy and attachment. It leads them to break up with that and start a new journey." In addition, this "fling" depends on a particular relationship with time, as Mutant Salon is built on a foundation of ephemerality, or what Kwak described as "temporariness." The Salon's brief duration and elastic form "is also part of its power, as we aren't a stable, durable, static kind of brand. There's an element of noncoherence, and we're asking, 'What can be born within noncoherence?' We're creating a temporary space of freedom, which is impossible, but having that glimpse is worthwhile in and of itself."

Kwak stopped for a moment as I took notes, and a wry expression flickered across their face.

"What?" I asked.

"I mean, that's why I think it's so interesting that a law professor is asking me about Mutant Salon."

"Because lawyers are supposed to be so rigid?"

Kwak was gracious enough not to say yes. "It's just, you know, legal theorists are so tied to these labels and categories, a certain kind of adherence to coherence. It's not like you could try to write a law and say, 'this piece of legislation is in service of potentiality.'"

"It would be interesting if we tried, though," I said.

After this exchange, Kwak and I settled back into the story of the Salon. Kwak recounted how the group's ambitious, "noncoherent" practice gained steam until the mutants seemed to achieve their big break when they were invited to participate in the Broad's 2016 Happening. But, Kwak said, the experience proved

a poor one for the mutants, and their rebellious escape from the Oculus was a response to an accumulation of many obstacles and frustrations of the type that Steiner seems to have sheltered them from at USC and that did not arise at REDCAT. The intimate and momentary culture of Mutant Salon clashed with the authoritarianism of the Broad because the museum's administrators "just wanted to control the content and the space. They just totally misunderstood our project from the beginning. For one thing, we didn't realize it was a paid event, that wasn't made clear to us. A lot of our audience is outside of this world, and they don't necessarily have $35 to pay for a ticket. On top of that, the Pulse tragedy had just occurred [Kwak here is referring to the June 12, 2016, massacre at Orlando, Florida's queer nightclub, where forty-nine people were killed and fifty-three wounded], and the Broad was tweeting that Mutant Salon was their response.[24] But a lot of our members work in nightlife and are Brown—and they wouldn't even let them in. I mean, there were all sorts of problems. Like, for the event, they had a sign outside of our door that said, 'Warning, you're going to see objectionable bodies'—or something like that! The whole point of our project was to do away with those ideas! Also, some of the queens in the Salon were very vocal and the Broad said to me, personally, 'You know, you need to control these people.' I was like, 'That's not how it works out here, I don't have control over them, I'm just creating a platform for these experiences. And there's going to be aggression and pain here, we don't step into this space without a collective mourning.' But they didn't want to hear that, and when we said that we were going to leave and take the show out to the street outside, they started threatening us, they put in our faces that we had signed a contract and that it would take place in this space." Kwak took a beat, shaking their head. "And then, just on a basic level, beyond all that, they wouldn't so much as feed us, you know. And they weren't even giving us much money to begin with." Kwak sighed. "Those were just a few of the things that led us to run outside and perform on the street that night."

I hesitated in my typing, as Kwak's mention of food and money gave me sudden insight into safe spaces. "So," I said, "for there to be a safe space, you not only need protection, freedom, and no surveillance, but the space has to be adequately funded? Safe spaces require food and money, along with shelter?"

"Yes," Kwak said. "This is about surviving and thriving, and that means everybody needs to get paid."

"Well, it sounds like it was a difficult night," I said.

Kwak nodded, looking angry as they remember how the Happening unfolded. "It was a really huge learning experience."

Since Mutant Salon's enactment at the Broad, the group has appeared at such venues as the Hammer Museum, Commonwealth and Council, and LACE in Los

Angeles. At the latter venue, they embarked upon a multifaceted 2018 undertaking titled *Cavernous*, which came with beauty makeovers as well as the installation of a community library, programming for seniors, and lecture offerings.[25] Sometimes Xina Xurner performs at Mutant Salons, and sometimes the performances have no musical accompaniment. As a solo artist, Kwak has also held gallery shows of their drip ceramics, sculptures of atypical bodies, and cathartic video work navigating parental relations and queerness. Kwak's oeuvre renews our perspective on bodies, sexuality, gender, society, and violence in many ways, and an entire book could be written on their place in art history and the teachings they offer to law. In the remaining sections, however, I focus on Mutant Salon's artistic, activist, and Black, Brown, female, queer, intersectional artivist lineage. I also examine the provocative questions the Salons raise about the law's role in the creation of identity and safe spaces, and these things' relationship to legal rights.

The Roots of Mutant Salon's Safer Spaces

Mutant Salon's inclusion in the Broad's "Nonobject(ive) Happening" event didn't necessarily stem from the Salon's resemblance to Allan Kaprow's free-form 1960s happenings. The rest of the acts that I saw at the Broad in June of 2016 didn't share in Kaprovian plays with time or eliminations of the artist-audience divide. But even if the Broad's branding of the event had more to do with the need to create a promotional lure than an interest in art historical revisitings, Mutant Salon still bears important connections to Kaprow's happenings and the feminist and queer responses that came after.

Mutant Salon's parallels with Kaprow's happenings will be found in the Salon's embrace of audience members as mutants who may share in makeup application, makeovers, and other bodily interactions. Just as Kaprow announced that in *Tree, a Happening*, there would "be no spectators at this event,"[26] Salon attendees are invited to shed their passive roles and play along. Further, just as Kaprow sought to liberate his happeners from the tyranny of the capitalist clock with his invocation of "natural time," Mutant Salon is also built around a concept of time that fosters freedom. Kwak created (or, rather, in keeping with its communal aspect, co-created) a Salon that observes "temporariness," like Cinderella's princesshood or the shimmering appearance of Brigadoon. The Salon's queer temporality allows it to convey experiences that would otherwise be unreachable, and it does so by giving a glimpse of impossible freedom that could conceivably change participants' lives.

The heady work of imagining and building liberty requires a space of safety, however, as the successors to Kaprow's happenings show. The need for radical

group work to occur within safe spaces was driven home in Schneemann's 1967 *Round House*, where Schneemann had participants ply each other with makeup and clothe themselves in rags until she was shouted at and derided by a male participant. Suzanne Lacy's 1977 formation of a woman-identified consciousness-raising group at LA's Studio Watts Workshop Garage Gallery is another case in point: Lacy's circle appears to have been leaderless, supportive, and undertaken within a safe environment. Kwak's strivings to ensure that mutants are relatively safe from commercial exploitation, shaming, and exclusion connects with this history of happenings in generative ways.

Mutant Salon's insistence on participant safety also links its practice to other important heritages. The term "safe space," or, as the term is now evolving, "safer space" and even "brave space," hails from a lengthy history of woman-of-color, queer, trans, and white feminist and feminist-lesbian efforts to meet in areas that are comparatively free of abuse and violence.[27] Kwak's engagement of the salon setting here is telling, as the history of safer spaces cannot be told without reference to Black-owned beauty salons: these venues have been noted as locations where Black women become the focus of attention and experience a "haven" from gendered racism.[28] Queer and trans people have also observed how the ritual of putting on makeup and dressing, and then displaying the results in community, can inspire feelings of protection and support.[29] As Kwak noted in their 2019 Instagram post, the Salon was designed to allow participants to let go of "shame and feel valued and respected and embrace our differences; where we could hear each other and help ourselves be heard." Kwak's achievement is to mark, create, and annex safer spaces as an artistic act, which brings them within not only activist but also artivist traditions.

Kwak's work allows us to look back and identify a lengthy artivist history that paved the route to Mutant Salon. As Kwak noted in our interview, Mutant Salon connects with the great French salonnières of history,[30] but it also descends from Harlem Renaissance salons, and Kwak's mutant sanctuary brings to light the ways in which Black women's development of these spaces might be framed as proto-artivist mutual aid. Stars in this firmament include the playwright and librarian Regina M. Anderson, who, with writer Ethel Ray and magazine employee Louella Tucker, founded a salon at their apartment in Harlem's Sugar Hill neighborhood, a region that has been described as a "citadel" and "elite."[31] Here, they gave safe harbor and intellectual nourishment to creatives such as Zora Neale Hurston, Langston Hughes, and poet Countee Cullen.[32] The Washington, DC–based poet Georgia Douglas Johnson also figures in this history, as she used a salary earned at the Department of Labor to turn her Italianate-style home at 1461 S. Street NW into a self-proclaimed "Half-Way House."[33] Here, she not only provided shelter to people who were indigent but also turned the space into a literary and artists'

salon that hosted many of the same creatives as did Anderson, Ray, and Tucker back in New York.[34]

Insofar as Mutant Salon creates temporary shelter for members of vulnerable populations, Marsha P. Johnson and Sylvia Rivera's work with the Street Transvestite Action Revolutionaries (STAR), and their development of the first shelter for trans youth, also springs to mind as an artivist forerunner, as STAR established interim housing for people with safety needs. Another precursor, as well as contemporary, is Theaster Gates, the polymath artist.[35] Beginning in 2009, Gates began developing social services and later low-income and affordable housing at Chicago's Dorchester Art and Housing Collaborative as an art project. Here, Gates and his partners (among them Brinshore Development and the Chicago Housing Authority) have built a thirty-two-unit housing complex with space for theater and dance.[36]

Kwak's landmark artivist accomplishment with Mutant Salon may also be traced in more recent experiments with merging safer shelter, mutual- and self-care, and community building as an arts gesture: One highlight of this development is poet and interdisciplinary artist Anaïs Duplan's 2015 founding curation of the Center for Afrofuturist Studies. This Iowa artist's residency and safe space for people of color is sponsored by the VIA Art Fund, the Black Art Futures Fund, and Iowa City (among other sources), and it houses Black artists in a private apartment and maintains a public reading room in a donated house.[37] Other milestones are painter Kehinde Wiley's 2019 establishment of the Black Rock international residency in Dakar and video artist Kalup Linzy's 2021 raising of the Tulsa Queen Rose Art House, a safe space and artists' residency that he built with the winnings from a Tulsa Arts Integration award.[38]

Kwak's practice is so multidimensional that it also connects with the direct action of Gladys Bentley, Eskew Reeder Jr., and Marsha Johnson, which could consist of nothing more than the gesture of appearing outside as *themselves*. Even while Kwak provides a shelter for their mutants, they also stage the salons in spaces that are open to the public, which creates relatively safer opportunities for mutants to exercise what philosopher and economist Amartya Sen describes as an essential human "capability"—that is, a person's capacity to *do*, *be*, or *have*. In this case, the capability is the power to appear in public without shame, which is necessary for conducting the critical functions of life.[39] Where enacted by a queer or trans person, the effect of such an appearance can be so provocative and potentially dangerous to the racist and transphobic social order that the gesture not only qualifies as potentially therapeutic ("we make each other beautiful") but also as a form of protest.

Situating Kwak within this history, we see that their creation of Mutant Salon participates in a long-developing and radical practice of transforming

the provision of space, safety, and self- and community-building into artwork. Beyond resonances with the artists mentioned above, Kwak's Salons also look back to Judy Baca (of *The Great Wall of Los Angeles* fame) and Faith Ringgold (and her *People's Flag Show*), as both of those artists understood that their community organizing and fabrication of a safer space designed for care and revelation were either part of their art or the essence of it. Furthermore, insofar as the Mutants committed civil disobedience at the Broad Museum by rebelling against its "unsafe space" and violating their contract with the museum when they rushed out of the Oculus (as Kwak said in our interview, "they started threatening us, they put in our faces that we had signed a contract and that it would take place in this space"), they also connect up with the artivism of Carrie Mae Weems, who initially began a lawful interaction with Harvard's Peabody Museum before the school's overreaching and injustice disgusted her and she rebelled through her own contract violation.

However, Kwak's riotous merging of their art with safer spaces, anarchy, queer and trans critique, beauty culture, self-care, collaboration, manifesting, contract-breaking, and socializing defies boundaries in ways not precisely seen before. Kwak is developing a new definition of "safer spaces" that here might be described as "thriving" spaces, as Kwak requires that these oases are packed with permissions and resources. The resulting unruly practices that occupy these zones push against norms and rules in manners that make law's barriers that much more apparent. What fresh ideas does Mutant Salon bring to the law with its intimation that safe and thriving spaces are a queer need or even right? What legal provocations does Kwak deploy in their striving to alter the way we see our bodies and ourselves?

Mutant Salon and the Law

Kwak's efforts to build a safer space for mutants has smacked up against challenges and barricades, not the least of which is that neither federal nor state constitutional law imagines queer safe spaces as part of the package of rights. Safe spaces are only available to those who can afford them and have the wherewithal to exclude toxic elements from their environments. With respect to the problem of affordability, it bears emphasizing that Kwak's work and the relevant history of early artivist engagements demonstrate that access to money and housing is central for the creation of safe spaces: Regina M. Anderson's salon was born when she opened the doors of her "elite" Sugar Hill apartment (a tenancy that required three women to lease out the space) and Georgia Douglas Johnson's salon flourished in her Italianate DC home (a largesse evidently made possible

by her day job at the Department of Labor). More recent artivist attainments of safe spaces also succeed because of access to funding and land, such as the success of Theaster Gates' Art and Housing Collaborative, Anaïs Duplan's Center for Afrofuturist Studies, and Kalup Linzy's Tulsa residency demonstrate. Yet neither queer, Brown, poor, or any other kind of people have a fundamental right to access such spaces: In 1972, the Supreme Court decided *Lindsey v. Normet*, which announced that federal constitutional rights do not encompass housing privileges.[40] And, while states such as California and Connecticut have seen the introduction of bills, ordinances, and proposed constitutional amendments that do announce such rights, these have been vetoed or otherwise failed or threaten to turn into laws that will forcibly cleanse the streets of unhoused people.[41]

Even if housing were elevated into a right in the future, Kwak's life story and work with Mutant Salon aligns with the writings of feminist and queer legal scholars who have noted that victory would not be enough to generate safe spaces: this is because homes may oftentimes qualify as the *least* safe of places for queer people. Kwak recounted for me how their family and schoolteachers taught them that they were a "failure" and "stupid" and enrolled them in religious camps where they were subjected to degrading and unsanitary conditions. They also allowed as how they didn't feel safe in their Koreatown apartment because "after Xina Xurner shows I'd have to do the walk of shame for five or six blocks away from my apartment, when it was late at night and it could be crazy sometimes." Kwak's experience connects with scholars' observations that private spheres can be the most dangerous, since neither the state nor Samaritans can spot and shield victims when they are enclosed in their homes.[42] Further, the criminal law's forbidding of domestic violence, stalking, and harassment has either not meaningfully touched the lives of vulnerable populations or, when it does, has created security for some at the cost of mass incarceration and its attendant traumas.[43]

Still, it might be said that laws forbidding discrimination in places of public accommodation (such as galleries or museums) could help create safer spaces for trans people of color, as those rights may well help them eliminate abusive elements that would forbid ecstatic experiences like those made possible by Mutant Salon.[44] Recall that Suzanne Lacy's 1977 consciousness-raising group took place in LA's Studio Watts Workshop Garage Gallery and seemed to deliver to its members a supportive atmosphere that gave them the courage to speak. Duplan has said the Center for Afrofuturist Studies is run along the lines of "DIY, people-centered, artist-run values."[45] Did these supportive cultures come about because of the law's protection? It is certainly a triumph of civil rights legislation that members of vulnerable populations may have a right to access places of public accommodations. Under statutes such as the federal Civil Rights Act of 1964,

the Americans with Disabilities Act of 1990, California's Unruh Act, and a host of other state and local laws and ordinances, owners of establishments that are thrown open to the public may not discriminate on the basis of race, religion, disability, and, in most cases, sex, and thus not only gender in a binary sense but also sexual orientation and gender identity.[46] But an examination of the law suggests that these statutory bans on discrimination alone will not lead to achievements like Lacy's or Duplan's or to the creation of Kwak's safe and thriving spaces.

For one thing, class is not a protected characteristic under any public accommodations law that I have been able to find; though some rare regimes prohibit discrimination based on lookism or homelessness, not even a human rights statute as expansive as New York City's Human Rights Law identifies socioeconomic status as a generally protected category.[47] Yet Kwak's mission is to create a safe space for intersectional transgender people, and poverty is a part of that calculus. Further, Kwak is asking for far more than *nondiscrimination* as it is understood in the law: under the District of Columbia's Human Rights Law, for example, it is illegal to "deny, directly or indirectly, any person the full and equal enjoyment of the goods, services, facilities, privileges, advantages, and accommodations of any place of public accommodations."[48] Will this rule be enough for the creation of Mutant Salons? As scholars Elizabeth Sepper and Deborah Dinner have observed, the rights of public accommodation are relatively conservative, permitting people "to move through public space and participate in leisure and civic life"—not to experience fulfillment.[49] We've seen that Kwak and the mutants seek not only formal entry into places and enjoyment of their privileges but also an affirmation that those places will be safe. And "safe," as revealed from Kwak's description of Mutant Salon's genesis at the Roski studios and their experience at the Broad, requires a lot.

At the outset, a queer-and-trans-POC positive safe space will have to be free of the "shit" that soiled Kwak when they were at "Jesus camp" and that they endured during the "walk of shame" to their apartment—dogma, violence, humiliation, surveillance and (as per the Broad) warning signs. US property laws *do* allow the owners and tenants of spaces like art galleries to exclude patrons who might make mutants uncomfortable, and the courts have also held that full and equal enjoyment of public accommodations requires that people be treated with a minimum of courtesy.[50] Yet even so, Kwak emphasized to me that more is needed than creating a vessel empty of bad things. *Good things*, too, must be provided: the emotional nourishment and protection of the type that A. L. Steiner offered at USC must also be at hand, as well as food and money. A hands-off official attitude will be required if Salon participants become "vocal" and express "collective mourning," and there must additionally be free entry for community members. Thus, Kwak's safe space may also be described as a "thriving" space.

Kwak's mission is so much more well-fed than the US skeletal schemes of legal rights that, at first glance, they barely look related. US federal constitutional laws are sometimes described as a system of "negative rights," that is, one that provides us rights to be free from undue government or private interference, rather than an affirmative warrant of necessities like housing or education.[51] For example, the First Amendment certainly would protect Kwak from state gag orders based on the content of their message, but it doesn't guarantee the provision of resources (food, drink, gear) that would support Mutant Salon members' capacities to assemble and exercise their freedom of speech.[52] Even where states fill the gaps by creating positive rights, or the distinction between positive and negative rights appear to fall apart—say, where negative rights lead to apparatuses of enforcement—I have never heard of a legal entitlement that required the endowment of as much freight and latitude as Kwak demands for their mutants.[53] And I'm not sure the law can handle the emotional requirements of the Salon, as a hard-and-fast rule forbidding behavior that leads to mutants' psychological discomfort could easily boomerang back on dancing, "aggressive" queers and lead to *their* evictions.

Further, Kwak seeks to build thriving safe spaces so that Salon participants experience a brief apprehension of impossible freedom, but this goal only reveals another rift between Mutant Salon and American jurisprudence: The law's emphasis on chronological and linear time is a world away from queer temporality, which might also be known as Kwakian "temporariness."[54] Though the scholars Carol Greenhouse and Sarah Harding have observed that the clash of change and continuity that is the story of law can sometimes lead legal discourse to occur both "in time" and "out of time,"[55] not even the most disruptive upsets of High Court reversals (and I wrote the first draft of this chapter in the wake of the leaking of *Dobbs v. Jackson Women's Health Organization*) partake in the "flings" and "glimpses" of freedom and queerness that are the heart of the Salon's mission.[56]

Worse still, the maze of red tape that Steiner may have helped Kwak evade at USC and the difficulties that Kwak encountered at the Broad demonstrate that the system of law and rights is *directed against* the kinds of ecstatic experiences that Kwak produces. Kwak doesn't own property like George Segal's farm or Georgia Douglas Johnson's Italianate manor, and the mechanics of Mutant Salon are so energetic that it remains unlikely that they could be staged in rented apartments where one must observe noise ordinances and other kinds of housing codes and landlord rules. Further, Kwak makes Salons a part of a marked art practice, which leads them to stage these productions in art spaces that are netted round not only with laws but also bureaucratic mandates, insurance ukases, and internal rules that are distinctly hostile to mutant-making. While Kwak had good luck at the arts organization REDCAT, it, as well as organizations such as

USC and the Broad, are perfectly within their rights to exist as surveillance societies with disciplinarian impedimenta and censorious cultures: Under the law, performers brought into venues are business invitees, and in many jurisdictions invitees who exceed the scope of their invitations (by, say, staging a mutiny) can be regarded as trespassers.[57] Property owners may also revoke invitations as long as they give invitees a sufficient opportunity to leave the premises, and the common law's imposition of duties on businesses to protect customers means that, in many cases, queer people who manifest ecstasy or "mourning" may well be asked to leave at the first sign of nonconformist behavior.[58] The law on whether museums and art galleries can be held responsible for injuries their performers inflict on each other or other patrons is sufficiently murky that institutions have the incentive to maintain an iron grip on the proceedings.[59] Ambiguities in insurance coverage and fears of loss of indemnity may also shape the behavior of institution officials.[60] Additionally, as Kwak noted in our interview, performers sign contracts with museums that they risk breaching when they stray from their employer's terms.

Does this mean, then, that Mutant Salon is a project that bears no relationship to the law, except insofar as it is regulated and endangered by it? While Kwak's invocations of "temporariness" and anarchy might mean their safe spaces are not deeply rooted in the Nation's history and traditions or implicit in the concept of ordered liberty—a common recipe for designating "fundamental rights" advanced by the Supreme Court in cases such as *Washington v. Glucksberg* (1997)[61]—Kwak does maintain that thriving safe spaces facilitate discoveries that are essential to personal development: As we'll recall, Kwak's safe spaces generate a "fling with queerness that blows people's minds and makes them evacuate their basic-ass heteronormative inadequate relationships and forms of intimacy and attachment. It leads them to break up with that and start a new journey." This account of the Salon's ability to trigger revelations that bear on one's ability to experience good kinships and selfhood bear a slim but exciting connection with Supreme Court cases that supposedly protect the same things that Mutant Salons strive for—love, affinity, and individuation. In *Griswold v. Connecticut* (1965), the Supreme Court declared a right to contraception within the marital relationship (later extended to singles) because "marriage is a coming together for better or for worse, hopefully enduring, and intimate to the degree of being sacred."[62] In the now-overruled *Planned Parenthood of Southeastern Pennsylvania v. Casey* (1992), the Supreme Court, in an opinion by Sandra Day O'Connor, Anthony Kennedy, and David Souter, narrowed the abortion right but not before asserting that "at the heart of liberty is the right to define one's own concept of existence, of meaning, of the universe, and of the mystery of human life."[63] Eleven years later, in *Lawrence v. Texas*, Justice Kennedy quoted that same language when striking

down anti-sodomy statutes, while noting also that intimacy can create bonds that are "more enduring."[64] And when Kennedy declared a right to same-sex marriage in *Obergefell v. Hodges* (2015), he did so because that institution "embodies the highest ideals of love, fidelity, devotion, sacrifice, and family."[65] These values relate to Kwak's, as the artist endeavors to create an atmosphere wherein people will journey away from inadequate attachments and definitions of intimacy in order to move toward something greater.

We know that there exist no fundamental rights to all the supplies we need to achieve affirming intimacies and define our existences—because if there were, this country would look much different: there wouldn't just be a right to safer spaces, there'd also be rights to benefits like kundalini classes, doulas, education, housing, clean air, clear water, nourishing food, and all of the other resources that support self-realization . . . the list extends into the horizon. However, that the Supreme Court may not mean what it says in cases like *Casey* and even *Obergefell* doesn't weaken the filament that extends between law and Kwak's work: happily, there exist within other areas of jurisprudence rich sources of the values that fuel the Mutant Salon.

Some of these sources are, as readers might guess, critical race, queer, and feminist legal theory. Members of these branches of legal thought have long attempted to understand and combat mental constructs like unconscious racism, internalized domination, and ossified conceptions of the self, the body, and "the other." In the 1980s and 1990s, critical race theory (CRT), queer, and feminist lawyers filled legal journals with personal stories of gender, sexuality, and race oppression to enrich legal culture with marginalized perspectives as well as to encourage change at what scholar Laura Padilla has called "the individual level."[66] A second early legal method that challenged oppressive individual and group perceptions is consciousness-raising (CR); five years after Suzanne Lacy could be found conducting a CR group in an LA gallery, law professor Catharine MacKinnon characterized consciousness-raising as *the* method used by the feminist movement.[67] More recent innovations harness CRT, feminist, and queer therapeutic and interdisciplinary work by training lawyers to deepen their emotional intelligence, invest the law with the "utopianism" found in queer theory and Black futurity, and even include self-care lessons and mindfulness practices in their classrooms to enhance lawyer stamina and empathy.[68]

Kwak's Mutant Salon connects with this jurisprudence by producing Salons that inspire revelation and healing emotions experienced in tandem with "collective mourning," but they do this through strategies that move beyond storytelling and classic consciousness-raising or studying mindfulness. Similar to the modern therapeutic movements in legal pedagogy, Mutant Salon achieves utopic contemplative practices and instances of self-care by summoning group experiences

that are enlivened by the ethics of the dance floor and are also art. Notably, Kwak is not interested in doing this for lawyers or law students. Kwak instead demonstrates how *a lot of people need this* because trans and queer existence may depend on the kind of awakening that Mutant Salon makes conceivable. In a world where trans life and identity is negated and destroyed daily, chances to have a "fling" with queerness thus can—in the language of Justice Kennedy in *Lawrence v. Texas*—lead to something more enduring.[69] Human exchanges like that made possible in Mutant Salon could be indispensable for both the birth of queer identity as well as the creation of a larger culture that will not strive to starve and kill it.

Harnessing our queer utopianism, then, Kwak's delineation of a thriving safe space could give rise to an awareness that such spaces are, or should be recognized as, fundamental rights. Spaces where queer and trans people are free and nurtured enough to do the difficult labor of "becoming something new, being something new" (in the language of Xina Xurner's *We Are One*) assist *Griswold's* "sacred" "intimacy," allow queers and trans people to "define" their own "meaning" a la *Casey* and *Lawrence*, and, as per *Obergefell*, rewire people's basic-ass heteronormative attachment styles so we might better embody the highest ideals of love, fidelity, devotion, sacrifice, and family. Insofar as constitutional rights go, the rights to privacy, equal protection, and due process have never expanded far enough to cover what might be described as therapeutic processes (such as Mutant Salon is). Yet, as the foregoing demonstrates, CRT, feminist, queer, futurist, cognitive- and self-care-forward legal theory has been building this language and consciousness for over a half century.

It must be said, though, that many radical students and practitioners of law fear that turning essential needs into legal rights only reinstalls state power in isolating and violent ways. Dean Spade asks whether legal recognition and inclusion are "felicitous" goals for trans politics.[70] Scholars such as Ratna Kapur and Margot Young worry that rights regimes only give the state new and better opportunities to control us.[71] There is a "need for rights to be actively dissociated from the assumption that they can deliver the disenfranchised into lasting freedom," as Kapur writes, while also observing that the human rights terrain should not be abandoned.[72] Other lawyers agree with this assessment; there exists a deep fund of scholarship that is devoted to rights critique and skepticism.[73] Kwak seemed to concur with this take on law's plausible support of the Salon when they maintained that "legal theorists are so tied to these labels and categories, a certain kind of adherence to coherence. It's not like you could try to write a law and say, 'this piece of legislation is in service of potentiality.'"

Still, even if we admit that the quantity of fundamental rights is not likely to be extended to ecstatic art therapeutics like the Salon and, even if it were, it

could prove just as dangerous as the status quo, legal analysis remains necessary to reveal how the state and its laws are built to silence mutants. It's important for legal actors to recognize how the system of laws snap shut where queer utopias appear. Property law, insurance law, noise ordinances, and landlord-and-tenant law are just some of the fields that lawyers may study to see where there exist red flags for movements like Mutant Salon, which kinds of venues may be the best for hosting them, and what kind of legal aid to supply to queer and trans sites of potentiality.

Mutant Salon Offers Us Options

With Mutant Salon, Kwak has created art out of dress and grooming rituals that provide safer shelter and catharsis. This achievement emerges from hundreds of years of art history, beginning with the salons of pre-revolutionary France, their Harlem Renaissance counterparts, and the happenings of Kaprow and the responding critiques of Lacy, Schneemann, and Ray Johnson. Chronicling Mutant Salon also helps us recognize the importance of direct action germinated by artivists such as Marsha P. Johnson and Judy Baca, which is today being pushed forward by not only Kwak themselves and Theaster Gates but next-generation creatives such as Anaïs Duplan and Kalup Linzy.

The through line connecting Kwak and the law is less defined, and at first these two forces appear to inhabit parallel worlds. Only when we look closely at the goals of the Salon and certain keystone Supreme Court cases can we see that Kwak's goals reflect US constitutional values or, at least, purported values. In the end, an examination of Kwak's work through the legal lens demonstrates the narrowness and even hypocrisy of High Court decisions that say they protect love, family, and individuation but do so only in a negative way and in limited circumstances. This insight is not new, but what Kwak's work does reveal in a fresh light are the diverse routines by which the law frustrates and impedes queer self-revelation. Its crabbed conception of time, and its takes on the rules of property, contract, and insurance, make the legal system resemble a trap that is wired to capture even the briefest of trans and nonbinary utopias.

Yet, there are other options. As a coda to this analysis, I want to end this chapter by relaying a discussion that I had in the spring of 2022 with LACE curator (and now, as of this writing, chief curator of LA's REDCAT arts center) Daniela Lieja Quintanar.[74] The reader will recognize her from this book's introduction, as Lieja Quintanar curated Tanya Aguiñiga's *Línea Pak* and *Metabolizing the Border* projects and guided me through LACE's *Intergalactix* show. As mentioned earlier, in 2018, Kwak and the Mutants were in residence at LACE for *Cavernous*, a

Lieja Quintanar-curated, multifaceted performance that also offered community services like lectures, senior programming, and a community library. During a Zoom call, Lieja Quintanar explained to me that Black@TED, a Black collaborative think tank leveraged by the artists Dove Ayinde and Sarah Gail Armstrong, delivered one of the *Cavernous* talks. After their presentation, she said, the LAPD were summoned to the gallery for unknown reasons. Law enforcement officers ticketed people who were drinking sodas out of cans while milling outside the gallery, on Sunset Strip. This surveillance and discipline created an atmosphere so corrosive that Black@TED participants later worried that there had been undercover police at the event itself. Lieja Quintanar, shaking her head at the memory of the police descending on Black attendees, relayed that she "tried to approach the police and they were not listening to me. I was like, this is an event, it's art, this is unnecessary, and they were just shutting me down. I also remember that I was wearing a T-shirt that said *Fuck ICE* and I could see they were staring at it. Anyway, thank God it didn't escalate."

As Lieja Quintanar told me about this tense episode at the gallery and her response to it, I couldn't help but compare her approach to that of the Broad during its hosting of the Mutant Salon.

"So, as a curator, you also take it as your job to protect artists like Young Joon and Black@TED?" I asked.

Lieja Quintanar shook her head. "Oh, no, I'm not a protector or a supervisor of the artist, that's not what we aim to do at LACE. I was just reacting. We all take care of each other."

"Okay..." I said. "But Daniela, how do you deal with issues like liability? Don't you have to kind of control your performers and audience or at least supervise them, because they're in your space? I mean, what does your contract look like?"

She smiled at me. "With the performers, we don't call it a contract. We call it an 'agreement.'"

"An agreement," I said.

"Yes. It doesn't even look like a contract, it's more like a narrative."

"Oh my God," I said.

"It's just where we tell the artists what we're going to pay them, and that they have a commitment from us."

"But don't you have a damages provision? What if they burn down the gallery?"

Lieja Quintanar gave me a long look. "We usually work with people that we trust, and we're all part of the LACE community. So it's not necessary to add this thing about damages. LACE has a history of supporting artists and we just want to do that."

4

"HOW DID WE GET HERE?"

Tanya Aguiñiga's Art about the Border and Disability Law

"I began to merge my art with my activism pretty much from the beginning, right when I started getting involved in art. That was in 1986, when I was eighteen," Tanya Aguiñiga told me during a morning Zoom call on November 16, 2021. As the reader will remember, Aguiñiga is the Los Angeles–based, Tijuana-raised artist whose art consists of border performance-protests as well as public relief and engagement projects, elements of which I first saw at the LACE gallery the previous May. As Aguiñiga and I ensconced ourselves in the COVID-era ceremonies of a Zoom conversation, this winner of a 2018 Creative Capital and a 2021 Heinz Award explained that she was exhausted, having just returned from the San Ysidro crossing zone, where she and her team of six assistants assembled on the Mexican "side" to execute *Línea Pak*, the action that saw the artists handing out packets of water, granola bars, saladitos, government petitions, and port-a-potties to migrants who waited up to ten hours to enter the United States. Wearing a silver nose ring, spectacles, and her hair shorn in a short, brushy cut, Aguiñiga exuded the frustration and fatigue that came from having just spent a day under the southwestern sun while trying to convince migrants to roll down their car windows and risk exposure during yet another uptick in COVID cases that spread across California and also amid concerning Mexican COVID statistics.[1] Despite her need for rest, Aguiñiga energetically told me stories that illustrated how and why she became a border-focused artivist, a calling that was inspired in large part by Aguiñiga's own experiences, as she spent the first fourteen years of her life crossing the US-Mexican divide almost daily in order to attend school in the states.[2]

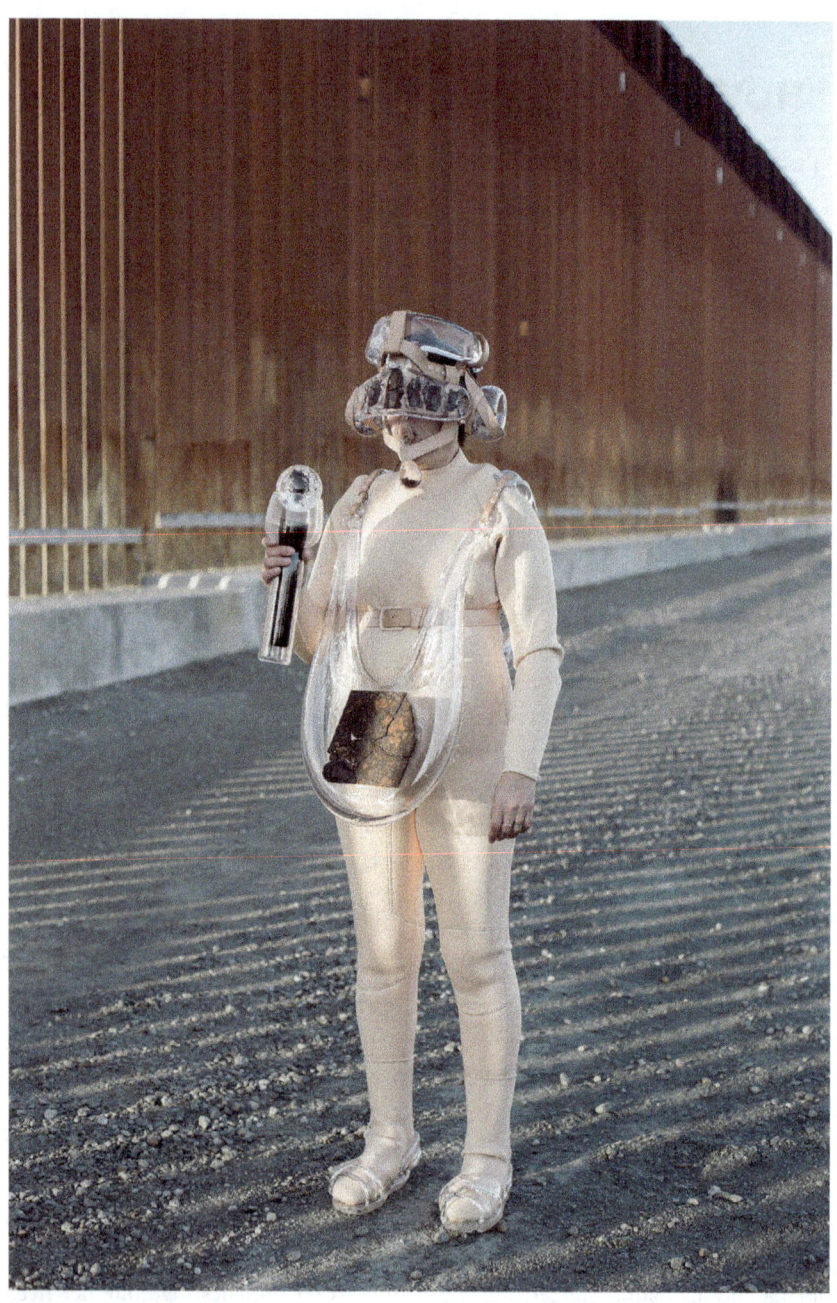

FIGURE 4.1. Tanya Aguiñiga performing *Metabolizing the Border*, © Gina Clyne 2020

At the outset of our conversation, Aguiñiga related that the border introduced her to scenes of death and suffering that have remained with her throughout her life. "As a kid crossing from Tijuana into the US, I just saw horrible stuff," she said quietly. "And it was really bad in the '80s, when I was young. Thousands of people were amassing to look for an opportunity to jump over the fence, so on my way to school every day I would see these crowds of people, men, lined up against the fence. A lot of times on my way back, we would see people getting run over by cars, and we'd see people die. I remember this one day when my dad was driving to the border and he had to pull over, because there was a corpse in the road, and he got out of the car and went to the body and closed its eyes, and that's stayed with me all these years."

Aguiñiga's parents often reached out to migrants to help them when they were in need, and she grew up learning that providing aid to them was an ethical obligation. "When I was three years old, I still remember how someone came knocking at the door and asked my mother if they could have any food. They were trying to make their way North, but they were starving. And she went right to the kitchen and brought out burritos and gave it to them. My grandmother's house was on the US side of the border, and there were just constantly people knocking on her door, too, asking her, 'Can I have food, can I use the bathroom,' and she would help them. So, I was always seeing this hardship, but also being aware of our responsibility to each other, that the fact that I'm a US citizen doesn't separate me from other people's realities. My family also taught me that the border itself is not exactly real, in some sense, because there's a constant back and forth, and the flow is a natural pattern. It's fluid, and that helps both sides, *both* the US and Mexico, and the more you restrict it the more deaths and abuses there will be."

Aguiñiga's family helped migrants though they, themselves, came from modest economic circumstances: after high school, Aguiñiga was not able to go to a four-year university because her parents didn't have enough money to pay for her to take the SAT. She enrolled at Southwestern College, where she took a film class taught by Michael Schnorr, a legendary founder of the Border Art Workshop/ Tallér de Arte Fronterízo (BAW).[3] The BAW was a pathbreaking gathering of artivists who made installations and initiated educational and arts programs for the surrounding community. "Even as young as I was," Aguiñiga remembered, "Michael's work resonated deeply with me because he grew up in Chula Vista, and my hometown, Playa, is a similar area. He brought me under his wing, first asking me if I wanted to work on a mural that protested Operation Gatekeeper [a Clinton-era program that increased the budget of the Immigration and Naturalization Service and instigated a fencing initiative].[4] I had never painted anything before, but he gave me a paint tin and a brush, and, after I dipped in the brush, I wiped the excess off and scraped it into the tin, and he said to me, 'How'd

you know how to do that?' I said, 'That's just what you do.' And just based on that, my knowing how to wipe off excess paint off a brush, the next day he brought me this huge stack of *Artforums* and *Art in America* and all of these books on border pedagogy. I mean, I had no access to this stuff—I didn't even have a cell phone, there wasn't an internet I could use, and I had no idea about Chicano art, any of it." Aguiñiga laughed at the recollection. "Which is to say, I didn't know I had agency to reshape my own identity. But Michael helped me see that I did. With Michael, I learned that I could coordinate stuff and handle a lot of difficult things. And soon enough, I was helping to build and co-run community centers and also doing a lot of massive site-specific installations to honor the lives of the migrants who had been found dead in the desert. And so, I began my career making social practice art, which wasn't a term at the time. Our art showed that immigration policy was killing more people than it was deterring immigration to the United States."

While helping Schnorr make these installations, Aguiñiga began to think of different ways that she could use art "to subvert government brutality." This commitment led her to reach out to an autonomous community located east of Tijuana called Poblado Maclovio Rojas.[5] The group consisted of Indigenous women who made built environments out of US trash and who showed Aguiñiga how to use art in "radical ways": "They created a small city as an arts and social practice," she recalled. "They policed the blocks of the city to make sure they were safe, and they subdivided it into areas for farming, and sustained it without intrusion from the Mexican government. Anyway, both of these groups, Poblado Maclovio Rojas and the Border Art group, taught me an incredible way of thinking about art—it wasn't just painting, it could be a community workshop, it could be running an arts literacy project, it could be educating children, it was helping the community."

Building on this apprenticeship, Aguiñiga embarked upon a multifaceted practice that combined craft with activism. Armed with an MFA that she received in 2005 from the Rhode Island School of Design (RISD), Aguiñiga became a skilled furniture maker, in part so that she could do something that was "working class but still artistic" and that gave her a "physical and emotional outlet" but also led to something "worthwhile" that would draw the approbation of her father.[6] While still at RISD, Aguiñiga also gravitated toward textile work, in large part because "New England was so *cold* and I felt so isolated. I had left Tijuana and the Border Art Workshop in part because of tensions and problems there. I found that I was having to do a lot of the work myself, and there wasn't enough support, and maybe also there was a problem with the white savior complex. I needed to get as far away as possible to get a better understanding of everything, but at RISD, it was culturally another world. I missed the warmth of my region,

and I missed the sounds and smells of Tijuana, and I wanted to do something that paid homage to the lessons that the aunts in my family had given me. So, I started working with wool felt, and a big lightbulb went on. I thought, 'This is the perfect medium for me to learn to bring back home. Because there aren't a lot of art or design processes that you can do without water or electricity. But you can with felt. The wool would just stick to itself, which was amazing. And from there, I got deeper into it, and I learned how to weave, and just went deeper and deeper into craft."

Aguiñiga began to create beautiful and functional chairs, tables, stools, trays and experimental, stunning textiles.[7] After graduation, she merged these skills with her talent for launching community projects: in 2013, for example, she made fabric and balloon installations with underprivileged kids of color from Los Angeles.[8] Aguiñiga understood that the seeming divisions between art, craft, and activism were based on a "hierarchy" that she rejected as a matter of ethics: "When I think about higher education, galleries, museums, all of those spaces have not been built to accommodate BIPOC work or to support our different ways of knowing, of creating, and of being there for our communities, to create mutual aid—that's not allowed in those spaces, it's not regarded as art. And why is that? Because 'art' is a commodity and monetized, it's all built around collectors and all these things that are patriarchal and capitalist."

Aguiñiga's textile, furniture, and community work continued to flourish, but in 2012, Michael Schnorr committed suicide and that trauma reshaped the way she saw her practice. "He killed himself and—and—" Aguiñiga stopped talking for a moment, having difficulty with telling this part of her story. "And I was like, 'I have to go back to working on the border. I think that everything is pointing to me continuing this work.'" Aguiñiga looked down, shaking her head, and said, in a rasping voice: "I just knew that I had to spend more time addressing the needs of my own community."

Aguiñiga's return to border work finally crystallized with the rise of Donald Trump in 2015 and 2016. She watched on television as Trump characterized Mexicans as rapists and drug dealers and flinched at his continual call to "build a wall."[9] As this political emergency mounted, she told me, "I just felt like we have been put through so much, but every few years there comes this person who takes it way too far, and we have to constantly figure out how we can survive in this system." Aguiñiga rapidly developed a platform called AMBOS (Art Made Between Opposite Sides), which hosts projects by binational artists.[10] Continuing to work both independently as a performance and craft artivist, as well as a collaborator with AMBOS, Aguiñiga has engineered a host of interventions, including holding workshops for children and participating in a drumming and percussion performance that memorialized the deaths of migrants in South Arizona in 2017.

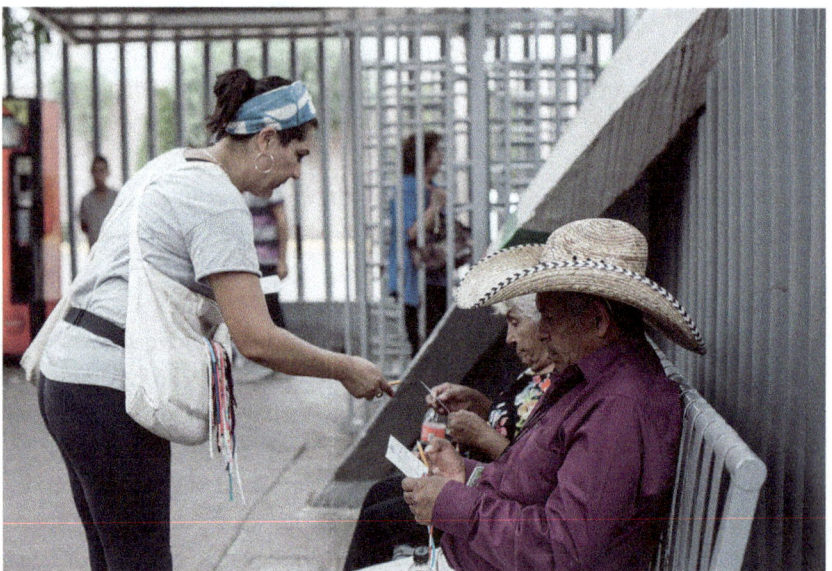

FIGURE 4.2. Aguiñiga passing out postcards during *Border Quipu*, © Gina Clyne 2018

As this brief description indicates, Aguiñiga's art in recent years has tackled US policies that maintain the border and its constant violence and worked to heal its harms through gentle and poignant actions. As such, her work participates in the artivist lineage: it embraces community connection, craft-work, protest, and mutual aid. In addition, her art also performs powerful critiques of US law. In the following sections, I focus on three of Aguiñiga's AMBOS-era events. I first analyze their themes and methods and their connections to the artivist and arts-activist lineage. Then, in a last section, I examine their legal meanings. These works are *Border Quipu*, *Metabolizing the Border*, and *Línea Pak*.

Border Quipu (2016–2018)

Border Quipu was a multiyear project that Aguiñiga enacted with AMBOS artists such as Gina Clyne, Cecilia Brawley, Natalie Godinez, Diana Ryoo, Jackie Amézquita, Gabriel Yarince Perez Setright, and Sydney Barnett. The action was inspired by Aguiñiga's continuing grief over Michal Schnorr's suicide as well as her memories of crossing the border when she was a child. "When I started AMBOS, I kept thinking of the times when I was going through emotional hardships and mental health issues. And it made me think of when I crossed as a really

young child, and how much it would have helped me if someone had just checked in with me, you know? If they'd just asked me a simple question, like, 'how are you?' Because border crossing for me was difficult as a little kid, when you really just don't understand."

Aguiñiga considered how she might facilitate exchanges with crossers by creating with them simple textile art at the border. She also wanted to make a project that was "therapeutic" so that "those hours that people wait at the border wouldn't just be passed in vain, but that people could participate in some kind of exchange. I wanted to use that space, that captive time, to really do things that would be healing. But I had to make it as inclusive as possible and make sure it was not too difficult for children to do. I kept thinking of ways to engineer the highest level of success for participant outcomes, so as to make it super open for everyone. And eventually, I realized, most people can make a knot."

This revelation led Aguiñiga to build an action that revolved around two forms of community outreach: Asking crossers questions and inviting them to participate in the "quipu," an Indigenous mode of communication that dates to the ancient Andes. Used by the Inca people at least a century before the 1532 Spanish conquest of Peru, the quipu consists of colored, knotted strings that documented historical, diplomatic, and jurisdictional records.[11] Traveling to ports of entry such as Tijuana/San Diego, Mexicali/Calexico, and Ciudad Juárez/El Paso, Aguiñiga and her team interacted with drivers waiting in line, people crossing on foot, and those who were not entitled to cross over. Whenever she approached an individual, she offered them two strings and asked them to tie a knot. She explained to each person that this yoking of the two strands represented the relationship between the United States and Mexico, the person's identity on either side of the border, and their mental state at the time of their crossing or not crossing.[12] After the knot was tied, the individuals were given pencils and postcards that contained the question: "¿Qué piensas cuando cruzas esta frontera? / What are your thoughts when you cross this border?" The participants were then offered the opportunity to write down their thoughts, feelings, and ideas on the blank side of the postcard. They were asked not to provide their names, as Aguiñiga believed that the dangers created by US border policy would deter identified interviewees from answering the question honestly. Over six thousand postcards were collected.[13]

Border Quipu possesses deep roots in the artivist tradition. It relates to Faith Ringgold's and Charlene Teters's uses of public-facing fabric and materials arts to convey political and protest messaging. *Border Quipu* additionally exists as a woman of color take on the data collection strategies pioneered by activist-artist Hans Haacke: In the 1970s, Haacke's *MoMA Poll* consisted of the artist polling MoMA patrons to see whether they would vote against New York Governor

Nelson Rockefeller for failing to denounce Nixon's Indochina policy.[14] A later information-gathering precursor is the work of Howardena Pindell, who in 1987 published her study listing the museums and galleries that almost exclusively presented the work of white artists.[15]

With *Border Quipu*, Aguiñiga's innovation was to bring together craft with the direct actions of public outreach and the amassing and synthesis of information. At the end of the project at each site, the quipus were tied together into a flowing, vibrantly colored textile that hung at the entrance of an AMBOS storefront. The information obtained through the postcards was also collated, revealing that in each location, different key words emerged as a theme. "In San Diego and Tijuana, the main thing was anger," Aguiñiga told me on our Zoom call. "But that was during the first Trump run where he was saying so many bad things about Mexicans that anger felt closer to being empowered, you know? It was as a result of that location having a much larger population of Latinos and knowing your worth, and the idea that 'You can't do this shit without us, we do the work that whites won't.' But in other places, like in Arizona, in Nogales, the sentiment was fear. In El Paso and Ciudad Juárez, the word was also 'fear.' But in Douglas and Agua Prieta, there was a big anomaly, because the word that came up there the most was 'gratitude,' which I think gives us something to look at closer and work toward.

FIGURE 4.3. Aguiñiga getting ready to perform *Metabolizing the Border*, © Gina Clyne 2020

"I wanted people to share their thoughts and to contemplate what their crossing means," Aguiñiga explained about the goals of *Border Quipu*. "We suffer this crossing in silence every single day for hours, not really acknowledging that you're mentally going into a different space where you have to shut everything down.... There was a huge part of the project that was checking in on the mental health of people crossing over. Are we just surviving? Or are we thriving? Or are we dying? What is happening to people in this space?"

Metabolizing the Border (2020)

As noted in the introduction, Aguiñiga's 2020 *Metabolizing the Border* was a performance-protest at the San Ysidro crossing; this action expressed the distress the artist had experienced and witnessed there during her earlier engagements: "So I didn't fully think out the AMBOS project and what that would do to my own mental state, and how I've been retraumatizing myself constantly," she explained to crafts curator and writer Claire Voon in 2019. "I am intentionally being vulnerable and open in order to help other people, but I didn't think about how much damage I could do to myself. I started thinking about how an emotional experience might get translated into materials or objects, and mirror and communicate those feelings to others."[16]

When I later asked Aguiñiga about the trauma that she had mentioned to Voon, she took a breath before explaining what she had witnessed during the making of *Border Quipu*. "During the last leg of the project, we went from El Paso to Brownsville. Well, that was the week that family separation started. We saw the first detention camps for children. We could see the children through the fence. And at the same time, we could see migrant families sleeping at the bridges at the ports of entry, the ones who were there to ask for asylum, knowing that as soon as they got processed their children were going to be taken away. It turned out that's the exact same spot, where we were looking at the child detention camps, where there are burials of victims of femicide. So, we were looking at the children in the camps, and then were also looking at these crosses for the murder victims. And it was more and more like us being witness to how horrible humans can be to each other."

Aguiñiga grew quiet once more and her face flushed. When she could speak again, she said, "We went to one of the shelters that was receiving people about to be deported. And I saw this one man was helping this little girl. She was probably three years old, and she had a massive tumor that had deformed her entire head." Aguiñiga raised her hands and gestured around her own skull to give me an idea of the dimensions of the child's ailment. "And she couldn't lift her head or walk, or anything. The amount of medical help she needed...." Aguiñiga's voice trailed

off. "And then you're there just trying to figure out, how did we get here? How can humans do this to each other? And how can you look at that little girl and say go back to where you came from? It was crazy, crazy difficult."

Beginning in 2018, Aguiñiga began to attend to those hurts and also prepare for *Metabolizing* during a residency at the Pilchuck Glass School, a renowned glass arts center in Stanwood, Washington. Aguiñiga brought along a box of fragments that she had cut from the border wall in Tijuana at the precise place where the wall meets the ocean. Once situated at Pilchuck, Aguiñiga hand-blew a series of "performative wearables" embedded with the border wall pieces: She created a headpiece, a snorkel, a backpack, ear cones that amplified sound, the miter, and delicate huaraches that were "designed to fail." In 2020, despite the dangers of COVID, Aguiñiga arrived at the border wall outfitted with a scuba-suit, over which she secured the wearables. As she walked before the wall, trying not to hurt her feet despite her cracking footwear, she inhaled the border, she saw the world through the border, she heard the city through the border, she translated her womb through the border, she steadied herself and protected herself with the border-infused miter, and she "failed" in her journey when the huaraches finally broke and collapsed.

Metabolizing's protest against the border links with other works of artivism, such as Charlene Teters's protests about racist mascots, Faith Ringgold's *People's Flag Show*, Marsha P. Johnson's participation in Stonewall, and Elizabeth Catlett's protest-ride to the Delgado Art Museum. In her evocation of failure, Aguiñiga also connects with Yoko Ono's *Cut Piece*, which, if not "designed to fail," appears to have been orchestrated with an awareness that the performance risked placing Ono in danger and exposing her to emotional pain. *Metabolizing*'s expression of failure and self-mortification also links with the work of other artists who treat the themes of endurance and collapse, such as William Pope.L, who embarks on his celebrated "crawls" through cities like New York to highlight the verticality of success and comment on the inability of all people to reach such heights.[17]

In Aguiñiga's conversation with me, she continued to detail the emotions and pains that inspired her to make *Metabolizing*, which echoes the cathartic tradition of woman of color and queer of color artivism, as well as the legacy of this "endurance failure" art. "For most of us that have grown up at the border in the southern end, on the Mexican side, our whole lives have been shaped by border policy. We've seen these waves of migrants coming to our border towns and, in the majority of the time, they are not welcome. These people's arrival shows up the cracks and weakness in a really fragile system. Mexico, at the border, is chaotic. We have waves of violence related to immigration and the U.S. demand for drugs and border policies. And you know that the Mexican government isn't going to take care of 20,000 children that arrive by themselves from Honduras

and El Salvador.[18] So, it's a place that's constantly shifting, and you're constantly adjusting and trying to regain your footing. You constantly have to tap into your humanity and empathy, and you're just constantly reminded of how it feels to be on the other side of a closed door, especially when you're thinking about the asylum policies in the last couple of years. You're like at the bottom of this filter that's constantly having to bear witness to insane and inhumane practices from two governments, as well as opportunistic people."

Metabolizing the Border deftly voices critiques of these "cracks and weaknesses" as well as the feelings of being at the "bottom of a filter" by creating an armature that identifies Aguiñiga as a kind of deep-sea diver whose eyes, mouth, womb, and ears are submerged in the border. The snorkel chokes her even while it suggests that it might aid her ability to breathe. She needs to bring her own survival kit in the backpack and come armed with a weapon and a light in the form of the shining miter. She strives to "regain her footing" but finds herself walking on broken glass.

"The whole thing is so difficult emotionally, and physically, and spiritually, because the border is this long scar that's constantly in your line of sight, and that reminds you you're not wanted," she said.

Línea Pak

After *Metabolizing* took place, Aguiñiga read about the death of the eighty-nine-year-old woman[19] at San Ysidro and once again leaned on her crafts and construction background to develop *Línea Pak*—the heat-sealed cellophane packages filled with water, granola bars, port-a-potties, saladitos (the dried plums), and the petitions "against the United States government" for violating the Americans with Disabilities Act (ADA) at the border. She also posted this document online, and as of this writing, it has 123 signatures.[20] An action that bears important resemblances and divergences from *Border Quipu*, *Línea Pak* tracks back to the lessons in mutual aid that Aguiñiga learned from her father, mother, and grandmother, since it consisted of handing out the care parcels to migrants. But the overwhelmingly positive achievements of *Border Quipu* did not prepare Aguiñiga for the problems she encountered in distributing food and water. During *Línea Pak*, Aguiñiga detected an increased level of fear at the border as a result of the threat of the highly transmissible Delta variant, which had been overwhelming California hospitals as late as August and whose cases had begun to rise in Los Angeles over the past few weeks.[21] Whereas crossers had largely welcomed her invitations to knot string and answer questions three years before, she now found that people were often too scared to roll down their windows or

FIGURE 4.4. Aguiñiga trying to pass out paks during *Línea Pak*, © Gina Clyne 2021

touch the things that she and her AMBOS team handled. "I didn't anticipate how difficult it would be because of the pandemic," she told me. "People's trust levels are really low, and they don't want to take something for free from a stranger, so it was a lot more work to give things away. People wouldn't look at us, there was no eye contact. It was just a lot of 'no thank you, no thank you.' They would pretend that we didn't exist."

Línea Pak found Aguiñiga and her fellow artists wandering around the "line" offering life-sustaining aid to people who were usually too frightened to take it, rendering the project a different type of public interaction than, say, Baca's *The Great Wall of Los Angeles* or Ringgold's *People's Flag Show*, where muralists and other artists appeared enthralled at taking part in those projects. *Línea Pak*'s "failure," however, ultimately conveyed a different emotional resonance than those achievements and so emerges as another action connected to the ancestry of artwork that traffics in defeats and breakdowns: Beyond the already-mentioned examples of William Pope.L., the Black American Conceptualist David Hammons is a remote forefather here, particularly when he performed his 1983 action *Bliz-aard Ball Sale*, which found him futilely trying to sell snowballs to passersby in New York's Cooper Square.[22] Artists such as Dynasty Handbag, whose frenzied comic work participates in what Jack Halberstam describes as "queer failure" and its related "antisocial" impulse also come to mind.[23] The difference between *Línea Pak* and those examples lies in Aguiñiga's literalness. In the end, *Línea Pak* exists as a pendant to the melancholic *Metabolizing the Border* and may also participate in a newer field in the history of art, as it acted as an inadvertent psychological experiment that revealed important data about the mental states of migrants at the border: in enacting *Línea Pak*, Aguiñiga learned that migrants' terror was so extreme that they would not even roll down their car window when a gentle-faced woman approached them with a care package.

This finding proves particularly devastating when we consider the need for migrant aid at border entrances that resulted in the death of the eighty-nine-year-old woman and hence spurred these aspects of Aguiñiga's art. In my interview with Aguiñiga, she detailed the reasons why she included in her paks not only food, water, and port-a-potties, but also petitions "against" the United States for violations of the ADA. "In all the ports of entry, the majority of the infrastructure is on the US side, because Mexico doesn't have enough money to do anything," she said. "For the most part, none of the crossers have access to bathrooms, and there's no shade, and you have to realize that we're talking about really hot desert, extreme heat, in large part because all of the cars create this heat dome that just becomes terrible.[24] The elderly have to stand for hours and hours waiting to cross on foot, and there is absolutely nowhere to sit down. Also, a lot of the terrain is super dangerous to walk over, you can fall easily. It's so painful, the government

is not thinking, 'this is a crossing for humans.' And I've been there when it's 120 outside, you see people that can barely walk, or have been in the car too long and might be about to suffer a stroke. And it's just going to get worse with global warming. There's no medical attention room, no cooling room, nothing like that, and no one is doing wellness checks. I don't think that the government is prepared.

"The thing that's really hard to deal with is that the US *does* have systems in place for people to cross faster. If you get Global Entry, this system that gives you 'expedited passage,' I think it's called, then you can go through faster. But it's expensive, and a lot of the people at the border do not have money. Or you can go through a 'Ready Lane,' which is a faster lane than the other ones, but to do that, you need a special card that has a chip. So, if you have money then you can get through faster. The Border Patrol is already set up to process people quickly, it's a matter of opening those systems not only to people who can afford it, but who need it because they're incapacitated. But another problem, besides the fact that now people are just too scared to talk to anyone or draw attention to themselves, is that when you're there at the border, in my experience, nobody really knows who's in charge. And so, even if they did have the money, how are they supposed to get any kind of accommodation to get through the line in a shorter period of time?"

She took a breath and looked at me as I typed down everything.

"I don't know," she said. "It's a lot to take in. You can only do what you can do."

Aguiñiga's Art and Its Critiques of Law

In the summer of 2021, while *Intergalactix* was up at LACE, Aguiñiga determined to take a kind of legal action against the United States in response to the conditions she'd witnessed and investigated at the border. She'd included her petition against the US government in her línea paks but decided she needed to do something more. After the show finished its run, she posted the document on the ¡Somos Presente! website, the Latinx campaign platform.[25] Alongside crusades calling for the end of warehousing immigrant children at the border and for UN investigations of the US government's violations of asylum seekers' human rights, Aguiñiga set up a posting whose title read "To: Homeland Security Administration, Make Border Ports of Entry Accessible for the Elderly and Disabled."[26]

"Dear Homeland Security Administration," her petition began:

> Our southern border Ports of Entry (P.O.E.), which are on US Federal Land, are not safe for the elderly and disabled. Excessive wait times in high temperatures make crossing at Ports of Entry dangerous for US

Citizens, Permanent Residents and Visa Holders. The elderly and disabled are forced to wait hours, sometimes standing, in the heat with no shade, which puts their lives at risk while trying to return to their legal country of residence. Please make designated crossing lanes for the elderly and disabled that are ADA compliant in both Pedestrian and Vehicular P.O.E. Lanes across our southern border.[27]

Aguiñiga's petition focused on one of the problems that she emphasized in our interview, namely the inequitable allocation of expedited lanes at the US border. American border crossings have slower and faster lanes, and her *Línea Pak* action and ¡*Somos Presente!* petition charge that the failure of Customs and Border Protection (CBP) to allow older and disabled people to use accelerated lanes when they're having problems dealing with the waits, the lack of water, the lack of cooling rooms, and the "heat dome," which she described as getting up to 120 degrees during the summer, constitutes a violation of disability rights law. Aguiñiga maintains that disabled crossers should be able to use what are known as "Ready Lanes" and Secure Electronic Network for Travelers Rapid Inspection Program Lanes (SENTRI Lanes). Ready Lanes are dedicated expedited lanes for vehicles and pedestrians and SENTRI Lanes offer the fastest passage and would be the obvious choice for disabled and elderly people who are suffering from extreme heat or otherwise are unable to manage the physical stresses of the line. But, as Aguiñiga explained to me, both lanes require special cards that can cost over one hundred dollars, and applicants can be denied SENTRI cards if they have a criminal history or "cannot satisfy CBP of [their] low-risk status."[28]

These problems sent me researching the intricacies of disability rights in the context of federal facilities, and I discovered that Aguiñiga's petition needs an amendment because section 504 of the Federal Rehabilitation Act of 1973, rather than the Americans with Disabilities Act, applies to the US Customs and Border Protection Agency.[29] The Rehabilitation Act applies to federally funded offerings and offers a parallel to the ADA, which forbids state and local governments, as well as places of public accommodation, from excluding disabled people from their participation in programs, services, or activities.[30] Under both the Rehabilitation Act and the ADA, a failure to *reasonably accommodate* disabled people—that is, to affirmatively aid their ability to participate in a covered program—will be illegal unless the accommodation would "fundamentally alter" the program or accommodation. Courts have found fundamental alterations in cases where accommodations would significantly change programs, such as where an educational system would have to lower its educational standards or a cruise ship would have to wait indefinitely in port for a plaintiff's medical part replacement.[31]

So, is Aguiñiga correct when she critiques the CBP for violating disability rights law in failing to regularly and immediately usher disabled people onto Ready and SENTRI Lanes? It looks like no, if recent case law stands: In the 2021 Southern District of California decision *Johnson v. United States*, a mentally disabled Marine Corps veteran sued the CBP for refusing him access to the SENTRI Lane, which would have helped reduce the anxiety he experienced during the border line's long waits.[32] The court didn't question whether the Rehabilitation Act applied to the border crossing nor whether Johnson was disabled. However, the court determined that Johnson's case failed because disability wasn't the only reason for the CBP's refusal to let him use the faster lane—he hadn't applied for a card, the court observed, and probably wouldn't qualify for one anyway because he had a criminal record. The court also held that Johnson didn't have a case because if he were allowed on-the-spot faster passage through SENTRI, that accommodation would "fundamentally alter" the program's nature, which depends on background screening. This reasoning would presumably extend to any failure to apply for the laser cards that allow entrance into the Ready Lanes.[33]

We might wonder, in the face of *Johnson*, what use we can make of Aguiñiga's critique of the law. She's not a lawyer, she's not even a plaintiff, and the law seems settled that her argument can't win where disabled people haven't yet applied for cards. But her work does several important things, one of the most important being that she reveals the magnitude of the disability rights crisis occurring at the border. Aguiñiga's art and related testimony show how intersectional disabled people are regularly crossing la frontera: Aguiñiga executed *Línea Pak* because, during the fourteen years of her own crossings and the period of *Border Quipu*, she'd observed that Mexican and Latin American migrants waiting on foot and in their cars stumbled on uneven terrain and otherwise endured physical suffering, particularly if they were (in her words) "incapacitated" and "elderly." These facts weigh in favor of these persons' legal qualifications as "disabled," which requires that they experience a mental or physical impairment that creates a "substantial limitation on a major life activity."[34] While Aguiñiga's observations and art don't tally the number of disabled people of color crossing the border, or prove crossers' disabilities under a legal standard, her data collection here remains relevant to our understandings of the factual and legal issues as she remains one of the few people beholding and working with the disabled at the border.[35]

The art that Aguiñiga has made from her witnessing, moreover, gives rise to both conventional as well radical critiques of the law. As the disability scholar Katherine Macfarlane has pointed out to me in email discussions about this case, Aguiñiga's dismay that the government didn't provide "medical attention room[s]" allows us to cast new eyes on *Johnson* and wonder why the court didn't acknowledge that border facilities dedicated to mental and physical care would

serve at least some of the needs of disabled people without fundamentally altering SENTRI or other programs. Even more pressingly, Aguiñiga's work reveals that the protections of the law can be barely discerned in the heat, desperation, and disordered conditions at the border. The sad fact is, that even if *Johnson v. United States* had found for the Marine Corps vet plaintiff, many disabled and indigent crossers wouldn't be eligible for accommodations because they hadn't—that is, they couldn't—give the government notice of their need for it. As Aguiñiga related to me, in *Línea Pak*, she delivered food and water to crossers because they weren't going to get help any other way: Crossers often will not be able to even *request* accommodations because the border is so chaotic that "nobody really knows who's in charge," and so it would be unclear whom to ask for help. Further, emotional factors may make it difficult or even impossible to navigate the morass of regulations necessary to apply for a laser card. During *Border Quipu*'s postcard questioning process, Aguiñiga discovered that hateful governmental rhetoric and other prevailing anti-immigrant US sentiment generated feelings of anger and fear in crossers that would corrode their abilities to function in the kind of assertive, methodical manner that is required of petitioners in bureaucratic settings. And *Línea Pak* only upped the ante, as there Aguiñiga learned that crossers now suffered under an even greater burden of anxiety because of COVID-19, a factor that would exacerbate their incapacities to search out accommodations or request forms to expedite their journeys over the border.[36]

Aguiñiga's art is especially telling on this question of crossers' impaired emotional states. In *Metabolizing the Border*, Aguiñiga illustrated the disorganizing effects of the rage and terror that were documented in *Border Quipu*. She demonstrated that the border is a site of trauma, and of physical and mental pain. Her performance showed that migrants at the border were drowning in it, suffocating in it, and failing in it. Further, her story about Michael Schnorr's suicide, as well as the horror she felt when she saw the ill child in the shelter, the children in El Paso's detention center, and the graves of the victims of femicide, also indicate that the border is a site of much unprocessed grief. The mounting pressures—financial, racial, bureaucratic, emotional—may make it impossible for disabled crossers to request access to SENTRI or Ready Lanes or to receive other aid. This failure to make a demand for help would render them out of luck under even the most liberal interpretation of the Rehabilitation Act, which requires the government to have notice of plaintiffs' disabilities and need for accommodations for those rights to arise.[37]

Aguiñiga's work helps us see that, at the border crossings, it is as if *the law simply did not exist at all*: The courts interpreting the Rehabilitation Act, our xenophobic immigration policy, and the agents making decisions in the surrounding

bureaucracies are so distanced from the life experiences of the most vulnerable migrants that the disability protections of the Act don't touch them.[38] We can see this expressed by Aguiñiga in the desperation she reveals in *Metabolizing the Border*, her attempt to feed and hydrate people at the border in *Línea Pak*, and in her story of the ill child languishing at the border shelter.

Aguiñiga's revelation bears important resemblances to existing legal theory that addresses the law's failure to improve or even interact with the lives of women, people of color, and intersectional people. In the 1980s, radical feminist Catharine MacKinnon questioned the law's interest in preserving the welfare of women to any degree, stating forcibly that the state was male and that it had its "foot" on women's "necks."[39] In 1991, Kimberlé Crenshaw continued this work when she noted that laws designed to help battered immigrant women obtain permanent resident status couldn't achieve their aim because so many of these women didn't have the resources to fulfill the paperwork requirements.[40] More recently, other activists and scholars have noted how criminal rape prohibitions remain largely unenforced when it comes to women of color and trans women, lambasted the illusion of rights in Guantanamo Bay, and excoriated the seemingly ineradicable phenomenon of police brutality despite the civil rights laws on the books.[41] At bottom, all of these critiques describe a netherworld where the law's protections do not make contact with, or are even perceived by, its vulnerable subjects.

Yet, even while Aguiñiga's art observes that the law is practically useless as it now applies to disabled people at the border, it makes vivid, or "spectacular," what is at this point invisible to the power structure—that is, those people's suffering.[42] Her art *also* provides a model for reform: To address the needs of disabled people at the border, the US government should do exactly what Aguiñiga did in *Línea Pak*. That is, the government *must come to the disabled migrants* who need the Rehabilitation Act's protection to see whether they should be given the forms and other resources necessary to apply for laser cards—and potentially even give them essential aid so that they gain the basic strength and mental capacity to undertake this bureaucratic task. When I reached out to the immigration law expert Professor Mark Weber and asked him about this possibility, he allowed that it wasn't "farfetched," citing cases where courts have required government officials to take affirmative action to protect plaintiffs' Rehabilitation Act rights; these decision have mandated that the government appoint counsel for people whose mental disabilities make them incompetent to represent themselves and issue paper currency that is distinguishable to the visually impaired.[43] Examples of the affirmative aid needed at the border already exist in the state practice of administering "welfare checks," that is, where state social service or law enforcement officers check in on vulnerable people to see whether they need government aid—yet,

even in the midst of making these recommendations, I must also note that these systems have failed to serve, or even led to the harm of, disabled populations.[44] We may also worry that Mexico would complain about CBP officers entering Mexican land to conduct these checks; still, the United States and Mexico *do* engage in (often fetid) collaborations on Mexican soil and, if administered in a humane way, this could be a rare happy example of US-Mexican synergy.[45] In an age where Mexico has been so offended by US anti-Latinx racism for so long, it is also possible that Mexico would welcome such an act of care.[46]

But the US government isn't going to come to the aid of disabled immigrants on the Mexican "side," is it? Aguiñiga's art shows us this harsh truth in its revelation of the US failure to even notice what is happening to disabled people at the border. In this way, *Línea Pak*, *Border Quipu*, and *Metabolizing the Border* challenge us to stop regarding national borders as inevitable designs of statehood and see them instead as sites of communicable violence. Along with analyzing Aguiñiga's art in light of the Rehabilitation Act's limitations and the law's general incapacity to touch the lives of disabled migrants, it also deserves to be studied alongside the work of other scholars, lawyers, and activists who call for *open borders* to reduce this brutality. UC Davis law dean and professor Kevin Johnson calls for opening the borders in response to the moral imperatives of halting "death at the border."[47] The Canadian political scientist Joseph Carens is another giant in this field and writes emphatically of the morality of open borders, noting that many acts of border regulation are forms of violence that bear no moral foundation.[48] The activists at Open Borders, the Free Migration Project, and Abolish ICE also make their own moral assessments to support their case for free movement.[49]

Aguiñiga's work operates in a way that is different than these thinkers' organizing, lawsuits, and written arguments, yet it strengthens their "moral wrong" case for open borders. Her art combines theater with mutual aid and data collection with healing; this potent synthesis of forms assaults the observer in an immersive emotional catharsis that is all the more persuasive because she relays the experiences of pain, desperation, illness, disembodiment, and death braved by those who suffer the direst effects of border policies. The anguish evoked by *Border Quipu*, *Metabolizing*, and *Línea Pak* is made even more immediate when we consider Aguiñiga's storytelling—in particular, her descriptions of seeing her father close the eyes of a corpse, of the little girl with the tumor on her head at a detention shelter, of the graves of the victims of femicide. "And then you're there just trying to figure out, how did we get here?" as she said to me. "How can humans do this to each other?"

The law must learn from artists like Aguiñiga, as she uses her artists' talents to manifest the torments that Johnson, Carens, the Open Borders Project, the Free Migration Project, and Abolish ICE activists fight against. The indelible images

that she creates alarm us about "death at the border," but also explain that the border is a generator of moral, psychological, physical, and spiritual extinction. This means that border policy as it now stands is a "necropolitics"[50] that must be overthrown in the name of peace and human safety. Aguiñiga's art should be contemplated as a teaching lesson when considering the legal and social arguments made by lawyers, legal scholars, philosophers, and activists who rally for open borders, as it brings home the exigencies of current immigration law in a unique and indispensable manner.

Aguiñiga, Artivism, and Law

Aguiñiga blazes the artivist trail forward through performances, public interactions, the creation of textiles, and public service. She gathers the strengths of the artivists who came before her by merging protest *and* performance, outreach *and* craft, data-collection *and* what might here be described as acts that convey "racial failure." The history of woman of color and queer of color artivism, as well as other forms of artist-activism, can be felt in her gestures, commitments, risk-taking, charisma, and thoughtfulness. She tackles the politics and law of the border, focusing on the lives of the elderly and disabled, and finds a new way to question the legitimacy of the federal government's prerogatives.

In this work, and in her testimony about her practice, Aguiñiga offers the law invaluable critiques that resonate on levels large and small. She shines light onto the intricacies of laser cards and disability accommodations. At the same time, she allows us to see that disability rights are effectively meaningless at the border and that significant legal reform must arrive to bring the law's promise of equality to the people. When we contemplate her discoveries, we find that her revelations interrogate the state itself, and the resulting answers lead to an emotional crisis that coheres with open borders movements. Her art and life example should be considered not only by those in the art world but by any person who cares about human rights and the future of immigration law.

5

"SO MANY STORIES LIKE THAT"
Imani Jacqueline Brown, Blights Out, and *Live Action Painting* (2015)

In October of 2014, nine years after the 2005 landfall of Hurricane Katrina, the government of New Orleans' Saint Bernard Parish announced that it intended to auction 151 properties that had been purchased by the now-defunct, and much criticized, Road Home program.[1] The 2014 sale would number among many other transfers of crumbling structures the people of New Orleans had witnessed since the flood devastated 80 percent of the city.[2] In the wake of Katrina, the state of Louisiana had purchased approximately 4,464 houses through Road Home, a federally funded program designed to assist housing and community recovery after the hurricane. Due to mismanagement and the evidently inescapable workings of structural racism, however, the program ultimately offered Black families far lower levels of assistance than their white counterparts.[3] The resulting loss of Black-owned property had already transformed the city by the time of the 2014 announcement. "'The result of this system is that a disparate number of poor blacks have their homes at these auctions, and a lot of people who are well-meaning are perpetuating this unfairness,'" complained an onlooker as far back as 2011.[4]

On hearing the news of this new sell-off, Imani Jacqueline Brown wandered through New Orleans' Mid-City district, trying to process the signs of transformation and upheaval that had altered her hometown. Born in 1988, she'd grown up in New Orleans and had been in the city during the storm. When the hurricane darkened the skies, she and her family evacuated first to her aunt's central Louisiana farm and then she moved to her father's house in Washington, DC. It would take her eight years to relocate to her hometown after a long stay in New

FIGURE 5.1. Imani Jacqueline Brown, flying over Temple Bay, Louisiana, after Hurricane Ida (2021), © Healthy Gulf c/o Southwings.org 2017

York City and, by 2014, she'd been back a year. Brown knew that during Katrina, the once majority-Black Mid-City had been inundated with stormwaters, and Tremé, a Mid-City subdistrict and the oldest Black neighborhood in the United States, had been swallowed.[5] As Brown examined the region's buildings, she saw they still bore the scars of not only the flood's blast but also later waves of damage in their battered and pocked facades. The widespread decay was a knock-on effect of owners being unable to afford repairs, tax liens, blight liens, and suffering so much trauma that many of them had abandoned the region.[6] Ruins now buckled throughout these once-bustling neighborhoods.[7]

Brown had been busy since her move away from home. Having graduated from Columbia University four years before, she already possessed a vibrant artivist practice as a member of the Occupy movement. In 2012, she'd organized *Debtfair*, the print-and-digital archive that shares the work and stories of more than six hundred artists whose student loans leave them in thrall to major lenders.[8] She'd also exhibited in, and curated, multiple collective interventions dedicated to art worker exhaustion and healing.[9]

Moving through Mid-City, Brown cast a knowing eye at evidence of a demographic shift toward white ownership of historically Black spaces. She'd heard rumors of strangers driving through the neighborhoods to check out the cheapest

and most desirable properties. Already, there were plans for two billion-dollar hospitals to be built in Mid-City, which would clear out the remains of an entire working-class neighborhood, and longtime Tremé residents were seeing greater incidents of policing and a loss of social networks as a result of the first stages of gentrification.[10]

For the past year, Brown had been fighting these developments as part of an art collective called Blights Out. When she heard the news about the auction, she was in the midst of preparing for a December performance in Mid-City/Tremé titled *Home Court Crawl*, where community members would read passages from a play by Suzan-Lori Parks in front of blighted buildings, give talks about housing insecurity, recite poetry, and enjoy communal feasting.[11] The sixteen-member group also planned for a brass band to weave through the properties, leading community members in a singing and dancing protest modeled on New Orleans' famous second line parades.[12] *Home Court Crawl* was going to be a big event, funded with the proceeds of a Creative Capital award won by a Blights Out member named Lisa Sigal, who is a Brooklyn-based Anglo female artist. It would also be covered by the local press.[13]

After Brown heard news of the auctions, though, she began to imagine a smaller and quieter action that might delve deeper into the problems of Katrina's destruction and the later problems of gentrification. She turned her attention back to the preparations for *Home Court Crawl*, and once that extravaganza was put to bed, commenced organizing an event she titled *Live Action Painting*. Reaching out to local Black artists Katrina Andry, Carl Joe Williams, Ron Bechet, Amy Bryant, Jer'Lisa Devezin, Keith Duncan, Horton Humble, Craig Magraff, and Varion Laurent, Brown invited them to set up easels in front of blighted houses in Mid-City during the spring of 2015.[14] The happening would be, she explained, another kind of protest.[15] The artists gathered in front of the home of a longtime Mid-City resident named Miss Sue and sketched the houses that had been left to fall to pieces during and since Katrina. They also tried to contact the neighborhood's changing population but felt as if their goals fell short on this last count, as new residents weren't inclined to speak to them. Miss Sue, meanwhile, came out of her house to give them glasses of water and encourage them in their work.

The event went unaccompanied by any press releases or media notification but Brown commissioned photographer Heidi Hickman to take images of the day's doings.[16] These pictures show the artists rendering the houses mostly in black and white. Printmaker Katrina Andry drew a battered home in an impressionistic style. Painter Keith Duncan fashioned a sharp realist portrayal of a house that was stripped to bricks and wooden planks. Visual artist, writer, and musician Craig Magraff drew a charcoal likeness of an ivy-infested building on a piece of wood salvage. The photos of the action also show the artists smiling while sitting on a broken porch that had been wrenched from a house's façade and posing in front of a moss-covered house.[17]

After the action, Brown posted the photographs on the Blights Out website and wrote a description of the occasion:

> It was a humble opportunity for artists to engage in dialogue with residents and meditate on the sensory experience of blight. The event took place soon after the City of New Orleans placed several hundred blighted properties up for auction; housing rights advocates and neighbors alike feared that the auction would lead to a land grab and bloodletting of rapidly gentrifying neighborhoods like New Orleans' historic 6th Ward. Residents reported non-local white folks "swarming" the neighborhood with cameras. Blights Out was interested in carefully navigating the delicate situation, strategically bringing only local Black artists to paint plein air and engage in candid conversation about the changing neighborhood. The decision to invite only Black artists was controversial among our participants and generated a meaningful discussion about race relations, gentrification, and public perception.[18]

I first saw images of *Live Action Painting* in 2018 while doing research in response to a recent troubling decision written by Judge Timothy Dyk for the Court of Appeals for the Federal Circuit. In *Saint Bernard Parish Government v. United States*, Judge Dyk struck down[19] a 2015 Court of Federal Claims decision by Judge Susan Braden,[20] where Braden found that the US government unconstitutionally "took" property from people in New Orleans' Lower Ninth Ward and Saint Bernard Parish by mismanaging the US Army Corps' Mississippi River-Gulf Outlet (MRGO), a navigational channel that bore deadly structural flaws:[21] After waters from Hurricane Katrina breached the MRGO, they swept through New Orleans, killing nearly 1,400 people and causing billions of dollars of damage, including wiping out districts with historically high levels of Black-owned homes.[22] One of the reasons Hurricane Katrina hit so hard was because the Corps, which built the MRGO, failed to keep it in sound condition, and its resulting dilapidation and structural flaws created a "funnel" that directed stormwaters at the city.[23] In her lower court opinion, Judge Braden decided the plaintiffs had proved their case that the "Army Corps' construction, expansions, operation, and failure to maintain the MR—GO" caused Katrina's storm surge, which flooded their properties and constituted an unconstitutional taking.[24]

I'm a property scholar, and when I first read Braden's 2015 decision, I knew that she'd made a remarkable finding. She'd held that the US government had violated New Orleanians' rights under the US Constitution's Fifth Amendment, which forbids *governmental takings of property without just compensation*.[25] This pretty much means what it says—if the government takes your property, it must pay you a fair price for it. I was intrigued because Braden had based her opinion on not only government actions but also failures to act: As far as I was aware,

there had never been a court opinion that explicitly decided that takings could exist not just where the government actively grabbed property but also where it *omitted* to act, and in its laziness or inattention allowed the landscape around a plaintiff's property to deteriorate so badly that it was destroyed.[26] I was also impressed because Braden's holding meant the federal government would owe the people of New Orleans *big*, to the tune of millions and maybe even billions of dollars. This made sense, I thought. The Army Corps of Engineers had built and then failed to maintain the MRGO, and this had exacerbated the effect of Katrina, leading to mass death and homelessness. It was also common knowledge that, in the days and weeks after the hurricane, other government errors and moral blind spots had led to an exodus from the city, so that half the residents fled and at least one hundred thousand never came back.[27] Wasn't *that* taking property from the homeowners in the Lower Ninth Ward and Saint Bernard Parish? Didn't the people of New Orleans deserve "just compensation" for these wrongs?

It turned out that appeals court Judge Dyk thought not: In reviewing Judge Braden's decision, Judge Dyk rejected Braden's reasoning because she'd found a taking based on the government's failure to maintain the MRGO, and *he* said that takings couldn't be based on governmental omissions—only positive acts. He also rejected her decision because he didn't think she'd considered all the relevant facts. "We reverse," Jude Dyk concluded in 2018.

I had difficulty understanding Dyk's resolution of the case and tried to make sense of it by researching everything I could about the relevant law as well as the community response to the storm. In the midst of my studies, I ran across articles about blight in New Orleans and stumbled on the Blights Out website. Here, I saw the images of *Live Action Painting*. Brown's name was nowhere to be found in the text describing the event. But as I examined the pictures of the artists drawing the broken houses and posing together before gentrifying neighborhoods, I knew that whoever had organized this art-protest understood what Judge Dky did not: that the United States had taken the homes of the people of New Orleans— first by letting the waters come and then by allowing the neighborhoods to fall further apart by not investing in the community in the years that followed.

It wasn't long after seeing those photos of *Live Action Painting* that I discovered Brown was the woman behind the event. I soon sought out to find everything I could about her and her work.

"Well, I've always been creatively engaged with the world as long as I can remember," Brown told me on June 9, 2022, via WhatsApp. She talked to me from a Berlin apartment, where she stayed while installing her newest project, *What Remains at the Ends of the Earth?* at the city's 12th Biennale. Enthusiastic and full of goodwill, Brown proved a vivid presence on the screen of my iPhone, with large brown eyes and a ready smile that often blossomed into laughter even when

she discussed the most difficult topics. At this point in time, I'd been interviewing Brown for various writing projects for years: first, when I discovered her leading role in Blights Out, and then when I continued to admire the fruits of her outstanding collaborative artivist practice. During the present interview, I commenced our conversation by asking her about how she came to art and activism and she told me that the two disciplines became central to her worldview early in her life because of her antiauthoritarian streak. Born in DC, she moved with her mother to New Orleans's Mid-City district when she was four years old. There, she grew up taking visual arts and theater classes until she was told, around 2001, that she had to choose between painting and performance. "I was told that one cannot be talented in more than one art form, and I didn't like that, so I stopped taking formal art classes, though I kept drawing."

This was also, as it so happened, the same point at which Brown found herself coming into political consciousness. "Nine-Eleven took place when I was thirteen, during my last year of middle school. I watched New Orleans, which had always prided itself on its multicultural internationalism, being a little Africa America, being the most European American city, the northern most Caribbean city, suddenly become xenophobic and jingoistic, with these flags flying from pickup trucks. We had to sing *I'm Proud to be an American* every day of the 8th grade. And I have a vivid memory of being in my environmental science class, and there being this wall-mounted TV that was just blasting Shock and Awe with this green night vision image, and my classmates were all kind of cheering along as though they were watching a fireworks display. So, I became involved in activism completely. I tried to start a group at my school called SALAAM: Student Activists of Louisiana Against Aggressive Militarism, but most people were pretty apathetic. Except my mother is a law professor at Loyola in New Orleans, so I began organizing law students and became involved in the anti-Iraq war movement."[28]

"You were organizing law students when you were in high school?" I asked.

Brown laughed. "Yeah. So, we would protest, and in New Orleans, we would always have a brass band, because in New Orleans it would be unconscionable to protest without a brass band. How can you protest without dancing? It was all normal, it flowed, and that's how I got started, merging the two things, political work and the arts. Later, in New York, there was this resistance to arts activism, because there artists were so market-oriented, and people didn't understand that the two things went together. But in New Orleans, you are an artist even if you don't declare yourself to be one, there's a creativity that's infused in the way we act and live. Art hasn't been alienated from life there, it hasn't been commercialized by neoliberalism, by capitalism. I just grew up with a different understanding of what it means to be artist there." Brown paused, then shrugged. "I mean, this was before Katrina."

At this mention of the hurricane, Brown grew distracted from the topic of arts-activism. She fretted about the changes that have occurred in New Orleans in the years since Katrina and soon became immersed in recalling the details of the disaster.

"You were in the city when the storm hit?" I asked.

Brown looked off into the distance as she described what happened on August 26, 2005. "I remember vividly going to the movies with a couple of my friends that day. We saw *The Skeleton Key*, which is funny, it's a movie about Louisiana, and it's a horror movie.... Anyway, on the ride home, my mom's friend picks us up, and she says, 'If the hurricane hits, we're getting out of town.' I'm like, 'What hurricane?' I came home and my mom said, 'We have to evacuate tomorrow.' We were lucky, because my family is very large, and is not entirely bound to New Orleans, there's mobility. My aunt lived in Opelousas, which was outside of Katrina's cone. She had a house with a trailer, and a lot of land, and big pigs." Brown smiles at the memory. "It was somewhere to go. I packed up a lot of my stuff, and then we had to make a bunch of different stops, to get my grandparents, their dogs, my uncles, my aunt, *their* dogs. What would have been a three-hour drive took something like fifteen hours because of the traffic. And at the beginning it was like a family vacation. But then it became a catastrophe. We were calling home and finding out that people we know didn't get out. They were on their roofs. We were on the phone, calling everyone we could to try to get our friends down, but we couldn't help them, really.

"Afterwards, I didn't go right back. I went to DC to be with my father and finish up high school, whereas my mother returned. Our house had been under eight feet of water. And all the insurance companies went bankrupt, and they didn't pay out. There are so many stories like that, too, of the government and private companies relinquishing their responsibility to the people of New Orleans who had lost everything." Brown shook her head. "When I finally went back in 2006, I just saw all these *houses*. Ruined. You're not supposed to go into them without a Tyvek suit and a respirator. But I didn't. I was eighteen. I felt invincible, so did my friends. I went into this house without protection and it was full of black mold. I can still see it. It was incredibly disturbing, because black mold conforms to these strange geometric shapes, it clings to the boards that are warping behind the drywall, and so there were these bizarre symbols of mold all over the wall and the piano was completely collapsing in mold. It was harrowing. It was disgusting."

Brown's face puckered as she saw the mold in her mind's eye. Soon, she described for me how these events would influence her entire creative life. After high school, she went to New York to attend Columbia and, after graduating in 2010, became affiliated with the Occupy movement. This activism saw her taking on many different roles, including canvassing, bagging lunches, and training other volunteers, but when Hurricane Sandy hit in 2012, she found herself

gutting houses in Far Rockaway, a lower-income neighborhood in Queens. There, she observed the effects of "disaster capitalism"—the neoliberal practice of using environmental disasters as advantageous economic opportunities—when white people would show up in the neighborhoods and try to buy homes from traumatized owners for cash.[29] Also, Brown recalled, "the art world was taking advantage of Sandy. I remember MoMA putting up this pop-up in Rockaway, and Klaus Biesenbach and Marina Abramović sort of showing up, stuff like that.[30] And that's when I realized that I had to go home. It just reminded me of everything that had happened in New Orleans."

When Brown reunited with her hometown in 2013, she began collaborating with the artist Lisa Sigal, who was in residence at the local arts center Prospect.3. The two women decided they wanted to do a project around housing inequality, because, Brown noticed, while certain segments of the city were refurbished, houses in other districts of New Orleans were even more decrepit than they had been before she had left for college. "I asked myself, how is it you travel through certain parts of New Orleans and some places look peachy, everything's redecorated, it's the new New Orleans, but then you go to the center of the city—Mid City, the upper Ninth Ward, Black neighborhoods—and that façade drops away? In New Orleans, we're really proud of our heritage. We always tell these stories about the city and one of them is that New Orleans has the highest population of Black homeowners. And then, I just had to wonder, how did we have this complete 180-degree flip?"

Sigal and Brown solicited the help of the painter and sculptor Carl Joe Williams and began the undertaking that became known as Blights Out. The group soon accrued a core membership of sixteen artists, historians, architects, and activists. At first, the collective sought to engage with the New Orleans Redevelopment Authority (NORA), which casts itself as an agency dedicated to the "revitalization" of the city and had absorbed some of the Road Home properties that were later put up for auction.[31] Blights Out members blanched when they realized that the Authority was selling people's homes. "NORA was, like, *sketchy*. What *is* this agency? we thought. We turned our backs on them, just, absolutely *not*. Afterwards, we turned our attention to blight, what it is, what it means, how it develops, how it functions. And we started doing actions based on that."

Blights Out created events that made arguments about the ways that the government had deprived people of property upon the landfall of Katrina in 2005 and in the years since. To illustrate and mourn this process, the brass band in *Home Court Crawl* wove through disintegrating houses in Mid-City and Tremé. Then, in 2015, Brown organized *Live Action Painting*.

"I was there the day we did *Live Action Painting*, though I didn't get into any of the photographs, because I don't like my picture to be taken," Brown chuckled. "I was organizing it, though. Yes, it was my idea, to paint the houses. What I remember about that action was that some people from the neighborhood didn't

care, and some people were intrigued. There was a white guy who had just bought into the neighborhood and he didn't want to talk to us. He was hostile, standoffish. But then there was Miss Sue, a woman we'd known since before *Home Court Crawl*, and she was very welcoming. We set up in front of her house and painted. She was a person who had been trying to navigate this system of housing, to keep property from going to the wrong people, she said. She wanted to get ahead of the problem, but she'd just gotten completely entangled. And then we did, too."

"What do you mean?"

"Around this time, we were trying to buy a piece of property so that we could turn it into a community center. And we almost succeeded three times, but it never worked. The first one was just a layer cake of corruption, and the other one, it just didn't pan out. And then the third time, the owner agreed to sell to us, and we were all ready. It was a house with blight liens on it, tax liens. But we were going to buy it. The week before the sale date, I'd been there, everything was fine. And then I biked over to the house a week later, and the house was just not there. I thought I was going crazy. But the city had demolished it. Without notice or anything. They just leveled it. And we found out that, even though the house was gone, we'd still have to pay for the liens if we bought it. Because the debt was all tied into the land itself. The debts were unforgivable. I don't know. It was frustrating. I kind of hit a wall after that."

Brown began to pivot from Blights Out in part because of the disappointment, calling her inability to purchase property in her hometown "catastrophic." To understand why the city was in so much trouble, she turned her attention from the local studies that had led to works like *Live Action Painting* and now examined the larger underlying reasons Katrina had hit New Orleans with such raging force. Unlike the plaintiffs in *Saint Bernard Parish*, she did not specifically focus on the structure of MRGO or the Army Corps' negligence in maintaining it. Instead, she analyzed the disaster from a much wider perspective that considered ecological and economic factors. "I started to realize that the events that succeeded Katrina are in fact related to events that preceded the hurricane, which is this continuum of extractivism"—here, Brown used the term that describes the governmental and corporate practice of extracting natural resources, including oil, coal, and even human capital in order to gain wealth.[32] "You have the rise of the fossil fuel industry and the dredging of oil and gas canals that created these hurricane highways, which flooded majority Black communities sited in the most vulnerable geographic areas. So, together, the government and the oil industry had been killing the vegetation that held the embankments together, and also contributing to the strength of storms."

Brown's increasing awareness of the interconnectivity of causes that led to the destruction of New Orleans inspired her to embark on projects that studied how communities could become enmeshed with energy companies and so indirectly

FIGURE 5.2. Imani Jacqueline Brown, *Debtfair* (2017), © Imani Jacqueline Brown 2017

support the operations that spurred on environmental calamities like Katrina. While still involved with Occupy Wall Street, Brown had started working on *Debtfair*, the crowd-sourced study of the corrosive effects that debt imposes on artists.[33] In 2017, she developed that archive into a broadside (a kind of graphic poster) that cited the activist artist Hans Haacke and visually traced the student debt of five hundred artists to "Five Nongovernmental SuperPowers."[34] Among other things, the broadside documented how BlackRock, Inc., the management investment corporation that today oversees over 300 billion dollars in investments in energy firms, qualified as the dominant holder of artist debt instruments—which meant that many artists, without realizing it, were supporting Big Oil.[35] A year later, while working at the New Orleans–based radical arts organization Antenna, Brown continued to push back on energy companies when she co-organized the *Fossil Free Fest*, an art, music, and food festival in New Orleans that she produced with only environmentally ethical backers and scheduled right before the city's *Jazz & Heritage Festival*, which is sponsored by Shell Oil.[36] She did so to warn artists about the dangerous coalitions they created with petrochemical firms when they accepted payment from energy companies who offered to fund their ventures. "I'm interested in complicity," Brown told me. "The ways that we often unwittingly sanction very violent destructive practices and policies, like fossil fuel production and extraction which produces not only climate change but also extremely high cancer rates. Is it a conscious effort? That we just don't give a crap? No, it's *not* an intentional nefarious decision. It's usually a lack of sensibility, and so there's a real need of a bird's eye view of these relations."

The "bird's eye view" wound up revealing to Brown the magnitude of the problems that had led to the disaster of Katrina along with so many other crises, such as worldwide environmental collapse, soil contamination, and pollution. During her organization of *Live Action Painting*, Brown had maintained a grassroots focus, but, after *Debtfair* and *Fossil Free Fest*, she started to wonder what she would be able to see from a "up high." While in New Orleans during her Blights Out phase, she'd studied its system of canals from documents she found on the web. Rather than immediately turn this into a project, though, she moved to London to continue her education, and while there, taught herself how to read satellite imagery. This skill allowed her to examine New Orleans from an entirely new vantage and she began using satellite pictures to map the city "so that the wider world would have access to it, so they had clearer information about what these companies are doing to our homeland," as she told me.

"I wanted to show how in New Orleans we're surrounded by these wetlands. They are skin, an essential buffer between our tiny fragile human bodies, our fragile precarious porous communities. They're this bulk where these hurricanes are rolling in more powerfully and frequently. But now the wetlands are

emaciated, they've been carved and whiplashed, but we can't see that from the ground. We can't observe the loss of vegetation, the poisoning of oysters, the eradication of muskrats—the scale of the disaster, what these companies have done. And what I found from satellite footage is that you can see the canal that brought water into these neighborhoods during Katrina. You can say, *this* is the levee that breached. *This* is the Exxon refinery that's a few miles down the road that spilled oil all over this community. You start to get a sense of the ecology of your wider body, the sense that your body is not just flesh and bones, and not just a social body. Instead, my body is the land that is dematerializing before my eyes. My body is this whole place."

Brown's "obsession" with "this whole place" led her to travel from London back to New Orleans so she could fly over Louisiana in a small plane, where she witnessed not only the network of canals, the oil sheen on the waters, and the emaciating buffers of wetlands, but also the area known as "Cancer Alley" and "Death Alley." This region is in the part of the lower Mississippi that extends from New Orleans to Baton Rouge,[37] and it is inhabited by a largely Black community as well as petrochemical fields. During this trip, she attended a local city council hearing where she heard the testimony of the celebrated environmental activist Sharon Lavigne, who explained that the Formosa petrochemical company planned to build yet another plant in Death Alley but that the land tagged for construction was a suspected site of the unmarked graves of enslaved people.[38]

These forms of research coalesced into a deeply energized stage in Brown's career. In 2019, she began working with the London-based Forensic Architecture (FA), a research-and-arts concern headed by the architect and Goldsmiths professor Eyal Weizman. Weizman maintains that aesthetics are not just an entry point to arts, culture, and pleasure, but also a "deep attunement to objects and surfaces."[39] This philosophy has catalyzed FA's expansive investigation methods, which often use "spatial analysis," a method of examining entities' geographic and topological dimensions. FA is known for many of its revelations, such as its tracking down the use of European arms in the ongoing bombing of Yemen, and it was shortlisted for the Tate Museum's Turner Prize in 2018 for its "use of creative practice in an image- and data-laden environment."[40] Brown brought the problem of Death Alley to Weizman, who greenlit her orchestration of a massive investigation into Death Alley and the suspected graves. This report was conducted in partnership with legal organizations such as the Center for International Environmental Law and Loyola University New Orleans College of Law.[41] Observing that Louisiana statutes put obstacles in the way of any development that would disinter the dead, Brown and her team studied old maps and records to determine that hundreds, and potentially thousands, of slave cemeteries resided in the land that was to host the Formosa plant.[42] The resulting study, "Environmental Racism in Death Alley, Louisiana/Phase I Investigative Report,"

was published in July of 2021. Three months later, the Army Corps of Engineers announced that Formosa would face a two-year delay so the Corps could conduct an environmental review of the company's plans.[43]

While she worked on the report, Brown commenced making films about Louisiana and its pollution by the energy industry. In 2020, she released *The Remote Sensation of Disintegration*, a poetic short showing ground footage and satellite images of the state. In a voiceover joined to images of a boat floating down the Mississippi and pixilated satellite cartographies of the bayous, Brown asks: "By stepping beyond my grassroots perspective and adopting the view from afar, as well as the technological view from above, have I abandoned an ethical position of local agency, in favor of one that sees like a state? . . . What does the bird's eye view, or the ancestor's eye view, make newly sensible?"[44]

Brown continues, as of this writing, to make films, conduct investigations, and pursue the problems that have transfixed her since she first organized law students as a high schooler, fled from New Orleans in 2005, and, upon her return, witnessed the symbols of black mold scrawling over the homes destroyed in the

FIGURE 5.3. Imani Jacqueline Brown, *What Remains at the Ends of the Earth?* (2022), © Imani Jacqueline Brown

flood. *What Remains at the Ends of the Earth?*, her project for the Berlin Biennale, is a film that joins her interests in mapping, ecology, and race to create a kind of cosmology of the earth. Showing our planet as a glowing black orb—or is it a blob from an oil spill?—spinning through space, Brown inscribes Earth with constellations, that, on a closer look, are actually the maps of petrochemical companies. "Capitalists are strange beasts that segregate existence from itself," she announces in the film's vocal accompaniment. "And put us to work against our own interests."[45]

While I still had Brown on the phone, I asked her about her earlier work with collectives, which had seen her arranging powerful forms of direct action such as witnessed in *Live Action Painting*. "Activism *is* collective," she said. "It's not just about questioning and challenging the status quo. If you're also trying to envision and enact alternatives, to enact other ways of being, and to envision them, you have to do it with other people. I mean, there's infinite reasons that I collaborate. Humans are social beings and it's important to build with others."

"And what does this have to do with art?" I pressed. "*How* is activism an arts practice?"

Brown looked at me for a moment, as if she were surprised that I asked such a question. "Capitalism says that there's this need to equate value with monetary value. But this depreciates the value of other forms of exchange with other human beings, with the earth, with oneself. There are other ways of being and exchanging and being in and with the world other than putting a monetary value on something. As soon as something becomes art, it becomes an asset. It's the same as when human bodies become an asset that entered circulation, just as land does, just as complex ecosystems do. It's essentializing and reductive and violent. But if you engage with the world in a way that is full, if your practice of engaging with the world is one of care and curiosity and respect and joy, it's going to be creative. There are many ways that cultures all over the world have designed really creative solutions, these practices of relating, of exchanging, of existing. And, yeah, they can all be considered art practices—or *not*, it doesn't matter. We're so obsessed with this question of 'is it art?' I'm so bored by this question, 'Is art political?' This question won't die! And I think it's so not the point! It's not the important question we should be asking ourselves."

In the years since Brown staged *Live Action Painting*, she has gone on to merge her art and activism in an increasingly ambitious and connected series of gestures, all of which critique the state and, more recently, energy conglomerates for their roles in suborning racism and classism. Brown's trajectory as an artivist finds her emphasizing how ignorance, inaction, and extractivism create and

perpetuate environmental racism. In 2015's grassroots event *Live Action Painting*, she exhibited the violent effects of the state's neglect of the MRGO and its disinvestment in Black neighborhoods. During her 2012–18 localized work with *Debtfair* and *Fossil Free Fest*, she examined how artists were, often without their comprehension, passively "complicit" with groups that exploit poor people and nourish industries that pollute Black communities. In 2019, when Brown began working with Forensic Architecture, she maintained her commitment to homegrown and ancestral knowledge but also expanded her view from the local level to look at the violent consequences of petrochemical industries from the "bird's eye" vantage. By doing so, she gained a radical vision of the interconnectivity of life, death, and causes. Her study of satellite images revealed how the state and its relationship with fossil fuel corporations create wide-scale inequality and death in Black communities living along the Mississippi. Her resulting 2021 Death Alley report and her art-research films *The Remote Sensation of Disintegration* and *What Remains at the Ends of the Earth?* leverage this transcendent perspective. These works also found Brown returning once again to the allegiances that have driven her career and impelled the orchestration of *Live Action Painting*, which mourned the dead and advocated for the surviving community.

Brown's work has many important legal implications, particularly those concerning the relationships between the Thirteenth Amendment, the Equal Protection Clause, the Due Process Clause, and the problem of environmental racism. But in the remainder of this chapter, I circle back to *Live Action Painting* because this quiet, unspectacular event contains arguments and information that help resolve the core social, environmental, and legal event that became the primal scene of Brown's life and work: Hurricane Katrina and its aftermath. In line with the goals of this book, I show how *Live Action Painting* contains insights that help us push back against Judge Dyk's reversal of Judge Braden in *Saint Bernard Parish*. *Live Action Painting* limns the quandaries of race, environmental destruction, death, and the intertwined relationships of actions and failures to act. When analyzed also in relationship to Brown's later efforts, such as her studies of interconnectivity and complicity and the mapping that obtains a "bird's eye view" of larger patterns, *Live Action Painting* applies to Dyk's *Saint Bernard Parish* in revelatory ways. Viewed in the light of Brown's larger oeuvre, *Live Action Painting* reveals to the student of artivism yet another means by which artivists produce important critiques of law and contribute to conversations of jurisprudence and rights.

To understand Brown's artistic and legal insights, however, we'll have to go back to the beginning of this story and look at what happened to New Orleans before, during, and after Hurricane Katrina.

The History of Hurricane Katrina and Its Impact on New Orleans, with a Focus on the Lower Ninth Ward and Saint Bernard Parish

Louisiana has a long track record of exploiting people of color and ensuring their inequality. Slavery was instituted in the state by virtue of the Black Code of 1806.[46] The institutionalization of this atrocity was also fostered by the Fugitive Slave Law of 1850 and the *Dred Scott v. Sandford* decision of the United States Supreme Court, which held that the descendants of African slaves could not be citizens and that enslaved people did not become liberated even after reaching a free territory. Despite these subjugations, in the 1800s a tradition of Black and minority housing tenure managed to take hold in New Orleans' Lower Ninth Ward, where African Americans and immigrants built residences because they were unable to afford land on higher ground. Throughout the twentieth century, Black citizens in New Orleans experienced police brutality, segregation, and, notwithstanding their high rates of property ownership, housing insecurity and poor living conditions.

Property owners residing in Saint Bernard Parish and the Lower Ninth Ward, who brought the takings claim that Judges Braden and Dyk ruled on, possess a collective identity as the Saint Bernard Polder; "polder" is the term for low-lying land reclaimed from the sea. As Brown related to me, the Lower Ninth Ward and the rest of the region have historically received protection from storms in the form of wetlands. Louisiana and the US government first began to construct wetlands-threatening waterway navigational canals in 1914 and 1925, and by 1955 the US Army Corps of Engineers alerted to the fact that New Orleans and nearby Lake Pontchartrain needed additional protection from storms. The Corps soon enacted a "Barrier Plan," which was supposed to consist of 125 miles of floodgates, floodwalls, and levees, the latter of which are embankments that guard against river overflow. However, by 2005, the Barrier Plan had not yet been completed.

In 1958, three years after the United States had first received notice that New Orleans needed storm protection, the Army Corps of Engineers implemented its earliest expansion of the MRGO, which would extend between the Gulf of Mexico and New Orleans. The federal government authorized the construction of this deep-draft, seventy-six-mile-long navigational channel to the west of the Mississippi even though it threatened cypress swamps, which were crucial for storm fortification and would eventually die out due to the change in surrounding water salinity. Soon afterwards, the US Fish and Wildlife Service warned the Corps that the channel would destroy the trees and threaten local environmental "disaster." Fish and Wildlife recommended delaying the project in light of these

findings, but the Corps did not respond to this advice. The construction of the MRGO continued apace.

By 1968, the Corps completed a third expansion of the MRGO, leading to the burial of over 10,000 acres of swampland. At this point, the MRGO possessed at least 24 miles of levee, including a portion protecting Saint Bernard/Chalmette and Orleans Parish East. Together, these levee sections created the funnel that would prove to be a delivery system of a cataclysmic tidal wave during Katrina.

In 1998, Louisiana authorities studying local environmental conditions issued a report predicting that the area's recurrent hurricanes could give rise to eighteen-foot storm surges topped by ten-foot waves, which no current or proposed safeguards could ward off. In 2000, the EPA recommended erecting a hurricane-protective gate to Saint Bernard Parish and the redevelopment of MRGO-destroyed wetlands. Then, in November 2004 and June 2005, Army Corps studies warned of potential "wakes" from the MRGO if it ever disconnected from the lake, as well as increased storm surges.

As Judge Braden noted in her 2015 decision, these studies turned out to be "prophetic" when Hurricane Katrina touched down on the tip of Florida on August 26, 2005.

While the National Weather Service had been disseminating accurate predictions of the hurricane at least two days prior to landfall, the federal and state government responders didn't react to the disaster with any kind of speed or efficiency. Katrina grew to a Category 5 storm on August 28, at around midnight. This means it blew at least 157 miles per hour. Waves east of the Mississippi River crested over 20 feet. The fury forced "considerable" breakers against the east-facing levees tracking the Mississippi River, also recruiting waters formed in a pocket created by the delta and the Mississippi coast. The storm then hurled into Lakes Borgne and Pontchartrain as Katrina pushed north. Colossal wave force blasted hurricane protection systems in Plaquemines, St. Bernard, and Orleans Parishes.

By 1 p.m., Katrina had been downgraded to a Category 1 storm, meaning that it raged at 74–95 miles an hour. Still, three breaches of the existing levees occurred at the Lower Ninth Ward, which was overwhelmed by waters from Lake Borgne. Around 70 percent of the MRGO levee ruptured, flooding Saint Bernard Parish. Storm surges eventually reached up to 15–19 feet. In the end, about 80 percent of the city was flooded up to 20 feet a day after landfall and 68–98 percent of homes were severely damaged or destroyed.

Brown and her family, who raced ahead of the worst of the storm to her aunt's farm in Opelousas, were luckier than many. Residents who found themselves stranded in the wave-lashed city were told to go to the Superdome, the Convention Center, and interstate bridges for safety. But they didn't find any help there:

a later House Subcommittee report on Katrina acknowledged that "thousands upon thousands" of victims "were subjected to unbearable conditions: limited light, air, and sewage facilities in the Superdome, the blistering heat of the sun, and in many cases limited food and water."

Survivors reported that neither FEMA nor other US government responders aided them and that they endured nightmarish conditions, such as sleeping by corpses when they ventured out of the Superdome. The government didn't deliver medical supplies for days. And in some areas, food, water, and ice deliveries were delayed for at least eleven days. Confusion between state and federal responders led to bodies being left unrecovered. Federal attention was so lacking that Canadian Mounties often acted as first responders, which led some residents to feel forsaken by their own government.

Meanwhile, thousands of members of the National Guard flowed into New Orleans. On September 7, they were given Title 32 status retroactive to August 29, two days after George Bush had declared a state of emergency. This status meant that the National Guard was acting in the name of the federal government. The Guard almost immediately grew beguiled by false reports of rapes, murders, and sniping. So intimidated, the Guards refused to approach the Superdome until September 2, one hundred hours after the hurricane, until "we had enough force in place to do an overwhelming force," Lieutenant General H. Steven Blum, Chief of the National Guard Bureau, told reporters on September 3. Louisiana Governor Kathleen Blanco described the "'landing'" in New Orleans of "'troops fresh from Iraq, well trained, experienced, battle tested . . . ready to shoot to kill, and they are more than willing to do so if necessary, and I expect they will.'" President George Bush announced that there would be "zero tolerance for armed gangs and profiteers." Tragically, these threats came to pass: On September 4, 2005, four New Orleans police officers shot six unarmed civilians on the Danziger Bridge, killing seventeen-year-old James Brissette and Ronald Madison, the latter of whom was a forty-year-old mentally disabled man.

National Guard planes airlifted many residents from the area, including six hundred people transported to Salt Lake City, Utah, a majority white city. Many people didn't know where they were going while en route. Residents complained of confusion, lack of communication, and of having no idea how to get back home. In the end, the trauma was so great that about half the city's people left New Orleans, abandoning their homes and properties. As I've noted, at least one hundred thousand never came back. The people left because of their trauma as well as the demolition and blight and tax liens that began to pile up against their properties. This abandonment accelerated the damage that New Orleans properties suffered, leading to the blight that Brown and her colleagues later addressed with Blights Out.

More than a million people were displaced in the Gulf Coast region in the immediate aftermath of the storm, and up to six hundred thousand households remained displaced a month later. Damages from Katrina and the later-arrived Hurricane Rita, in total, reached $125 billion, or $190 billion in 2022 dollars. Of the nearly 1,400 fatalities overall, it is estimated that 40 percent were caused by "drowning, 25 percent by injury and trauma, and 11 percent from heart conditions." Almost half of the dead in Louisiana were people over seventy-four years of age.

By the time that Brown orchestrated *Live Action Painting* nearly a decade later, which was also the same time that Judge Susan Braden issued her decision in *Saint Bernard Parish I*, the landscape of New Orleans had transformed on account of mass death, survivor flight, and later gentrification. The Housing Authority of New Orleans reported in 2016 that "Areas that were majority African American ... changed quickly and are now majority white or moving in that direction."

As Carl Joe Williams, one of the members of Blights Out who performed in *Live Action Painting*, said to me during in an interview in January of 2019:

> [There's a] sense of loss that's happening here. . . . And it's based on seeing the city change too much. The people who live here feel a sense of helplessness of what they can do to actually hold on to their space and the way that it has been. So yeah, there's a sense of things being taken. Here. And not just in the Lower Ninth Ward but the whole city. It feels like the disaster capital at its finest. There's a lot of people taking advantage of the fact that people are really vulnerable in the city, especially the poor. And they don't have maybe the resources or the game plan to combat some of the things that have been going on. But yeah, I feel like there's been a sense of something being taken.

While Judge Braden, in *Saint Bernard Parish I* (2015), did not mention "disaster capitalism," gentrification, or address New Orleanians' feelings of helplessness, she agreed that "something" had been "taken" from the people of New Orleans by the government. She based her decision on the fact that the Army Corps of Engineers had caused a temporary taking of Saint Bernard Parish and Lower Ninth Ward properties by building and neglecting the MRGO, whose structural problems created risks of flooding that were realized in 2005.

The Court Decisions

On May 1, 2015, Judge Braden considered what happened in New Orleans by the lights of the Fifth Amendment's Takings Clause, which provides: "No person

shall . . . be deprived of . . . property, without due process of law; nor shall private property be taken for public use, without just compensation"[47] and held that the United States was liable for violating these rights in Saint Bernard Parish and the Lower Ninth Ward.[48] In a detailed fifty-eight-page opinion, she wrote that the US Army Corps' construction and failure to maintain the MRGO increased the surge of Hurricanes Katrina and Rita.[49] The resulting waters flooded the plaintiffs' properties, due to the funnel effect created by the channel.[50] Homeowners were consequently entitled to recover under the doctrine of "inverse condemnation," which allows plaintiffs "just compensation" in cases where takings occur other than through condemnation proceedings.[51]

On April 20, 2018, however, the Court of Appeals for the Federal Circuit reversed Judge Braden.[52] In a brisk, twenty-three-page decision, Judge Dyk held that Braden had erred because she had based her takings analysis in large part on government *inaction*—that is, the government's failure to maintain MRGO. Dyk ruled that, under High Court precedent, takings could be based only on affirmative conduct, like where the government condemns a property or commits a positive act that intrudes on private land.[53] Dyk also held that Braden's causation analysis failed because it focused on MRGO's destruction of the Lower Ninth Ward and Saint Bernard Parish without analyzing the possible benefits of the Army Corps' Barrier Plan (that is, the incomplete system of levees and floodwalls).[54]

There are many issues presented by *Saint Bernard Parish*, but I focus on Dyk's conclusion that prevailing Fifth Amendment law forbids takings claims where the government's *failures to act* result in property invasion and damage.[55] I also examine Dyk's criticism of Braden's *causation* analysis. With respect to the first point, I maintain that Dyk was wrong and that US Supreme Court case law *doesn't* forbid takings claims where the government's omissions lead to property invasions and destruction. In his opinion, Dyk cited various decisions, *none of which* pivot on an omission/commission distinction.[56] The case he leaned on the most was the famous *Arkansas Game & Fishing Commission v. United States* (2012), where the Supreme Court held that the US government could be held liable for property invasion and damage incurred in northeastern Arkansas after the Army Corps of Engineers released water from a dam at a slower and longer rate than usual.[57] This leisurely discharge led to the destruction of timber in the area because, as the *Arkansas Game* Court said, the "lower rate of release . . . extended the period of flooding"—an action that could be described either as failing to release the water at its typical faster and shorter rate or affirmatively releasing it at a slow and extended pace.[58] The Court never characterized the Army Corps' conduct as either a positive act or an omission, yet Dyk acted as if it were obvious that cases like *Arkansas Game* decided that only positive acts could lead to actionable takings.[59]

As noted, Dyk also accused Braden of overlooking important facts in her causation review. Dyk held that Braden erred because she'd failed to consider the "totality of the government's actions," which rendered her causation analysis fatally flawed. Dyk was right with respect to the general rule: It is beyond cavil that in takings cases plaintiffs must prove that the government caused the taking. To establish this cause, all circumstances must be evaluated.[60] When applying this doctrine, Dyk found the plaintiffs had made this impossible because they'd objected to the admission of evidence on the Barrier Plan's supposedly protective effects on the flooding. The Barrier Plan, the plaintiffs had argued in the lower court, was irrelevant to the question of damage created by the MRGO because the Barrier Plan and the MRGO were two different projects and didn't function together to protect against flood.[61] Dyk disagreed, holding that the Barrier Plan constituted relevant, similar governmental conduct for the purposes of causation, because it was dedicated to stem "the risk of flooding" and "avoiding flooding damage."[62] In a striking assessment, Dyk held that "[t]he result is that plaintiffs failed to take account of other government actions ... that mitigated the impact of MRGO and may *well have placed the plaintiffs in a better position than if the government had taken no action at all.*"[63] Dyk then concluded that because government inaction could not state a takings claim, and the plaintiffs had "not established that the construction or operation of MRGO caused their injury," the victims' claims failed.[64]

So, to recap, Dyk held that the plaintiffs lost because Supreme Court precedent mandates that only positive government acts could give rise to takings claims and because Braden hadn't considered all the facts in her causation analysis. Was Dyk correct when he reversed Judge Braden? Was his analysis persuasive? My response to these questions is no, because something important was left out of the judge's analysis. I'm not just talking about the fact that cases like *Arkansas Game* don't forbid takings claims where there's government inaction. I'm even more worried that Dyk's opinion completely leaves out *the local and ancestral knowledge* that Brown has privileged in her work. Furthermore, the "big picture"—that is, in Brown's parlance, a "bird's eye" view—is also missing in Dyk's opinion, because, for all his criticisms of Braden's causation analysis, he didn't consider the larger scope of the government's actions and how federal agents' mismanagement of disaster relief efforts alienated people from their property during and directly after the storm.

As we've seen in previous chapters of this book, a large part of the "artivism and the law" project seeks to introduce different forms of knowledge to jurisprudence, particularly that of women of color and queer people of color who endure the law's power firsthand. Many thought leaders have observed that these groups have been historically excluded from positions of legal authority even though

they possess critical wisdom about the experience of domination and the on-the-ground meanings of equal protection, due process, and other core jurisprudential concepts.[65] Moreover, scholars such as Reva Siegel, Peggy Cooper Davis, and Dorothy E. Roberts acknowledge that outsider communities can be "underappreciated architects in the Constitution's meaning."[66] In such a contested case as *Saint Bernard Parish II*, where so many people of color and poorer people were refused just compensation, it's well worth our time to consider alternative perspectives to see if Judge Dyk got it right. Dyk isn't from the community affected by Katrina, after all, as he was born in Massachusetts, went to Harvard, and sits in DC.[67] But Brown is a New Orleans native, a Black woman, and an artivist who has spent considerable time researching the issues that Dyk succinctly dispensed of in *Saint Bernard Parish*.

When we study Brown's work, we will find that it *does* allow us to see the issues in *Saint Bernard Parish* from an important, alternative point of view that she developed from her intimate knowledge of New Orleans and her examinations of the ways that white-dominant power structures exploit Black people. As I've noted, my main emphasis here will be on *Live Action Painting*. I also fold in observations that are prompted by some of Brown's later projects, such as *Fossil Free Fest*, *Debtfair*, the Death Alley report, *The Remote Sensation of Disintegration*, and *What Remains at the Ends of the Earth?* We'll see that even while *Live Action Painting* draws on the tradition of Brown's artivist forebears, it also can help make the case that a wide swath of government acts *and* omissions, stemming from Katrina onward, has taken property from the people of New Orleans.

Live Action Painting

As the reader will recall, *Live Action Painting* consisted of Brown and her Blights Out colleagues setting up easels in front of Miss Sue's house in the Mid-City district of New Orleans in 2015. Ten years after Katrina, these artists drew and painted the neighborhood's ruined buildings in plein air; they also attempted to engage with some of the newer neighbors who had moved into the area since the storm had destroyed local land values.

With this gesture, Brown and her comrades committed an ingenious action that reflected meaningfully on Enlightenment-era European art history and also took its place in the pantheon of work made by woman and queer of color artivists. Simultaneously, *Live Action Painting* connects powerfully to the law of takings, and the case of *Saint Bernard Parish* in particular. It communicates a broad view of property loss, fighting the notion that government omissions can't result

FIGURE 5.4. Katrina Andry's contribution to *Live Action Painting* (2015), Heidi Hickman for Blights Out, © Imani Jacqueline Brown 2015

in cognizable takings and reframing the appropriate "totality of government actions" to be considered.

Live Action Painting and Its Roots in the Art of the European Eighteenth Century and the Practice of Artivism

Live Action Painting brought together two European art traditions, being plein air painting as well as the heritage of house portraits. Plein air painting sees artists working outside and painting "from life." It rose as a favored form in late eighteenth-century France, and artists prized it for its ability to convey facts or "truth"[68] in a variety of contested manners. The practice has been associated with, for example, the Enlightenment obsession with natural science and the precise study and rendering of nature, passions that led to sometimes distressing collections of "specimens" and evolved into racist forms of taxonomy (as we saw before, in the chapter on Carrie Mae Weems).[69] The history of home portraits can similarly be traced to at least the eighteenth century, when English nobles commissioned artists to paint their domiciles in order to convey their own grandeur. As art historian Linda Chisholm writes, the house became the "symbol and measure

FIGURE 5.5. Keith Duncan working on *Live Action Painting*, Heidi Hickman for Blights Out, © Imani Jacqueline Brown 2015

of position. The larger and more impressive the house, the greater the esteem in which the owner was held."[70]

Live Action Painting engaged this history and flipped it on its head, using an inventive method of critique that avoided fetishizing Black pain while making a persuasive argument that the government had committed "actionable" wrongs in its handling of Katrina and its later abandonment of the Black community. While *Live Action Painting* didn't trumpet its accusation of government wrongdoing in explicit gestures or language, its embrace of historical European art forms points toward atrocities committed against Black people by governments, as racist Enlightenment philosophy was coterminous, and promoted, contemporary official acts that enslaved or otherwise subordinated people of color.[71]

Live Action Painting additionally resonates as a form of valuable knowledge because it qualified as direct action that shares in the history of artivism. As such, it builds on a foundation of woman and queer of color affinity, fidelity, epistemology, issue spotting, and problem-solving. Brown's organization of collaborative art-making, which was simultaneously a gesture of protest and outreach, recalls Judy Baca's community engagements in *The Great Wall of Los Angeles*. Her orchestration of *Live Action Painting* additionally evokes the work of Marsha P. Johnson, Faith Ringgold, and Charlene Teters, who all staged public, identity-conscious actions that involved fellow artists and created alternative interpretations of rights.

These foundations give *Live Action Painting* a source of enormous critical strength. Once the subject of racist taxonomy and investigative science, Black people now looked at the world around them to see what was true—loss, destruction—and marked it down as a form of evidence. And while house portraits once functioned as high-status signaling, these studies recorded how the government's failures to act had allowed Katrina to visit New Orleans with such ferocity, since the artists registered the flood's scars on the buildings' facades. Furthermore, *Live Action Painting* uncovered how Katrina's dispossession, which was aided by the government's failure to reinvest in the community, had begun to take the form of gentrification.[72] That is, in *Live Action Painting*, Brown didn't just confine herself to the facts of the storm but also found wrongful dispositions of Black property caused by later government divestment and auctions.

Bringing this all together, *Live Action Painting* draws on the history of European and English art and US woman and queer of color artivism in ways that signal a rejection of capitalist, white-centered, and racist forms of knowledge. Brown and her collaborators gathered in a group to perform outreach (that was sometimes rejected) and to signal an alternative consensus on the destructiveness of government acts and omissions. *Live Action Painting*'s public artmaking

rendered visible the taking that has been occurring in New Orleans since the flood and identified the bearers of this knowledge as skilled perceivers who stand apart from the legal and formal political world that dictates the fates of Black New Orleanians.

In other words, *Live Action Painting* offers a different reading of the rectitude of property outcomes in the Lower Ninth Ward and Saint Bernard Parish. It provides us with another reading of property rights in the city and whether they have been taken by the federal government without just compensation.

Applying *Live Action Painting* (2015) and Some of Brown's Later Works to *Saint Bernard Parish I and II*

What does this all mean for *Saint Bernard Parish*? As we recall, appeals court judge Timothy Dyk reversed Judge Susan Braden based on the issues of *omission* and *causation*.[73] Dyk said that government inaction couldn't result in a takings finding and held that Braden had failed to consider the totality of the circumstances because the plaintiffs objected to the introduction of evidence of the Barrier Plan's flood walls and levees. Consequently, it was unclear, Dyk said, whether the government had put the victims in a "better position" than if it had acted otherwise. He held that the plaintiffs had failed to shoulder their burden of proof that the government had caused the taking.

Live Action Painting gives us another interpretation of the case. Regarding omission, *Live Action Painting* shows that the government's failures to act *can* lead to takings: By having artists document the rot and scars that mar Mid City properties, Brown reveals that the government's failure to guard New Orleans from storms and stave off blight and gentrification committed terrible harms on communities of color. Rooted in community grief and perception, *Live Action Painting* rejects Dyk's omission/commission distinction in the case of takings in New Orleans and looks instead to the magnitude of the deprivation to determine whether an "actionable" taking has occurred. Brown's other work, too, supports this reading since she demonstrates in *Fossil Free Fest* and *Debtfair* that passivity can be dangerous and destructive. Further, Brown's "on high" perspective, reflected in *The Remote Sensation of Disintegration* and the Death Alley report, as well as the cosmology of *What Remains at the Ends of the Earth?*, reveals the deep interconnections of acts and omissions, such that we might begin to wonder whether the omission/commission distinction even makes rational sense.

It's true that Brown's more radical takes on acts, omissions, and interconnectivity surely stray from the tight confines of most (probably all) courts' approaches

to Fifth Amendment jurisprudence, which wouldn't have much patience with the glowing black orbs and cosmic environmentalism found in *The Remote Sensation of Disintegration* and *What Remains at the Ends of the Earth*? "You start to get a sense of the ecology of your wider body, the sense that your body is not just flesh and bones, and not just a social body. Instead, my body is the land that is dematerializing before my eyes. My body is this whole place," as Brown reflected to me when remembering the transformative experience of seeing New Orleans from a plane and realizing how the energy firms had lacerated local wetlands. While Brown's big, prophetic worldview excitingly offers to change the scope of law and society as we know it, no Fifth Amendment opinion that I've ever seen takes such a wide view of takings that it would consider a state's failure to stop 2015 gentrification or the government's lengthy relationships with extractive petrochemical firms relevant in a case that addressed a 2005 flood—much less "the ecology of [the] wider body."[74]

That being said, though, Brown's basic point that omissions can lead to wrongful property disposals *is* a feasible, even persuasive, legal argument. Not only is it supported by my reading of *Arkansas Game*, it's also backed by mainstream, elite legal theory: In a much-cited 2014 *Michigan Law Review* article, the influential property theorist Christopher Serkin argues that government inaction *should* give rise to takings claims where the government exerts sufficient "control" over the conditions that led to the deprivation and there is "real and cognizable harm."[75] Serkin's writings dovetail neatly with Brown's assessments, since *Live Action Painting* documents the devastation that resulted from the US government's failure to maintain its creation, the MRGO. In fact, the white male lawyer Serkin and the woman of color artist Brown here *mutually reinforce one another* on the question of omissions and takings because of Serkin's status as a renowned property scholar and Brown's status as a visionary artist and firsthand observer of how government inaction led to "real and cognizable harm" in New Orleans.

What about the rule that Fifth Amendment claims must be considered in light of "the totality of circumstances" to determine if the US caused the taking? Again, *Live Action Painting* and Brown's later work offer a *very* wide window for framing federal, Katrina-related conduct to see whether the US government wrongfully took (and continues to take) property: *Live Action Painting* considers not only the events of the storm but also looks forward to the mismanagement of the federally funded Road Home program and the government's failure to stop the auctions of the 2010s; her films, moreover, examine the interactions between the government and petrochemical firms that destroyed New Orleans' surrounding wetlands. This recitation of facts most certainly veers far beyond what most courts would be willing to consider on the *Saint Bernard Parish* cause issue, if

only because judges typically strive to limit the scope of their inquiries and recoil at ecstatic arguments that "have no logical stopping point."[76]

Yet, just as we found that Brown offered a workable theory in the omissions analysis, Brown's insights can still move the lever on this area of law. *Live Action Painting*'s generous vision of the "totality of government actions" and Brown's later election to examine broader currents from "on high" (in *The Remote Sensation of Disintegration*, the Death Alley report, and *What Remains at the Ends of the Earth*), can inspire us to contemplate quite a few other federal government behaviors that *directly* conspired to separate New Orleanians from their property during and just after Katrina but weren't considered by either Judges Braden or Dyk. As Brown explained to me, it's important for us to widen our view of the facts so that we obtain "clearer information." And in *The Remote Sensation of Disintegration*, she advises that the "bird's eye view" can make issues "newly sensible." Thus, in Brown's aesthetic and moral language, we should look to larger yet still relevant "maps" of what happened in New Orleans on August 26, 2005, and the weeks that came after, to understand whether the government caused the taking of the *Saint Bernard Parish* plaintiffs' properties.

When we look at the bigger picture, we see that *many* governmental acts and omissions separated people in New Orleans from their properties in the days and weeks after Katrina hit. For one thing, after the storm hit, FEMA's failure to come to the aid of residents led to a terrifyingly high body count in the streets and brutal conditions at the Superdome. George Bush's threats of the "zero tolerance" that would be exhibited by the National Guard intimidated residents with threats of violence, which caused them to fear that the Guard would remove them from their homes and take over the city as occupying troops.[77] Moreover, the National Guard airlifted New Orleanians to places like Salt Lake City, but the federal government didn't give the passengers adequate resources for communicating with NOLA residents or knowing how to get back to their homes.

How did this sum of the totality of government conduct take property? It shows us that the federal government did not take people's homes just by creating a hurricane delivery system in the form of MRGO (which may or may not have been offset to some degree by the Barrier Plan's floodwalls and levees). The "totality" of the government's conduct also frightened, shocked, repulsed, and deterred people from returning to their domiciles—either by allowing New Orleans to descend into death and chaos and triggering a diaspora or by physically preventing residents from having access to their properties.[78]

Motivated by Brown's veneration of not only "bird's eye" views but also local and ancestral knowledge, I'd like to illustrate this last point with the comments of former NOLA resident Linda Santi, a public policy analyst and consultant who

is not a part of Blights Out but who was in New Orleans during the storm. I met Ms. Santi on Facebook, where I saw her making comments about Katrina, and when I contacted her, she was kind enough to describe the reasons for property abandonment to me in a telephone interview on December 27, 2018:

> You couldn't get to your house.... And once you went away, it was hard to come back. Emotionally and physically. Remember that ... not everyone had cell phones ... it was incredibly difficult to talk or communicate to people ... it was hard and with flip phones.... You didn't have a lot of intelligence and you didn't have a way back and your car was ruined because say, you stayed and then were airlifted away ... and if that was the case, people ... had just landed wherever the plane dropped them, which in my case was Salt Lake City ... so just trying to find out what was going on and what you had to do and where everybody was, was incredibly hard for people ... it just worked your last nerve....
>
> But if you did come back to New Orleans, there were buses that would let you go past your house. These buses started at The Sanchez Community Center on Claiborne.[79] The military put shrinks on the buses and we would all would ride on the bus ... so you could drive past your house and see if it was gone or standing, but you couldn't get out.
>
> On these buses, it was remarkable to hear the fatalistic humor—at first, people would say things like, "Oh look, there's Uncle Peet's truck, why's it on my roof? ... Or, "that's Mr. Gerald's couch, what's that doing on the pole?" And people would kind of at the beginning laugh about how crazy everything was and then the bus would get so overwhelming, and everybody would just get quiet. [*She cries.*][80]

Live Action Painting's wide vision of relevant government behavior, combined with Brown's later "big picture" work in projects such as *The Remote Sensation of Disintegration*, the Death Alley report, and *What Remains at the Ends of the Earth?*, urge us to consider these facts because they concern (as per Dyk's opinion) "all government actions ... directed to the same risk that is alleged to have caused the injury to the plaintiffs"—that is, related directly to the storm. From this perspective, could a reasonable person find that the government placed the people of Saint Bernard Parish and the Lower Ninth Ward in a worse position relative to their property than if it had acted otherwise or not acted at all? It is definitely possible. As we see with Brown's *Live Action Painting*, as well as with the testimonies of Linda Santi and Carl Joe Williams, during the storm and immediately afterwards the government performed a multitude of noxious acts and omissions that forever alienated the people of New Orleans from their property.

Brown's Artivism and US Takings

Imani Jacqueline Brown and her colleagues in Blights Out produce work that grows from the history of European art as well as the contemporary practice of artivism. In pieces such as *Live Action Painting*, Brown engaged the Enlightenment's traditions of plein air painting and English house portraiture to deploy devastating critiques of the government's dereliction of its duties. She also connected with the history of woman and queer of color artivism by committing direct action that was public-facing, a political protest, and an outreach.

Live Action Painting also produced legal thought that is worth considering in cases such as *Saint Bernard Parish*. *Live Action Painting*, particularly when read in connection to more recent projects like *Fossil Free Fest*, *Debtfair*, *The Remote Sensation of Disintegration*, the Death Alley report, and *What Remains at the Ends of the Earth?* sees Brown making cogent arguments about the irrelevance of the omission/commission distinction and gives us new insight about the totality of the circumstances that should be considered in cases like *Saint Bernard Parish*.

In the end, Judge Dyk's decision that inaction cannot leverage a takings finding and his narrow obsession with the Barrier Plan crack under the pressure imposed by Brown's passionate and incisive observations and accusations. Together with plain readings of Supreme Court opinions and prestigious property theory, she shows that, in 2005, the federal government could and did take property from the people of New Orleans within the meaning of the Fifth Amendment's Takings Clause.

6

"WE WANTED TO OPEN UP"

Drawn Together and Fair Artists' Contracts

"The art world is both a support structure and it's also something that I'm constantly battling against," Brenda, a white female curator, said during a group Zoom chat.[1] She shook her head and smiled ruefully: "The moment I decided to go to graduate school and commit to this *thing* it was because I was imagining it to be different than the labor market as I knew it. The arts opened doors for me, it taught me things I wasn't learning in public school. Art taught me uglier aspects of our history and it pulled me in for twenty years. It sounds pathetic, but it really is my whole identity. I found myself in the art world and I thought that I was achieving something different." She paused as an anxious expression flickered across her features. "But then I realized, here I am, and the model is just as warped and damaged as any other kind of employment. And I'm complicit in a system that has absolutely failed us."

Simon Wu, a queer male Asian American curator and art critic, gestured empathetically in response to Brenda's comments and then looked straight at his computer's camera. "That's what we're here for, everybody, to understand people's contracts and relationships with arts institutions. Are they good? Are they bad? Fair? Unfair?"

It was in the early days of 2021, and Brenda, Simon, and about twenty other people had gathered virtually to talk about fair contracts in the arts. This group had been convened by Simon, Mira Dayal, Anaïs ("An") Duplan, Maia Chao, and me at the invitation of New York's Cuchifritos Gallery & Artists Space, a Lower

140 CHAPTER 6

FIGURE 6.1. Simon Wu, © Simon Wu and Thomas Blair 2021

East Side gallery run by the artist-run nonprofit Artists Alliance, Inc. Our project was titled *Drawn Together* and had been in the works since the summer of 2019, when Mira, a multidisciplinary female artist of Indian descent, and her longtime collaborator Simon had received a commission from Cuchifritos to curate a show that would address social justice concerns related to "art and the marketplace,"[2] a latitudinarian brief that covered any aspect of art production and capitalism. Mira and Simon had quickly invited the participation of Maia and An, who were respectively a queer Chinese American biracial woman and a trans* Black and autistic American man both well known for their social practice art.[3] I was later

FIGURE 6.2. Mira Dayal, courtesy of Mira Dayal

brought on board because Mira knew me as an arts writer and thought my legal training might come in handy.

Though we each came from different backgrounds, these artists and I had one thing in common, which was our charged relationships with art markets: We'd all worked with varying kinds of arts organizations—from museums to galleries to art schools to magazines to publishing houses—and, while many of these experiences were heartening and productive, we'd also endured discriminatory treatment and low pay. Additionally, we'd heard horror stories about abusive working conditions in the art world from our friends and colleagues. These experiences had inspired us to respond to Cuchifritos's brief by studying

FIGURE 6.3. Maia Chao, courtesy of Maia Chao

the contracts that artists sign with arts institutions, agreements we understood to be shaped by an unequal balance of power. Seeking to discover how that disparity operated, and wondering if contract law could come to the aid of artists, we'd begun interviewing creatives about their interactions with arts institutions. Now sitting in our homes and offices and looking at our interviewees' miniaturized faces on our computer screens, we listened to them describe the hopes and ambitions that had drawn them to careers in the arts and the insecurity, instability, and disappointment that plagued them once they had established themselves as professionals.

Rachel, a white nonbinary multimedia artist, had nodded when Brenda talked about the "warped" and "damaged" art world and now said: "The relationship I have with these places is really complicated. The art world, it's both my home and my support and my, like, *family*. But it's also something that I question constantly."

Miguel, a male Latinx visual artist, concurred. "I have polyamorous relationship with these places. I'm a student, in grad school, art school. And then my other relationship is as an adjunct art teacher. And then my third relationship is as an artist. But there's inequality in all of it. As a student, you get grades. In museums, you feel beneath the art you're looking at. As an adjunct, that's a whole other conversation. And as an artist, you're submitting work."

"And how does that go, submitting work?" I asked.

FIGURE 6.4. Anaïs Duplan, courtesy of Anaïs Duplan

"You want to have a show," Miguel said. "You want to present your work other than have it exist in flat boxes in your studio forever. But to do that, you have to deal with a power dynamic. It's something that you have to live with and understand."

"The problem is, there's a lack of a real relationship with these galleries or museums," said Sal, a Black female interdisciplinary artist. "Because you're *not*

FIGURE 6.5. Yxta Maya Murray, © Andrew Brown 2022

family. You're more like a checklist, and once you've fulfilled their need, then you're, like, gone. They're onto the next person. There's no continuation of a relationship with these institutions, which is bad for artists because this is what we need to grow."

"What do you need to have an ongoing relationship?" I asked.

"Well, think about going to a doctor," Sal said. "There's a real relationship there. Because the doctor's invested in you as a patient and will get to know you a bit better so they can take care of you. And that's the kind of relationship we need. But with galleries, it's like you're speed dating. Like, you never see them again. You get ghosted. After a performance, it's like you had a one-night stand and then you get ghosted. That's the equivalency of the type of experience I'm having."

"The thing is," Rachel said, "and I'm speaking here today as an easily cowed artist—but these institutions wouldn't exist except for us. And they don't seem to understand that. I don't feel like that's *ever* acknowledged, you know? It's always like, 'Here you are, aren't you lucky?' Is there any way that could get put into a contract?"

Mira asked, "So what we'd need to do is reflect the artist's value in the agreement?"

"Yes," Rachel said. "There are so many things that we bring to these galleries beyond our work. Like, our mailing list. The eyes you're bringing to the show. The networks. That's never recognized."

"But there are other problems with the culture," said Georgie, a white female arts worker who got her start in curation and later moved into museum staff union organizing. "Which actually comes from this idea that artists are special. In the beginning of my career, I didn't see artists as art workers, but as something higher. And I was just totally enamored of them. And this sort of blinded me to forego my own rights as a human being. To the right to a living wage, the right to good health insurance."

"Tell me more about being enamored," I said.

"It's an indoctrination," Georgie said. "The idea that artists and art workers are doing their work because they're exceptional. That they're this sort of cool higher power. At some point in the history of, like, white supremacist culture, some asshole said, 'Artists are above money or health care. They don't need these things.'"

Hanna, a Black female administrator of a New York museum's events programming, said: "For me, the issue is discrimination. I mean, I found out that there were white women with less experience than me who made thousands of dollars a year more than I did. And I wished I'd had this information when I accepted the job and was being undervalued for the experience I was bringing. I made $53,000 and they were making $70,000 to $80,000 a year. So I didn't feel like my contract experience was a positive one. I hadn't leaned into the negotiation process like I wish I had."

"Why didn't you, though?" I asked.

Hanna thought about this. "All I know is that I had to have an internal reckoning. I later brought it up with management and convinced them I was worth more."

"I once had an experience where I was contracting with a big organization as an artist," Maia said. "And it wasn't until after the show that I heard what other artists were making. And I thought, 'I wish I'd talked to you sooner.' But were all siloed in our own phone calls, and I felt alone. When we could have all looked out for each other."

Amal, a female arts manager and curator, related to these stories but thought the problems could also be tied to the text of the contracts that artists signed. "How can you even negotiate with some of this contractual language, though? You're asking people to enter into the spirit of this contract, in a mutual relationship that's about collaboration and trust, but the contracts I've entered into have lots of threatening scenarios in order to guard the institution from hypothetical behavior a person might inflict upon it, and I found that to be really difficult to navigate."

"So, people see the language as threatening," An said.

"Yeah, the contracts I've signed are these documents of power that contribute to the dissolving of some of the trust and mutuality that we're trying to create."

Francoise, a white female artist and educator, agreed. "A few years ago, I did a gig with a university, and I was all ready to sign a contract with them for a project. I don't remember how it finally came to my attention, but I learned that the contract said that everything I made for the project would belong to them, and nobody had told me that. And I hadn't read all of the terms. It was a turning point. A teaching lesson. That you need to read the whole thing very carefully and be prepared to push back."

"But why hadn't you look at the contract to begin with?" I asked. "What prevented you from doing that?"

"The language of it, like we're talking about," she said. "The goal is to be opaque. And, also, I needed the money. You have to sign the paperwork to get paid, and if you're in financial need, you're more likely to let the contract specifics slide."

"What if you had a contract mentor, or something like that?" I asked. "Someone who could give you advice, help you through the process?"

"That would be amazing," she said.

"It's just that there's so much fear when you're entering these relationships," Miguel said.

"Fear of what?" I asked.

"I'm an immigrant," Miguel replied. "And I've learned to just say yes to the opportunities I get, no matter if things are unfair. You just say yes, let's do it."

"But what exactly are you afraid of?"

"Of burning a bridge. Of not being included in that show."

Rachel said, "Even you asking that question about negotiation, it makes my heart beat so hard. I know some people negotiate, and I'm always amazed by them. I want some of that entitlement."

"Except, it's even more than that," said Jaco, a Latinx genderqueer curator, graduate student, and critic. "Sometimes these institutions are working with precarious people. I have a friend, a poet, struggling with mental health issues

and multiple types of structural and interpersonal trauma. There are times when she can't give you advanced notice that she can't get out of bed that day. And I have another artist friend who's an immigrant and is constantly being asked by the government to show up for interviews or to fill out paperwork, and it can take up so much time that they can't make it to work, and *nobody* cares about that, nobody will even listen to it. What I want to know is, what other models of accountability can take into consideration these traumas of people who have been historically excluded from the art world? How can we center these kinds of histories?"

"How do you think that we should center them?" I asked.

"You need to just be able to have a conversation," he said. "The basic thing of sitting down with people and being like, "Hey, what is going on? What is happening?"

Murmurs of assent rose from the group. An bent over his keyboard to take notes and I scrawled some thoughts into a journal.

"What we really need is mutual aid," said Karl, a Black male sculptor and art installer. "I'm not talking about traditional mutual aid like food banks and stuff. More of a mutual aid-ish dynamic. Because, typically, I'm forced to accept the arts contract that I enter with galleries and museums as an art handler while also knowing that I am wholly exploited in that context.[4] You know, like having to arbitrate and overcome instances of classist or racist aggression from members of staff within institutions that are protective of the institution but are supposed to be protective of me. And when I *have* had good experiences, usually as an artist, I've later learned that they were lubricated by the suffering of other people in the institution. That is, the art handlers."

"What would mutual aid look like in an art gallery?" I asked.

"Something more horizontal. Places with greater degrees of reflexivity."

"But the institution that we're talking about is not just a gallery or a museum, it's society," said Camila, a Latin-American female performance artist. "Society has a relationship with art and activism that is both necessary and disposable. We give a lot to society and get very little. We need to discuss that relationship. Because we don't have the basic rights that we need to do the work."

"And those rights are . . . ?" I asked.

"Childcare. Health insurance. We give up all these rights just to exist. To say that we work as an artist."

I wrote all that down. "Camila, how do you deal with that?"

She sighed. "It's so hard. It's an abusive relationship. Eventually, you just develop a hard shell."

The conversation went on and on. Simon, Mira, Maia, An, and I listened to stories about artists being disrespected by curators, curators being underpaid by

galleries, art handlers and interns being paid nothing for overtime, and nearly everybody's feelings of anger and angst over their inabilities to control essential terms of their careers and lives.

In my notebook, I wrote down words like *rage, depression, poverty, ghosting*. I tried to understand how I could formulate the needs I was hearing about and honor and protect them through contract law. The stories multiplied and tailed off. They veered into topics that spilled over from contracts and employment discrimination into historical oppression, structural traumas, and the inequality that seems inextricable from US culture. How could we fix this? I wondered.

At some point, I leaned back and let the narratives wash over me. I bent over my notebook again and wrote *????*

It's long been a commonplace that artists suffer. Their endurances include the indigence and voicelessness that come from living in a society that does not care about or fund the artistic process or its fruits. The image of the despairing and starving creative is typically deployed to tell the story of white male artists—Vincent van Gogh's depiction in the 1934 Irving Stone novel *Lust for Life* and Edvard Munch's portrayal in Peter Watkins's eponymous 1974 docudrama being just two cases in point—but racism, sexism, ablism, homophobia, and transphobia have proven deep-rooted parts of this problem. In the late 1920s, the Black painter and educator Lois Mailou Jones applied for a teaching job at her alma mater, the Boston Museum School, but was turned down on the grounds that she should go work in the Black south.[5] The 1930s saw queer Black artist Beauford Delaney represented by the Whitney in a group show, but he was paid so little that he had to take menial jobs at the gallery.[6] In the 1950s, the Black painter Romare Bearden was dropped by his gallerist Sam Kootz when his work didn't sell enough and didn't hew to Kootz's vision of abstract expressionism.[7] A decade later, Bernice Bing, the queer Chinese American abstractionist painter, faced the humiliation of being included in a group show titled "Gangbang"; this 1960 exhibit at San Francisco's Batman Gallery featured the work of cis male artists who would later achieve varying degrees of name recognition, while Bing drifted into a long phase of obscurity.[8] In the 1970s and onward, Marsha P. Johnson had to exhibit most of her performative art in the streets, and the Black abstract painter McArthur Binion so struggled that today he says he had to "fucking make myself up."[9] During this same period, the eminent Black sculptor Betye Saar worked to maintain an agnostic attitude toward the art world and its market and made her art while laboring as a social worker and jewelry designer.[10]

Story after story of this kind can be found throughout the twentieth and early twenty-first centuries, though this is a difficult history to unearth, as it traces

negatives and obliteration.[11] Since at least the mid-twentieth century, frustration over agonizing working conditions has spurred artivists and other change-agents to take action. In the 1950s, Lois Mailou Jones successfully fought for an entrance into the Society of Washington Artists after being shut out from teaching,[12] and I have already noted how the Black Emergency Cultural Coalition (BECC) protested the Metropolitan Museum of Art's exclusion of Black artists in the 1969 show "Harlem on My Mind" and how Faith Ringgold co-organized 1970's "Women Students and Artists for Black Art Liberation"(WSABAL). At the same time, the Puerto Rican branch of the Art Workers Coalition lobbied the Metropolitan Museum to hire art workers of color and the conceptualist Seth Siegelaub and lawyer Robert Projansky devised the now-famous The Artist's Reserved Rights Transfer and Sale Agreement (1971), a model artists' contract that provides creatives resale royalties.[13] In the 1980s, Roland Palencia, Mike Moreno, Luis Alfaro, and others organized *Viva!*, a collective dedicated to Latinx artists' economic health and Howardena Pindell came out with her art world study revealing the effects of white supremacy on gallery representation. By the 1990s, the Guerrilla Girls, an activist organization dedicated to protesting the lack of female representation in museums, had grown world-famous.[14] In 2008, A. K. Burns, K8 Hardy, Lise Soskolne, and A. L. Steiner helped found Working Artists and the Greater Economy (W.A.G.E.), and under its auspices created a fee calculator that sets fair wages for artists.[15] This landmark operation was soon joined by the Arts & Labor working group, an arm of Occupy Wall Street that seeks the eradication of "exploitative working conditions" for arts workers, as well as Imani Jacqueline Brown's *Debtfair* (2012–present), which documents art student debt.[16]

In recent years, there has been an explosion of activity on the issues of fair pay, discriminatory gatekeeping, and other unfair terms of work promulgated by arts institutions and the art collection industry. In 2014, the mostly Black and queer Yams Collective withdrew from the Whitney Biennial to protest its inclusion of racially appropriative work.[17] In 2017, artist Alex Strada unveiled an iteration of Siegelaub's artists' contract, including terms that advantage female-identified artists (though the document is silent on race).[18] In the summer of 2022, a collective of artists protested institutional racist violence Black women experienced at the Wisconsin Triennial and also demanded that the Madison Museum of Contemporary Art revisit its payment and contract practices.[19] Further, employees of the New Museum, the New-York Historical Society, the Dia Foundation, MASS MoCA, the Guggenheim, and the Whitney voted to join United Auto Workers (UAW) Local 2110, which MoMA staff joined in the 1970s.[20] Art workers have also joined their demands for fair pay and inclusion with other calls to action. The movement Decolonize This Place puts on protests and publishes open letters

aimed at the diversification of the Brooklyn Museum's holdings and the institutional acknowledgment of Indigenous land occupation.[21] Working toward similar commitments, Strike MoMA seeks reparations, the return of land to Indigenous people, the betterment of working conditions for MoMA staff, and the "renewal of art" that might come with institutional demise.[22]

The need for efforts of this kind remains pressing. Many art institutions continue to repeat long-standing patterns set in place by patriarchy, heteronormativity, and white supremacy. In 2017, *Artnet* reported that 80 percent of the artists represented by New York City's top galleries were white;[23] and in 2019, the journal *Plos One* reported that an analysis of the holdings of eighteen major US museums revealed collections that were 85 percent white and 87 percent male.[24] In 2019, the Guggenheim's practices of racial exclusion were brought under scrutiny when Chaédria LaBouvier—the first Black curator and Black female to curate a show at the museum—spoke out about racist treatment she had suffered when working on a Basquiat exhibit.[25] The 2022 Burns & Halperin Report documented that between 2008 and 2020, 11 percent of US museum acquisitions were of work by female-identifying artists and 2.2 percent were by Black American artists.[26] And, though much ink was spilled about museums scrambling to diversify their collections and staff in the wake of the 2020 racial reckoning, dangers in this arena emerged when the Whitney appeared to quickly throw up a show exhibiting the art of photographers such as Dana Scruggs, who is Black; it was later revealed that some of this art was purchased by the museum at a cut rate at a fundraising sale designed to aid Black organizations. In the end, the Whitney canceled the exhibit.[27]

During the earliest stages of our project, Mira, Simon, An, Maia, and I found ourselves tested by the prospect of creating work about fair art contracts when facing this lengthy history of prejudice, injustice, and resistance. Nevertheless, the five of us first assembled by Zoom in September of 2020, about six months into the pandemic and in the waning days of the Trump presidency. Mira kept us grounded with her patience and deep bank of knowledge about arts institutions that she'd been developing since beginning her studies in art history and studio practice at UC Berkeley and Barnard in 2013. A writer and feminist curator who was previously an editor at *Artforum* and today works for *Art in America*, and an installation artist who shows at New York's Spencer Brownstone Gallery and The Gallery Ltd, she honed our mission by asking a series of questions in her gentle voice: "Do we want to make an object? Should we make a film? What should our art look like?" Simon, who, beyond his work as a curator and critic is also the program coordinator for Claudia Rankine's The Racial

Imaginary Institute, similarly helped refine the parameters of our project by telling funny stories about his frustrations with arts institutions. "I'm just here to do whatever I can to help," he'd say. An, a poet who was born in Haiti and raised in the United States, was leading the Center for Afrofuturist Studies and stood on the precipice of publishing his breakout book *Blackspace: On the Poetics of an Afrofuture* (2020). He highlighted the disparities that exist between artists and wealthier organizations. "Blue chip museums act like you should be so grateful to be there when they ask you do to work for them, and you are, and so you don't insist on being paid fairly, or being treated right," he said. Maia, a Philadelphia-based interdisciplinary artist known for democratizing arts institutions through a social practice project called *Look At Art. Get Paid* (cocreated with artist Josephine Devanbu) also provided necessary guidance. During one early conversation, she mentioned that she'd often done work with organizations "where there wasn't even a contract, everything was oral, and it gave me a sense of things being really disorganized and not great from my end." For my part, I was teaching property law at Loyola Law School in Los Angeles and coming out with a novel about a performance artist. Otherwise, I stayed busy studying the fundamentals of contract law and trying to figure out how I could map that doctrine onto a project that addressed the wide body of social, political, and economic problems as were to be discovered in the art world.

During that first meeting in September, Mira, Simon, An, Maia, and I brainstormed about the shape our project would take by playing with the language of contract formation. We researched the etymology of basic concepts and phrases, observing that "contract" came from the Latin *contractus*, which means "drawn together," a piece of information we found so compelling that we used the phrase as the name of our project. We also delved into contract doctrine's traditional requirements that an enforceable agreement must contain an offer, an acceptance, and consideration (that is, bargained-for value) and were delighted that a synonym for offer, "tender," comes from the Old French *tendre*, which means "soft" and "delicate."[28] Additionally, we found that the word *consideration* comes from the Latin "considerationem," which means "to look at closely, observe" and began to signify "sympathetic regard" in English in the 1400s. Enchanted with these backstories of contract law's vocabulary, we mulled over various incarnations our project could take. We eventually decided to talk to people in the "art world," by which we meant artists, curators, gallerists, art handlers, and what I otherwise collectively refer to as "art workers" who are connected with galleries, museums, and other like spaces. We decided that some of the art we'd produce for Cuchifritos would be the interviews themselves, and we also planned on sifting our interviewees' testimonies for insights that we'd develop into a list of

commitments that Artists Alliance's Board of Directors could use to build fairer contracts in the future.

Jodi Waynberg, the Director of Artists Alliance, helped us get to the next stage of the project by compiling a list of art workers, whom she selected for their experience with arts institutions as well as for their diverse identities and viewpoints. Simultaneously, the *Drawn Together* team (the DT team) commenced working on a video, which Maia and An directed and edited. This part of the project found me giving a lecture on some of the traditional elements of legal contracts. For my performance, I dressed up in a professional-looking navy suit and a silk scarf and taped myself on my iPhone. The resulting lecture, however, wasn't a traditional law school–type of product. I ran through concepts such as offer, acceptance, and consideration but also talked about the etymology of the words used in contracts law. I told viewers that the DT team was interested in thinking about artists' contracts in ways that would amplify the hidden values of this language by recognizing the need for the arts community to be drawn together, recognize vulnerability, look closely, and have sympathetic regard for its partners and colleagues.

In the notes that I received from Maia and An after my initial take of the video, I was asked to heighten my performance. An suggested that I stand in front of a fan, which would blow my hair as I spoke and add a surreal element, signaling to the viewer that we were exiting the realm of pure law and moving into a blended space influenced by the artists' viewpoints. I didn't have a fan, though, and so just danced in an impromptu way, and An and Maia later cut this interlude into the video. Maia also filmed scenes between herself and her father, which consisted of illustrations of the terms that I discussed in my lecture. For example, when enacting "consideration," and that word's colloquial meaning of "sympathetic regard," Maia shot her and her father's hands fluttering around each other against the backdrop of a suburban forest.[29] These shots were strange, moving, and beautiful.

Still, we encountered a problem: At the end of 2020, the video's hyperreal sections presented the only aesthetic component we planned for the show, and there were no interactive elements. An worried that our project was becoming excessively documentary. "Our show can't just be didactic," he told us on at least two occasions. "It can't just be a bunch of papers in a room." We considered how to fix this issue and eventually asked An to create a graphic that would visually illustrate *Drawn Together*'s themes. He fashioned a bright, black, splashy icon that consisted of language he took from one of the memos I'd drafted about my legal and etymological research. Words and phrases such as "society," "contract," "dynamic," and "virtual dialogues" can be discerned in this striking mandala,

FIGURE 6.6. Me dancing in *Drawn Together*, © Maia Chao and Anaïs Duplan 2021

which melts into a dizzy and stuttering series of shapes and lines.[30] When Jodi installed the show in the Cuchifritos Gallery in the winter of 2021, she built a white wall and projected onto it the video as well as the graphic.

Moreover, Maia developed an intriguing document that she called "intake forms." These questionnaires were influenced by the documents that we fill out at the doctor's office, as well as personality tests, exit interviews, and other kinds of data-collection records. The intake forms asked art workers to respond to True or False statements, such as "I read my contracts with art institutions thoroughly" and "I have signed a contract that was breached, by myself or another party." They also provided a line drawing of a human figure and asked, "When you find yourself in social conflict, where are you likely to feel this in

FIGURE 6.7. Maia and her father's hands in *Drawn Together*, © Maia Chao and Anaïs Duplan 2021

your body?" The forms additionally asked, "What do contracts often leave out that should be included?"

Ultimately, art workers returned to us twenty-four filled-out surveys (they were also made available to visitors when Cuchifritos hosted our show in its gallery). On the question of whether the participant read their contracts thoroughly, fifteen people said they did and seven people said they didn't; two abstained. On the question of whether they'd ever signed a contract that was later breached, half the respondents said they had and half said they hadn't. When asked where they felt social conflict in their bodies, subjects often marked the head, chest, and stomach of the line drawing of the human form. The answers to the question regarding terms that are left out of contracts but should be included were illuminating. Some of these responses averred:

"The idea of collaboration."
"Unexpected change of feelings."

"Feelings/personal feelings."
"People's feelings."
"Misunderstanding negotiation."
"The unintended consequences."
"Human decency."
"Humanity."
"Can they be personalized or tailored to signees' situations?"

In January 2021, we commenced the group interviews. As the first part of this chapter reveals, interviewees shared the intense sensations of alienation and fear that they endured when interacting with institutional gatekeepers. Several

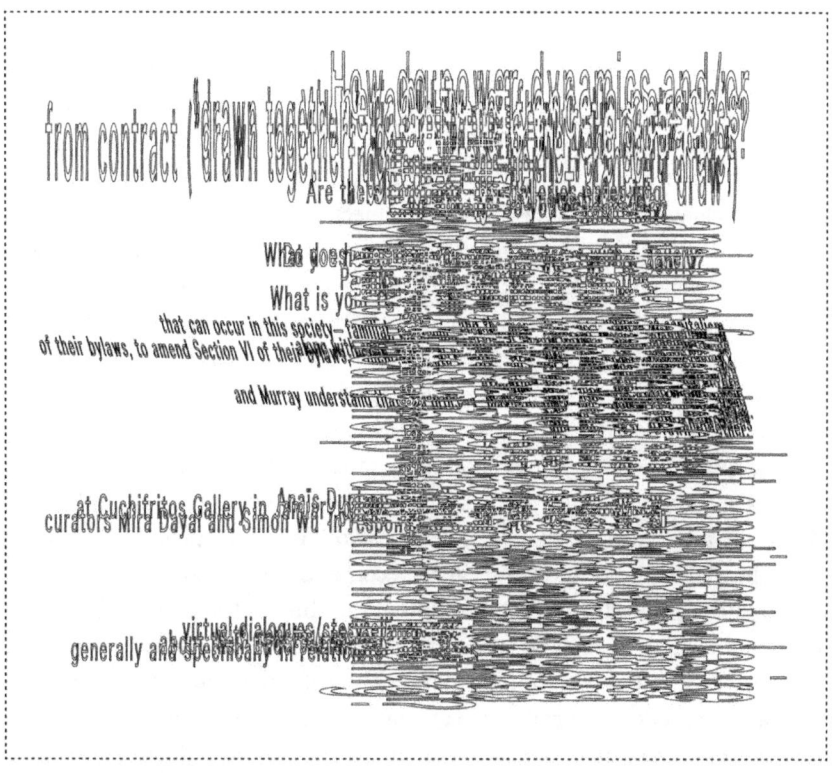

FIGURE 6.8. Anaïs Duplan, *Concrete Poem* (2021)

key points struck the DT team: We observed that many art workers described their relationship with the art world using language usually reserved to describe close family ties, sexual relationships, and necessary medical care—that is, love, belonging, the body, life, and death. Several interviewees also revealed that they created their personal identities by belonging to the art world but simultaneously felt rejected and treated as disposable by its guardians. Race, gender, class, mental health, and disability statuses were powerful indicators of whether participants regarded themselves as being given a fair shake in their dealings with institutions. Immigrants, people of color, women, disabled people, and poor people were furious at their fungible status but at the same time knew that they had to agree to almost any conditions to remain players in this profession.

At the end of these conversations, my DT colleagues and I felt awed by the information our interviewees had generously handed to us. But it remained unclear to us how we could address these grievances, especially using a tool as blunt as the law.

Could the path toward a fairer art world be found in the law governing contracts? the DT team wondered. The more we considered this question, the more we determined that this doctrine alone didn't hold much promise for many art workers who bear the psychological and financial weights of the interviewees who participated in the *Drawn Together* project.

Art workers might enter several different types of contracts with arts organizations. As Maia had already flagged for us, we found that a number of galleries do deals on a handshake.[31] This is an iffy custom because verbal contracts lasting longer than a year might be unenforceable.[32] And even when the verbal deal leads to a written contract, terms that are orally agreed upon but never included in the writing could also be unenforceable.[33] Artists who make paintings and objects for sale thus often enter into oral or, more rarely, written *consignment* contracts with gallery owners, where the dealer agrees to exhibit and sell the object and divide the proceeds with the artist; if the artwork isn't sold, then it's returned to its maker.[34] The dealer in this instance becomes the artist's agent and is bound by a fiduciary duty to the artist (meaning that they act for the benefit of the artist and abide by a high duty of care) and the artwork becomes a trust property and its proceeds trust funds.[35] Artists also enter into *commissions* contracts with arts institutions, sometimes via a grants process, where the artists create a new artwork for a gallery or a museum; in a best-world scenario, these contracts set forth the production schedule and institutional expectations.[36] Additionally, there are *representation* contracts, where the institution agrees to represent the work of the artist.[37] With respect to curators, some work for institutions on a permanent basis, but those we spoke to usually entered *guest curator* contracts

which set a fee, oblige the curator to obtain works for an exhibit, and extend for limited durations.[38] Art handlers—that is, those who (among other duties) install and de-install art in shows—receive hourly wages or typically low day rates and can be required to work overtime without extra pay.[39] Art institution interns can encounter a spectrum of contractual situations, some formally executed, others informally created, and with some jobs paid and others unpaid.[40] Administrators at arts institutions can also enter a variety of contracts, ranging from written agreements regarding full-time work to oral agreements for gig jobs.[41] Looking beyond gallery spaces, it's also worth noting that adjunct art professors (and other adjuncts) sign contracts that are, for many, synonymous with "wage theft."[42]

How can the law reply when these deals leave art workers feeling desperate, unseen, insulted, silenced, "ghosted," or worse? Courts do sometimes strike down contracts that are executed under extreme conditions of unfairness. Judges examine contracts to see whether they were entered into under *duress* or *undue influence*, for example.[43] Some readers, examining the comments made by our interviewees, might conclude that these art workers *were* coerced into their contracts or otherwise unduly influenced by arts institutions, which possess so much power that the workers have no choice but to sign on the dotted line—and sometimes feel so disempowered that they don't even read the contract at all, as a full 29 percent of respondents to Maia's intake forms revealed. But even if arts institutions seem to hold all the leverage, and the workers we spoke to admitted to entering relationships with these institutions while fending off sensations of fear and impotence, these problems alone most likely don't qualify as duress or undue influence.

For duress to be found, the contractor must make an improper threat that leaves the other with no reasonable alternative but to assent to the contract.[44] This will be a hard defense for an art worker to make in the event they commit a breach (that is, not fulfill their contractual obligations and consequently get sued by the arts institution). Courts adhere to the proposition that parties to a contract have roughly equal rights and know how to take care of themselves in the market. How this translates in practice means that arts institutions are legally entitled to propose just about any kind of contract that they want with art workers who, in turn, are legally entitled to walk away from a gig even if (as per Miguel) the prospect of "not being included in that show" makes the artist afraid. In other words, the art institution's legal right to dictate the terms of the contract and present it to the artist on a take-it-or-leave it basis is deemed to be *equal to* the artist's legal right to *choose* to *not* enter into the contract at all.[45] The fact that artists like Miguel are afraid of the consequences if they don't agree to the deal is not enough to convert the take-it-or-leave-it nature of the proposed contract into an improper threat. Presenting a contract on a take-it-or-leave-it basis would just

be considered hard bargaining, which is not prohibited by contract law in general and duress in particular.

Undue influence will be found where one party exhibits *undue susceptibility* and the other party exercises *undue pressure*. Could this doctrine void artists' unfair contracts? Undue susceptibility does not have to be totally incapacitating or long lasting. Instead, it can consist of "a lack of full vigor due to age . . . physical condition . . . emotional anguish . . . or a combination of such factors."[46] Our interviewees did describe difficult life circumstances and emotional stresses, not the least of which was their subordinate position relative to the art world: Camila told us that the dynamics led to "abuse," which made her develop "a hard shell." But, even if art world gatekeepers impose pressure during negotiations, an artist's hard shell may mean that their contract remains valid, since the doctrine often comes to the aid of vulnerable parties where they're elderly, sick, senile, suffering extreme grief, "hysterical," or otherwise exhibiting "subnormal capacities."[47] It's possible that the health troubles raised during our interviews could qualify art workers as suffering from undue susceptibility. But undue susceptibility by itself is not enough. The interviewees would still have to show that the art institutions used excessive pressure to "coerce" them into agreeing to the contract. To show excessive pressure, courts look for things like whether the contract was discussed at an unusual or inappropriate time or place, there was an extreme emphasis on the unfavorable consequences of any delay in agreeing to the contract, there was no time to consult an attorney or other advisers; and the list continues.[48] It's really not clear that the interviewees would be able to show excessive pressure, or enough of it, to get out of their contracts using undue influence.

What about other legal protections? Courts will also scrutinize an agreement to see if it's tainted by *misrepresentation*.[49] Interviewees did indicate that they sometimes entered into relationships with arts institutions that they initially believed were suffused with goodwill and trust, only to later find that the gallerists or museum administrators were bigoted, operated according to their own self-interest, weren't invested in a long-term relationship with the artist, and hadn't mentioned unfavorable terms that were included in written contracts. This certainly makes it appear as if the workers *had* been defrauded, in the term's colloquial sense, by the art world. One of the most striking stories we heard on this count came from Hanna, who found that she was making thousands of dollars less than her white counterparts but hadn't realized that when she signed her employment agreement. Upon hearing this and other scenarios, the DT team wondered if these interviewees' contracts were unenforceable because of misrepresentation.

Upon investigation, it didn't necessarily appear so. Misrepresentation exists where a party makes an important statement that isn't in accord with the facts.[50]

When a party fails to disclose an important fact that they know would correct a basic (and wrong) assumption underlying the agreement, there can also be a finding of misrepresentation where the nondisclosure amounts to bad faith and unfair dealing—as these concepts are understood in the legal world.[51] In Hanna's case, her employer failed to disclose that she was making less than her white colleagues, the New York Pay Equity Law requires equal pay for substantially equal work for women and people of color (among other protected classes), *and* most people probably assume that their employment contracts do not violate their legal rights.[52] I think that her story is a good one for misrepresentation, particularly after New York passed its pay transparency law, but I also fear that most courts nationwide won't think that employers who keep mum about other employees' salaries are guilty of fraud.[53] The doctrine of *caveat emptor*—Latin for "let the buyer beware"—may come into play here, as it protects contracting parties who don't disclose important information unless their conduct amounts to active concealment or affirmative deception.[54]

The other interviewees had even weaker cases. For example, art workers like Brenda, Francoise, and Georgie spoke more generally of *feeling* defrauded by institutions that first looked pro-artist and art worker but then turned out to be exploitative. "I thought that I was achieving something different," as Brenda said. And Georgie said that as a young worker she'd been "enamored" with artists "and this sort of blinded me to forego my own rights as a human being. To the right to a living wage, the right to good health insurance." But these problems don't amount to illegal misrepresentation; they're just the wages of innocence and the difficult process of losing one's naivety.

Even though the rules concerning duress, undue influence, and misrepresentation didn't offer any solid solutions, the DT team continued to worry that some workers admitted to signing contracts they didn't think they could negotiate and often didn't read. Amal said she didn't read contracts because "they have lots of threatening scenarios." And Francoise said she was unnerved by her contracts and had failed to read them because "the goal is to be opaque. Also, I needed the money."

Do these facts make the interviewees' contracts unenforceable under any other laws?[55] The workers who described being railroaded into entering unfavorable agreements appeared to have accepted contracts of *adhesion*, a legal term that describes standardized "take it or leave it" contracts drafted by parties with superior bargaining power.[56] The term "contracts of adhesion" comes from the colorful image of a fly being stuck to flypaper and consequentially unable to set itself free;[57] the phrase traditionally designates consumer contracts, though arts contracts have also qualified.[58] Contracts of adhesion are common and enforceable unless they are determined to be *unconscionable*—that is, deeply

unfair.[59] Unconscionability is a legal doctrine whose roots can be found in the seventeenth century, and judges can use it to make unenforceable contracts that are so one-sided and compromised by power imbalances that they shock the conscience.[60]

One of the lessons the DT team learned through our conversations with interviewees is that, at least in layperson's terms, there exists within the art world a predatory culture that is unconscionable—literally without conscience. Workers were "ghosted," they weren't given written contracts, they were hurried into agreements, they were paid little money, they were "siloed," and their fears went unassuaged. As a legal matter, though, courts examine contracts for unconscionability by looking at the conditions of their formation (known as *procedural unconscionability*) and the fairness, or one-sidedness, of the contract's terms (known as *substantive unconscionability*).[61] If a party to the agreement has vastly inferior bargaining power and didn't read an unfair contract, some courts have found unconscionability, particularly where the contract terms limit the more powerful party's economic liability or impose steep penalties on the weaker party for breaches.[62] Language skills and education may also support unconscionability defenses.[63] But a gallery or museum's failure to consider an art worker's racial and gender subordination, historical trauma, submission to systemic and structural racism, sexism, homophobia, and classism alone does not likely create unconscionability: In my research, I discovered only one 1978 case that found a consignment contract to be unconscionable and that was where the widow of an artist handed over hundreds of artworks to a dealer who said they would pay her 50 percent of any proceeds if and when they sold the works, and never made a provision for the art's return.[64]

So, the doctrines of duress, fraud, undue influence, and unconscionability didn't hold promise for most of our interviewees. Moreover, even if these contracts *were* found by a court to be so legally compromised, what good would that do them? These defenses to contract enforcement would only allow a court to tear up a contract or delete or limit the application of an unfair term of the agreement.[65] But the *last thing* our interviewees wanted was a cancellation of their contracts or to roil the waters by taking their art dealers to court! They wanted, if anything, *more* contracts and friendly relationships with art institutions. Rachel and Miguel explained how fearful they were of "burning bridges," and rational, vulnerable art workers who want healthy careers in the small and insular arts community might certainly be loath to earn a reputation as litigious troublemakers. Further, some of these defenses, particularly undue influence, are humiliating as well as potential career-killers, since they broadcast to the world that the art worker is "subnormal." As the DT team continued to study contract defenses as potential aids for artists in the fall and winter of 2020–21,

these factors showed us that they were nearly useless for a community that dares not press its rights in a court of law or even negotiate fair terms in a forceful manner.

Starting in February, I took stock of our limited options and began searching for other fixes. A review of contemporary labor movements revealed how some art workers have found themselves so stymied by the slender protections of contract law that they've turned to collective bargaining. This is an exciting development. These unions have mostly succeeded (where they do) in museums, and for the benefit of staff members, sometimes including art handlers: As I've mentioned previously, staffers at New York's New Museum, the Whitney, MoMA, the New-York Historical Society, the Dia Foundation, MASS MoCA, and the Guggenheim, as well as the Brooklyn Museum and the Tenement Museum have all unionized.[66] But what about the artists who contribute their artworks to those museums' collections? Artists' unions and associations *have* had some victories with obtaining moneys and better work conditions for artists. The most notable of these is the short-lived Artists Union, which staved off cuts from the Works Progress Administration in 1936, and the Artists' Equity Association, which was formed in 1947 and developed welfare and legal funds for artists until it folded as a national organization in 1965 (the New York Association is still in operation).[67] As already noted, since the '60s, artists' non-union collectives have also pressed for change within the art world (WSABAL, the Black Emergency Cultural Coalition, the Art Strike, W.A.G.E., among others). And actors, writers, and visual effects workers have unionized, as have some adjunct art professors.[68] Nevertheless, a modern large-scale union for freelance fine artists and other art makers, dedicated to collective bargaining, has not taken off.

When researching the history of the Artists Union (which is a thrilling chapter in the history of American arts and labor), I entertained the dizzying and probably messianic possibility of redirecting the DT team toward a project that would lead to the unionization of all art workers. Some creatives and labor advocates argue that the time has come for collective bargaining in the fine arts.[69] Such a pronouncement isn't surprising, considering that unions have helped transform the landscape of US workers' rights since at least the nineteenth century and forced workplaces to respond to their employees' humanity—exactly what our interviewees most wanted. "What does labor want?" Samuel Gompers, the first president of the American Federation of Labor, asked in 1893: "It wants the earth and the fullness thereof."[70] "All my life, I have been driven by one dream, one goal, one vision: To overthrow a farm labor system in this nation which treats farm workers as if they were not important human beings," César Chávez said nearly a century later.[71] These and other labor visionaries organized movements

in favor of the eight hour work day, workplace safety, higher wages, and the right to bargain collectively.[72] Moreover, some recent studies find positive associations between union membership and the decrease of anti-Black racism and possibly protective mental health effects for both women and men of color.[73] Since the pandemic, imperiled workers have grown increasingly attracted to unionization and not just in the art world: In March of 2022, the *Guardian* reported on a "wave of union victories" in the United States among employees at Starbucks, outdoor outfitter R.E.I., and the media group at the *New York Times*, among others.[74] Moreover, in November of 2022, 48,000 union employees at the University of California struck for higher wages.[75] So, unionization appears likely to help with some of these art workers' concerns, especially insofar as they aren't receiving fair payment for their work and feel isolated and alone.

But—apart from the fact that such a suggestion would derail the group's agreed-upon contracts focus—was a union the right solution for the DT project? Recall that, for our interviewees, recognition of their humanity required attention to their individuality, feelings, and intersectionality: as one intake form respondent asked about artists' contracts, "Can they be personalized or tailored to signees' situations?" Yet legal scholars maintain that "tailoring" doesn't align perfectly with unions' capacities to make broad changes using collective bargaining. Adjusting workers' employment conditions to their individual class, immigration, gender, and other experiences can conflict with the goals of labor unions, which aim to limit employers' discretion.[76] I spent some difficult weeks grappling with these dilemmas, and in the end, the DT team remained committed to working on contracts even though contract law was a sparse resource that mostly allowed complainants to exit the agreements that our interviewees cherished.

By the Spring of 2021, I felt stalled and went back once again to the proverbial drawing board. Having shelved contract law defenses and unions, I began to study disability-rights social movements, since their members had argued for many of the same things that our interviewees had insisted on for fair contracts: that society respectfully respond and adjust to their complex identities. I found myself drawn especially to the history of the "504 sit-ins," protests that occurred nationally in 1977, when two successive secretaries of the US Department of Health, Education and Welfare (HEW) stalled on enforcing the Rehabilitation Act—a federal law that forbids disability discrimination, as readers will remember from chapter 4. The San Francisco sit-in was the white-hot center of the protests, a lively, month-long demonstration that saw disabled activists occupying the city's Federal building, and it involved organizers such as Judith Heumann and Kitty Cone as well as Black Panthers such as Brad Lomax.[77] Together, these

activists succeeded in pressuring HEW Secretary Joe Califano to implement the law on April 28, 1977.[78]

As I learned by diving through web archives, the 504 sit-in also succeeded on account of an artist—an artivist! The Black disability rights activist and poet Leroy Moore has posted documents showing how the mainstream history of the sit-ins has mostly, and wrongly, emphasized the roles of white leaders such as Heumann and Cone. Moore corrects that account of the protest by emphasizing the driving role of Brad Lomax and also teaches us that the group of protesters occupying the Federal building in '77 included a Black choir singer, DJ, keyboardist, and wheelchair-user named Brigardo Groves. Moore's revelation triggered my search for all available information I could find on this unsung artivist, and Moore himself helped me locate tapes of Groves's jazz recordings.[79] Groves died in 2010, and my efforts unfortunately didn't otherwise yield a full record of his life, music, and activism. I was able to contact a friend of his named Janette Rodriguez, a fifty-two-year-old woman who knew Groves in 2005, when she sang with him in the choir of San Francisco's Glide Church, a social justice–focused community religious center. Rodriguez told me that Groves was a pillar of that society who "knew everybody, he made time for everyone." She also said that he expressed his concern for the well-being of vulnerable populations by supporting people dealing with addiction, as well as helping to feed and shelter refugees from Hurricane Katrina who had fled to the Bay Area. He was, she told me, a man who "lived his principles."[80]

Even this slim record of Groves's presence in the 504 social movement and work on behalf of the underclass inspired me to learn more about disability law and its relevance for fair contracts. During the sit-ins, Groves had "lived his principles" by protesting for inclusion, and he did so as a Black man, an artist, and a member of the disabled community. I grew eager to find out how his and his comrades' demands might shine a light on the DT project and the needs that our team had been hearing about for the past several months.

As the reader will remember, the Rehabilitation Act's regulations require "reasonable accommodation" of disabled people in federal programs.[81] After its enforcement in 1977, the law would later offer a model for the Americans with Disabilities Act of 1990, as well other protective statutes, which today create rights to reasonable accommodation for disabled people, people of religious faith, and people with families.[82] The Rehabilitation Act also blazed the trail for a remarkable set of protections found in the New York City Human Rights Law (NYCHRL), which creates rights to reasonable accommodations for people who are disabled, are pregnant or have needs related to childbirth or other associated medical conditions, have religious needs, or who suffer from domestic violence.[83] In the workplace setting, the reasonable accommodations mandate means that

FIGURE 6.9 Timothy Hull, *Brigardo Groves* (2023), © Timothy Hull 2023

employers must consult with their qualified employees and devise ways to adjust the workplace and the job to meet their needs, unless the accommodation would create an undue hardship for the employer or other employees.[84] In the language of Jaco, one of our interviewees, the right of reasonable accommodations encourages those employers to "just be able to have a conversation, the basic thing of

sitting down with people and being like, 'Hey, what is going on? What is happening?'" And in the words of Karl, it allows the workplace to possess "greater degrees of reflexivity."

At this juncture, it's important to acknowledge that the right to reasonable accommodations grew from the disability community's struggle, culture, and specific set of commitments, as the 504 sit-ins' history, and Brigardo Groves's activism, makes clear. Extending the inclusivity promised by laws such as the Rehabilitation Act to the art world setting is a delicate process, as it could run the danger of appropriating the hard-won victories of disability activists to the world of cultural production without giving sufficient credit or while committing other trespasses.[85] NYCHRL's extension of reasonable accommodations to people who suffer from domestic violence inspired my hopes that the innovations of the Rehabilitation Act and other laws that offer accommodations rights might eventually help a wide array of vulnerable people—immigrants, poor people, queer people, as well as people who experience mental and physical disabilities, among others—who work in the arts. While the art world and the disability community may come from different traditions (though, of course, characterizing these spaces as a binary would be a mistake, as many artists experience disabilities), the art workers who contributed to *Drawn Together* taught the DT team that they needed workplace acknowledgments of their identities, emotional needs, and life chances. These claims resonated with the pioneering revelations that arrived with disability rights activism, which created a generative, and hopefully expansive, source of legal language and reform. While recognizing these rights' particular heritage of disability justice, we concluded that our interviewees needed accommodation in an art world that does not attend to art workers' intersectional identities and needs. After a significant period of drafting, the DT team and I formed a list of *contractual* (not statutory) rights that would meet these needs when art workers labored on Artist Alliance (AAI) projects. We imagined that these terms, which were severable (that is, that AAI could choose some or all of them), would be included in future AAI contracts and would mandate:

1. That Artists Alliance (AAI) and the art worker's professional agreements be committed to writing.
2. That AAI's contract affirm the value the worker brought to the institution.
3. That the contract be written in plain, coherent, and nonthreatening language.
4. That the art worker receives an opportunity to have a conversation about the contract with a representative of AAI, so they could understand its terms. The worker can waive this opportunity if they so choose.

5. That the art worker be afforded adequate time to negotiate and sign the contract, which we estimated at seven to ten working days. This period could be waived if the worker so chose.
6. That AAI create at least one opportunity during the contract negotiation period for a conversation about contracts between the worker and other employees of the arts institution, in order that arts workers were not "siloed off" and deprived of information and fellowship critical to the development of fair and transparent contracts.
7. That during the negotiation period AAI offer art workers opportunities for "contract mentoring," that is, connecting them with more experienced workers who had mastered the art of reading and negotiating contracts.
8. That AAI acknowledge in the contract its federal, state, and city-imposed legal duty to prevent discrimination or harassment based on age, race, creed, color, national origin, citizenship or immigration status, sexual orientation, gender identity or expression, military status, sex, disability, predisposing genetic characteristics, familial status, marital status, status as a victim of domestic violence, arrest record or conviction record, or religion.[86]
9. That the art worker could renegotiate their signed contracts if they experienced changed circumstances arising from their race, gender, sexual orientation, gender identity, disability, immigrant, and class identity, their family care obligations, their endurances of domestic violence, or other vulnerable status. This list is illustrative rather than exclusive. Under this clause, the parties would restructure the schedule or other details of their agreement to provide reasonable accommodation for the art worker unless the accommodation created an undue hardship on AAI.

The DT team and I shaped these terms based on our interviewees' needs to experience affirmation, cherish hope, be treated with humanity, understand the contracts they signed, not feel rushed or intimidated, participate in a transparent process, and experience working conditions that honored their identities and challenges. In addition, we looked to workers' and consumers' rights laws, customs, and legal theory for help in crafting our interviewees' demands into a list of administrable rights.[87] The last item (#9), which would allow art workers to renegotiate the terms of their agreements, was inspired by Jaco and Karl's reflections on art institutions' failures to respond to people with mental health issues, immigration pressures, or other liabilities. The example of Brigardo Groves also drove this provision, as his activism called for the federal government to provide reasonable accommodation for disabled people. As I have noted, federal, state, and city laws already create accommodation rights for the disabled, people

of faith, people with families, and people experiencing domestic violence, but the DT team noticed that many of our interviewees did not know about their basic rights of accommodation, and so we wanted those rights specified in their contracts. In addition, we sought to recognize a larger span of dominations and needs for accommodations.

The DT team's list certainly didn't cover all the needs or desires articulated by our interviewees. The workers we spoke to, and the resistance movements that we had studied, revealed that museums and galleries failed to include intersectional artists in their shows or "ghosted" them once an exhibit or performance had ended. Our terms didn't work toward ending that barricade, though Alex Strada's contract, which creates affirmative action for female artists, did create a pathway for this. With respect to pay, we only included items that would push toward equal renumeration, and didn't, like W.A.G.E., push for *adequate* renumeration. We didn't demand the return or acknowledgment of Indigenous land or the unwinding of institutions, like Decolonize this Place and Strike MoMA. We didn't enumerate measures that would address directly "people's feelings" (as per an answer on the intake forms), the financial scarcity that could make art workers sign unread contracts, the cultural message that artists don't need essentials like money or childcare or health care, and the artists' overarching desire to be "drawn together" with the art world. Other problems existed, as well: We didn't set forth a full definition of "threatening" language that was forbidden by our terms and we didn't specify a support system for the mentoring provision. We didn't make a sufficient distinction in approaches to fair contracts for artists, art handlers, art administrators, and interns.[88] We didn't offer guidelines for the accommodations process, a disability-rights mechanism that has been shown to have pitfalls and dangers.[89] We failed to fix the problem of institutional motivation, as we didn't impose a cost for a failure to negotiate with art workers in good faith; moreover, our waiver provisions threatened to undo the benefits of the project altogether, as poorer and less confident cultural producers possess more incentives to always waive. The paucity and weaknesses of this list frustrates me now, though some of its omissions were motivated by the strategic concern that we couldn't ask for too much if we hoped to get anything at all.

The DT team wrote up our catalog of terms and in 2021 submitted it to the head of Artists Alliance, Jodi Waynberg.[90] We expressed our hope that the AAI board of directors would vote on including every item in its nonprofit's bylaws, so that AAI would be bound to always offer contracts that hewed to those conditions. Jodi promised to give our list to the AAI board so they could discuss the provisions and come back to us with edits or other changes. Then we waited. As 2022 turned into 2023, the only measure on which the *Drawn Together* project managed to achieve concrete progress concerned #8, which

requires that AAI acknowledge its duty to prevent illegal discrimination and harassment. While the AAI board hasn't yet incorporated this commitment and obligation in its contracts as of this writing, I learned from Jodi that AAI needed to update its discrimination and harassment policy in accord with New York state and city law; I was able to help facilitate this process. I consider this a significant accomplishment for the project, but the DT team's larger goals remain outstanding.

I'll admit that this process has not been effortless. When the weeks of waiting turned into months, I went through a heavy period when I came to believe that the project would come down to yet another iteration of artivist "racial failure." I second-guessed myself, deciding that the DT team made a mistake: we should have used our commission as an occasion to write an expansive manifesto about the rights of arts workers or pared back our list even further, I thought. I did, in fact, wind up writing a slimmer version of our proposals and sent it to Jodi, but that didn't appear to make our policies any more feasible for Artists Alliance. A sense of defeat began to dog me, particularly when I thought about how Brigardo Groves didn't back down and helped propel the implementation of the Rehabilitation Act's section 504 despite his many challenges. This hurt, though I also was aware that stumbles and reversals of this kind punctuate the history of artivism. As we've seen, artivists from Marsha P. Johnson to Charlene Teters to Tanya Aguiñiga have faced down obstacles when making art dedicated to the transformation of an unjust society. These mothers of artivism soldiered on and weren't halted by the questions that sometimes had cast a pall on the DT project. These questions were: Were we wasting our time? Were we even making art anymore?

At one point during this work, Mira joked to me that we shouldn't have identified ourselves as artists to Artists Alliance but rather as human resource (HR) consultants and then maybe we would have been paid more for our labor. Earning $1,000 a head, and raking in a modest sum from grants, the DT team certainly wasn't getting rich. But Mira's complaint about money also raised a larger question that the team sometimes skirted around during our meetings, which concerned whether we were really doing *art*. *Was* this work "art?" Or were we just slapping an art label on a business systems analysis? Maybe we were just glorified HR grunts whose recommendations were getting put in the circular file! And if *Drawn Together was* art, why was that? Because we called ourselves artists? Because we were putting on a show in a white cube gallery? Because we were underpaid? Or did the aesthetic elements of the action make *Drawn Together* into an artwork—that is, An's graphic design, our play with etymology, and the poetic and dancing aspects of the video?

After *Drawn Together* was finished, I had a conversation with Mira where I asked her these questions. She said:

> I think the show would have been framed as art successfully without the objects or film, but it wouldn't have occupied the gallery space as successfully. It would have seemed odd to leave the gallery empty while making a show about how the space is used. It would have been confusing for visitors. We wanted people to understand that this labor was happening, that we were conducting these interviews, that this is what the artists were thinking.
>
> We were interested in approaching our questions from a legal standpoint: what is the gallery's responsibility to its community, and what can the gallery do in this situation? But we were also interested in the vocabulary that is involved in legal or governmental language that deals with questions of responsibility and community involvement. That language is kind of stiff. The video was a way to approach these issues from a looser, maybe more poetic or abstract angle. And this contrasted with the pragmatic and logistical things that we were talking about with people. We wanted to work between those two poles. Maybe people have a routine way of thinking about these issues, but we wanted to open up and surpass those usual understandings. So, the parts that were beautiful or poetic were trying to access that other set of potential understandings.

Mira helped me realize that the more traditionally "artistic" parts of *Drawn Together* were essential to its political and activist aims. For at least the past century, artivists from Gladys Bentley to Imani Jacqueline Brown have infused their artistic disciplines with their activism and so created powerful hybrid political statements. Similarly, the DT team played with images, sound, dance, and language to get "looser" and see things from another "angle." We wanted to be radical when it came to thinking about art workers' contracts. And art—that is, the poetic and surreal elements of Maia and An's video, my dancing, and An's text-based graphic design—was a vehicle to help us get there.

But, even though An balked at the prospect of a "didactic" show, I think that other, less archetypically artistic, features of the Drawn Together project also identify it as art. I can't help but note here that interrogating whether *Drawn Together*'s more bureaucratic elements "really qualify" as art might be a circular and defunct exercise because we live in a post–Marcel Duchamp world; after all, Duchamp made a urinal into a piece of art over one hundred years ago and did more than perhaps any other artist to make the "is it art" question moot. The inquiry also reminds me all too well of Imani Jacqueline Brown's exasperated

reply when I asked her whether her activism was art: "We're so obsessed with this question of 'is it art?'" she said. "I'm so bored by this question, 'Is art political?' This question won't die!" Still, I think the inquiry remains an interesting one, because it can help clarify how art is unfolding in the current age. By these lights, I regard *Drawn Together*'s direct action—its organizing, information-gathering, and legal components—as forms of art that take their place within the artivist and activist-artist lineage.

The DT team gathered assemblies of artists, art handlers, curators, gallerists, and critics to talk about injustice in artists' contracts in a (hopefully) safer space. Similarly, many artivist and activist-artist products have consisted of organizing, either as a part of the art project or as its principle purpose. Just to focus on those artists already addressed in this book: Faith Ringgold's 1970s co-organization of WSABAL stands as a progenitor, as do Marsha P. Johnson's and Sylvia Rivera's contemporaneous building of the STAR homeless shelters, Judy Baca's assembly of *The Great Wall of Los Angeles* painters and lookouts, and Suzanne Lacy's orchestration of a woman-only consciousness-raising session. Closer to the present moment, Young Joon Kwak's Mutant Salon and An Duplan, Kehinde Wiley, and Kalup Linzy's residencies also make up part of this history.

The interviewing, data-gathering, and legal work of the *Drawn Together* project likewise align it with other artivist and activist-artistic direct action that collates information to argue for legal reform or to protest existing injustice. Hans Haacke's *MoMA Poll* (1970) saw the artist polling MoMA patrons about Nixon's Indochina policy and nearly two decades later, Howardena Pindell published her first study on race, demographics, and art galleries.[91] Today, the concept of "research artist" is well established and gaining ascendency such that I could probably fill hundreds of pages with examples;[92] I'll constrain myself by noting that this book has portrayed several such creatives. In the mid-1990s, Carrie Mae Weems researched the backstory of the Descendant/Lanier daguerreotypes, and her findings drove the substance and energy of *From Here I Saw What Happened and I Cried*. While undertaking *Border Quipu* between 2016 to 2018, Tanya Aguiñiga and her AMBOS team interviewed thousands of people at the border using postcards. In 2017, Imani Jacqueline Brown laboriously traced the debt of artists to energy firms in *Debt of 500 Artists Largely Owned by Five Non-Governmental Economic Super Powers (after Hans Haacke)*.[93] Two years later, she joined her research with legal inquires when she embarked on her investigation of the unmarked burial plots of enslaved people in Louisiana's "Death Alley," which she conducted with the aid of the Center for International Environmental Law and Loyola University New Orleans College of Law.[94] As Brown's work reveals, art research can give rise to jurisprudential reflection. Aguiñiga's study of border conditions and her resulting 2020 petition to the "US government" to address

ableism at the San Ysidro border and Alex Strada's 2017 feminist artist's contract offer additional precursors to *Drawn Together*'s law-driven efforts. Other artist-activists who tangle with law and legal culture also deserve mention here: these include the law professor and conceptualist Sergio Muñoz Sarmiento and the "bureaucracy artist" and public administrator Camilo Cruz.[95]

As art, then, I think that *Drawn Together* succeeded. But as policy making? The results remain to be seen, but, as I sit in my bedroom editing this chapter in the mid-winter of 2023, I'm happy to report that we have seen some signs of hope: In February, Jodi informed the DT team that she was partnering with a law firm that would help Artists Alliance work toward implementing nearly all of the recommendations that we'd made. She also said that she'd like Simon, Mira, Maia, An, and me to continue consulting on this goal.

In the winter of 2021, Mira, Maia, An, Simon, and I met with dozens of art workers to learn about their experiences in the art world, and their revelations revealed a community confounded by low pay, lack of power, an absence of choices, and almost no access to institutional support. Simultaneously, these art workers manifested resilience, fury, humor, and bountiful insights and innovations that could help repair this broken system. With our resulting project, *Drawn Together*, we struggled to reform art workers' experiences with forming and fulfilling contracts with arts institutions, though we were dogged by the scanty protections of contracts law and manifold social injustices that keep many art workers from attaining necessities like housing, health care, and childcare.

The immensity of our goal sometimes led me to question whether, as a lawyer or an artist, I could add any value. I sometimes found my attention fragmenting and considered other byways, such as artists' unions, a divagating art process that finally led me to learn about Brigardo Groves, the musician and DJ who formed an essential part of the disability rights social movement. While I could find little information about him, his art and activism heartened me and so spurred on the work of forming contractual terms my colleagues and I hoped, and still hope, that Artists Alliance will implement in their own practice.

My experience with artivism introduced me to utopianism, disappointment, and fear of failure, but the legacy of women of color and queer of color artists hewed an emotional and professional route through these pitfalls. The artivists discussed in this book, after all, were remarkable for their ability to stand up to fear. I can't claim the bravery of the many people whose art I've studied here, but it was my honor to do work that included me in their ranks as well as the collective that became *Drawn Together*.

Artivism challenges the definitions of art, which is maybe an old-fashioned investigation but one that I find fascinating, nevertheless. During the making

of this project, I learned that videos and poetic vignettes can be art but so can interviewing people and amending corporate bylaws. The refreshment, energy, and controversy that artivism offers will help ensure that art's practice will be continually renewed for the needs of the people even as artivism's centaur's status—somewhere between protest and painting, drawing and interviewing, performing and sheltering, dancing and drafting contracts—will give rise to ambiguity and growing pains. The greatest gifts of *Drawn Together* were the solidarities of the DT team, the generosity of Artists Alliance in giving us a space and its attention, and the revelations of our interviewees. Their contributions created a bank of stories that convey shattering lessons about what it means to be a person of color, a queer person, a woman, a disabled person, or a person levitating in the interstices of these identities and to try to make art in this difficult and unjust world.

Conclusion

AN ART DEDICATED TO SURVIVAL: LAW, HOPE, AND THE WAY AHEAD

Back home in Lakewood, California, my grandmother always liked to make things "nice." In the 1970s, María Aldrete Adastik decorated her house with glassware and ceramic items she salvaged from weekly outings to local garage sales, which she laughingly called "my store." She painted pictures of flowers and mountains that she hung from the walls. Stooping over her Singer sewing machine, she ran me up pink and red frocks with peplums and puffy sleeves. She was constantly cooking—tortillas that she shaped by hand before slapping them on a red-hot stove burner, buttered rice, meat stews that she took care to not make too spicy for fear that my white step-grandfather would object. Sometimes, she would put on Elvis Presley records and show me how to dance with gentle, simple steps to the King's "Blue Suede Shoes" or "Can't Help Falling in Love." At Christmastime, she filled the house with glittering ornaments and fairy lights, so her living room vied with Disneyland's famous winter parades. At Halloween, she'd make me elaborate costumes: I was a pumpkin one year; a princess, another. And my birthday cakes were always epic, created out of Barbie dolls dressed in sumptuous chiffon-and-buttercream skirts and hand-piped rosettes.

My mother, Thelma, learned many of these talents from her but stayed so busy taking care of me and managing her full-time career as a middle school Spanish teacher that she didn't have the time to craft dollhouses that resembled miniature mansions or arrange elaborate holiday centerpieces built out of fresh fruits and gourds. Nor could she dedicate herself, as María did, to hours-long personal grooming rituals that involved intricate applications of eyeliner and

FIGURE 7.1. Aldrete-Diaz family photo, unknown date, courtesy of Yxta Maya Murray

adoring herself with the shining baubles our neighbors sold us for a quarter or fifty cents apiece from their front lawns. And even if Mom did have the time, she wasn't much interested in being arty. After all, cooking for a crowd and decorating the house hadn't made María a happy person, or even earned her the respect

of Walter, her husband, who had picked her up as a mail-order bride when she was a thirty-year-old Mexican national with a fourteen-year-old child. When I was ten years old, I learned firsthand about my grandmother's chronic unhappiness, which had made my mother turn away from her style of domesticity: I'd watch María weep as she put on makeup and talked about the poverty and rape she'd endured in Mexico as a young person. She'd burn up her stomach lining while brooding over a disagreement that she'd had with my grandfather over his suspected wandering eye. And later, all the cooking, cosmetics, linens, gewgaws, and shopping didn't stop her from going mad. She once saw a green devil walk out of her bedroom and disappear into the bedroom. Her belief system shimmered with angels and ghosts, and she was certain that I possessed "the gift," meaning that I was psychic. She'd sit among her coruscating Christmas finery, her eyes hollow and her mouth trembling, even as she handed me a Barbie for whom she'd made a tiny bespoke gown, or a jar of homemade applesauce that she explained was twice as good as the stuff I saw advertised on *Bozo the Clown*, a show that we watched together every Wednesday afternoon on her small black-and-white TV.

It wasn't until much later that I realized that my grandmother was an artist and hers was an activist art dedicated to her personal survival as well as that of my mother and me. When she filled up the house with chipped Limoges china and doilies and damaged Baccarat, she was taking up space as a kind of protest, for the house was otherwise dominated by Walter, a massive man and quiet Midwesterner who had married my grandmother despite her daughter (he called my mother "the girl" until she herself wed my father) out of the mistaken belief that Mexican women were ornamental and obedient. If María was supposed to be pretty and yielding, then *he* was "the law," earning for himself the sovereign position in the household as the breadwinner and her savior. My grandmother resisted these unhappy categories with her willpower and her talent. When she painted her eyes and adorned herself in her handmade finery, she was appearing in her home and out in public without the shame that had been drilled into her in Mexico, as a rape victim, a fifteen-year-old bride, and later, as a divorcee who developed a dubious reputation by earning her own meager living after escaping her first husband. When she cooked for herself and the family, she exercised the skills in mutual aid that had been passed down to her by her own mother, a taciturn woman named Otilia who had neglected María in a thousand awful ways due to an unmanageable life that had been distended and crushed by the patriarchy. María's forbearance during her fights with my grandfather, wherein she'd hold herself stiffly as if she were a human sacrifice, also was a protest and performance designed to shame him and convey her own dissent and dignity. With her dance lessons, which were a triumvirate of protest, pedagogy, and aid, she tried

to show me how to exist in a way that was both joyful and artfully practiced, as I'd need to demonstrate grace and give tantalizing hints of my own sexuality if I were to succeed in a literally manmade society. Her immaculate house and her baking and cooking were her crafts. Her shopping was assemblage and self-care. There was no language for these things at the time, and it would take decades for me to look away from the illusions of the legal profession, and my distrust of women's claustrophobic sphere, to understand her for the warrior and creative that she was once and will always remain in my heart.

This description of my grandmother, I think, must mirror the lives of millions of women of color and queer of color people who have had to create themselves in this world. For these communities, art, craft, or whatever you want to call it, is a survival strategy and a life raft to build and share with others. As Imani Jacqueline Brown explained to me, art is inextricable from many home grown forms of problem-solving and, as such, is both a tactic and a way of life. The world being as it is, there are no archives or records that I can offer up to prove that this art-life or craft-life that I saw manifest in my grandmother's private and unsung career was part of a limitless tradition of women of color that later flowered into the artivism practiced by the people described in this book. I can only suggest it and admit that I suspect it. But this heritage certainly establishes the reason why, when I entered LACE back in May of 2021 and saw the dark and shriveled saladitos in Tanya Aguiñiga's línea paks, I was possessed of a recognition so intense and uncanny that I pursued it until I could finally find the grammar that I had been lacking for all this time. I found in this research a wealth of art that I was able also to connect to my "day job," wherein I study social movements and the laws that grow out of them. Governing all this territory—which encompasses my grandmother's house, the border monitored by Aguiñiga, the ecstatic spaces of Young Joon Kwak, the stage of Carnegie Hall where Yoko Ono sat in feminist satyagraha, the hushed Ivy League halls where Carrie Mae Weems dared to disobey, the impoverished classrooms mourned by Judy Baca, the dangerous boulevards catwalked by Marsha P. Johnson, the cosmos mapped by Imani Jacqueline Brown, and the contracts worried over by my *Drawn Together* colleagues—is the fear of injustice and the bravery to face down the deadening effects of oppression with an undivided self.

As I observed in the introduction, the practice of artivism proves so vast that once we began listing its many incarnations we would never stop. In these pages, I have dedicated myself to studying the direct action of artists who are women of color, queer people of color, and, in one case, a disabled man of color. The concept of direct action itself is capacious and I have winnowed that down to a collection of powerful practices—civil disobedience, other kinds of protesting, rule-breaking, contract-breaching, providing mutual aid,

performing public outreach, fomenting rebellion, and researching, identifying, and monitoring governmental and institutional abuse. Just as my grandmother once used her arts to fight "the law" of her home, the artivists in this book have directly acted to defend against an unjust society whose power and malfeasance is gathered in statutes and court decisions. In most of the instances that I've studied, these artivists' actions flow seamlessly from their work. Just to mention the artists I've dedicated whole chapters to: Weems's contract breach and litigation courtship issued from her appropriations art, Kwak's mutual aid is the point of Mutant Salon, Aguiñiga's protest and mutual aid form the foundations of *Metabolizing the Border* and *Línea Pak*, Brown elegantly meshes these worlds until they become indistinguishable, and the *Drawn Together* team did policy work that became art both because we declared it so and because we struggled to introduce beauty into our project. In other cases, an artist's activism connects to but also exists side-by-side with an aesthetic practice, as in the cases of Elizabeth Catlett and perhaps John Rechy, Howardena Pindell, and Brigardo Groves. These different manifestations of artivism raise questions about where and when artivism can be found—any time an artist dedicated to intersectional justice acts against a repressive social order? Or when we can identify a link visibly tethering their art and action? These are important issues that I will continue pondering, but I suspect also that the inquiry is best resolved by looking to the advancements made by Marsha P. Johnson and Imani Jacqueline Brown, as well as Theaster Gates, An Duplan, and other like creatives who make art, resistance, and politics out of the raw materials of life and do not distinguish between them.

But how does this work? Even as I write this homily to the artivist I can hear the lawyer's question, as I have made large claims in this book: not only that direct action is art (but others have said this before me) but also that, in the hands of artists, it relates to the law. My answer is that artivism "works" as an agent of legal change in the same way that social movements have always done: by pushing at the law, disagreeing with it, challenging it, breaking it, and thus transforming it. Sometimes the artivist's reference to law is explicit. This is found in the cases of Marsha P. Johnson's demand that there be no more police brutality; Faith Ringgold's breaking of the flag desecration law; Assotto Saint's speech to the Superior Court of DC; Charlene Teters's illegal flag-burning and lawsuit; Carrie Mae Weems's litigation ideation as well as that of her unsought collaborator, Tamara Lanier; Aguiñiga and her "petitions" to the "government"; Brown's gigantic report on unmarked slave graves at petrochemical plant sites; and *Drawn Together*'s attempts to make Artists Alliance change its approach to contractual obligations. Here, the artists' challenge to law and their alternative readings of it are readily evident and available. In other cases, the law is more remote, if not

regarded altogether with skepticism, as the examples of Yoko Ono and Young Joon Kwak reveal.

On occasion, the student of law and artivism will have to think deeply to track the legal meanings of artworks, as my studies of Brown's *Live Action Painting*, Kwak's Mutant Salon, and Weems's *From Here I Saw* demonstrates. But that same investigation shows that this labor is worth it, since it discloses a rich source of jurisprudence that bears its own important forms of intelligence and warning bells and untapped authority. In an age where both legal scholars and activists question the wisdom of looking to law, I insist on alerting the legal community to this transformative source of social and jurisprudential critique, which often precedes the work of even the most radical legal philosophers. My other objective is to clarify for artists how their work is, or can be, a source of law.

The artists I've discussed here also offer another well from which to drink. In their fights for justice, they embody courage and they keep hold of hope. These are lessons that I draw strength from personally, particularly when I recall the life of my grandmother, but they are also essential for everyone who is alive right now. We should remember how Gladys Bentley performed despite the Wales Padlock Law. Marsha P. Johnson strode in the streets in her finery in the face of police brutality. Yoko Ono didn't flinch before "The Creep." Charlene Teters protested racist mascots despite threats to her home and her safety. Carrie Mae Weems wasn't intimidated by Harvard nor was Tamara Lanier. Tanya Aguiñiga weathered the spiritual onslaught of border policies. Young Joon Kwak fought the Broad Museum. Imani Jacqueline Brown did her anti-gentrification work even though the transformation of New Orleans proved unstoppable. The *Drawn Together* team continued working toward our goal even though the success of our project remains, as of this writing, a work in progress. During this phase in US history, when rights are under attack, the Supreme Court feels like a lost cause, and catastrophes continue unspooling even as we frantically try to repair the tatters and vestiges of justice, we are well-counseled to pay attention to the work of artists, who point to the way ahead.

Notes

INTRODUCTION

1. AP, "San Ysidro Border Line Waits Grow to 10 Hours in Coronavirus Crackdown," *KTLA.com*, August 25, 2020, https://ktla.com/news/california/san-ysidro-border-line-waits-grow-to-10-hours-in-coronavirus-crackdown/.

2. One of the first reports of the eighty-nine-year-old woman's death was Marinee Zavala and Ana Gomez, "Woman Dies While Waiting to Cross into US at San Ysidro Port of Entry," *NBC San Diego*, August 23, 2020, https://www.nbcsandiego.com/news/local/woman-dies-while-waiting-to-cross-into-us-at-san-ysidro-port-of-entry/2391471/.

3. "Metabolizing the Border," *Art 21*, 2020, https://smarthistory.org/tanya-aguiniga-borderlands/. Tanya Aguiñiga, *Metabolizing the Border*, 2020, http://www.tanyaaguiniga.com/public-performance#/metabolizing-the-border/; Tanya Aguiñiga, "*Metabolizing the Border*," January 2020, https://vimeo.com/395051560.

4. Most of this description and the quotes come from "Every Border Is a Wound to Heal," *Welcome to Lace*, (interview between Guadalupe Maravilla and Tanya Aguiñiga), July 17, 2021, https://welcometolace.org/wp-content/uploads/2020/05/Every-Border-is-a-Wound-to-Heal-Terremoto-pdf.pdf. Daniela Lieja Quintanar, Personal Interview, May 26, 2021.

5. Lieja Quintanar, Personal Interview.

6. Somos Presente, "About Us," https://somos.presente.org/about_us.

7. Email from Alex Jovanovich to Yxta Maya Murray, May 21, 2021, at 1:17 p.m. PST.

8. See a picture of Fannie Lou Hamer singing and dancing at this march at "THIS DAY IN HISTORY: Oct. 6, 1917: Fannie Lou Hamer Born," Zinn Education Project, https://www.zinnedproject.org/news/tdih/fannie-lou-hamer-born/.

9. Travis Diehl, "Land Rites," *Frieze*, March 20, 2017, https://www.frieze.com/article/land-rites.

10. Bras were never actually burned at the protest. Instead, the activists threw girly items like girdles and heels into a "freedom trash can" because they weren't able to obtain a fire permit. Roxane Gay, "Fifty Years Ago, Protesters Took on the Miss America Pageant," *Smithsonian Magazine*, January 2018, https://www.smithsonianmag.com/history/fifty-years-ago-protesters-took-on-miss-america-pageant-electrified-feminist-movement-180967504/.

11. Yxta Maya Murray, "'Creating New Categories': Anglo-American Radical Feminism's Constitutionalism in the Streets," *Hastings Race & Poverty Law Journal* 9, no. 2 (Summer 2012): 449.

12. LACE, "About," 2021, https://welcometolace.org/about/.

13. Andrew Russeth, "Joseph Beuys Sculpture Made After Documenta 5 Boxing Match Goes to MMK Frankfurt," *Artnews*, November 15, 2018, https://www.artnews.com/art-news/news/joseph-beuys-sculpture-made-documenta-5-boxing-match-goes-mmk-frankfurt-11352/.

14. Vivien Green Fryd, "Suzanne Lacy's Three Weeks in May: Feminist Activist Performance Art as 'Expanded Public Pedagogy,'" *NWSA Journal* 19, no. 1 (2007): 23–38.

15. Chela Sandoval and Guisela Latorre. "Chicana/o Artivism: Judy Baca's Digital Work with Youth of Color," in *Learning Race and Ethnicity: Youth and Digital Media*, ed. Anna Everett (Cambridge, MA: The MIT Press, 2008), 87.

16. Chela Sandoval and Guisela Latorre, "Chicana/o Artivism.: Judy Baca's Digital Work with Youth of Color."

17. Jennifer González and Adrienne Posner, "Facture for Change: U.S. Activist Art since 1950," in *A Companion to Contemporary Art since 1945*, ed. Amelia Jones and Dana Arnold (New York: Wiley-Blackwell, 2006), 61–62, (detailing the rise of political art and noting the first instances of abstract expressionists such as Jackson Pollock working as an assistant for David Siqueiros, a member of the Communist Party, and Mark Rothko's involvement in the Artists Union).

18. Lucy Lippard, *Get the Message? A Decade of Art for Social Change* (New York: EP Dutton, 1984), 52, 10.

19. González and Posner, "Facture for Change," 66–67.

20. On Emory Douglas, see Angelica McKinley and Giovanni Russonello, "Fifty Years Later, Black Panthers' Art Still Resonates," *New York Times*, October 15, 2016, https://www.nytimes.com/2016/10/16/arts/fifty-years-later-black-panthers-art-still-resonates.html; On Keith Haring, see "Keith Haring: Street Artist and AIDS Activist Who Changed the World With a Piece of Chalk," *Hero*, August 12, 2020, https://hero-magazine.com/article/175640/keith-haring.

21. On the Zapatista revolution, see Oliver Froehling, "The Cyberspace 'War of Ink and Internet' in Chiapas, Mexico," *Geographical Review* 87, no. 2 (1997): 291–307.On the Tute Bianche movement, see Christian Scholl, *Two Sides of a Barricade: (Dis)order and Summit Protest in Europe* (Albany: Suny Press, 2012): 76; On Reclaim the Streets, see André Carmom, "Reclaim the Streets, the Prostetival and the Creative Transformation of the City," *Finisterra*, XLVII, 94 (2012), https://doi.org/10.18055/Finis2683. On Santiago Sierra, see *Workers Who Cannot Be Paid, Remunerated to Remain Inside Cardboard Boxes*, 2000; Caludette Lauzon, *The Umaking of Home in Contemporary Art* (Toronto: University of Toronto Press, 2017), 95 ("For *Workers Who Cannot Be Paid, Remunerated to Remain inside Cardboard Boxes at the Kunst Werke in Berlin in 2000*, Sierra hired six undocumented Chechen asylum seekers to spend four hours per day for six weeks inside boxes installed in the gallery.").

22. See Nicolas Bourriaud, *Relational Aesthetics* (Dijon: Les Presses du Reel, 2002), 113; Claire Bishop, "Antagonism and Relational Art," *October* (Fall 2004): 69–70; on social practice art, see Jennie Klein, "Social Practice Art, Then and Now," *PAJ: A Journal of Performance and Art* 37, no. 2 (2015): 103–10.

23. Chantal Mouffe, "Artistic Activism and Agonistic Spaces," *Art & Research* 1, no. 2 (2007): 5.

24. Mouffe, "Artistic Activism and Agonistic Spaces," 5 ("It would be a serious mistake to believe that artistic activism could, on its own, bring about the end of neo-liberal hegemony.").

25. Bridget R. Cooks, "Black Artists and Activism: Harlem on My Mind (1969)," *American Studies* 48, no. 1 (Spring 2007): 5–39; Lisa Gail Collins, "Activists Who Yearn for Art That Transforms: Parallels in the Black Arts and Feminist Art Movements in the United States," *Signs* 31, no. 3 (Spring 2006): 717–52; Renée Ater, "Reviewed Work: *Creating Their Own Image: The History of African-American Women Artists* by Lisa E. Farrington," *NWSA Journal* 19, no. 1 (Spring, 2007): 211–17.

26. See Judy Baca, *About*, http://www.judybaca.com/artist/biography/; Sandoval and Latorre, "Chicana/o Artivism," 87.

27. Sandoval and Latorre, "Chicana/o Artivism," 105.

28. Chon A. Noriega, "Laura Aguilar: Clothed Unclothed: Challenging Normative Conceptions of the Body," *UCLA: Center for the Study of Women* (May 2008): 1; Robb Hernández, *Archiving an Epidemic: Art, AIDS, and the Queer Chicanx Avant-Garde* (New York: New York University Press, 2019). Other scholars who examine queer intersectionality include Joshua Chambers-Letson, James F. Wilson, Chris Bell, and Jenifer L. Barclay.

29. Intersectionality was first coined in 1989. Kimberlé Crenshaw, "Demarginalizing the Intersection of Race and Sex: A Black Feminist Critique of Antidiscrimination Doctrine, Feminist Theory and Antiracist Politics," *University of Chicago Legal Forum* 43, no. 6 (1989): 139.

30. This emphasis also pushes back against the patriarchal, heterosexist, and racist practices of canon formation and art movement mapping. Mira Schor, "Wheels and Waves in the U.S.A.," in *A Companion to Feminist Art*, ed. Hilary Robinson and Maria Elena Buszek (Hoboken: Wiley, 2019), 141 (noting "'patrilineage' of art canon formation.").

31. Such schools of thought are known as demosprudence, popular constitutionalism, democratic constitutionalism, movement law, and community constitutionalism. Lani Guinier and Gerald Torres, "Changing the Wind: Notes Toward a Demosprudence of Law and Social Movements," *Yale Law Journal* 123, no. 8 (June 2014): 2740–804; Robert Post and Reva Siegel, "*Roe* Rage: Democratic Constitutionalism and Backlash," *Harvard Civil Rights-Civil Liberties Review* 42, no. 2 (June 2007): 379; Larry D Kramer, *The People Themselves: Popular Constitutionalism and Judicial Review.* (Oxford: Oxford University Press, 2005); Amna A. Akbar, Sameer M. Ashar, and Jocelyn Simonson, "Movement Law," *Stanford Law Review* 73, no. 4 (April 2021): 821; Yxta Maya Murray, "The Takings Clause of Boyle Heights," *New York Review of Law and Social Change* 43, no. 1 (Fall 2018): 141–42.

32. Jack M. Balkin, "'Wrong the Day It Was Decided': Lochner and Constitutional Historicism," *Boston University Law Review* 85, no. 3 (2005): 679; Reva Siegel's recent work has made claims for democratizing constitutional memory by looking at a panoply of public acts that contain legal and constitutional meaning. Reva B. Siegel, "Memory Games: Dobbs's Originalism as Anti-Democratic Living Constitutionalism—and Some Pathways for Resistance," *Texas Law Review* 75 (2022): 1127; on Robert Post, see Siegel and Post, "*Roe* Rage," 379; Douglas NeJaime, "Winning through Losing," *Iowa Law Review* 96 (April 2011): 943–44; Serena Mayeri, "Constitutional Choices: Legal Feminism and the Historical Dynamics of Change," *California Law Review* 92, no. 3 (May 2004): 763; Serena Mayeri, *Reasoning from Race: Feminism, Law, and the Civil Rights Revolution* (Cambridge, MA: Harvard University Press, 2011); see Reva B. Siegel, "Constitutional Culture, Social Movement Conflict and Constitutional Change: The Case of the de Facto ERA," *California Law Review* 94, no. 5 (October 2006): 1331; Jack M. Balkin, "How Social Movements Change (or Fail to Change) the Constitution: The Case of the New Departure," *Suffolk University Law Review*, 39, no. 1 (December 2005): 27.

33. Guinier and Torres, "Changing the Wind"; Lani Guinier, "Courting the People: Demosprudence and the Law/Politics Divide," *Boston University Law Review* 89, no. 1 (November 2009): 545.

34. Martha C. Nussbaum, *Poetic Justice: The Literary Imagination and Public Life* (Boston: Beacon Press, 1994); Robin West, "Economic Man and Literary Woman: One Contrast," *Mercer Law Review* 39, no. 1 (Fall 1988): 874.

35. Derrick Bell, *And We Are Not Saved: The Elusive Quest for Racial Justice* (New York: Basic Books, 1987); Patricia J. Williams, "Alchemical Notes: Reconstructing Ideals from Deconstructed Rights," *Harvard Civil Rights-Civil Liberties Law Review* 22, no. 2 (Spring 1987): 401; Richard Delgado, "Storytelling for Oppositionists and Others: A Plea for Narrative," *Michigan Law Review* 87, no. 8 (Winter 1989): 2411–41; Mari J. Matsuda, "Looking to the Bottom: Critical Legal Studies and Reparations," *Harvard Civil Rights-Civil Liberties Law Review* 22, no. 1 (Fall 1987): 323; Dorothy E. Roberts, "The Future of Reproductive Choice for Poor Women and Women of Color," *Women's Rights Law Rep*orter 14, nos. 2–3 (Spring/Fall 1992): 310.

36. Joan Kee, "Art Chasing Law: The Case of Yoko Ono's *Rape*," *Law and Literature* 28, no. 2 (June 2016): 187–208; Sarah Elizabeth Lewis, "*Groundwork*: Race and Aesthetics in the Era of Stand Your Ground Law," *Art Journal* 79, no. 4 (Spring 2020): 92–113; Sarah Elizabeth Lewis, "The Arena of Suspension: Carrie Mae Weems, Bryan Stevenson, and the 'Ground' in the Stand Your Ground Law Era," *Law and Literature* 33, no. 3 (2002): 487–518; Sonya K. Katyal, "The Public Good in Poetic Justice," *Cornell Journal of Law and Public Policy* 26, no. 3 (October 2017): 497; Adrienne D. Davis, "Bad Girls of Art and Law: Abjection, Power, and Sexuality Exceptionalism in (Kara Walker's) Art and (Janet Halley's) Law," *Yale Journal of Law and Feminism* 23, no. 1 (June 2011): 1; Amy Adler, "Performance Anxiety: Medusa, Sex and the First Amendment," *Yale Journal of Law & Humanities* 21, no. 2 (May 2009): 227; Amy Adler, "The Shifting Law of Sexual Speech: Rethinking Robert Mapplethorpe," *University of Chicago* 2020 *University of Chicago Legal Forum*, 1 (2020): 1; Yxta Maya Murray, "Rape Trauma, the State, and the Art of Tracey Emin," *California Law Review* 100, no. 6 (December 2012): 1631–1710.

37. The gains of the Civil Rights Movement of the 1950s and 1960s, which led to much-needed changes in federal and state discrimination law, are well known. Other, more recent, examples of legally transformative social movements will be found in Aimee Meredith, *Shapeshifters: Black Girls and the Choreography of Citizenship*. (Durham: Duke University Press, 2015); and Jocelyn Simonson, "Copwatching," *California Law Review* 104, no. 2 (April 2016): 391.

38. Robert E. Klitgaard, "Gandhi's Non-Violence as a Tactic," *Journal of Peace Research* 8, no. 2 (1971): 143–53; Martin Luther King Jr., "Letter From a Birmingham Jail," *The Journal of Negro History* 71, no. 1/4 (Winter–Autumn, 1986): 38–44; Herbert Kohl, "The Politics of Children's Literature: The Story of Rosa Parks and the Montgomery Bus Boycott," *The Journal of Education* 173, no. 1 (1991): 35–50Fabio Rojas, "Social Movement Tactics, Organizational Change and the Spread of African-American Studies," *Social Forces* 84, no. 4 (June 2006): 2150. Please note that this is just one of many interpretations of the term. The revered arts organization Self Help Graphics participates in a related and expansive artivist practice, which often looks toward direct action. See, e.g., Self Help Graphics & Art, "You Committee & Artivism Internship," https://www.selfhelpgraphics.com/youth-committee (last viewed August 6, 2023). For additional approaches, see, e.g, Katy Deepwell, *Feminism Art Activisms and Artivisms* (Amsterdam: Valiz/Plural Series, 2020).

39. For examples of direct action, see Archibald Cox, "Direct Action, Civil Disobedience, and the Constitution," *Proceedings of the Massachusetts Historical Society* 78, no. 3 (1966): 106; Dean Spade, *Mutual Aid: Building Solidarity During This Crisis (and the Next)* (London and New York: Verso, 2020); Dawson Barrett, "DIY Democracy: The Direct Action Politics of U.S. Punk Collectives," *American Studies* 52, no. 2 (2013): 34–35.

40. "Appearing in public without shame" is deemed a core human capability by the philosopher and economist Amartya K. Sen. Armatya K. Sen, *Inequality Reexamined* (Cambridge, MA: Harvard University Press, 1992), 115.

41. See interview with Young Joon Kwak (chapter 3), as an example of this.

42. Consider not only the examples of the ERA activists, who developed fruitful communications with Pauli Murray and Ruth Bader Ginsburg; the Montgomery Bus Boycott activists, who engaged with Fred Gray; and Fannie Lou Hamer, who sharpened her agenda on Joseph Rauh; but also the members of the contemporary Black Liberation movement who interact with the legal aid group Law for Black Lives. Law for Black Lives, "Mission Statement," http://www.law4blacklives.org/our-work-1.

43. See, e.g., Laura M. Padilla, "Social and Legal Repercussions of Latinos' Colonized Mentality," *University of Miami Law Review* 53, no. 2 (Fall 1999): 769.

44. Aristotle, *The Poetics*, trans. James Hutton (New York: W.W. Norton, 1982), §1449b.

45. See Inciativa Feminista, Facebook, http://colectivoiniciativafeminista.blogspot.com/.

46. Hannah Bloch, "A Rap Star and a Therapist Fight Female Genital Mutilation," *Goats and Soda*, February 6, 2015, https://www.npr.org/sections/goatsandsoda/2015/02/06/384124396/a-rap-star-and-a-therapist-fight-female-genital-mutilation; United Nations, Commission on the Status of Women, "Ending Female Genital Mutilation," March 12, 2010, https://www.un.org/womenwatch/daw/beijing15/outcomes/L%208_FGM_Advance%20unedited.pdf; James Ciment, "Senegal Outlaws Female Genital Mutilation," *British Medical Journal* 318, no. 7180 (1999): 348.

47. "'Better Together': A Glimpse into China's Queer Community," *Fair Planet*, April 18, 2022, https://www.fairplanet.org/story/better-together-a-glimpse-into-chinas-queer-community/; "Have You Considered Your Parents' Happiness? Conversion Therapy against LGBT People in China," *HRW*, Nov. 15, 2017, https://www.hrw.org/report/2017/11/15/have-you-considered-your-parents-happiness/conversion-therapy-against-lgbt-people ("China does not have a law protecting individuals from discrimination due to sexual orientation or gender identity.").

48. Ryan D. Doerfler and Samuel Moyn, "The Constitution is Broken and Should Not Be Reclaimed," *New York Times*, August 19, 2022, https://www.nytimes.com/2022/08/19/opinion/liberals-constitution.html.

49. Dean Spade, "For Those Considering Law School," *Unbound: Harvard Journal of the Legal Left*, 6 (2011): 110–19.

50. Harvard Law School, "HLS in the World | The Changing Political and Intellectual Landscape of Criminal Justice Reform," at 33:01, *Youtube.com* (November 17, 2017), https://www.youtube.com/watch?v=cWjlL9-bVq0 [http://perma.cc/P7S3-4G3J], quoted in "Introduction," *Harvard Law Review* 132, no. 6 (2019): 1568.

51. For Defund the Police's gathering of "legislation and policy reforms proposed and passed to defund the police in communities across the country," see Defund the Police, "Legislative Resources," https://defundpolice.org/legislation-resources/.

52. Siegel, "Memory Games," 75.

53. Dorothy E. Roberts, "Foreword: Abolition Constitutionalism," *Harvard Law Review* 133, no. 1 (November 2019): 1.

54. With thanks to Doug NeJaime for alerting me to these issues and helping me express these ideas.

1. ARTIVISM AVANT LA LETTRE

1. Chela Sandoval and Guisela Latorre, "Chicana/o Artivism: Judy Baca's Digital Work with Youth of Color," in *Learning Race and Ethnicity: Youth and Digital Media*, ed. Anna Everett (Cambridge, MA: The MIT Press, 2008), 87.

2. I thank Elizabeth Ferrer for introducing me to the concept of archive building as an alternative to canon formation.

3. See, e.g., Monica Lam, Julie Chang, and Beth LaBerge, "'War on Us': Black Women Rally in Oakland for Breonna Taylor," *KQED*, September 24, 2020, https://www.kqed.org/

news/11839529/war-on-us-black-women-rally-in-oakland-for-breonna-taylor (describing a rally protesting a Kentucky grand jury's decision not to charge Louisville police officers for the killing of Breonna Taylor; participants performed spoken word poetry, offered personal storytelling, and gave speeches that covered racism and sexism as well as gentrification).

4. This is a limited listing of intersectional artists who engaged in direct action that contained legal meaning during the 1930s and 1940s. A review of this history reveals an almost overwhelming cascade of examples of women of color and queer people of color merging their direct resistance of state oppression with aesthetic elements. Billie Holiday, Pearl Primus, and Lillian Nakano are just some names from this period that deserve extended considerations.

5. Jack Halberstam, *Female Masculinity* (Durham: Duke University Press, 1999), 229; James F. Wilson, *Bulldaggers, Pansies, and Chocolate Babies: Performance, Race, and Sexuality in the Harlem Renaissance* (Ann Arbor, University of Michigan Press, 2011), 172; Wilson, *Bulldaggers*, 173; Gladys Bentley, "I Am Woman," *Ebony Magazine*, August 1952, 94, republished in Shirlette Ammons, "'I Am Woman,' Gladys Bentley (Ebony Magazine, August 1952)," *Shirlette Ammons* (blog), February 11, 2014, http://shirletteammons.com/?p=899.

6. Haleema Shah, "The Great Blues Singer Gladys Bentley Broke All the Rules," *Smithsonian Magazine*, March 14, 2019, https://www.smithsonianmag.com/smithsonian-institution/great-blues-singer-gladys-bentley-broke-rules-180971708/; Jack Halberstam, *Feminine Masculinity* (Durham: Duke University Press, 1999), 229; James F. Wilson, *Bulldaggers, Pansies, and Chocolate Babies: Performance, Race, and Sexuality in the Harlem Renaissance* (Ann Arbor, University of Michigan Press, 2011), 172; Wilson, *Bulldaggers*, 177.

7. Wilson, *Bulldaggers*, 154; Whitney Strub, "Lavender, Menaced: Lesbianism, Obscenity Law, and the Feminist Antipornography Movement," *Journal of Women's History* 22, no. 2 (Summer 2010): 83–107

8. Wilson, *Bulldaggers*, 177.

9. Wilson, *Bulldaggers*, 156.

10. Klare Scarborough and Elizabeth Catlett, "Singing the Blues," in *Elizabeth Catlett: Art for Social Justice*, ed. Klare Scarborough (La Salle: La Salle University Art Museum, 2015), 16. *See also* "Object Lesson: Mother and Child by Elizabeth Catlett," NOMA, https://noma.org/object-lesson-mother-and-child-by-elizabeth-catlett/ (identifying Catlett as Chair of Dillard's Art Department).

11. Doug MacCash, "Artist Elizabeth Catlett, Sculptor of Louis Armstrong Statue, Dies," *NOLA.com*, April 5, 2012, https://www.nola.com/entertainment_life/arts/article_ab1d56ca-12b1-5b17-a087-6388fbb6d624.html.

12. One definition of conceptual art finds that it privileges ideas over objects. John Bird and Michael Newman, *Rewriting Conceptual Art* (London: Reaktion Books, 1999), 2; "The artists of the counterculture jettisoned the practice of creating discrete objects in favor of practices that were durational, performative, experiential, and built on communal encounter." Elissa Aurther and Adam Lerner, "The Counterculture Experiment: Consciousness and Encounters at the Edge of Art," in *West of Center: Art and the Counterculture Experiment in America, 1965–1977*, ed. Elissa Aurther and Adam Lerner (Minneapolis: University of Minnesota Press, 2011), xxviii; Jennifer González and Adrienne Posner, "Facture for Change: US Activist Art since 1950," in *A Companion to Contemporary Art Since 1945*, ed. Amelia Jones (Malden: Blackwell, 2006), 213. In 1976, the artist Ulay stole one of Hitler's favorite paintings, Carl Spitzweg's *Der arme Poet* (1839), from Berlin's Neue Nationalgalerie and installed it in a Turkish family's living room,

earning himself an arrest as well as a thirty-six-day jail term that he evaded by escaping the country. Jörg Schmidt-Reitwein filmed the heist and installation, resulting in *There is a Criminal Touch to Art* (1976). One definition of institutional critique sees it as "putting pressure on the disjuncture between the self-presentation of the art institution (as democratic and free of discrimination, partisanship, and, plainly put, ideology) and the highly gendered, raced, and classed ideology that actually permeates it." Alexander Alberro, "Preface," in *Institutional Critique: An Anthology of Artists' Writings*, ed. Alexander Alberro (Cambridge, MA: The MIT Press, 2011), 12; Jennie Klein, "Social Practice Art, Then and Now," *PAJ: A Journal of Performance and Art* 37, no. 2 (2015): 103–10. Joseph Beuys is one of the most famous proponents of pedagogy-as-art practice. Willoughby Sharp, "An Interview with Joseph Beuys," *Artforum*, December 1969, https://www.artforum.com/print/196910/an-interview-with-joseph-beuys-36456 ("[Teaching is] my most important function. To be a teacher is my greatest work of art. The rest is the waste product, a demonstration.") However, Ruth Asawa may predate Beuys's blending of teaching and art in her early artivist gesture of forming the Alvarado Arts Workshop in San Francisco in 1968. Kathlyn Simotas, "Interwoven Histories: The Generational Legacy of Ruth Asawa's Arts Education Activism," *Foundsf*, 2021, https://www.foundsf.org/index.php?title=Interwoven_Histories:_The_Generational_Legacy_of_Ruth_Asawa%E2%80%99s_Arts_Education_Activism.

13. Betty Perry, "Lois Mailou Jones: An Indefatigable Black Woman Artist," *Washington Post*, February 23, 1983, https://www.washingtonpost.com/archive/local/1983/02/23/lois-mailou-jones-an-indefatigable-black-woman-artist/91bbdec6-f18b-4293-a19d-7d9936bb31ab/.

14. Baynard Woods, "Esquerita and the Voola," *Oxford American*, November 19, 2019, https://main.oxfordamerican.org/magazine/item/1857-esquerita-and-the-voola.

15. Lillian Faderman and Stuart Timmons, *Gay L.A.: A History of Sexual Outlaws, Power Politics, and Lipstick Lesbians* (New York: Basic Books, 2006), 1–2. Some sources have since questioned the accuracy of Rechy's representations. See Erik Piepenburg, "A Gay Riot at a Donut Shop? The Legend Has Some Holes," *New York Times*, June 6, 2023, https://www.nytimes.com/2023/06/05/dining/gay-riot-los-angeles-doughnut-shop.html.

16. Patrick J. Hearden, *The Tragedy of Vietnam* (Oxfordshire: Routledge, 2016), 78.

17. Christopher Schmidt, *The Sit-Ins: Protest and Legal Change in the Civil Rights Era* (Chicago: University of Chicago Press, 2018), 2; Raymond Arsenault, *Freedom Riders: 1961 and the Struggle for Racial Justice* (Oxford: Oxford University Press, 2006), ix. The CRA outlawed workplace and public accommodations discrimination based on race, color, religion, sex, or national origin. Civil Rights Act of 1964, 78 Stat. 243, 42 U.S.C. § 2000a et seq. The Voting Rights Act prohibited discriminatory voting practices. The Voting Rights Act of 1965, Pub. L. 89–110, 79 Stat. 437.

18. Roxanne Gay, "Fifty Years Ago, Protesters Took on the Miss America Pageant and Electrified the Feminist Movement," *Smithsonian Magazine*, January/February 2018, https://www.smithsonianmag.com/history/fifty-years-ago-protestors-took-on-miss-america-pageant-electrified-feminist-movement-180967504/.

19. David Carter, *Stonewall: The Riots That Sparked the Gay Revolution* (New York: Saint Martin's Press, 2010), 1.

20. Among the many other intersectional artists who make up this history, consider Ruth Asawa, Ana Mendieta, Mabel Hampton, and Luz Esther Benítez.

21. Ken Wilder, *Beholding: Situated Art and the Aesthetics of Reception* (London: Bloomsbury Visual Arts, 2020), 201–3.

22. Kevin Concannon, "Yoko Ono's 'Cut Piece': From Text to Performance and Back Again, *PAJ: A Journal of Performance and Art* 30, no. 82 (September 2008): 81–93.

23. Yxta Maya Murray, "Cut Piece: The Art of Yoko Ono and the Law of Rape in the United States, *Law and Literature*, Loyola Law School, Los Angeles Legal Studies Research Paper No. 2020-10, 1–2.

24. Roger Perry and Tony Elliott, "Yoko Ono," *UNIT* (December 1967): 26–27 ("It was a form of giving, giving and taking. It was a kind of criticism against artists who are always giving what they want to give. I wanted people to take whatever they wanted to, so it was very important to say you can cut wherever you want to.").

25. "Cut Piece. 1964," MoMA, at https://www.moma.org/audio/playlist/15/373.

26. For associations between the performance and satyagraha, see Murray, "Cut Piece," 23.

27. Henry J. Abraham and Barbara A. Perry, *Freedom and the Court: Civil Rights and Liberties in the United States*. (Lawrence: University Press of Kansas, 2003), 437; Charlotte Alter, "Here's What All Successful Student Protests Have in Common," Time, November 9, 2015, https://time.com/4105460/student-protests-university-missouri-president-tim-wolfe/. On protesters' quiet during the sit-ins in Greensboro, see Jennifer Bringle, *The Civil Rights Act of 1964* (New York: Rosen Publishing Group, 2015), 21.

28. Harriet Ann Jacobs, *Incidents in the Life of a Slave Girl* (Boston: Thayer & Eldridge, 1861), 45 ("He told me I was his property; that I must be subject to his will in all things."). For an astute analysis, see Jennifer Bailey, "Voicing Oppositional Conformity: Sarah Winnemucca and the Politics of Rape, Colonialism, and 'Citizenship' 1870–1980" (PhD diss., Portland State University, 2012), 119. See also Nick Estes, "You Can't Vote Harder: Between American Indian Citizenship and Decolonization," *Verso Books Blog*, February 7, 2019, https://www.versobooks.com/blogs/4227-you-can-t-vote-harder-between-american-indian-citizenship-and-decolonization (studying Winnemucca's 1883 autobiography *Life Among the Paiutes*). Danielle L. McGuire, *At the Dark End of the Street: Black Women, Rape, and Resistance—and New History of the Civil Rights Movement from Rosa Parks to the Rise of Black Power* (New York: Vintage, 2011), 15.

29. Yxta Maya Murray, "Cut Piece," 1–2.

30. The early 1970s saw the Redstockings' Speak Out in front of St. Clemens' Episcopal Church in 1971 and the 1972 formation of the organizations Bay Area Women Against Rape (BAWAR) in Berkeley, California, and the Washington, DC Rape Crisis Center. Nancy A. Mathews, *Confronting Rape: The Feminist Anti-Rape Movement and the State* (Oxfordshire: Routledge, 1994), 8–9.

31. See, e.g., Catharine MacKinnon, "Feminism, Marxism, Method, and the State," *Feminist Theory* 7, no. 3 (Spring 1982): 532; Susan Estrich, "Rape," *Yale Law Journal* 95, no. 6 (May 1986): 1087.

32. William L. Standard, "United States Intervention in Vietnam Is Not Legal," *American Bar Association Journal* 52, no. 7 (1966): 627.

33. Usha Mahajani, "The Question Indira Gandhi Asked," *Women on the March* 17, no. 1 (1973): 50 ("As Usha Mahajani wrote in 1973, the Vietnam War became an 'anti-Asian war' that revealed "strong racial anti-Asian bias" in the United States.").

34. Korematsu v. United States, 323 U.S. 214 (1944), abrogated by Trump v. Hawaii, 138 S. Ct. 2392 (2018).

35. Mary Lodu, "Michele Wallace," *Third Rail Quarterly*, (undated), http://thirdrailquarterly.org/mary-lodu-michele-wallace/; Michele Wallace, "Women Students and Artists for Black Art Liberation (WSABAL)," *Rethinking Guernica* (undated), https://guernica.museoreinasofia.es/en/document/women-students-and-artists-black-art-liberation-wsabal.

36. Wallace, "Women Students and Artists for Black Art Liberation (WSABAL); Lodu, "Michele Wallace"; Grace Glueck, "Women Artists Demonstrate at Whitney," *New York*

Times, December 12, 1970, https://www.nytimes.com/1970/12/12/archives/women-artists-demonstrate-at-whitney.html.

37. Practitioners of womanism, a term coined by the novelist and activist Alice Walker, "see[] womanism as rooted in black women's concrete history in racial and gender oppression." Patricia Hill Collins, "The Black Scholar," *The Challenge of Blackness* 26, no. 1 (Winter/Spring 1996): 10; Rosalind Rosenberg, *Jane Crow: The Life of Pauli Murray* (Oxford: Oxford University Press, 2017), 275; Pauli Murray, "Memorandum in Support of Retaining the Amendment to H.R. 7152, Title VII (Equal Employment Opportunity) to Prohibit Discrimination in Employment Because of Sex," April 14, 1964 (Pauli Murray Papers, MC 412, Box 85, Folder 1485, on file with the Schlesinger Library, Radcliffe Institute, Harvard University), included in "How and Why Was Feminist Legal Strategy Transformed, 1960–1973?," documents selected and interpreted by Serena Mayeri (Binghamton: State University of New York at Binghamton, 2007), https://documents.alexanderstreet.com/d/1000680941; Kimberly Springer, "The Interstitial Politics of Black Feminist Organizations, *Meridians* 1, no. 2 (Spring, 2001): 155.

38. Maggie Doherty, *The Equivalents: A Story of Art, Female Friendship, and Liberation in the 1960s* (New York: Knopf, 2020), 268.

39. Amy J. Sepinwall, "Conscience in Commerce: Conceptualizing Discrimination in Public Accommodations," *Connecticut Law Review* 53, no. 1 (May 2021): 1; Sara Tam, "In Museums We Trust: Analyzing the Mission of Museums, Deaccessioning Policies, and the Public Trust," *Fordham Urban Law Journal* 39, no. 3 (2012): 849.

40. Jean Troche and John Hendricks were identified as co-organizers of the show, but in a later interview, Michele Wallace said that "it was WSABAL action." Lodu, "Michele Wallace." November 9 is listed on Ringgold's poster as the beginning date of the exhibition. Faith Ringgold, *People's Flag Show*, Museum of Modern Art, https://www.moma.org/collection/works/202867.

41. Stephen Radich's 1967 arrest triggered The People's Art Show. Faith Ringgold, *We Flew Over the Bridge: The Memoirs of Faith Ringgold* (Durham: Duke University Press, 2005), 181. The year before, Sidney Street also burned the flag upon hearing of the attempted murder of civil rights activist James Meredith. Street v. New York, 394 U.S. 576, 594 (1969).

42. Ringgold, *We Flew Over the Bridge* ("On opening night, Yvonne Rainer and her dancers did a dance in the nude with flags loosely tied around their necks," 181); ("An open show meant anyone who wanted to participate in the show could put in any piece they chose. There was no selection committee and no jurying of pieces," 181).

43. Ringgold, *People's Flag Show*.

44. Lodu, "Michele Wallace"; "Three Arrested in Raid on Flag Art Show," *New York Times*, November 14, 1970, https://www.nytimes.com/1970/11/14/archives/3-arrested-in-raid-on-flag-art-show.html; "Flag Show Artists Fined $100 Apiece," *New York Times*, May 25, 1971, https://www.nytimes.com/1971/05/25/archives/flag-show-artists-fined-100-apiece.html.

45. "Flag Show Artists Fined."

46. Rodric B. Schoen, "A Strange Silence: Vietnam and the Supreme Court," *Washburn Law Journal* 33, no. 2 (Spring 1994): 275.

47. Jyotsna Sreenivasan, *Poverty and the Government in America: A Historical Encyclopedia*, vol. 1 (Santa Barbara: Greenwood, 2009), 133.

48. Texas v. Johnson, 491 U.S. 397, 420 (1989); United States v. Eichman, 496 U.S. 310, 315 (1990).

49. Michael Kasino, *Marsha P. Johnson: Pay It No Mind*, Redux Films, 2012. See statement of Agosto Machado, around minute 7.

NOTES TO PAGES 21–23

50. *Rasquachismo* connotes an artistic practice of DIY or making do. Tomás Ybarra-Frausto, "Rasquachismo, a Chicano Sensibility," in *Chicano Art: Resistance and Affirmation, 1965–1985*, ed. Richard Griswold del Castillo, Teresa McKenna, and Yvonne Yarbro Bejarano (Los Angeles: Wight Art Gallery, University of California, Los Angeles, 1991), 155–62. Michael Kasino, *Pay It No Mind* at 7:21, showing Johnson wearing a khaki shirtdress and silver jewelry; Steve Watson, "Stonewall 1979: The Drag of Politics," *Village Voice*, June 16, 1979, https://www.villagevoice.com/2019/06/04/stonewall-1979-the-drag-of-politics/ ("[She] set all these new trends in dressing. She was the abundance and beauty of the street trash. And flowers, always flowers. Going after this sky-high energy with extreme makeup and colored wigs and pins and jewelry."); Kasino, *Pay It No Mind*. "She would say, 'We're in the Village, we're free, live!'" (statement of Agosto Machado at 7:22.).

51. Chapter 112, 1981 Wis. Laws; Amnesty International, *Stonewalled: Police Brutality and Abuse against Lesbian, Gay, Bisexual and Transgender People in the U.S* (London: Amnesty International, 2005), 45; Williams v. United States, 341 U.S. 97, 98 (1951); Pryor v. Mun. Ct., 25 Cal. 3d 238, 252 (1979) ("Three studies of law enforcement in Los Angeles County indicate that the overwhelming majority of arrests for violation of Penal Code section 647, subdivision (a), involved male homosexuals.").

52. Eric Marcus, *The Stonewall Reader* (New York: Penguin Classics, 2019), 138 "[The police would] say, 'All yous drag queens under arrest,' so we, you know, it was just for wearing a little bit of makeup down Forty-second Street.").

53. Marsha P. Johnson Interviewed by Betty Brown, (undated), https://www.youtube.com/watch?v=tvW-Fif4KFE.

54. Marsha P. Johnson, "You Gotta Have Soul," https://www.youtube.com/watch?v=T_XQU2_fF5E; Tom Fitzgerald and Lorenzo Marquez, *Legendary Children: The First Decade of Rupaul's Drag Race and the Last Century of Queer Life* (New York: Penguin, 2020), 91; Kasino, *Pay It No Mind* at minute 27; "Interview with Tom Robinson," *Glad To Be Gay*, https://gladtobegay.net/interview-tom-robinson/part-2/ ("Hot Peaches kind of embodied this whole thing of it being drag but very tacky drag and not meant to be realistic. It was kind of radical drag, and genderfuck drag . . . [there was] this life-affirming energy, talent and humour—laced with sheer righteous anger—that fueled the Hot Peaches' incendiary stage show.").

55. Carter, *Stonewall*, 261. ("We can name three individuals known to have been in the vanguard: Jackie Hormona, Marsha Johnson, and Zazu Nova."); Marcus, *The Stonewall Reader*, 138.

56. Marcus, *The Stonewall Reader*, 136–37.

57. Marcus, *The Stonewall Reader*, 138; Kasino, *Pay It No Mind* at minute 15, showing footage of Johnson's last interview, given on June 26, 1992; Steve Watson, "Stonewall 1979: The Drag of Politics," *Village Voice*, June 15, 1979, https://www.villagevoice.com/2019/06/04/stonewall-1979-the-drag-of-politics/.

58. Matilda Bernstein Sycamore, *That's Revolting! Queer Strategies for Resisting Assimilation* (New York: Soft Skull, 2008), 124.

59. Sycamore, *That's Revolting!*, 126; Leslie Feinberg, "Street Transvestites Action Revolutionaries," *Workers World*, September 24, 2006, https://www.workers.org/2006/us/lavender-red-73/.

60. Rachel Corbman, "Sylvia Rivera and Marsha P. Johnson: Listen to the Newly Unearthed Interview with Street Transvestite Action Revolutionaries," *Women at the Center*, June 26, 2019, https://womenatthecenter.nyhistory.org/gay-power-is-trans-history-street-transvestite-action-revolutionaries/#_edn2; Sessi Kubawara, "At STAR House, Marsha P. Johnson and Sylvia Rivera Created a Home for Trans People," *VICE*, June 8, 2020, https://www.vice.com/en/article/z3enva/star-house-sylvia-rivera-marsha-p-johnson.

61. Sreenivasan, *Poverty and the Government in America*, 133 (Black Panthers' 1966 10-Point Plan's item #6 demanded decent housing).

62. Lindsey v. Normet, 405 U.S. 56 (1972).

63. Some artists whom I read as artivists reject any or most forms of categorization, which would defy their inclusion in this book. Stephanie Bailey, "Theaster Gates," *Ocula Magazine*, March 31, 2017, https://ocula.com/magazine/conversations/theaster-gates/. See also Adrian Piper, "Caste in Stone: Why Classifying Artists by Race is Not Just a 'Social Construct,'" *Artnet*, December 16, 2022, https://news.artnet.com/art-world/caste-in-stone-why-classifying-artists-by-race-is-not-just-a-social-construct-2229595.

64. Karla Jay and Allan Young, *Out of the Closets: Voices of Gay Liberation* (New York: New York University Press, 1992), 119.

65. Anna Hopkins, "What Happened to Marsha P. Johnson? New Documentary Probes Death of the 'Rosa Parks of the LGBT movement' Who Was Found Dead in the Hudson in 'Suicide'—But Friends Insist She Was Murdered," *Daily Mail*, October 5, 2017, https://www.dailymail.co.uk/news/article-4952444/Marsha-P-Johnson-s-death-probed-new-documentary.html.

66. Joseph Beuys invented many art forms, including those of "social sculpture," "extended art," and Lebenskunst, or art-as-living. Cara M. Jordan, "Joseph Beuys and Social Sculpture in the United States," *CUNY Academic Works* (2017), https://academicworks.cuny.edu/gc_etds/1731; Catherine Wagley, "Moon, Laub, and Love," *CARLA* 4 (2016): 6, https://contemporaryartreview.la/wp-content/themes/carla/assets/img/issues/04/Carla_Quarterly_Issue4_Moon,laub,andLove.pdf.

67. "The Society of Human Rights," Legacy Project, https://legacyprojectchicago.org/milestone/society-human-rights (naming them as the first documented queer rights organization in United States); Zoë Sonnenberg, "Daughters of Bilitis," *Found SF*, 2015, https://www.foundsf.org/index.php?title=Daughters_of_Bilitis (first lesbian organization in United States); Tyler Antoine, "Before Stonewall, a Reminder," *Historical Society of Pennsylvania*, July 9, 2015, https://hsp.org/blogs/fondly-pennsylvania/before-stonewall-a-reminder (Noting that between 1965 to 1969, the Annual Reminder Day was a Philadelphia-based "demonstration where gay men and lesbians protested for the same civil rights granted to their fellow heterosexuals."); Will Roscoe, "Mattachine: Radical Roots of the Gay Movement," *Found SF* (undated), https://www.foundsf.org/index.php?title=Mattachine:_Radical_Roots_of_the_Gay_Movement (1950s queer discussion group and liberation organization); Rachel Tashjian, "A Brief History of Stormé DeLarverie, Stonewall's Suiting Icon," *GQ.com*, June 27, 2019, https://www.gq.com/story/storme-delarverie-suiting. DeLarverie is known as the person who threw the first punch; David Kaufman, How the Pride March Made History," *New York Times*, June 16, 2020 (naming Craig Rodwell, Fred Sargeant, Ellen Broidy, Linda Rhodes, and Brenda Howard as the organizers). Kozachenko, an Ann Arbor city councilperson, was the first out gay person to serve public office in the United States. Julie Compton, "Meet the Lesbian Who Made Political History Years Before Harvey Milk," *NBC News*, April 2, 2020, https://www.nbcnews.com/feature/nbc-out/meet-lesbian-who-made-political-history-years-harvey-milk-n1174941; "Harvey Milk Biography," https://www.harveymilk.com/biography/. Milk, elected to the San Francisco Board of Supervisors in 1977 as an out gay man, was one of the first visible queer people in US office and pursued a gay rights agenda. Audre Lorde, *I Am Your Sister: Black Women Organizing across Sexualities* (New York: Kitchen Table, Women of Color Press, 1985); Jack Lowery, *It Was Vulgar & It Was Beautiful: How AIDS Activists Used Art to Fight a Pandemic* (New York: Bold Type Books, 2022).

68. Lawrence v. Texas, 539 U.S. 558, 578 (2003) ("The case does involve two adults who, with full and mutual consent from each other, engaged in sexual practices common to a homosexual lifestyle. The petitioners are entitled to respect for their private lives.").

See also Obergefell v. Hodges, 576 U.S. 644, 681 (2015) ("They ask for equal dignity in the eyes of the law. The Constitution grants them that right.").

69. Bostock v. Clayton Cnty., Georgia, 207 L. Ed. 2d 218 (2020).

70. Carolyn Simon, "The Cold Case of an LGBTQ Pioneer Marsha P. Johnson," *Human Rights Campaign*, September 29, 2017, https://www.hrc.org/news/the-cold-case-of-an-lgbtq-pioneer-marsha-p-johnson.

71. Judy Baca, "Brief History," SPARC, https://sparcinla.org/brief-history/ (mentioning that she began to work for the Parks and Recreation Department in 1970).

72. California Penal Code section 594.5, subdivision (a) provided that "Any person who, without the consent of the owner, willfully defaces, by paint or any other liquid, the property of another is guilty of a misdemeanor." (Stats. 1974, ch. 340, § 2, 671).

73. Mary Olmstead, *Judy Baca* (Oxford: Raintree Press, 2004), 45.

74. Olmstead, *Judy Baca*, 45; "The Great Wall of Los Angeles and the Interpretive Green Bridge," SPARC, https://sparcinla.org/wp-content/uploads/downloads/Green BridgeBooklet.pdf.

75. "The Great Wall of Los Angeles and The Interpretive Green Bridge" (statements of participants).

76. Ernesto Chávez, *"¡Mi Raza Primero!" (My People First!): Nationalism, Identity, and Insurgency in the Chicano Movement in Los Angeles, 1966–1978* (Oakland: University of California Press, 2002), 49.

77. Kelly Simpson, "East L.A. Blowouts: Walking Out for Justice in the Classrooms," KCET, March 7, 2012, https://www.kcet.org/shows/departures/east-l-a-blowouts-walking-out-for-justice-in-the-classrooms.

78. Isaac Chotiner, "A Black Lives Matter Co-Founder Explains Why This Time Is Different," *New Yorker*, June 3, 2020, https://www.newyorker.com/news/q-and-a/a-black-lives-matter-co-founder-explains-why-this-time-is-different ("we need social workers. We need these resources to go to our social workers and educators. We need it to go to our schools.").

79. Ta-Nehisi Coates, "The Black Family and Mass Incarceration," *Atlantic*, October 2015, https://www.theatlantic.com/magazine/archive/2015/10/the-black-family-in-the-age-of-mass-incarceration/403246/ ("From the mid-1970s to the mid-'80s, America's incarceration rate doubled, from about 150 people per 100,000 to about 300 per 100,000."); San Antonio Independent School District v. Rodriguez 411 U.S. 1 (1972) (holding that educational policies and tax laws saddling poor Latinx and Black students with inferior educational resources did not violate the constitution).

80. Rashawn Ray, "What Does 'Defund the Police' Mean and Does it Have Merit?" Brookings, June 19, 2020, https://www.brookings.edu/blog/fixgov/2020/06/19/what-does-defund-the-police-mean-and-does-it-have-merit/; Dale Mezzacappa, "Closing Arguments in Pennsylvania School Funding Case Set for Thursday," *Chalkbeat Philadelphia*, March 9, 2022, https://philadelphia.chalkbeat.org/2022/3/9/22969775/school-fair-funding-trial-pennsylvania-closing-arguments-student-outcomes.

81. Murray, "Cut Piece," 1–2.

82. Kylar W. Broadus, "The Criminal Justice System and Trans People," *Temple Political and Civil Rights Law Review*, 3, no. 2 (Spring 2009): 565–66 ("Trans people are subject to abuse at the hands of officers who come to their aid on the street. Trans people face the same verbal, physical, profiling, and sexual abuse as well as the same unnecessary stops, assaults, frisk, strip searches, and pat downs."); White v. City of New York, 206 F. Supp. 3d 920, 938 (S.D.N.Y. 2016) (plaintiff failed to state a claim of regarding widespread police abuse of transgender people when plaintiff only referred to general reports of excessive force and brutality).

83. Jonathan Zasloff, "Children, Families, and Bureaucrats: A Prehistory of Welfare Reform," *Journal of Law and Politics* 14, no. 2 (Spring 1998): 286 ("The Reagan budget reduced federal spending on AFDC by more than a billion dollars; together with more than $35 billion dollars of cuts in seventeen other programs, the Reagan cuts fell disproportionately on African-Americans, particularly black women with children. Reagan's AFDC cuts fell the hardest on the working poor."); Alex M. Johnson Jr., "What the Tea Party Movement Means for Contemporary Race Relations: A Historical and Contextual Analysis," *Georgetown Journal of Law and Modern Critical Race Perspectives* 7, no. 2 (Fall 2015): 203.

84. Artists who helped create the artivist lineage at this time include Lorraine Grady, the artist collective SLAAAP!!! (Sexually Liberated Asian Artist Activist People), Sabrina Margarita Alcantara-Tan, and Howardena Pindell, among others.

85. "Biography," *Howardena Pindell*, https://www.howardenapindell.org/.

86. Howardena Pindell, "Free, White, and 21," *MoMALearning*, https://www.moma.org/learn/moma_learning/howardena-pindell-free-white-and-21-1980/.

87. Andrianna Campbell and Amanda Tewes, "Howardena Pindell: Artist, Teacher, and Social Observer," Getty Trust Oral History Project African American Art History Initiative, Getty Research Institute (2019), 1; "Howardena Pindell," Garth Greenan Gallery, https://www.garthgreenan.com/artists/howardena-pindell; Pindell, "Free, White, and 21"; Howardena Pindell, "Art Crow/Jim Crow (1988)." "Howardena Pindell, Art Crow/Jim Crow," Yale University Art Gallery, https://artgallery.yale.edu/collections/objects/55526.

88. Pindell, "Free, White, and 21," MoMA, https://www.moma.org/collection/works/119105.

89. Meagan Day, "How to Unionize the Artworld," *ArtReview*, August 10, 2022, https://artreview.com/how-to-unionize-the-artworld/; Andrianna Campbell and Amanda Tewes, "Howardena Pindell: Artist, Teacher, and Social Observer," 35 ("But I met a lot of friends there, and we did unionize. I was on a picket line twice."); Louisa Buck, "Howardena Pindell: 'In Terms of Museums, I'm Optimistic; In Terms of the World, I'm Pessimistic,'" *Art Newspaper*, July 1, 2022, https://www.theartnewspaper.com/2022/07/01/howardena-pindell-interview-kettles-yard-cambridge.

90. "Howardena Pindell In Conversation With Lauren O'Neill Butler," *November* (November 2020), https://www.novembermag.com/content/howardena-pindell ("Sometimes I protest anonymously. Sometimes I use my name. Years ago, in the 1970s, I would protest the art world by sending letters in the mail about racism to institutions and individuals that were signed 'The Black Hornet.'").

91. Jonathan Griffin, "Full Circle—Howardena Pindell Comes Into Her Own," *Apollo Magazine*, February 4, 2022, https://www.apollo-magazine.com/howardena-pindell-interview-abstract-painter-retrospective/.

92. Griffin, "Full Circle—Howardena Pindell Comes Into Her Own"; "A Short History," AIR Gallery, https://www.airgallery.org/history.

93. Howardena Pindell, "Testimony," in Art World Surveys, https://pindell.mcachicago.org/art-world-surveys/statistics-testimony-and-supporting-documentation/.

94. "Saving the Black Farm," *Washington Post*, February 27, 1984; "Fact-Finding Project Begun/Anti-Asian Bigotry: An 'Alarming' Rise as Refugees Pour In," *Los Angeles Times*, February 4, 1985; R. H. Melton, "Panel Charges Montgomery Bias; School Officials Pondering Special Education Complaints," *Washington Post*, August 22, 1984, https://www.washingtonpost.com/archive/local/1984/08/22/panel-charges-montgomery-bias/9ee9760b-fc85-4027-8b6b-de0b7eb5ad57/.

NOTES TO PAGES 29–30

95. "'Policing the Police': How the Black Panthers Got Their Start," NPR, September 23, 2015, https://www.npr.org/2015/09/23/442801731/director-chronicles-the-black-panthers-rise-new-tactics-were-needed#:~:text=The%20Black%20Panthers%2C%20as%20they,tells%20Fresh%20Air's%20Terry%20Gross. ("The Black Panthers, as they became known, would follow the police around, jumping out of their cars with guns drawn if the police made a stop. 'They would observe the police and make sure that no brutality occurred,' filmmaker Stanley Nelson tells *Fresh Air's* Terry Gross.").

96. Howardena Pindell, "Gallery Statistics" and "Statistical Overview (Museums) (1980–Present)," in Statistics, Testimony, and Supporting Documentation (1987), https://pindell.mcachicago.org/art-world-surveys/statistics-testimony-and-supporting-documentation/.

97. Howardena Pindell, "Testimony," in Statistics, Testimony, and Supporting Documentation (1987), https://pindell.mcachicago.org/art-world-surveys/statistics-testimony-and-supporting-documentation/.

98. Christine Temin, "Fighting Racism in the Art World," *Boston Globe*, February 7, 1989; Alexis Moore, "Black Art Finds Its Own Space: More Galleries Are Showing It, More People Are Buying It, and Philadelphia Just Might Be Emerging As Its 'National Mecca,'" *Philadelphia Inquirer*, August 30, 1989, https://octobergallery.com/1989/08/30/black-art-finds-its-own-space-more-galleries-are-showing-it-more-people-are-buying-it-and-philadelphia-just-might-be-emerging-as-its-national-mecca/; Maurice Berger, "From the Archives: Are Art Museums Racist?" *Art in America*, March 31, 2020, https://www.artnews.com/art-in-america/features/maurice-berger-are-art-museums-racist-1202682524/2/.

99. Adrian Piper, "The Triple Negation of Colored Women Artists," in *The Feminism and Visual Culture Reader*, ed. Amelia Jones (London and New York: Routledge, 2003), 241; Kirsten Pai Buick, "Introduction: Unk., Untitled, n.d., lost," in *The Unforgettables: Expanding the History of American Art*, ed. Charles C. Eldredge and Kirsten Pai Buick (Oakland: University of California Press, 2022), 3 (Pindell's studies made Buick "aware of the large gaps in my education, aware of the silences and absences of artists of color and artists who were women in the museums and galleries that I had visited.").

100. "Howardena Pindell In Conversation With Lauren O'Neill Butler."

101. See, e.g., "Masterpiece Cakeshop, Ltd. v. Colo. C.R. Comm'n, 138 S. Ct. 1719, 1733 n.* (2018) (Kagan, J., concurring) ("A vendor can choose the products he sells. . . ."); Tam, "In Museums We Trust," 861.

102. See, e.g., Runyon v. McCrary, 427 U.S. 160, 170–71, 96 S. Ct. 2586, 2594, 49 L. Ed. 2d 415 (1976) ("a Negro's right to 'make and enforce contracts' is violated if a private offeror refuses to extend to a Negro, solely because he is a Negro, the same opportunity to enter into contracts as he extends to white offerees.") (citing 42 U.S.C.A. § 1981 (West)). For high barriers to winning such cases, see Comcast Corp. v. Nat'l Ass'n of Afr. Am.-Owned Media, 206 L. Ed. 2d 356, 140 S. Ct. 1009 (2020). Other possibilities may exist under city and state human rights laws that prohibit employers from committing racial discrimination against independent contractors, such as the New York City Human Rights Law, N.Y.C. Administrative Code § 8–101 et seq. Beyond the fact that it would be difficult to compose a class of plaintiffs for a class action, at least two major barriers exist in these cases: the free speech rights of galleries and curators to make independent aesthetic judgments and artists' reasonable fears of losing credit in the insular art world by instigating litigation. On the first matter, see, Arkansas Educ. Television Comm'n v. Forbes, 523 U.S. 666, 673 (1998); and Raven v. Sajet, 334 F. Supp. 3d 22, 31 (D.D.C. 2018), *aff'd sub nom.* Raven v. United States, No. 18-5346, 2019 WL 2562945 (D.C. Cir. May 17, 2019); Shelley v. Kraemer, 334 U.S. 1 (1948). On the second matter, see chapter 6.

103. Lesley Wexler, "#metoo and Law Talk," *University of Chicago Legal Forum* 29, no. 1 (2019): 353.

104. "Framework and Terms for Struggle," Strike MoMA, https://www.strikemoma.org/.

105. Jasmine Liu, "Citing 'Institutional Racist Violence,' Half of the Wisconsin Triennial Artists Withdraw Their Work," *Hyperallergic*, August 23, 2022, https://hyperallergic.com/755393/citing-institutional-racist-violence-half-of-the-wisconsin-triennial-artists-withdraw-their-work/; "Open Letter to the Brooklyn Museum: Your Curatorial Crisis is an Opportunity to Decolonize," Decolonize This Place, April 3, 2018, https://decolonizebrooklynmuseum.wordpress.com/; "Framework and Terms for Struggle," Strike MoMA, https://www.strikemoma.org/. This recent history is detailed in chapter 6.

106. Erin Durban-Albrecht, "The Legacy of Assotto Saint: Tracing Transnational History from the Gay Haitian Diaspora," *Journal of Haitian Studies* 19, no. 1 (Spring 2013): 241 (quoting Saint's "Addendum").

107. Durban-Albrecht, "The Legacy of Assotto Saint," 238.

108. Durban-Albrecht, "The Legacy of Assotto Saint," 248.

109. "And performance artist Assotto Saint, circa 1991 and Assotto Saint (Yves Lubin) NYC.," The New York Public Library Digital Collections, https://digitalcollections.nypl.org/search/index?keywords=assotto+saint&sort=mainTitle_ns+desc; "Assotto Saint," Facebook, June 29, 2021, https://www.facebook.com/264077640451533/photos/a.698881306971162/1708944225964860/ (showing Saint wearing a veil, a pillbox hat, opera gloves, black beaded jewelry, rhinestone or diamond earrings, and expertly applied makeup).

110. Assotto Saint, Facebook Watch, undated video posted April 7, 2016, https://www.facebook.com/watch/?v=499632700229358.

111. Assotto Saint, *Wishing for Wings* (New York: Galiens Press, 1994), 44–45.

112. Assotto Saint, *Spells of a Voodoo Doll: The Poems, Fiction, Essays, and Plays of Assotto Saint* (New York: Masquerade Books, 1996), 230; Andia Augustin-Billy, "Assotto Saint's Search for Home," *Journal of Haitian Studies*, 22, no. 1 (Spring 2016), 88.

113. Durban-Albrecht, "The Legacy of Assotto Saint," 244.

114. Joseph Bennington-Castro, "How AIDS Remained an Unspoken—but Deadly—Epidemic For Years," (undated), *History.com*, https://www.history.com/news/aids-epidemic-ronald-reagan.

115. Harold H. Koh, "No Vacancy in the Land of Liberty," *Connecticut Legal Tribune*, August 2, 1993, 22.

116. Michael Ratner, "How We Closed the Guantanamo HIV Camp: The Intersection of Politics and Litigation." *Harvard Human Rights Journal* 11, no. 1 (Spring 1998): 188–89.

117. "ACT UP Turns to HIV-Positive Haitian Detainees," *Guantanamo Public Memory Project*, https://gitmomemory.org/timeline/resisting-and-protesting-guantanamo/act-up-turns-to-hiv-positive-haitian-detainees/.

118. Assotto Saint, "No More Metaphors (Part Three): Statement Delivered at the Superior Court of the District of Columbia on 28 April 1993," in *Spells of a Voodoo Doll: The Poems, Fiction, Essays, and Plays of Assotto Saint* (New York: Masquerade Books, 1996), 127–28.

119. Ratner, "How We Closed the Guantanamo HIV Camp"; Haitian Centers Council, Inc. v. Sale, 823 F. Supp. 1028, 1047 (E.D.N.Y. 1993).

120. "Native American artist, educator and activist Charlene Teters is inaugural speaker at CSUSB Native American Speaker Series," CSUSB, 19 Apr. 2019, https://www.csusb.edu/inside/article/446101/native-american-artist-educator-and-activist-charlene-teters-inaugural.

121. "Native American artist, educator and activist Charlene Teters is inaugural speaker at CSUSB Native American Speaker Series."

122. The history of this activism and resistance is rich and deep, and counts the actions of the occupation of Alcatraz, The Trail of Broken Treaties, Wounded Knee, and the Longest Walk. William Wood, "The (Potential) Legal History of Indian Gaming," *Arizona Law Review* 64, no. 4 (Winter 2021): 14; Andrea Dworkin and Catharine A. Mackinnon, *Pornography and Civil Rights: A New Day for Women's Equality* (Minneapolis: Organizing Against Pornography, 1988), 36, 46; Richard Delgado, "Words That Wound: A Tort Action for Racial Insults, Epithets, and Name Calling, in *Words That Wound: Critical Race Theory, Assaultive Speech, and the First Amendment*, ed. Mari J. Matsuda (Oxfordshire: Routledge, 1993), 89–110.

123. "Native American artist, educator and activist Charlene Teters is inaugural speaker at CSUSB Native American Speaker Series."

124. "National Coalition on Sports & Media," AIM, http://www.aimovement.org/ncrsm/index.html.

125. Leonard Shapiro, "Indian Group to Protest at Sunday's Game," *Washington Post*, Oct. 31, 1991.

126. Benjamin S. Faurote, "Bellecourt v. City of Cleveland 104 Ohio St. 3d 439, 2004 Ohio 6551, 820 N.E.2d 309 Decided December 15, 2004," *Ohio Northern University Law Review*, 32 (2006): 563. For a description of the effigy, see James V. Fenelon, *Redskins? Sport Mascots, Indian Nations and White Racism* (Oxfordshire: Routledge, 2016), 1–9.

127. I thank James Fenelon, visiting professor at Swarthmore, of the Lakota/Dakota people, and a participant in the protest, for sending me a photograph of the effigy. Email to Yxta Maya Murray from James V. Fenelon, September 1, 2021, at 7:59 a.m. PST.

128. The Anti-Racist Five, "Press Release by the American Indian Movement Grand Governing Council," AIM Movement, August 1, 2001, https://www.aimovement.org/moipr/CleveLawsuit.html.

129. This was alleged to be in violation of 42 U.S.C.A. § 1983.

130. Bellecourt v. City of Cleveland, 104 Ohio St. 3d 439, 441 (2004); United States v. O'Brien, 391 U.S. 367, 377 (1968). For the test, see *Bellecourt* at 440–41 ("A regulation is sufficiently justified 'if it is within the constitutional power of the Government; if it furthers an important or substantial governmental interest; if the governmental interest is unrelated to the suppression of free expression; and if the incidental restriction on alleged First Amendment freedoms is no greater than is essential to the furtherance of that interest.'") (quoting *O'Brien* at 377).

131. Frederick Schauer, "Opinions as Rules," *University of Chicago Law Review* 62, no. 4 (Autumn 1995): 1458 (reviewing the argument that "when courts set forth intricately crafted multipart tests that switch subjectively between different levels of scrutiny . . . they project a false precision and a false determinacy.").

132. One remarkable exhibit was *Route 66 Revisited: It Was Only an Indian* (1993) at the Institute of American Indian Arts in Santa Fe. Karen Ohensorge, "Image, Text, Landscape, and Contemporary Indigenous Artists in the United States," *American Indian Quarterly* 32, no. 1. (Winter, 2008): 60, https://www-jstor-org.electra.lmu.edu/stable/pdf/30114281.pdf?refreqid=excelsior%3A1753b45e2ab7432a815b29b88a7b35a4 (describing the exhibit).

133. Carla Baranauckas, "A Comeback for Chief Illiniwek," *New York Times*, November 12, 2008, https://thelede.blogs.nytimes.com/2008/11/12/a-comeback-for-chief-illiniwek/; Mimi Simonich, "Santa Fe artist carried the long fight against Cleveland Indians," *Santa Fe New Mexican*. July 25, 2021, https://www.yahoo.com/lifestyle/opinion-santa-fe-artist-carried-150100581.html.

2. FROM HERE I SAW WHAT HAPPENED AND I CRIED

1. Facts that concern Ms. Weems's 1990s engagement with Harvard and its Peabody Museum, Louis Agassiz, and the history of racist science will be found cited in Yxta Maya Murray, "From Here I saw What Happened and I Cried: Carrie Mae Weems's Challenge to

the Harvard Archive," *Unbound: Harvard Journal of the Legal Left* 8, no. 1: 1–78 (Winter 2012–2013).

2. Brian Wallis, "Black Bodies, White Science: Louis Agassiz's Slave Daguerreotypes," *American Art*, 9, no. 2 (1995): 39, 42.

3. Wallis, "Black Bodies, White Science," 102; Murray, "From Here I Saw What Happened and I Cried," 9.

4. Murray, "From Here I Saw What Happened and I Cried," 9.

5. Agassiz was a believer in polygenesis, a theory that posited that Black people came from a separate and inferior species from whites. Murray, "From Here I Saw What Happened and I Cried," 10–11.

6. Murray, "From Here I Saw What Happened and I Cried," 51.

7. "Faces of Slavery," *American Heritage Magazine*, June 1977, http://www.americanheritage.com/content/faces-slavery.

8. Karma Allen, "Harvard Sued for 'Shamelessly' Profiting from Images of Slaves, Claim Says," *ABC News*, March 20, 2019, https://abcnews.go.com/US/harvard-sued-shamelessly-profiting-images-slaves-claim/story?id=61828467 ("Harvard has buildings named after Agassiz, including the Louis Agassiz Museum of Comparative Zoology.").

9. Jenny E. Heller, "Harvard Leads in Black Enrollment," *The Harvard Crimson*, September 8, 1998, https://www.thecrimson.com/article/1998/9/8/harvard-leads-in-black-enrollment-pthe/#:~:text=In%201996%2C%20black%20students%20comprised,Dionne%20A ("In 1996, black students comprised 7.2 percent of the Harvard student body—up 38.5 percent from 1980 when, among the Ivy League schools, only Cornell University had a lower percentage."); Robert Bruce Slater, "The First Black Faculty Members at the Nation's Highest-Ranked Universities," *The Journal of Blacks in Higher Education* 22, no. 1 (Winter 1998–99): 106.

10. Jordana Hart, "Recognition of Medford Landmark Creates a Storm," *Boston Globe*, June 10, 1990 (naming the founder as Royall Sr.); Sara Jerde, "Harvard Law School Votes To Change Its Symbol From Slave-Owning Family Crest," *Talking Points Memo*, March 15, 2016, https://talkingpointsmemo.com/livewire/harvard-law-school-drops-slave-owning-family-crest.

11. This image is of a man named Gordon, whose scars were documented by photographers William D. MacPherson and one Mr. Oliver in 1863. Gordon's photograph was widely reproduced in the United States, serving both prurient and abolitionist interests. Murray, "From Here I Saw What Happened and I Cried," 4; Carrie Mae Weems, "From Here I Saw What Happened And I Cried" (1995–96). The complete series is available at Carrie Mae Weems, "From Here I Saw What Happened and I Cried," http://carriemaeweems.net/galleries/from-here.html.

12. Telephone Interview with Dr. Pamela Gerardi, Director of External Relations, Peabody Museum of Archaeology and Ethnology, June 26, 2012. See also *Art in the 21st Century*, Season 5: "Compassion" (PBS 2009) (Weems segment available at http://www.art21.org/videos/segmentcarrie-mae-weems-in-compassion).

13. Murray, "From Here I Saw What Happened and I Cried," 6.

14. "Tamara K. Lanier: Oral History and the African-American Experience," at minute 43, https://www.youtube.com/watch?v=WrvhqykY-r8. Ms. Lanier informed me of the events that led to her decision to sue in an interview dated February 1, 2022.

15. Tamara Lanier v. President and Fellows of Harvard College, slip op. at 27, https://cases.justia.com/massachusetts/supreme-court/2022-sjc-13138.pdf?ts=1656072221 (Cypher, J., concurring) (noting that Lanier alleged she had become reasonably certain of her descent in 2017 and demanded Harvard's relinquishment of the daguerreotypes in October of that year; her lawsuit was filed in 2019). But see Collin Binkley, "Harvard Profits from Early Photos of Slaves, Lawsuit Says," *AP*, March 20, 2019,

https://apnews.com/article/harvard-university-north-america-lawsuits-us-news-ap-top-news-1105a521e969423b8f5a64609b804621 ("Lanier alleges that she wrote to Harvard in 2011 detailing her ties to Renty.").

16. Vivian Patterson, *Carrie Mae Weems: The Hampton Project* (New York: Aperture, 2000), 22.

17. Andrea Kirsh and Susan Fisher Sterling, *Carrie Mae Weems* (Washington, DC: National Museum of Women in the Arts, 1993), 9.

18. Dawoud Bey and Carrie Mae Weems, "Carrie Mae Weems," *BOMB*, Summer 2009, 60, 63.

19. Murray, "From Here I Saw What Happened and I Cried," 16.

20. Carrie Mae Weems, *Colored People* (1989–90), https://carriemaeweems.net/galleries/colored-people.html.

21. "[Composite Portraits of Criminal Types] 1877," *The Metropolitan Museum*, https://www.metmuseum.org/art/collection/search/301897.

22. Carrie Mae Weems, "Honey Colored Boy," in *Colored People* (1989–90).

23. Suzanne Muchnic, "Going for a Gut Reaction: Outspoken African American Artist Carrie Mae Weems Could Be Expected to Provide a Hot Response to Historical Images of Blacks," *Los Angeles Times*, February 26, 1995, http://articles.latimes.com/1995-02-26/entertainment/ca-36188_1_artistcarrie-mae-weems.

24. Sherrie Levine, *President Collage 1* (1979), https://www.moma.org/collection/works/96493.

25. Louise Lawler, *"Does Andy Warhol Make You Cry?"* (1988), https://www.moma.org/collection/works/46258.

26. Sven Lütticken, "The Feathers of the Eagle (2005)," in *Appropriation*, ed. David Evans (Boston: MIT Press, 2009), 219 (citing Douglas Crimp and Hal Foster).

27. Campbell v. Acuff-Rose Music, Inc., 510 U.S. 569 (1994).

28. *Campbell*, 587 (1994) ("We also agree with the Court of Appeals that whether 'a substantial portion of the infringing work was copied verbatim' from the copyrighted work is a relevant question.").

29. As it stands, Harvard's copyright claim did not seem to be a good one. See Murray, "From Here I Saw What Happened and I Cried," 25.

30. As Tulane law professor Robert Westley wrote in 1998, "Black reparations[' enforcement] . . . lies outside of the dominant legal imagination." Robert Westley, "Many Billions Gone: Is It Time to Reconsider the Case for Black Reparations?," *Boston College Third World Law Journal* 19, no. 1 (1998): 433.

31. With thanks to David E. Pozen for helping me think about the progressive nature of Weems's disobedience. Regarding Rosa Parks's determination to not move her position on the bus, see Lily Rothman and Arpita Aneja, "You Still Don't Know the Whole Rosa Parks Story," *Time*, November 30, 2015, https://time.com/4125377/rosa-parks-60-years-video/.

32. Martin Luther King Jr., *Letter from Birmingham Jail* (New York: Penguin Press, 2018); David E. Pozen, "Edward Snowden, National Security Whistleblowing, and Civil Disobedience," in *Whistleblowing Nation: The History of National Security Disclosures and the Cult of State Secrecy*, ed. Kaeten Mistry and Hannah Gurman (New York: Columbia University Press, 2020), 327–38.

33. Anemona Hartocollis, "The Major Findings of Harvard's Report on Its Ties to Slavery," *New York Times*, April 26, 2022, https://www.nytimes.com/2022/04/26/us/harvard-slavery-report.html.

34. *Art in the 21st Century*, Season 5: "Compassion."

35. Factors considered include the purpose and character of the use, most importantly whether the use is of a commercial or nonprofit nature. Whether or not the use is

"transformative" is a guiding light of this prong, and, indeed might be the most powerful inquiry in the entire analysis. 17 U.S.C. §107 (1) (2006); Campbell v. Acuff-Rose Music, Inc., 510 U.S. 569, 579 (1994).

36. *Campbell*, 578–79.
37. *Campbell*, 579.
38. *Campbell*, 577.
39. Suntrust Bank v. Houghton Mifflin Co., 268 F.3d 1257 (11th Cir. 2001).
40. *Suntrust Bank*, 1270–71. The U.S. Supreme Court's recent decision in Andy Warhol Foundation for Visual Arts, Inc. v. Goldsmith, 598 U.S. ___ (2023), which finds commercial uses less favorable for fair use defenses, does not seem to much undercut the holding of *Suntrust*. In *Goldsmith*, derivative works that did not sufficiently comment on the original and were more or less substitutions leased for commercial purposes were not good candidates for fair use.
41. Rosemary J. Coombe, "The Properties of Culture and the Politics of Possessing Identity: Native Claims in the Cultural Appropriation Controversy," *Canadian Journal of Law and Jurisprudence* 6, no. 2 (July 1993): 249–85; Keith Aoki, "(Intellectual) Property and Sovereignty: Notes Toward a Cultural Geography of Authorship," *Stanford Law Review* 48, no. 5 (May 1996): 1341–42.
42. Margaret Chon, "Intellectual Property and the Development Divide," *Cardozo Law Review*, 27, no. 6 (April 2006): 2823; Ruth L. Okediji, "Africa and the Global Intellectual Property System: Beyond the Agency Model," *African Yearbook of International Law*, 12, no. 1 (2004): 207–51; Madhavi Sunder, "IP3," *Stanford Law Review* 59, no. 2 (November 2006): 257.
43. Anjali Vats and Deidré A. Keller, "Critical Race IP," *Cardozo Arts and Entertainment Law Journal* 36, no. 3 (2018): 735.
44. Notable examples of such works include K. J. Greene, "'Copynorms,' Black Cultural Production, and the Debate over African-American Reparations," *Cardozo Arts and Entertainment Law Journal* 25, no. 3 (2008): 1221; and J. Carolina Chavez, "Copyright's 'Elephant in the Room': A Realistic Look at the Role of Moral Rights in Modern American Copyright," 36 *AIPLA Quarterly Journal* (2008): 143.
45. Carrie Mae Weems, *And 22 Million Very Tired and Very Angry People* (1991), http://carriemaeweems.net/galleries/22-million.html.
46. Murray, "From Here I Saw What Happened and I Cried," 69.
47. 3 Cai. R. 175 (N.Y. 1805).
48. See Harvard Museums, "& A Photographic Subject," httpss://harvardartmuseums.org/collections/object/332926 (providing the Weems's versions with the object number P2001.28.4).
49. *Art in the 21st Century*, Season 5: "Compassion," 22:20.
50. Harvard University, Vision and Justice, https://www.radcliffe.harvard.edu/event/2019-vision-and-justice-convening.
51. Harvard University, "Originality and Invention Panel," https://www.radcliffe.harvard.edu/event/2019-vision-and-justice-convening#:~:text=%E2%80%9CVision%20%26%20Justice%E2%80%9D%20is%20a,art%2C%20race%2C%20and%20justice, at around 3:30.
52. "Originality and Invention Panel," starting around 6:30.
53. "Originality and Invention Panel," starting around 16:54.
54. Binkley, "Harvard Profits from Early Photos" ("Lanier alleges that she wrote to Harvard in 2011 detailing her ties to Renty."); Lanier v. President and Fellows of Harvard College, On Appeal From the Judgment of the Middlesex County Superior Court, No. SJC-13138, at page 13, No. SJC-13138 (giving the filing date of the initial action in Middlesex County as March 20, 2019).

55. Memorandum of Decision and Order on Defendants' Motion to Dismiss Second Amended Complaint, Superior Court Civil Action No. 1981CV00784, p. 4. March 1, 2021, https://www.courthousenews.com/wp-content/uploads/2021/11/lanier-msjc-brief-harvard.pdf; Tamara Lanier v. President and Fellows of Harvard College, slip op. at 9, https://cases.justia.com/massachusetts/supreme-court/2022-sjc-13138.pdf?ts=1656072221.

56. Susan Svrluga and Mara Reinstein, "Harvard Accused in Lawsuit of Retaining and Profiting from Images of Slaves," *WashingtonPost.com*, March 20, 2019, https://www.washingtonpost.com/education/2019/03/20/harvard-accused-lawsuit-seizing-profiting-images-slaves/; Gabriela Borter, "Harvard Sued by Descendant of U.S. Slave Photographed in 19th Century," *Reuters*, March 20, 2019, https://www.reuters.com/article/us-usa-harvard-lawsuit/harvard-sued-by-descendant-of-u-s-slave-photographed-in-19th-century-idUSKCN1R12IU; Larry McShane, "Lawsuit by Great-Great-Great Granddaughter of Slaves Blasts Harvard University for Turning a Profit On Photos of Her Ancestors," *New York Daily News*, March 20, 2019, https://www.nydailynews.com/news/ny-harvard-lawsuit-slaves-20190320-rt42icsxnjd2fklxowi26vxkdm-story.html; Anemona Hartocollis, "Who Should Own Photos of Slaves? The Descendants, not Harvard, a Lawsuit Says," *New York Times*, March 20, 2019, https://www.nytimes.com/2019/03/20/us/slave-photographs-harvard.html. I am quoted in this article, where I side with Lanier's claim.

57. On March 28, 2019, Weems did say the following to Artnet, when asked about her response to Lanier's lawsuit: "'I've known about the case for some time, and of course, I too have a long history with these images. . . . It's wonderful that the varying stories are finally emerging after so many years.'" Eileen Kinsella, "'Morally, Harvard Has No Grounds': Inside the Explosive Lawsuit that Accuses the University of Profiting from Images of Slavery," *Artnet*, March 28, 2019, https://news.artnet.com/art-world/harvard-university-slaves-images-1500412.

58. Yxta Maya Murray, "Backstory," *Aperture*, Winter 2022, https://issues.aperture.org/article/2022/12/01/backstory (on Stokely Carmichael and Gordon Parks.)

59. Henry Louis Gates Jr., "Foreword: Who Are These People?," in *To Make Their Own Way in the World: The Enduring Legacy of the Zealy Daguerreotypes*, ed. Ilisa Barbash, Molly Rogers, and Deborah Willis (Cambridge, MA and New York: Harvard/Aperture, 2020), 12.

60. Molly Rogers, *Delia's Tears* (New Haven: Yale University Press, 2010); Henry Louis Gates Jr., "Foreword: Who Are These People?," in *To Make Their Own Way in the World: The Enduring Legacy of the Zealy Daguerreotypes*, ed. Ilisa Barbash, Molly Rogers, and Deborah Willis (Cambridge, MA and New York: Harvard/Aperture, 2020), 12; Molly Rogers, *Delia's Tears* (New Haven: Yale University Press, 2010); Molly Rogers, "Introduction" in *To Make Their Own Way*, 20.

61. Email from Molly Rogers to Yxta Maya Murray, January 28, 2022, at 8:33 a.m. PST (Noting that the book's writings were completed by summer 2018, that Rogers and Lanier corresponded and met in 2010 or possibly 2010–11, and that Rogers wasn't informed about the certainty of Lanier's claim until the 2019 lawsuit. Rogers also explained that the two women fell out of touch, and made the observation that events might have unfolded in a different way if Rogers had learned of a 2018 attempt by Lanier to contact her again).

62. Email from Rogers to Murray.

63. Murray, "From Here I Saw What Happened and I Cried." Weems gave me permission on October 18, 2012, see email from Carrie Mae Weems to Yxta Maya Murray, October 18, 2012, on file with author. On January 30, 2014, I sent the finished article to her via email. Email from Yxta Maya Murray to Carrie Mae Weems, January 30, 2014, on file with author.

64. Jones v. Alfred H. Mayer Co., 392 U.S. 409, 439 (1968).

65. Carrie Mae Weems, "While Sitting Upon the Ruins of Your Remains, I Pondered the Course of History," in *To Make Their Own Way in the World*, 391.

66. Deborah Willis, "In Conversation with Carrie Mae Weems," in *To Make Their Own Way in the World*, 403.

67. Ilisa Barbash, "Exposing Latent Images: Daguerreotypes in the Museum and Beyond," in *To Make Their Own Way in the World*, 412 ("The stewardship of the daguerreotypes highlights some of the fundamental changes in the concerns of anthropologists over the years, with contemporary and past policies in direct confrontation with each other.").

68. Compare Molly Rogers, "Introduction" in *To Make Their Own Way*, 20, where Rogers does ask whether the daguerreotypes could conceivably belong to "the subjects of the images" with id. at 22, concluding that "[t]he daguerreotypes are no longer the property of a scientist who embraced white supremacy; they are instead curated by an institution devoted to the study and preservation of human cultural history and diversity. . . ." See also Rogers email to Murray (wondering if things would have turned out differently if she and Lanier had continued to communicate [see note 61]).

69. Willis, "In Conversation with Carrie Mae Weems," 397. The Aperture book contains a fuller assessment of Harvard's engagements with Weems in relation to the daguerreotypes. Sarah Elizabeth Lewis, "The Insistent Reveal: Louis Agassiz, Joseph T. Zealy, Carrie Mae Weems, and the Politics of Undress in the Photography of Racial Science," in *To Make Their Own Way in the World*, 297.

70. Willis, "In Conversation with Carrie Mae Weems, 404.

71. Lanier v. Harvard, Superior Court Civil Action No. 1981CV00784, at page 2/AD-063, https://www.courthousenews.com/wp-content/uploads/2021/11/lanier-msjc-brief-harvard.pdf; Eamon Whalen, "A Lawsuit at Harvard Pries Open Debates about Science and Reparations," *Nation*, November 28, 2019, https://www.thenation.com/article/archive/harvard-slavery-racism/.

72. Commonwealth v. President and Fellows of Harvard College, Superior Court Civil Action No. 1981CV00784, March 1, 2021, beginning at AD-062, https://www.courthousenews.com/wp-content/uploads/2021/11/lanier-msjc-brief-harvard.pdf. See page 11 of the decision, AD-072.

73. Commonwealth v. President and Fellows of Harvard College, 10 n. 12.

74. Mary Carmichael, "Louis Agassiz Exhibit Divides Harvard, Swiss Group," *Boston Globe*, June 27, 2012, contained in an email from Tamara K. Lanier to Yxta Maya Murray, February 2, 2022, at 2:13 p.m. PST.

75. Charles Hamilton Houston Institute for Race and Justice, "About," https://charleshamiltonhouston.org/about/.

76. Nate Raymond, "Harvard Must Face Lawsuit Over 'Horrific' Slave Photos—Massachusetts Court," *Reuters*, June 23, 2022, https://www.reuters.com/world/us/harvard-must-face-lawsuit-over-horrific-slave-photos-massachusetts-court-2022-06-23/#:~:text=Lanier%20and%20her%20attorneys%2C%20Ben,and%20moral%20battle%20for%20justice.%22.

77. Bellecourt v. Cleveland, 104 Ohio St. 3d 439, 439 (naming Vernon Bellecourt, Juan Reyna, James Watson, Charlene Teters, and Zizwe Tchiquka).

78. Pozen, "Edward Snowden, National Security Whistleblowing, and Civil Disobedience," 331 (citation omitted).

79. Serena Mayeri, "Constitutional Choices: Legal Feminism and the Historical Dynamics of Change," *California Law Review* 92 (2004): 763.

80. His partner in the litigation was Charles Langford. Browder v. Gayle, 142 F. Supp. 707 (M.D. Ala.), *affirmed*, 352 U.S. 903 (1956), and *aff'd sub nom*; Owen v. Browder, 352 U.S. 903 (1956). Lani Guinier and Gerald Torres, "Changing the Wind: Notes Toward a Demosprudence of Law and Social Movements," *The Yale Law Journal* 123, no. 8 (2014): 2779.

81. Lani Guinier, "Courting the People: Demosprudence and the Law/Politics Divide," *Harvard Law Review* 127, no. 1 (2013): 550.

82. Gladys Bentley, "I Am a Woman Again," *Ebony Magazine*, August 1952, found at *Queer Music Heritage*, https://queermusicheritage.com/bentley6.html; Julia Diana Robertson, "Bentley was Pushed to Admit Lesbians Aren't Women . . . a Stance Now Eerily Echoed," *Velvet Chronicle*, November 14, 2019, https://thevelvetchronicle.com/gladys-bentley-pushed-to-admit-lesbians-are-not-women-stance-now-echoed/ (asking whether Bentley's statements were "just a front.").

83. Lindsay Zoladz, "Yoko Ono and the Myth That Deserves to Die," *Vulture*, May 13, 2015, https://www.vulture.com/2015/05/yoko-ono-one-woman-show.html ("After connecting with Lennon, it was easy for other artists to dismiss her as a sellout or a gold digger, but really Lennon completed her vision, gave her the populist audience she'd long desired.").

84. Susan Faludi, "Death of a Revolutionary," *New Yorker*, April 15, 2013, https://www.newyorker.com/magazine/2013/04/15/death-of-a-revolutionary.

85. James Colaiaco, *Martin Luther King, Jr.: Apostle of Militant Nonviolence* (New York: Macmillan Press, 1988), 163 ("While King participated in the March on Washington, Malcolm denounced it as 'a sellout.'"); Jane Kramer, "Steinem's Life on the Feminist Frontier," *New Yorker*, October 19, 2015, https://www.newyorker.com/magazine/2015/10/19/road-warrior-profiles-jane-kramer (mentioning "looks attacks.").

86. Tamara Lanier, "Lanier v. Harvard; Harvard's Oral Argument," Youtube.com, November 3, 2021, https://www.youtube.com/watch?v=PDn3bOj_uLw.

87. Aliyyah I. Abdur-Rahman, "Aliyyah Abdur-Rahman: An Endorsement of an Amicus Brief for Lanier v. Harvard," *Hyperallergic*, October 27, 2021, https://hyperallergic.com/author/aliyyah-i-abdur-rahman/; Kimberly Juanita Brown, "Kimberly Juanita Brown: An Endorsement of an Amicus Brief for Lanier v. Harvard," *Hyperallergic*, October 27, 2021, https://hyperallergic.com/686920/kimberly-juanita-brown-an-endorsement-of-an-amicus-brief-for-lanier-v-harvard/; Eunson Kim, "Eunsong Kim: An Endorsement of an Amicus Brief for Lanier v. Harvard," *Hyperallergic*, October 27, 2021, https://hyperallergic.com/686937/eunsong-kim-an-endorsement-of-an-amicus-brief-for-lanier-v-harvard/.

88. David Grubin, *Free Renty*, https://www.freerentyfilm.com/#screenings.

89. Gillian Brockell, "In 1850, a Racist Harvard Scientist Took Photos of Enslaved People. A Purported Descendant is Suing," *Washington Post*, November 5, 2021, https://www.washingtonpost.com/history/2021/11/05/harvard-agassiz-racist-enslaved-photos/.

90. Anemona Hartocollis, "Harvard Details Its Ties to Slavery and Its Plans for Redress," *New York Times*, April 26, 2022, https://www.nytimes.com/2022/04/26/us/harvard-slavery-redress-fund.html.

91. Gillian Brockell, "Harvard Has Remains of 7,000 Native Americans and Enslaved People, Leaked Report Says," *Washington Post*, June 2, 2022, https://www.washingtonpost.com/history/2022/06/02/harvard-human-remains-indigenous-enslaved/.

92. Lanier v. President & Fellows of Harvard College, 490 Mass. 37, 55 (2022).

93. *Lanier*, 56.

94. *Lanier*, 57.

95. *Lanier*, 83 (Cypher, J., concurring).

96. *Lanier*, 57–58.

97. *Lanier*, 45.

98. *Lanier*, 42.

99. *Lanier*, 42.

100. *Lanier*, 51.

101. Justin Gamble, "Descendant of Enslaved People Can Sue Harvard University Over Photos of Half-Naked Ancestors, State Supreme Court Rules," *CNN*, June 29, 2022, https://www.cnn.com/2022/06/29/us/harvard-slavery-photographs/index.html; Valentina Di Liscia, "Tamara Lanier May Sue Harvard for 'Emotional Distress' Over Images of Enslaved Ancestors, Court Rules," *Hyperallergic*, June 23, 2022, https://hyperallergic.com/742516/tamara-lanier-may-sue-harvard-for-emotional-distress-over-images-of-enslaved-ancestors/.

102. Yxta Maya Murray interview with Tamara Lanier, July 12, 2022, at 3:00 p.m. PST.

3. "I JUST DIDN'T FEEL SAFE"

1. Kaylee Randall, "8 of the World's Most Valuable Art Collections," *Collector*, October 20, 2019, https://www.thecollector.com/8-of-the-worlds-most-valuable-art-collections/.

2. "Allan Kaprow at George Segal's farm, 1963 May 19," *Smithsonian*, https://www.aaa.si.edu/collections/items/detail/allan-kaprow-george-segals-farm-9306.

3. Yxta Maya Murray, "Summer Happening at the Broad," *Artillery*, June 30, 2016, https://artillerymag.com/summer-happening-broad/; Zillow, "136 Davidson Mill Rd, North Brunswick, NJ 08902," https://www.zillow.com/homedetails/136-Davidson-Mill-Rd-North-Brunswick-NJ-08902/39168307_zpid/; Allan Kaprow, "The Happenings Are Dead. Long Live the Happenings," *Artforum*, March 1966, https://www.artforum.com/print/196603/the-happenings-are-dead-long-live-the-happenings-37842 ("All occurrences have their own time; these may or may not concur according to the fairly normative needs of the situation.").

4. Allan Kaprow, "Allan Kaprow Instructions for Tree, A Happening, 1963," Smithsonian, Archives of American Art, https://www.aaa.si.edu/collections/items/detail/allan-kaprow-instructions-tree-happening-9358 ("A male member of the group who is physically strong and has an equally powerful voice will be selected to lead the forest in its activity.").

5. Robert Hewison, *Too Much: Art and Society in the Sixties 1960–75* (London: Methuen, 1986), 139.

6. Catherine Spencer, *Beyond the Happening* (Manchester: Manchester University Press, 2020), 154.

7. Spencer, *Beyond the Happening*, 143.

8. Spencer, *Beyond the Happening*, 151.

9. Vivien Green Fryd, "Suzanne Lacy's Three Weeks in May: Feminist Activist Performance Art as 'Expanded Public Pedagogy,'" *NWSA Journal* 19, no. 1 (2007): 24.

10. Fiona Anderson, "'A Trail of Drift and Debris': Traces of Whitman in the Correspondence Art of Ray Johnson," *Journal of American Studies* 49, no. 1 (2015): 55–56, 65.

11. Catherine Spencer, "A Calendar of Happenings: Allan Kaprow, Counter-Chronologies and Cataloguing Performance, c. 1970," *Art History*, 39, no. 3 (February 2016): 18. See also Kara Keeling, "Looking for M__: Queer Temporality, Black Political Possibility, and poetry from the Future," *GLQ: A Journal of Lesbian and Gay Studies* 14, no. (October 2009): 565.

12. At least, the central building cost that much. The Broad, "The Building," https://www.thebroad.org/about/building.

13. Charles Young, "Young Joon Kwak by Charles Long," *Bomb Magazine*, April 9, 2019, https://bombmagazine.org/articles/young-joon-kwak/.

14. Dublab, "Xandão—Sound Study w/Marvin Astorga (07.24.21)," https://www.dublab.com/archive/xandao-sound-study-w-marvin-astorga-07-24-21.

15. Young Joon Kwak, "Die," Bandcamp, https://xinaxurner.bandcamp.com/track/we-are-one.

16. Young, "Young Joon Kwak by Charles Long."

17. Melissa Hidalgo, "How Mustache Mondays Built an Inclusive Queer Nightlife Scene and Influenced the Arts," *KCET*, November 17, 2021, https://www.kcet.org/shows/artbound/mustache-mondays-inclusive-nightlife-and-contemporary-art; Sharon Mizota, "Latinx, Queer, Punk. Club Scum Exhibition Captures The Fierceness, In Full," *Los Angeles Times*, August 20, 2019, https://www.latimes.com/entertainment-arts/story/2019-08-19/latinx-queer-punk-club-scum-exhibition-captures-the-fierceness-in-full.

18. "USC Roski Studios Building," USC Roski School of Art and Design, https://roski.usc.edu/facilities/usc-roski-studios-building; "USC Roski MFA Open Studios: Annual Open Studios Event Gives Emerging Artists a Chance to Shine," USC Roski School of Art and Design, 2015, https://roski.usc.edu/events/usc-roski-mfa-open-studios (showing images of studios); Kurt W. Forster, "The New Museum in New York: A Whitewash?" *Log*, no. 12 (2008): 5 n. 1.

19. Trojan Event Services, Certificate of Liability Insurance, https://trojanevents.usc.edu/forms-and-permits/liability/.

20. USC Cultural Relations and University Events: Event Management Tools, https://events.usc.edu/tools.

21. Young Joon Kwak, Instagram post, July 16, 2019, https://www.instagram.com/p/Bz_Nj46lOJM/?igshid=1l9ge8dgeb728.

22. Taylor Gorski, "Former Roski Professor Sues USC for Discrimination," *USC Annenberg Media*, November 7, 2016, https://www.uscannenbergmedia.com/2016/11/07/former-roski-professor-sues-usc-for-discrimination/. Other problems with the Roski program infamously led the entire MFA class of 2015 to drop out. Brian Boucher, "Entire 2016 MFA Class Drops out of USC's Roski School of Art and Design," *Artnet*, May 15, 2015, https://news.artnet.com/art-world/mfa-class-drops-out-usc-roski-school-299068.

23. "Mutant Salon at REDCAT Lounge," Mutant Salon, July 2, 2014, https://mutantsalon.com/post/90587303490/mutant-salon-at-redcat-lounge.

24. I have not been able to find these tweets.

25. "CAVERNOUS: Young Joon Kwak and Mutant Salon," LACE, July 12-August 26, 2018, https://welcometolace.org/lace/cavernous-young-joon-kwak-mutant-salon/.

26. Kaprow, "Allan Kaprow Instructions for Tree, a Happening, 1963."

27. The queer, trans, and sex-positive bookstore Bluestockings Cooperative initiated one of the first known safer space policies. Bluestockings Cooperative, "Safer Space Policy," https://bluestockings.com/about-us/safer-space-policy; Brian Arao and Kristi Clemens, "From Safe Spaces to Brave Spaces: A New Way to Frame Dialogue around Diversity and Social Justice," in *The Art of Effective Facilitation: Stories and Reflections from Social Justice Educators*, ed. Lisa M. Landreman (Sterling: Stylus, 2013), 135–50; Moira Kenney, *Mapping Gay L.A.: The Intersection of Place and Politics* (Philadelphia: Temple University Press, 2001), 113 ("Attempts to claim safe space have been critical to the development of the lesbian movement.").

28. Adia Harvey Wingfield, *Doing Business with Beauty: Black Women, Hair Salons, and the Racial Enclave Economy* (Lanham: Rowman and Littlefield, 2008), 84; Monica C. Bell, "The Braiding Cases, Cultural Deference, and the Inadequate Protection of Black Women Consumers," *Yale Journal of Law and Feminism* 19, no. 1 (April 2007): 150.

29. Jack Halberstam, *Female Masculinity* (Durham: Duke University Press, 1999), 264 ("'If a femme girl comes to the club femme one week, in a mustache the next, and even more in drag the next week, people will encourage that. . . .'") (quoting Retro); Ricardo Lopez, "For East Valley LBGTQ Teens, Summer Programs Like 'Drag Makeup 1010' Fill Demand for Safe Spaces," *Desert Sun*, August 15, 2019, https://www.desertsun.com/

story/news/local/coachella/2019/08/15/drag-queen-program-a-safe-space-for-eastern-coachella-valley-lgbt-teens/1894490001/.

30. Jolanta T. Pekacz, "The Salonnières and the Philosophes in Old Regime France: The Authority of Aesthetic Judgment," *Journal of the History of Ideas* 60, no. 2 (1999): 277–97.

31. Charisse Bureden-Stelly, "Radical Blackness and Mutual Comradeship at 409 Edgecombe," *Black Perspectives*, July 16, 2019, https://www.aaihs.org/radical-blackness-and-mutual-comradeship-at-409-edgecombe/.

32. Ethelene Whitmire, *Regina Andrews: Harlem Renaissance Librarian* (Champaign: University of Illinois Press, 2014).

33. Poetry Foundation, "Georgia Douglas Johnson," https://www.poetryfoundation.org/poets/georgia-douglas-johnson.

34. Jone Johnson Lewis, "Biography of Georgia Douglas Johnson, Harlem Renaissance Writer," Thought Co., December 19, 2020, https://www.thoughtco.com/georgia-douglas-johnson-3529263#:~:text=Moving%20to%20Washington%2C%20D.C%2C%20in,shelter%20for%20those%20in%20need. Regarding the architecture of the property, see "GeorgiaDouglasJohnson.1461S.NW.WDC.7June2010," Ipernity, http://www.ipernity.com/doc/elvertbarnes/album/192227.

35. Mariel Villeré, "The Queer Urbanism of Theaster Gates," *Urban Omnibus*, May 16, 2014, http://urbanomnibus.net/2014/05/the-queer-urbanism-of-theastergates/; Theaster Gates, "Dorchester Art and Housing Collaborative (DAHC)," Theastergates.com, https://www.theastergates.com/project-items/dorchester-art-and-housing-collaborative-dahc.

36. Stephanie Bailey, "Theaster Gates," *Ocula Magazine*, March 31, 2017, https://ocula.com/magazine/conversations/theaster-gates/.

37. Center for Afrofuturist Studies, "Mission," https://afrofuturist.center/about/mission_and_vision.

38. Kehinde Wiley, "About Black Rock," https://blackrocksenegal.org/our-story/; Lyndsay Knecht, "Kalup Linzy Bought a House and He's Sharing It with Artists," *Hyperallergic*, April 10, 2022, https://hyperallergic.com/720633/kalup-linzy-bought-a-house-and-is-sharing-it-with-artists/?s=03.

39. "Appearing in public without shame" is deemed a core human capability by the philosopher and economist Amartya K. Sen. Amartya K. Sen, *Inequality Reexamined* (Cambridge, MA: Harvard University Press, 1992), 115.

40. Lindsey v. Normet, 405 U.S. 56 (1972).

41. Chris Nichols, "Sacramento Could Obligate Homeless Residents to Accept Shelter under Mayor's 'Right-to-Housing' Ordinance," *Cap Radio*, November 16, 2021, https://www.capradio.org/articles/2021/11/15/sacramento-could-obligate-homeless-residents-to-accept-shelter-under-mayors-right-to-housing-ordinance/; Isabella Marin Quintero, "Connecticut Must Establish a Right to Housing," *CT Mirror*, July 2, 2021, https://ctmirror.org/2021/07/02/connecticut-must-establish-a-right-to-housing-isabella/. Note, however, that in June 2023, a proposed California constitutional amendment that would declare a fundamental right to housing "passed its first vote 6-2 in the state Assembly Housing Committee on June 7." See Seth Sandronsky, "Assembly Committee okays amending state constitution to add housing as a right," *Center Square*, June 8, 2023, https://www.thecentersquare.com/california/article_3d998d74-0631-11ee-8041-b3c9267bbb70.html.

42. Catharine A. MacKinnon, *Toward a Feminist Theory of the State* (Cambridge, MA: Harvard University Press, 1989) 168; Sarah E. Valentine, "Traditional Advocacy for Nontraditional Youth: Rethinking Best Interest for the Queer Child," *Michigan State Law Review*, 4, no. 1 (2008): 1076.

43. Deborah M. Weissman, "A New Domestic Violence Pedagogy," *University of Miami Race and Social Justice Law Review* 5, vol. 1 (Fall 2015): 637.

44. 42 U.S. Code § 2000a(b)(3) (banning discrimination based on race, color, religion, and national origin in "any motion picture house, theater, concert hall, sports arena, stadium or other place of exhibition or entertainment.").

45. Dessane Lopez Cassell, "Queer Art Workers Reflect: Anais Duplan on 'Becoming a Better Lover'—Not just in a Romantic Sense," *Hyperallergic*, June 15, 2020, https://hyperallergic.com/569471/anais-duplan-becoming-a-better-lover/.

46. Elizabeth Sepper and Deborah Dinner, "Shared Histories: The Feminist and Gay Liberation Movements for Freedom in Public," *University of Richmond Law Review* 54, no. 1 (Fall 2020): 761, 789, 762; Bostock v. Clayton County, 207 L. Ed. 2d 218 (2020).

47. D.C. Code Ann. § 2-1402.31(a) (covering unhoused status). This was enacted in 2022. "District of Columbia Human Rights Act Amendment Expands Protections," *Crowell*, December 12, 2022, https://www.crowell.com/NewsEvents/AlertsNewsletters/all/District-of-Columbia-Human-Rights-Act-Amendment-Expands-Protections#:~:text=The%20DCHRA%20prohibits%20discrimination%20in,the%20DCHRA%20as%20an%20individual. My research indicates that this makes Washington, DC the first jurisdiction to extend these protections; New York City, N.Y., Code § 8-107 (4)(1); Danieli Evans Peterman, "Socioeconomic Status Discrimination," *Virginia Law Review* 104, no. 7 (November 2018): 1287.

48. D.C. Code Ann. § 2-1402.31(a)(1). (West).

49. Elizabeth Sepper and Deborah Dinner, "Sex in Public," *Yale Law Journal* 129, no. 1 (October 2019): 110.

50. Eduardo M. Peñalver, "Property As Entrance," *Virginia Law Review* 91, no. 8 (September 2005): 1903; Elizabeth Sepper, "The Original Meaning of 'Full and Equal Enjoyment' of Public Accommodations," *California Law Review Online* (2021): 584.

51. San Antonio Independent School District v. Rodriguez, 411 U.S. 1, 18 (1973) (there is no fundamental right to education).

52. Erik Ugland, "Demarcating the Right to Gather News: A Sequential Interpretation of the First Amendment," *Duke Journal of Constitutional Law & Public Policy* 3, no. 1 (December 2008): 140–41(construing Supreme Court First Amendment jurisprudence as largely conveying negative rights except in cases declaring a right of the public to court proceedings).

53. Serrano v. Priest (*Serrano I*), 487 P. 2d 1241, 1263 (Cal. 1971) (holding that education is a fundamental interest); but see Rachel Dow, "'Settling' Brown's Promise: Seeking More Equal Access to Quality Education Through Settlement," *UCLA Law Review* 68, no. 4 (December 2021): 1157 ("[Later California cases] determined that the right is no longer robust enough to guarantee an education of any quality."); Joseph Fishkin, "Voting as a Positive Right: A Reply to Flanders," *Alaska Law Review* 28 (2011): 33 ("most negative rights entail an apparatus of state enforcement.").

54. Elise C. Boddie, "The Contested Role of Time in Equal Protection." *Columbia Law Review* 117, no. 7 (November 2017): 1846 (noting Justice Rehnquist's attraction to Paul Brest's conception of chronology in discrimination cases).

55. Sarah Harding, "Perpetual Property," *Florida Law Review* 61, nos. 2/3 (2009): 289.

56. Josh Gerstein and Alexander Ward, "Supreme Court Has Voted to Overturn Abortion Rights, Draft Opinion Shows," *Politico*, May 5, 2022, https://www.politico.com/news/2022/05/02/supreme-court-abortion-draft-opinion-00029473.

57. See, e.g., Koppelman v. Ambassador Hotel Co. of Los Angeles, 35 Cal. App. 2d 537, 540 (1939) (regarding business invitees); Gastine v. Ewing, 65 Cal. App. 2d 131, 140 (1944); Acad. Indus., Inc. v. PNC Bank, N.A., No. 0634 July Term 2000, 2002 WL 1472342,

at *16 (Pa. Com. Pl. May 20, 2002) (trespass "encompasses intrusions that begin as privileged but ultimately exceed the scope of the privilege.").

58. Sammons v. Am. Auto. Ass'n, 912 P. 2d 1103, 1106 (Wyo. 1996); Davis S. Vaughn, "Dealing A Duty: Why Casino Markers Should Establish a Legal Duty of Care to Patrons," *Texas Review of Entertainment and Sports* 19 (2018): 9 (observing "the well-established principle of Indiana common law that business owners must use reasonable care to protect their customers while on the business premises.").

59. West v. SMG, 318 S.W.3d 430, 440–41 (Tex. App. 2010) ("[W]hen the hiring entity retains control over the specific details and methods by which the task is to be accomplished, the independent contractor acts as an agent and the individual or entity that hired the contractor can be held to be vicariously liable for the torts or negligent acts of the agent. By contrast, when one has the right to control the end sought to be accomplished, but not the means and details of how it should be accomplished, the person employed acts as an independent contractor, and not as an agent, and the person or entity that hired the contractor is not liable for the contractor's negligent acts.") (citation omitted).

60. Jason Schossler, "Texas Music Venue Owed No Coverage for Patron's Fatal Shooting," *WESTLAW Insurance Daily Briefing*, 2021 WL 570850, December 2, 2021 (no coverage where "negligent" "assault and battery" of patron was alleged).

61. Washington v. Glucksberg, 521 U.S. 702, 721 (1997).

62. Griswold v. Connecticut, 381 U.S. 479, 486 (1965).

63. Planned Parenthood of Se. Pennsylvania v. Casey, 505 U.S. 833, 851 (1992).

64. Lawrence v. Texas, 539 U.S. 558, 574, and 567 (2003). It's unclear how much this language of *Casey* bears weight after Dobbs v. Jackson Women's Health Organization, however. See Dobbs v. Jackson Women's Health Org., 213 L. Ed. 2d 545, 142 S. Ct. 2228, 2257 (2022) ("While individuals are certainly free *to think* and *to say* what they wish about 'existence,' 'meaning,' the 'universe,' and 'the mystery of human life,' they are not always free *to act* in accordance with those thoughts.").

65. Obergefell v. Hodges, 576 U.S. 644, 681 (2015).

66. Laura M. Padilla, "Social and Legal Repercussions of Latinos' Colonized Mentality," *University of Miami Law Review* 53 (1999): 781–82. Derrick Bell, Richard Delgado, Mari Matsuda, Francisco Valdes, and Patricia Williams are other writers who have made related contributions.

67. Catharine MacKinnon, "Feminism, Marxism, Method, and the State: An Agenda for Theory," *Signs* 7, no. 3 (Spring 1982): 519.

68. Susan L. Brooks, Marjorie A. Silver, Sarah Fishel, and Kellie Wiltsie, "Moving Toward a Competency-Based Model for Fostering Law Students' Relational Skills," *Clinical Law Review* 28 (2022): 369; Dylan Rodríguez, "Abolition as Praxis of Human Being: A Foreword," *Harvard Law Review* 132, no. 6 (April 2019): 1607 (advocating an imaginary of prison abolition futurity with reference to queer utopian and Black futurist writers); Ronald Tyler, "The First Thing We Do, Let's Heal All the Law Students: Incorporating Self-Care into a Criminal Defense Clinic," *Berkeley Journal of Criminal Law* 21, no. 2 (Fall 2016): 3.

69. As legal scholar Dean Spade wrote in 2011, "Trans people are told by the law, state agencies, private discriminators, and our families that we are impossible people who cannot exist, cannot be seen, cannot be classified, and cannot fit anywhere." Dean Spade, *Normal Life: Administrative Violence, Critical Trans Politics, and the Limits of Law* (Brooklyn: South End Press, 2011), 41.

70. Spade, "Normal Life," 33.

71. Margot Young, "Gender, Alterity and Human Rights: Freedom in A Fishbowl by Ratna Kapur," *Law and Society Review* 54, no. 1 (January 2020): 305.

72. Ratna Kapur, *Gender, Alterity and Human Rights: Freedom in a Fishbowl* (Northampton: Edward Elgar, 2018) 14–15.

73. One example is the school of Critical Legal Studies, see, e.g., Mark Tushnet, "The Critique of Rights," *SMU Law Review* 47, no. 1 (September/October 1993): 23.

74. Yxta Maya Murray interview with Daniela Lieja Quintanar, April 21, 2022.

4. "HOW DID WE GET HERE?"

1. Tom Tapp, "Los Angeles & California Covid Positivity Rates Rise for First Time in Months," *Deadline,* October 28, 2021, https://deadline.com/2021/10/los-angeles-california-covid-positivity-rate-rise-1234864581/; "Mexico Reports 775 New Coronavirus Cases, 57 More Deaths," *Reuters,* November 15, 2021, https://www.reuters.com/world/americas/mexico-reports-775-new-coronavirus-cases-57-more-deaths-2021-11-15/.

2. Tanya Aguiñiga, "Art in Times Like This," https://artintimeslikethis.com/the-life-instinct/tanya-aguiniga ("Much of my life has been shaped by growing up a few blocks from the border fence and having had to cross the US/Mexico border every day for 14 years to attend school in the US, while living in Tijuana, Mexico.").

3. The Border Arts Workshop/Taller de Arte Fronterizo was built in part by the muralist and Southwestern College professor Michael Schnorr. See "Obituary: Michael Schnorr, June 19, 1945–June 29, 2012," *Dignity Memorial,* July 14, 2012, https://www.dignitymemorial.com/obituaries/chula-vista-ca/michael-schnorr-5161140.

4. Pedro Rios, "For 25 years, Operation Gatekeeper Has Made Life Worse for Border Communities," *Washington Post,* October 1, 2019, https://www.washingtonpost.com/outlook/2019/10/01/years-operation-gatekeeper-has-made-life-worse-border-communities/.

5. For more information on Poblado Maclovio Rojas, see Rose Costello, "On . . . art," *Artwork* 34 (1997), https://insiteart.org/uploads/files/Artwork_April-1997.pdf.

6. "Tanya Aguiñiga: Crafting Lineage," *Art 21,* https://news.artnet.com/art-world/tanya-aguiniga-art21-2027539.

7. "Furniture," Tanya Aguiñiga.com, http://www.tanyaaguiniga.com/furniture-2; "Commissions," Tanya Aguiñiga.com, http://www.tanyaaguiniga.com/commissions-1.

8. "Transforming the Everyday: An Hola Art Project with Tanya Aguiñiga," Heart of Los Angeles, January 16, 2014, https://www.youtube.com/watch?v=NYdQDiRxxMQ.

9. "Full text: Donald Trump Announces A Presidential Bid," *Washington Post,* June 16, 2015, https://www.washingtonpost.com/news/post-politics/wp/2015/06/16/full-text-donald-trump-announces-a-presidential-bid/; Laura Bult, "President-Elect Trump's Proposed Wall Along U.S.-Mexico Border Would Be An Additional 200 Miles, Border Patrol Official Says," *New York Daily News,* November 17, 2017, https://www.nydailynews.com/news/national/trump-proposed-u-s-mexico-wall-200-miles-long-article-1.2877220.

10. "MISSION//MISIÓN," AMBOS, http://www.ambosproject.com/about.

11. Antje Christensen, "The Incan Quipus," *Synthese* 133, no. 1/2 (October–November 2002): 159–72.

12. "Border Quipu//Quipu Fronterizo," AMBOS, http://www.ambosproject.com/quipu.

13. Alia Akkam, "Tanya Aguiñiga's Exploration of Craft Along the U.S.-Mexico Border," *Yahoo News,* May 30, 2018, https://www.yahoo.com/news/tanya-agui-iga-exploration-craft-185159824.html.

14. Aruna D'Souza, "What Can We Learn from Institutional Critique?" *Art in America,* October 28, 2019, https://www.artnews.com/art-in-america/features/hans-haacke-new-museum-retrospective-institutional-critique-63666/ (discussing *MoMA Poll* [1970] and other works).

15. Howardena Pindell, "Testimony" (1987), https://pindell.mcachicago.org/art-world-surveys/statistics-testimony-and-supporting-documentation/. Pindell also documented racist shows. Howardena Pindell, "Documentation I" (1987), https://pindell.mcachicago.org/art-world-surveys/statistics-testimony-and-supporting-documentation/.

16. Claire Voon, "Object Lessons," *American Craft Council Magazine*, June 19, 2019, https://www.craftcouncil.org/magazine/article/object-lessons-0.

17. William Pope.L and Chris Thompson, "America's Friendliest Black Artist," *PAJ: A Journal of Performance and Art*, 24, no. 3 (September 2002): 68–72.

18. Priscilla Alvarez, "More Than 20,000 Unaccompanied Migrant Children Are Now in US Custody," *CNN*, April 7, 2021, https://www.cnn.com/2021/04/07/politics/unaccompanied-migrant-children-in-us-custody/index.html.

19. Marinee Zavala and Ana Gomez, "Woman Dies While Waiting to Cross into US at San Ysidro Port of Entry," *NBC San Diego*, August 23, 2020, https://www.nbcsandiego.com/news/local/woman-dies-while-waiting-to-cross-into-us-at-san-ysidro-port-of-entry/2391471/.

20. Tanya Aguiñiga, "Make Border Ports of Entry Accessible for the Elderly and Disabled," *Somos Presente*, https://somos.presente.org/petitions/make-border-ports-of-entry-accessible-for-the-elderly-and-disabled?share=cc600158-9092-43e4-9a9d-343a8bfd4325&source=&utm_source=&mc_cid=84c5a50a90&mc_eid=8a01eb7c01.

21. Luke Money and Lin II Rong-Gong, "California Is Shaking off the Worst of the Delta Surge," *Los Angeles Times*, October 6, 2021, https://www.latimes.com/california/story/2021-10-06/california-shaking-off-worst-of-delta-variant; "LACo Sees Slight Uptick in Coronavirus Cases, Ferrer Says," *Patch.com*, November 4, 2021, https://patch.com/california/los-angeles/la-sees-slight-uptick-coronavirus-cases-ferrer-says.

22. Bruce Hainley, "The Snowball Effect," *Artforum*, Summer, https://www.artforum.com/print/201806/bruce-hainley-on-elena-filipovic-s-david-hammons-bliz-aard-ball-sale-75510.

23. Jack Halberstam, *The Queer Art of Failure* (Durham and London: Duke University Press, 2011), 3.

24. As I was editing this chapter in the fall of 2022, news reports continued to come across my feed describing extreme heat at the border and its consequences for crossers. Sonia Zavala, "Extreme Heat and More Than 4 Hours to Cross From Tijuana to San Ysidro," *San Diego Red*, September 5, 2022, https://www.sandiegored.com/en/news/228607/Extreme-heat-and-more-than-4-hours-to-cross-from-Tijuana-to-San-Ysidro.

25. Somos Presente, "About Us," https://somos.presente.org/about_us.

26. Nancy Hernandez, "To: Board and CEP of Southwest Key Programs Inc./Demand Southwest Key Programs Inc. Stop Warehousing immigrant Children," Somos Presente, https://somos.presente.org/petitions/demand-southwest-key-programs-inc-stop-warehousing-immigrant-children-1?source=homepage&utm_medium=promotion&utm_source=homepage.

27. Aguiñiga, "Make Border Ports of Entry Accessible for the Elderly and Disabled."

28. Ready Lanes can only be accessed by travelers who have obtained a "laser card," otherwise known as a "radio-frequency identification-enabled identity document" that can facilitate the CBP's expedited process and inspection. Johnson v. United States, No. 3:18-CV-2178-BEN-MSB, 2021 WL 256811, at *1 (S.D. Cal. Jan. 25, 2021). For the details on how to obtain and qualify for these cards, see, "Ready Lanes," United States Customs and Border Protection, https://www.cbp.gov/travel/clearing-cbp/ready-lanes (mentioning US Passport Cards, Enhanced Driver's Licenses, Enhanced Tribal Cards, Enhanced Border Crossing Cards, Enhanced Permanent Resident Cards, and Trusted Traveler Program cards.). For SENTRI Lanes, begin with U.S. Customs and Border Protection, "Information Center," https://help.cbp.gov/s/article/Article-969?language=en_US.

29. Johnson v. United States, No. 3:18-CV-2178-BEN-MSB, 2021 WL 256811, at *3 (S.D. Cal. Jan. 25, 2021) ("The Parties do not dispute that Johnson is disabled or that CBP is a program that receives federal assistance within the meaning of 29 U.S.C. § 794.").

30. 29 U.S.C.A. § 794 (West) (setting requirements for the Rehabilitation Act). See also Brumfield v. City of Chicago, 735 F.3d 619, 622 (7th Cir. 2013) (the ADA's "Title II provides that state and local governments may not exclude eligible disabled persons from 'participation in' or 'the benefits of' governmental 'services, programs, or activities' or otherwise 'subject[]' an eligible disabled person 'to discrimination.' *See* 42 U.S.C. § 12132.").

31. Se. Cmty. Coll. v. Davis, 442 U.S. 397, 413 (1979) (Rehabilitation Act); Larsen v. Carnival Corp., 242 F. Supp. 2d 1333, 1344 (S.D. Fla. 2003) (ADA). See also Johnson v. United States, *3. An accommodation is not reasonable where it would "alter the fundamental nature" of the program or policy. Fortyune v. American Multi-Cinema, Inc., 364 F.3d 1075, 1082 (9th Cir. 2004).

32. Johnson v. United States, *1.

33. Johnson v. United States, *1.

34. An elderly person, or any other person, who has a physical or mental impairment that "substantially limits one or more of the major life activities of such individual" will qualify as disabled under the Rehabilitation Act. Coons v. Secretary of U.S. Dept. of Treasury, 383 F.3d 879, 884 (9th Cir. 2004).

35. Under the Rehabilitation Act, proof of disability must be established according to the preponderance of the evidence, or the "more likely than not" standard. David A. Larson, "What Disabilities Are Protected under the Rehabilitation Act of 1973?," *University of Memphis Law Review* 16, no. 2 (Winter 1986): 239; Sarah Kim, "The Forgotten: Disabled and Detained at the Border," *Forbes*, June 28, 2019, https://www.forbes.com/sites/sarahkim/2019/06/28/immigrants-with-disabilities/?sh=6060a7c72cb6 ("little to no attention is given to them."). For a cogent article addressing the needs of disabled unaccompanied minors and emphasizes custodial educational settings, see Adrian Alvarez, "Special Education No Man's Land," *St. John's Law Review* 95, no. 2 (Fall 2022), SSRN: https://ssrn.com/abstract=3874201.

36. On other emotional factors that deter the assertion of accommodations rights, see Doron Dorfman, "Fear of the Disability Con: Perceptions of Fraud and Special Rights Discourse," *Law and Society Review* 53, no. 4 (October 2019): 1051–91.

37. Cf. Graves v. Finch Pruyn & Co., 457 F.3d 181, 183–84 (2d Cir. 2006) ("A plaintiff suing under the ADA for disability discrimination bears the burden of establishing . . . [that the entity] covered by the statute had notice of his disability."). See also Schrader v. Fred A. Ray, M.D., P.C., 296 F.3d 968, 972 (10th Cir. 2002) ("the Third Circuit simply recognized that 'the substantive standards for determining liability are the same' in both the ADA and the Rehabilitation Act.") (citation omitted).

38. One of the reasons for the failure to the law to affect the lives of these migrants may be that their suffering is insufficiently spectacular. Stephen Lee, "Family Separation as Slow Death," *Columbia Law Review* 119, no. 8 (December 2019): 2319–84. Many thanks to Stephen Lee for teaching me about the theories of slow violence and slow death.

39. Catharine A. MacKinnon, *Feminism Unmodified: Discourses on Life and Law* (Cambridge, MA: Harvard University Press, 1987), 45.

40. Kimberlé Crenshaw, "Mapping the Margins: Intersectionality, Identity Politics, and Violence against Women of Color," *Stanford Law Review* 43, no. 6 (July 1991).

41. "Transgender People over Four Times More Likely Than Cisgender People to Be Victims of Violent Crime," Williams Institute, March 23, 2021, https://williamsinstitute.law.ucla.edu/press/ncvs-trans-press-release/ ("About half of all violent victimizations were not reported to police.").

42. Rob Nixon, *Slow Violence and the Environmentalism of the Poor* (Cambridge, MA: Harvard University Press, 2013). See also Lauren Berlant, "Slow Death," *Critical Inquiry* 33, no. 4 (Summer 2007): 760.

43. Franco-Gonzalez v. Holder, No. CV 10–02211 DMG DTBX, 2013 WL 3674492, at *3 (C.D. Cal. Apr. 23, 2013); Am. Council of the Blind v. Paulson, 525 F.3d 1256, 1259 (D.C. Cir. 2008).

44. A welfare check program flourishes now in San Diego (among other places) and is designed for the county's elderly residents. Lauren J. Mapp, "Law Enforcement Wants Seniors to Know 'You Are Not Alone,'" *San Diego Tribune,* January 21, 2020, https://www.sandiegouniontribune.com/caregiver/caregiving-essentials/resources/story/2020-01-21/law-enforcement-wants-seniors-to-know-you-are-not-alone. But see City & Cty. of S.F. v. Sheehan, 135 S. Ct. 1765 (2015) (police officers entitled to qualified immunity after shooting a mentally disabled woman after a social worker was threatened during a welfare check).

45. Gonzalo Soltero, "October 2 and the CIA in Mexico," *NACLA,* October 2, 2021, https://nacla.org/october-2-and-cia-mexico.

46. Vanda Felbab-Brown, "The Upcoming Friction in US-Mexico Relations," *Brookings,* December 4, 2020, https://www.brookings.edu/blog/order-from-chaos/2020/12/04/the-upcoming-friction-in-us-mexico-relations/ (noting offense taken by Mexico by assorted US acts and statements).

47. Kevin R. Johnson, "Open Borders?" *UCLA Law Review* 51, no. 1 (October 2003): 205.

48. Joseph H. Carens, "Aliens and Citizens: The Case for Open Borders," *The Review of Politics* 49, no. 2 (Spring 1987): 251.

49. "Moral Case For Open Borders," Open Border*s*, https://openborders.info/moral-case/. "Arguments from the Left," Free Migration Project, https://freemigrationproject.org/resources/egalitarian-case-for-open-borders/; Rachel Levinson-Waldman and Haley Hinkle, "The Abolish ICE Movement Explained," Brennan Center, July 30, 2018, https://www.brennancenter.org/our-work/analysis-opinion/abolish-ice-movement-explained.

50. Achille Mbembe, *Necropolitics* (Durham: Duke University Press, 2019).

5. "SO MANY STORIES LIKE THAT"

1. Benjamin Alexander-Bloch, "St. Bernard Parish to Auction 151 Properties Bought By Road Home," *NOLA.com,* October 3, 2014, https://www.nola.com/politics/index.ssf/2014/10/st_bernard_parish_to_auction_1_1.html.

2. Michelle Krupa, "Brisk Sales of Abandoned Properties at Recent New Orleans Redevelopment Authority Auction," *NOLA.com,* April 12, 2011, https://www.nola.com/politics/2011/04/brisk_sales_of_abandoned_prope.html.

3. "'The Road Home' Is a Road to Nowhere for Black New Orleanians," *Planners Network,* October 14, 2010, https://www.plannersnetwork.org/2010/10/the-road-home-is-a-road-to-nowhere-for-black-new-orleanians/.

4. Robert Morris, "Road Home Auction Draws Overflow Crowd from Preservation Enthusiasts to Protestors," *Uptown Messenger,* April 2, 2011, https://uptownmessenger.com/2011/04/road-home-auction-draws-overflow-crowd-from-preservation-enthusiasts-to-protestors/.

5. Doug MacCash, "In Hospital Footprint, Sculptures Recall Lost Neighborhood Demolished after Hurricane Katrina," *NOLA.com,* January 14, 2020, https://www.nola.com/entertainment_life/arts/article_4e006e80-2dae-11ea-9afc-a711259c4d30.html; AP, "New Orleans' First Black Subdivision Officially Historic," *NBC News,* July 16, 2020, https://www.nbcnews.com/news/nbcblk/new-orleans-first-black-subdivision-officially-historic-n1233700.

6. Michael Eugene Crutcher Jr., *Tremé: Race and Place in a New Orleans Neighborhood* (Athens: University of Georgia Press, 2010), 15.

7. See "Hurricane Katrina aftermath in Mid City New Orleans," *Wikimedia.org*, https://commons.wikimedia.org/wiki/Category:Hurricane_Katrina_aftermath_in_Mid_City_New_Orleans.

8. Imani Jacqueline Brown, "CV," Imani Jacqueline Brown, https://imanijacquelinebrown.net/cv.

9. Brown, "CV."

10. "Mid-City Hospitals on Track for Completion in 2015, 2016," *Mid City Messenger*, May 20, 2014, https://midcitymessenger.com/2014/05/20/mid-city-hospitals-on-track-for-completion-in-2015-2016/; Doug MacCash, "In Hospital Footprint, Sculptures Recall Lost Neighborhood Demolished After Hurricane Katrina," *NOLA*, January 14, 2020, https://www.nola.com/entertainment_life/arts/in-hospital-footprint-sculptures-recall-lost-neighborhood-demolished-after-hurricane-katrina/article_4e006e80-2dae-11ea-9afc-a711259c4d30.html; Trushna Parekh, "'They Want To Live in the Tremé, But They Want It for Their Ways of Living': Gentrification and Neighborhood Practice in Tremé, New Orleans," *Urban Geography* 36, no. 2 (2015): 201–20.

11. "Home Court Crawl," Blights Out, Projects, http://www.blightsout.org/projects (last visited November 9, 2019); Yxta Maya Murray interview with Carl Joe Williams, January 5, 2019, in New Orleans, Louisiana.

12. "Home Court Crawl, Photography by Scott McCrossen," Blights Out, Projects, http://www.blightsout.org/projects/ ("The performance was carried from house to house by a second line with music and food.").

13. "Home Court Crawl/Blights Out," Creative Capital, https://creative-capital.org/projects/home-court-crawl-blights-out/#:~:text=Lisa%20Sigal's%20project%2C%20Home%20Court,four%20New%20Orleans%20neighborhoods%E2%80%94St (calling it "Lisa Sigal's project."); Doug McCash, "Prospect.3 'Home Court Crawl' Blends Theater and Blighted Architecture On Saturday, December 13," *NOLA.com*, December 10, 2014, https://www.nola.com/entertainment_life/arts/article_8c8a65b2-c756-50e2-9a31-f68dd3800ced.html.

14. Rosemary Reyes, "Connecting Intentionally: The Beginning of Blights Out," *Pelican Bomb*, January 13, 2016, http://pelicanbomb.com/art-review/2016/connecting-intentionally-the-beginning-of-blights-out (giving locations).

15. Interview with Carl Joe Williams.

16. Interview with Carl Joe Williams.

17. "Blights Out/Live Action Painting," Blights Out, Projects, 2015, http://www.blightsout.org/projects; Rosemary Reyes, "Connecting Intentionally: The Beginning of Blights Out," *Pelican Bomb*, January 13, 2016, http://pelicanbomb.com/art-review/2016/connecting-intentionally-the-beginning-of-blights-out.

18. "Blights Out/Live Action Painting."

19. St. Bernard Par. Gov't v. United States, (*Saint Bernard Par. II*), 887 F.3d 1354 (Fed. Cir. 2018), cert. denied sub nom. St. Bernard Par. v. United States, 139 S. Ct. 796 (2019).

20. St. Bernard Par. Gov't v. United States, (*Saint Bernard Par. I*), 121 Fed. Cl. 687 (2015), *rev'd*, 887 F.3d 1354 (Fed. Cir. 2018).

21. *Saint Bernard Par. I* at 723 ("The funnel effect caused by the MR—GO further exacerbated the increased storm surge that resulted from Hurricane Katrina.").

22. Mark Schleifstein, "How Many People Died in Hurricane Katrina? Toll Reduced 17 Years Later," *NOLA.com*, January 14, 2023, https://www.nola.com/news/hurricane/how-many-people-died-in-katrina-toll-reduced-17-years-on/article_e3009e46-91ed-11ed-8f2a-a7b11e1e8d34.html#:~:text=And%20while%20the%20National%20

Hurricane,weather%20disasters%20in%20modern%20times; Mark Schleifstein, "Study of Hurricane Katrina's Dead Show Most Were Old, Lived Near Levee Breaches," *NOLA. com*, August 28, 2009, https://www.nola.com/news/weather/article_35741734-68e1-575e-86d0-29366eed38e5.html.

23. *Saint Bernard Par. I*, at 746 ("Plaintiffs established that the Army Corps' construction, expansions, operation, and failure to maintain the MR—GO caused subsequent storm surge that was exacerbated by a 'funnel' effect during Hurricane Katrina and subsequent hurricanes and severe storms, causing flooding on Plaintiffs' properties that effected a temporary taking under the Fifth Amendment. . . .").

24. *Saint Bernard Par. I*, at 747.

25. U.S. Const. Amend. 5.

26. Cf. Christopher Serkin, "Passive Takings: The State's Affirmative Duty to Protect Property," *Michigan Law Review* 113, no. 3 (December 2014): 349 ("Courts and commentators frequently assert—and even more frequently assume—that the Takings Clause is implicated only when the government changes the law.") (Serkin writes in the context of "regulatory takings," that is, takings that exist where the government enacts a regulation that infringes on property rights).

27. Tom Dart, "'New Orleans West': Houston Is Home for Many Evacuees 10 Years after Katrina," *Guardian*, August 25, 2015, https://www.theguardian.com/us-news/2015/aug/25/new-orleans-west-houstonhurricane-katrina ("Of the 250,000-odd evacuees who arrived in Houston after the storm, up to 100,000 likely stayed permanently.").

28. Jeanne M. Woods is the Ted and Louana Frois Distinguished Professor in International Law Studies at Loyola University College of Law in New Orleans, Louisiana. She is a Professor Emerita. "Jeanne Woods," Loyola University New Orleans, https://law.loyno.edu/academics/faculty-and-staff-directory/jeanne-m-woods.

29. Naomi Klein, *The Shock Doctrine: The Rise of Disaster Capitalism* (Toronto: Knopf Canada, 2007), 6 (excoriating "orchestrated raids on the public sphere in the wake of catastrophic events combined with the treatment of disasters as exciting market opportunities").

30. Jen Chung, "Photos: Madonna Visiting Sandy-Damaged Rockaways," *Gothamist*, November 12, 2012, https://gothamist.com/arts-entertainment/photos-madonna-visiting-sandy-damaged-rockaways (noting that Biesenbach has a house in the Rockaways and that Marina Abramović had signed a celebrity-sponsored letter demanding that Mayor Bloomberg issue greater support to the region).

31. "About New Orleans Redevelopment Authority," NORA Works, https://www.noraworks.org/about/; David Hammer, "8,800 Road Home Properties to Return to Private Hands," *NOLA.com*, October 19, 2008, https://www.nola.com/news/8-800-road-home-properties-to-return-to-private-hands/article_1ae485bb-3d27-5c05-b4dc-e4a576772ce8.html.

32. Thea Riofrancos, "Extractivism and Extractivismo," *Global South Studies* (undated), https://globalsouthstudies.as.virginia.edu/key-concepts/extractivism-and-extractivismo.

33. Imani Jacqueline Brown, "Debtfair Manifesto," http://www.debtfair.org/viewer/38.

34. Imani Jacqueline Brown, "Debt of 500 Artists Largely Owned by Five Non-Governmental Economic Super Powers (after Hans Haacke)," https://imanijacquelinebrown.net/Debt-of-500-Artists-Largely-Owned-by-Five-Nongovernmental-Economic.

35. Silla Brush and Shelly Hagan, "'BlackRock Tells Texas It Supports Investments in Oil and Gas," *Bloomberg*, May 18, 2022, https://www.bloomberg.com/news/articles/2022-05-18/blackrock-tells-texas-it-supports-investments-in-oil-and-gas#xj4y7vzkg; Brown, "Debt of 500 Artists Largely Owned by Five Non-Governmental Economic Super Powers (after Hans Haacke)."

36. *Fossil Free Fest*, https://www.fossilfreefest.org/home/mesmerize/; "A Brief History of the New Orleans Jazz & Heritage Festival," NO Jazz Fest, https://www.nojazzfest.com/history/ (undated) ("But with the invaluable support of Shell Oil, who signed a long-term presenting sponsorship arrangement with the Festival").

37. Tristan Baurick, "Welcome to 'Cancer Alley,' Where Toxic Air Is about to Get Worse," *Pro Publica*, October 30, 2019, https://www.propublica.org/article/welcome-to-cancer-alley-where-toxic-air-is-about-to-get-worse.

38. Imani Countess, "Human Rights Are Not a Threat to Development," *St. Cloud Times*, September 30, 2021, https://www.sctimes.com/story/opinion/2021/09/29/your-turn-human-rights-not-threat-development/5900553001/.

39. Oliver Basicano, "Eyal Weizman: Why Aesthetics Must Mean More Than Beauty," *Art Review*, February 4, 2022, https://artreview.com/eyal-weizman-why-aesthetics-must-mean-more-than-beauty/.

40. Forensic Architecture, "European Arms in the Bombing of Yemen," https://forensic-architecture.org/investigation/european-arms-in-the-bombing-of-yemen; Tate Museum, "Forensic Architecture," https://www.tate.org.uk/whats-on/tate-britain/turner-prize-2018/forensic-architecture.

41. Forensic Architecture, "Environmental Racism in Death Alley, Louisiana/Phase I Investigative Report," July 4, 2021, 2, https://content.forensic-architecture.org/wp-content/uploads/2021/07/Environmental-Racism-in-Death-Alley-Louisiana_Phase-1-Report_Final_2021.07.04.pdf.

42. Forensic Architecture, "Environmental Racism," 3.

43. David J. Mitchell, "Massive Louisiana Plastics Plant Faces 2+ Year Delay for Tougher Environmental Review," *Advocate*, November 1, 2021, https://www.theadvocate.com/baton_rouge/news/article_c58e7f22-3997-11ec-909f-9bdd7461a90c.html. Later, in September of 2022, a federal court revoked the plant's air pollution permit. Isabella Kaminski, "US Court Revokes Permits for Plastics Plant in Louisiana's 'Cancer Alley,'" *Guardian*, September 16, 2022, https://www.theguardian.com/us-news/2022/sep/16/plastics-plant-louisianas-cancer-alley.

44. Imani Jacqueline Brown, *The Remote Sensation of Disintegration*, 2020, https://vimeo.com/454990300. At around minute 3.

45. Imani Jacqueline Brown, *What Remains-Long*, 2022, https://vimeo.com/user68648380.

46. See Black Code, Act of June 7, 1806, as amended April 14, 1807 ("prescribing the rules and conduct to be observed with respect to Negroes and other Slaves of this Territory."). For documentation about the history of Louisiana, the MRGO, and the details of the storm, see Yxta Maya Murray, "Blights Out and Property Rights in New Orleans Post-Katrina," *Buffalo Law Review* 68, no. 1 (2020): 9–26.

47. U.S. Const. Amend. V.

48. *Saint Bernard Par. I*, 746. Liability was also established under the Tucker Act, which gives the Court of Federal Claims jurisdiction "to render judgment upon any claim against the United States founded either upon the Constitution, or any Act of Congress or any regulation of an executive department, or upon any express or implied contract with the United States, or for liquidated or unliquidated damages in cases not sounding in tort." 28 U.S.C. § 1491(a)(1) (2011).

49. *Saint Bernard Par. I*, 746.

50. *Saint Bernard Par. I*, 746.

51. *Saint Bernard Par. I*, 738. Judge Dyk, in the 2018 decision, specified that this was an inverse condemnation case. *St. Bernard Par. II*, 1364 (Fed. Cir. 2018).

52. *Saint Bernard Par. II*.

53. *Saint Bernard Par. II*, 1357 ("We conclude that the government cannot be liable on a takings theory for inaction. . . .").

54. *Saint Bernard Par. II*, 1357 ("Both the plaintiffs and the Claims Court failed to apply the correct legal standard, which required that the causation analysis account for government flood control projects that reduced the risk of flooding. There was accordingly a failure of proof on a key legal issue. We reverse.").

55. For a review of some other relevant issues, including limitless liability and the confusion of takings with torts, see T. Chan, M. Burger, V. Colatriano, and J. Echeverria, "Determining Climate Responsibility: Government Liability for Hurricane Katrina?," *Environmental Law Reporter* 49, no. 1 (January 2019): 10005. Briefly, I'll respond by noting that these concerns did not prevent the Supreme Court from arguably creating takings liability based on omissions in Arkansas Game and Fish Comm'n v. United States, 568 U.S. 23, 32 (2012) (hereinafter *Arkansas Game and Fish*).

56. *Saint Bernard Parish II*, 1360 (citing Sanguinetti v. United States, 264 U.S. 146, 149–50 (1924), which required that a taking be a "direct result" of a government structure); *Saint Bernard Parish II*, 1361 (citing *Arkansas Game and Fish* at 33, which found that temporary takings could be established on a proof of a "direct and immediate interference with the enjoyment and use of the land"). For a fuller analysis of the cases cited by Judge Dyk, see Murray, "Blights Out and Property Rights in New Orleans Post-Katrina."

57. *Arkansas Game & Fish*, 32.

58. *Arkansas Game & Fish*, 28.

59. *Arkansas Game & Fish*, 27.

60. *Saint Bernard Par. II*, 1365 (quoting United States v. Archer, 241 U.S. 119, 132 (1916)).

61. *Saint Bernard Par. II*, 1365 ("Plaintiffs on appeal are clear that in their view the LPV levees cannot be considered in the causation analysis."). Note that the plaintiffs argued that the LPV/Barrier project was unrelated to the MRGO because "the relevant beneficial government action must be part of the same project and that '[t]he Government cannot defeat Plaintiffs' claim by pointing to benefits provided by the separate LPV project.'" *Saint Bernard II*, 1365.

62. *Saint Bernard II*, 1365.

63. *Saint Bernard II*, 1365 (emphasis added).

64. *Saint Bernard II*, 1368.

65. Kevin R. Johnson, "Dred Scott and Asian Americans: Was Chief Justice Taney the First Critical Race Theorist?" *University of Pennsylvania Journal of Constitutional Law* 24, no. 4 (2022): 751 ("Critical Race Theory (CRT) posits that the law serves to operationalize, maintain, and replicate white supremacy in the United States.").

66. Reva B. Siegel, "Memory Games: Dobbs's Originalism as Anti-Democratic Living Constitutionalism and Some Pathways for Resistance." *Texas Law Review* 101 (2022): 73; Peggy Cooper Davis, *Neglected Stories: The Constitution and Family Values* (New York: Hill and Wang, 1997); Dorothy E. Roberts, "Abolition Constitutionalism," *Harvard Law Review* 133 (2019): 73 (urging activists to look to the history of abolitionist constitutionalism practice and thought to "imagine[] an alternative constitutionalism as part of a movement to abolish prisons.").

67. "Timothy Dyk," Ballotpedia, https://ballotpedia.org/Timothy_Dyk (last visited November 9, 2019).

68. These are my own scare quotes since disclosures of "truth" by documentary methods in the eighteenth century were horrifying racist exercises. Yxta Maya Murray, "From Here I saw What Happened and I Cried: Carrie Mae Weems's Challenge to the Harvard

Archive," *Unbound: Harvard Journal of the Legal Left* 8, no. 1 (Winter 2012–2013): 18 (describing Georges Cuvier's 1815 dissection of Sarah Baartman).

69. Anthea Callen, *The Work of Art: Plein Air Painting and Artistic Identity in Nineteenth Century France* (London: Reaktion Books, 2015), 11.

70. Linda Chisholm, *The History of Landscape Design in 100 Gardens* (Portland: Timber Press, 2018), 142.

71. William Max Nelson, "Making Men: Enlightenment Ideas of Racial Engineering," *The American Historical Review* 115, no. 5 (December 2010): 1364–94 (noting the rise of racist thought in the second half of the eighteenth century); Samuel L. Chatman, "There Were No Slaves in France: A Re-Examination of Slave Laws in Eighteenth Century France," *The Journal of Negro History* 85, no. 3 (Summer, 2000): 145.

72. Interview with Carl Joe Williams.

73. *Saint Bernard Par. II*, 1365.

74. United States v. Sponenbarger, 308 U.S. 256, 265 (1939), and Kansas Game & Fish Comm'n v. United States, 568 U.S. 23, 27 (2012) (refusing to extend takings findings to cases that are only "conjectural."). Note, however, there is precedent for taking the United States and corporations to legal task for their roles in contributing to climate change, even where they fail to act. See Massachusetts v. E.P.A., 549 U.S. 497, 523 (2007) ("EPA does not dispute the existence of a causal connection between manmade greenhouse gas emissions and global warming. At a minimum, therefore, EPA's refusal to regulate such emissions 'contributes' to Massachusetts' injuries.").

75. See Christopher Serkin, "Passive Takings: The State's Affirmative Duty to Protect Property," 70.

76. Wygant v. Jackson Bd. of Education, 476 U.S. 267, 275 (1986) ("Unlike the analysis in *Hazelwood*, the role model theory employed by the District Court has no logical stopping point.").

77. Mark Guarino, "Misleading Reports of Lawlessness after Katrina Worsened Crisis, Officials Say," *Guardian*, August 15, 2016, https://www.theguardian.com/us-news/2015/aug/16/hurricane-katrina-new-orleans-looting-violence-misleading-reports ("Mike Kelly, 60, a former sniper in Iraq who was shipped to New Orleans with the national guard, said people they encountered were often afraid of being forced to leave their houses."); Jonah Walters, "A Guide to Hurricane Katrina and Its Aftermath," *Jacobin*, August 28, 2015, https://www.jacobinmag.com/2015/08/hurricane-katrina-bush-gulf-new-orleans-climate-change-racism-fema/ ("In the weeks and months that followed Katrina, working-class residents of New Orleans saw their city transformed into a literal police state, where movement was monitored and storm victims were marked as criminals and delinquents by hostile police and National Guard forces.").

78. Dennis Devine, "Katrina Survivors Touch Down in San Diego," *San Diego Union—Tribune*, September 5, 2005, https://www.sandiegouniontribune.com/sdut-katrina-survivors-touch-down-in-san-diego-2005sep05-story.html ("His wife shuddered thinking of the terrifying tide of corpses floating in the flood. 'I couldn't go back to that,' Denise Powell said. 'Some of them could be my family.'").

79. See Katy Reckdahl, "The Andrew 'Pete' Sanchez Multi-Service Center," *NRPA*, September 5, 2017, https://www.nrpa.org/parks-recreation-magazine/2017/september/the-andrew-pete-sanchez-multi-service-center/ (describing the corner as "a hub").

80. Interview with Linda Santi.

6. "WE WANTED TO OPEN UP"

1. The following recounting of a group Zoom chat is an edited and compressed amalgamation of a series of conversations that Mira Dayal, Simon Wu, An Duplan, Maia Chao, and I had with about twenty-five cultural producers during Zoom group conferences that

were spread out over the winter of 2021. The names of the people interviewed for *Drawn Together* have been changed to protect their privacy.

2. "2019/2020 Cuchifritos Gallery Curatorial Open Call," *Rivet*, https://rivet.es/calls/view/copy-of-2019-2020-cuchifritos-gallery-curatorial-open-call.

3. Trans* is an umbrella term that designates the number of identities that organize under the concept of trans, including transgender folks, transsexual folks, as well as agender, gender fluid, genderqueer, and other kinds of people. Katy Steinmetz, "The Oxford English Dictionary Added 'Trans*': Here's What the Label Means," *Time*, April 3, 2018, https://time.com/5211799/what-does-trans-asterisk-star-mean-dictionary/.

4. Art handlers install and deinstall shows and otherwise handle art objects at museums. Mikei Hall, "Working in Art Handling," Tate Museum (undated), https://www.tate.org.uk/about-us/working-at-tate/working-in-art-handling.

5. Lisa E. Farrington, *Creating Their Own Image: The History of African-American Women Artists* (Oxford: Oxford University Press 2011), 87–88.

6. Eloise Johnson, "Out of the Ashes: Cultural Identity and Marginalization in the Art of Beauford Delaney," *Notes in the History of Art* 24, no. 4 (Summer 2005): 48.

7. Paul Trachtman, "Romare Bearden: Man of Many Parts," *Smithsonian Magazine*, February 2004, https://www.smithsonianmag.com/arts-culture/romare-bearden-man-of-many-parts-105681968/ ("Bearden considered these paintings 'abstractionist,' but they were too figurative for Kootz; when he reorganized his gallery in 1948, Bearden was dropped.").

8. Charles Desmarais, "What If Bernice Bing's Art Had Been Celebrated and Supported?" *San Francisco Chronicle Datebook*, October 3, 2019, https://datebook.sfchronicle.com/art-exhibits/what-if-bernice-bings-art-had-been-celebrated-and-supported. Her fellow artists at that show were Bruce Conner, Wally Hedrick, George Herms, Robert Hudson, and William Wiley. As I was writing this chapter, San Francisco's Asian Art Museum put on its show *Into View: Bernice Bing*, which was on from October 9 until November 30, 2022. *Into View: Bernice Bing*, Asian Art Museum, https://exhibitions.asianart.org/exhibitions/into-view-bernice-bing/.

9. Loney Abrams, "'I Made Myself Up!': Painter McArthur Binion on Forging His Own Path in a White Art World," *Artspace*, November 4, 2016, https://www.artspace.com/magazine/interviews_features/qa/in-a-predominately-white-art-world-mcarthur-binion-had-to-make-himself-up-to-succeed-54340.

10. Janelle Zara, "How I Became an Artist: Betye Saar," *Art Basel*, 2022, https://www.artbasel.com/stories/betye-saar-interview-ica-miami?lang=en.

11. Joni L. Murphy, Beyond Sweetgrass: The Life and Art of Jaune Quick-To-See Smith (PhD diss., University of Kansas, 2008), 16, https://kuscholarworks.ku.edu/bitstream/handle/1808/5335/Murphy_ku_0099D_10101_DATA_1.pdf;jsessionid=9D17D0E92EFC29682809CD07BD12C33D?sequence=1 ("When Smith became aware of Tlingit artist Jesse Cooday's Native photography she became extremely interested in finding a venue for Native photographers who had nowhere to exhibit their work."). For an essential description of the foreclosures experienced by Latinx artists, see Arlene Dávila, *Latinx Art: Artists, Markets, and Politics* (Durham: Duke University Press, 2020).

12. Betty Perry, "Lois Mailou Jones: An Indefatigable Black Woman Artist," *Washington Post*, February 23, 1983, https://www.washingtonpost.com/archive/local/1983/02/23/lois-mailou-jones-an-indefatigable-black-woman-artist/91bbdec6-f18b-4293-a19d-7d9936bb31ab/.

13. Yasmín Ramírez, "The Activist Legacy of Puerto Rican Artists in New York and the Art Heritage of Puerto Rico," ICAA, Documents Project Working Papers, no. 1, September 2007, 47, https://www.yasminramirezphd.com/_files/ugd/73ee56_ab804524796546a091895be6bfe26f4d.pdf; Daniel Mellis, "The Law as Art Material," *J. Marshall Review of Intellectual Property Law* 14 (2015): 420–21 (detailing the agreement).

14. Robb Hernández, *VIVA Records, 1970–2000: Lesbian and Gay Latino Artists of Los Angeles (The Chicano Archives)* (Los Angeles: UCLA Chicano Studies Research Center Press, 2013); Carol Small, "Reviewed Works: *Confessions of the Guerrilla Girls* by the Guerrilla Girls; Divisions of Labor: 'Women's Work' in Contemporary Art by Linda Yee, Arlene Raven, Michele Wallace," *Woman's Art Journal* 19, no. 2 (Autumn 1998–Winter 1999): 38 ("By the early 1990s the Guerrilla Girls commanded 'the kind of name recognition and success that any artist would covet.'").

15. Greig De Peuter, "Organizing Dark Matter: W.A.G.E. as Alternative Worker Organization," in *Organizing Equality: Dispatches From a Global Struggle*, ed. J. Compton, N. Dyer-Witheford, A. Grzyb, and A. Hearn (Montreal and Kingston: McGill-Queen's University Press, 2022); W.A.G.E., "Fee Calculator," https://wageforwork.com/fee-calculator#top.

16. Arts and Labor, "About," http://artsandlabor.org/about-al/#sthash.qN6a9XJT.dpbs.

17. Mostafa Heddaya, "Artist Collective Withdraws from Whitney Biennial," *Hyperallergic*, May 14, 2014, https://hyperallergic.com/126420/artist-collective-withdraws-from-whitney-biennial/.

18. Alex Strada, "Artist Contract," 2017, http://www.alexstrada.com/contract.html. The contract requires the purchaser of an artwork to sell it in ten years and invest the appreciated value into a work by an emerging female artist. On March 7, 2023, Strada emailed me in response to an inquiry about the identities mentioned, and not mentioned, in her contract, and stated: "*Artist Contract* does not explicitly mention race, ethnicity, or other identities. It was initially drafted in 2017, and my goal was to be as open as possible with the terms of the agreement to address the gender biases that adversely affect emerging female-identifying artists. At the same time, it was important to me to create a document that could easily be adapted to account for race, ethnicity, gender expression, sexuality, age, disability, or any other identities marginalized by the white and male dominated art market."

19. Jasmine Liu, "Citing 'Institutional Racist Violence,' Half of the Wisconsin Triennial Artists Withdraw Their Work," *Hyperallergic*, August 23, 2022, https://hyperallergic.com/755393/citing-institutional-racist-violence-half-of-the-wisconsin-triennial-artists-withdraw-their-work/; FWD:Truth, "Open Letter," 2022, https://fwdtruth.com/open-letter/.

20. Meagan Day, "How to Unionize the Artworld," *ArtReview*, August 10, 2022, https://artreview.com/how-to-unionize-the-artworld/. The Dia Foundation, MASS MoCA, the Guggenheim, and the Whitney unionized in 2021; the other institutions unionized earlier.

21. Brooklyn Museum, "Decolonize This Place," https://decolonizethisplace.org/bk-musuem.

22. Strike MoMa, https://www.strikemoma.org/.

23. Henri Neuendorf, "It's Official, 80% of the Artists in NYC's Top Galleries Are White," *Artnet.com*, June 2, 2017, https://news.artnet.com/art-world/new-york-galleries-study-979049.

24. Hakim Bishara, "Artists in 18 Major US Museums Are 85% White and 87% Male, Study Says," *Hyperallergic*, June 3, 2019, https://hyperallergic.com/501999/artists-in-18-major-us-museums-are-85-white-and-87-male-study-says/.

25. Helen Holmes, "The Guggenheim's First Black Curator Is Denouncing the Museum's Treatment of Her," *Observer*, June 5, 2020, https://observer.com/2020/06/guggenheim-museum-chaedria-labouvier/.

26. Julia Halperin and Charlotte Burns, "Introducing the 2022 Burns Halperin Report," *Artnet*, December 13, 2022, https://news.artnet.com/art-world/letter-from-the-editors-introducing-the-2022-burns-halperin-report-2227445 ("Between 2008 and 2020, just 11

percent of acquisitions at U.S. museums were of work by female-identifying artists and only 2.2 percent were by Black American artists.").

27. Nancy Kenny, "Protest Letter Urges New York Arts Institutions to Rectify 'Egregious Acts' Rooted In White Supremacy," *Art Newspaper*, June 19, 2020, https://www.theartnewspaper.com/2020/06/20/protest-letter-urges-new-york-art-institutions-to-rectify-egregious-acts-rooted-in-white-supremacy; Julia Jacobs and Zachary Small, "Whitney Cancels Show That Included Works Bought at Fund-Raisers," *New York Times*, August 25, 2020, https://www.nytimes.com/2020/08/25/arts/design/whitney-museum-exhibition-canceled.html.

28. Miller v. Dombek, 390 S.W.3d 204, 207 (Mo. Ct. App. 2012).

29. Artists Alliance, still from *Drawn Together* (2021), https://www.artistsallianceinc.org/drawn-together/.

30. *Drawn Together*, https://www.artistsallianceinc.org/drawn-together/.

31. Paul Sullivan, "Protect Your Art with More Than a Handshake," *New York Times*, April 2, 2010, https://www.nytimes.com/2010/04/03/your-money/home-insurance/03wealth.html.

32. This would be under the Statute of Frauds. N.Y. Gen. Oblig. Law § 5–701(a)(1); Kubin v. Miller, 801 F. Supp. 1101, 1120 (S.D.N.Y. 1992) ("[T]his statute must be construed so that its effect is limited to those contracts which, by their terms, cannot possibly be fully performed within one year.").

33. This, under the parol evidence rule. Margaret N. Kniffin, "Conflating and Confusing Contract Interpretation and the Parol Evidence Rule: Is the Emperor Wearing Someone Else's Clothes?," *Rutgers Law Review* 62, no. 1 (Fall 2009): 102 ("The rule is typically stated thusly: '[E]xtrinsic or parol evidence which tends to contradict, vary, add to, or subtract from the terms of a written contract must be excluded.'") (citation omitted). This section could not have been written without the significant aid of my friend and colleague, Victor Gold.

34. Robyn Freedman, "Putting the Color into Black and White: Artists, Dealers and Agreements," *Entertainment and Sports Law* (Fall 2003): 3.

35. Philip Lucrezia, "New York's Property Condition Disclosure Act: Extensive Loopholes Leave Buyers and Sellers of Residential Real Property Governed by the Common Law," *Saint John's Law Review* 77, no. 2 (Spring 2003): 441; Ralph E. Lerner, "Agreements for Visual Artist," *Entertainment and Sports Law* (Fall 1998): 19.

36. For a cautionary tale on the need for contracts in this context, see Arantxa S. Rodriguez, "Never Take on a Commission Without a Contract," *Hyperallergic*, August 11, 2021, https://hyperallergic.com/668004/artists-should-never-take-commission-without-contract/.

37. Of such an agreement gone awry, see Sarah Cascone, "An Artist Shut Down His Own Show at New York's HG Contemporary After Claiming the Dealer Didn't Pay Him or His Framers," *Artnet*, October 8, 2019, https://news.artnet.com/art-world/louis-carreon-pulls-show-philippe-hoerle-guggenheim-1473244.

38. Traditional Fine Arts Organization, "Sample Curator Agreement," https://tfaoi.org/aa/1aa/1aa689.htm.

39. Daniel Cassady, "Christie's Comes under Fire for 'Art Handler' Streetwear Collaboration," *Art Newspaper*, October 6, 2022, https://www.theartnewspaper.com/2022/10/06/art-handlers-uproar-christies-streetwear-collaboration-highsnobiety.

40. American Association of Museum Volunteers, "Embracing the Power of College Interns as Volunteers," May 26, 2016, https://aamv.wildapricot.org/College-Students-as-Interns. See also Temple University, The Center for Public History, "Internships," (undated), https://sites.temple.edu/centerforpublichistory/internships/ (noting that contracts can be formal or informal).

41. See, e.g., New York Academy of Art Director of Admissions & Recruitment, "NYFA Jobs," https://www.nyfa.org/view-job/?id=7c6b3d71-66f5-4204-bf88-829b5becd095 (advertising a full-time job for a person with a college degree); NFYA Jobs, "Juror for the Pink Bison Prize," https://www.nyfa.org/view-job/?id=729a63ad-330b-4169-bfbf-9fa82d74b1bf (offering $250 for ten hours of work).

42. Jennie Smith-Camejo, "California College of the Arts Staff, Adjunct Faculty Ratify New Contract That Will Provide a Big Improvement Following February's Strike," *SEIU/1021*, April 8, 2022, https://www.seiu1021.org/article/california-college-arts-staff-adjunct-faculty-ratify-new-contract-will-provide-big.

43. Restatement (Second) of Contracts §§ 175 (1981) (duress); Danielle Kie Hart, "Cross Purposes & Unintended Consequences: Karl Llewellyn, Article 2, and the Limits of Social Transformation," *Nevada Law Journal* 12, no. 1 (Fall 2011): 82.

44. Steven W. Feldman, "Pre-Dispute Arbitration Agreements, Freedom of Contract, and the Economic Duress Defense: A Critique of Three Commentaries," *Cleveland State Law Review* 64, no. 1 (2015): 59; Restatement (Second) of Contracts § 175.

45. See, e.g., Crossroads Ford Truck Sales, Inc. v. Sterling Truck Corp., 341 Ill. App. 3d 438, 446, 792 N.E.2d 488, 494 (2003).

46. Odorizzi v. Bloomfield School District, 246 Cal.App. 2d 123, 131 (1966) (citations omitted).

47. See the famous case of Odorizzi v. Bloomfield Sch. Dist., 246 Cal. App. 2d 123, 132 (Ct. App. 1966). This involved a queer teacher, who had just been arrested under anti-sodomy laws and signed a written resignation statement. See also Olam v. Cong. Mortg. Co., 68 F. Supp. 2d 1110, 1141 (N.D. Cal. 1999) (mentioning "lack of full vigor due to age, physical condition, physical exhaustion, and emotional anguish" as determining undue susceptibility); *Tanner* at *6 (mentioning "lack of full vigor due to age, physical condition, emotional anguish, or some combination thereof.").

48. Tanner v. Kaiser Found. Health Plan, Inc., No. C 15-02763-SBA, 2016 WL 4076116, at *6 (N.D. Cal. Aug. 1, 2016) ("Excessive pressure is generally accompanied by certain characteristics that tend to create a pattern, including: (1) discussion of the transaction at an unusual or inappropriate time; (2) consummation of the transaction in an unusual place; (3) insistent demand that the business be finished at once; (4) extreme emphasis on untoward consequences of delay; (5) the use of multiple persuaders by the dominant side against a single servient party; (6) absence of third-party advisors to the servient party; and (7) statements that there is no time to consult financial advisers or attorneys."). With thanks to Danielle Kie Hart for help on this section.

49. Restatement (Second) of Contract 2d, § 164 (1981).

50. Restatement (Second) of Contracts 2d, § 164. ("If a party's manifestation of assent is induced by either a fraudulent or a material misrepresentation by the other party upon which the recipient is justified in relying, the contract is voidable by the recipient."). Note that the misrepresentation need not be intentional, it can be negligent (that is, the result of an oversight or mistake).

51. Restatement (Second) of Contracts § 161 (b)(1981). ("[W]here he knows that disclosure of the fact would correct a mistake of the other party as to a basic assumption on which that party is making the contract and if non-disclosure of the fact amounts to a failure to act in good faith *and* in accordance with reasonable standards of fair dealing.").

52. New York Labor Law 194, https://www.nysenate.gov/legislation/laws/LAB/194. Other protected classes are age, creed, color, national origin, sexual orientation, gender identity or expression, military status, disability, predisposing genetic characteristics, familial status, marital status, or domestic violence victim status.

53. New York State Department of Labor, *Pay Transparency Law* (2023), https://dol.ny.gov/pay-transparency-law-fare-grant.

54. Cf. Schottland v. Brown Harris Stevens Brooklyn, LLC, 107 A.D.3d 684, 685 (2013) ("'New York adheres to the doctrine of caveat emptor and imposes no duty on the seller or the seller's agent to disclose any information concerning the premises when the parties deal at arm's length, unless there is some conduct on the part of the seller or the seller's agent which constitutes active concealment.'") (citation omitted).

55. Francoise's failure to read her contract, and her surprise at its work product clause, also brings up the possibility of misrepresentation, but this claim would be unlikely to succeed if she had a reasonable opportunity to look over the agreement and wasn't fraudulently induced into consenting. Chapman v. Skype Inc., 220 Cal. App. 4th 217, 233 (2013).

56. State v. Terrell, 40 N.E.3d 501, 506 (Ind. Ct. App. 2015).

57. Andrew A. Schwartz, "Consumer Contract Exchanges and the Problem of Adhesion," *Yale Journal on Regulation* 28, no. 2 (Summer 2011): 347.

58. Graham v. Scissor-Tail, Inc., 28 Cal. 3d 807, 818, 623 P. 2d 165, 171 (1981) (finding an arbitration clause in a music performance contract adhesive and unconscionable).

59. Colleen McCullough, "Unconscionability as a Coherent Legal Concept," *University of Pennsylvania Law Review* 164, no. 3 (February 2016): 780 ("with the law's endorsement, contracts of adhesion have proliferated."); State v. Terrell, 40 N.E.3d 501, 506 (Ind. Ct. App. 2015) ("An adhesion contract is unconscionable and therefore unenforceable if it is 'such as no sensible man not under delusion, duress or in distress would make, and such as no honest and fair man would accept.'").

60. McCullough, "Unconscionability as a Coherent Legal Concept," 792.

61. McCullough, "Unconscionability as a Coherent Legal Concept," 781.

62. Frona M. Powell, "Unconscionability in the Lease of Commercial Real Estate," *Real Property, Probate and Trust Journal* 35, no. 1 (2000): 209 (Unconscionability "is most frequently employed to shield disadvantaged and uneducated consumers from overreaching merchants.").

63. Conceivably, an inability to speak English or educational issues could support a finding of unconscionability, but this is not an assured defense. Est. of Benitez v. Sears, Roebuck & Co., No. 3:13-CV-0468-D, 2013 WL 4223875, at *5 (N.D. Tex. Aug. 14, 2013) (monolingual Spanish speaker with limited education and anxiety about computers did not succeed on unconscionability defense to arbitration agreement where there were interpreters and he signed onto computer program and clicked on a box).

64. Matter of Friedman, 64 A.D.2d 70, 407 N.Y.S.2d 999 (2d Dep't 1978). Note also that education, mental health, language abilities, poverty, and other factors may also relate to the *incapacity* defense, which holds that certain vulnerable parties are legally incapable of entering into contracts in the first place. In the art world context, though, this seems like a true nonstarter: if the process of arguing undue influence would be humiliating, incapacity would potentially be career-destroying, if only because it would announce to the world that the art worker was unable to do any business at all with arts institutions. See 12 Ill. Law and Prac. Contracts § 60.

65. Susan Landrum, "Much Ado about Nothing?: What the Numbers Tell Us about How State Courts Apply the Unconscionability Doctrine to Arbitration Agreements," *Marquette Law Review* 97, no. 3 (Spring 2014): 764 ("The court may (1) refuse to enforce the contract; (2) excise the unconscionable clause and enforce the remainder of the contract; or (3) 'so limit the application of any unconscionable clause as to avoid any unconscionable result.'").

66. Kitty Krupat, "Modern Art/Ancient Wages," *New Labor Forum*, January 2022, https://newlaborforum.cuny.edu/2022/01/14/modern-art-ancient-wages/ (describing museum unions that benefit "workers" and "staffers").

67. Gerald M. Monroe, "Artists as Militant Trade Union Workers During the Great Depression," *Archives of American Art Journal* 49, no. 1/2 (Spring 2010): 50; David M. Sokol, "The Founding of Artists Equity Association after World War II," *Archives of American Art Journal* 39, no. 1/2 (1999): 25 and 28, http://artsandlabor.org/wp-content/uploads/2011/12/ArtistsEquityHistory.1.pdf; New York Artists Equity Association, "Mission & History," https://www.nyartistsequity.org/mission-history#:~:text=New%20York%20Artists%20Equity%20Association%20was%20founded%20in%201947%20to,economic%20issues%20affecting%20American%20artists.&text=Equity%20Gallery%20was%20made%20possible,Lawrence%20and%20Gwendolyn%20Knight%20Lawrence.

68. IATSE, the Union Behind Entertainment, https://iatse.net/; "SAG-AFTRA," https://www.sagaftra.org/; Writers Guild of American West, https://www.wga.org/; National Writers Union, https://nwu.org/about/; Michael Sainato, "'Like Being in the Military': Embattled VFX Artists Push to Unionize," *Guardian*, September 9, 2022, https://www.theguardian.com/us-news/2022/sep/09/visual-effects-artists-union-push-movies; Jennie Smith-Camejo, "California College of the Arts Staff, Adjunct Faculty Ratify New Contract That Will Provide a Big Improvement Following February's Strike," *SEIU/1021*, April 8, 2022, https://www.seiu1021.org/article/california-college-arts-staff-adjunct-faculty-ratify-new-contract-will-provide-big.

69. Mary Ellen Dowd, "Why We Need Creative Unions," *Fem Lens*, June 28, 2021, https://femlens.com/blog-post/why-we-need-creative-unions/.

70. Thomas R. Donahue, "The Role of and Challenges Facing Unions in the 1940's and the 1980's-A Comparison Remarks of Thomas R. Donahue," *Fordham Law Review* 52, no. 6 (1984): 1063.

71. César Chávez, "César Chávez Address to the Commonwealth Club of California, 1984," in *Documents of the Chicano Movement*, ed. Roger Bruns (Santa Barbara: ABC-CLIO, 2018), 47.

72. Sidney Fine, "The Eight-Hour Day Movement in the United States, 1888–1891," *The Mississippi Valley Historical Review* 40, no. 3 (December 1953): 441–62; Scott Myers-Lipton and Charles C. Lemert, *Social Solutions to Poverty: America's Struggle to Build a Just Society* (Oxfordshire: Routledge, 2006), 219.

73. Jake Grumbach and Paul Frymer, "Labor Unions and White Racial Politics," *American Journal of Political Science* 65, no. 1 (2021), https://scholar.princeton.edu/sites/default/files/pfrymer/files/ajps12537_rev.pdf ("union membership is negatively associated with racial resentment."); Jerzy Eisenberg-Guyot, Stephen J. Mooney, Wendy E. Barrington, and Anjum Hajat, "Does the Union Make Us Strong? Labor-Union Membership, Self-Rated Health, and Mental Illness: A Parametric-G Formula Approach," *American Journal of Epidemiology* 190, no. 4 (2021): 636, doi: 10.1093/aje/kwaa221.

74. Steven Greenhouse, "Wave of Union Victories Suggests Union-Busting Consultants May Have Lost Their Sway," *Guardian*, April 13, 2022, https://www.theguardian.com/us-news/2022/apr/13/union-victories-busting-consultants-amazon-tactics.

75. Shawn Hubler, "University of California Academic Employees Strike for Higher Pay," *New York Times*, November 14, 2022, https://www.nytimes.com/2022/11/14/us/university-of-california-strike-pay.html.

76. Shirley Lin, "Bargaining for Integration," *New York University Law Review* 96, no. 6 (December 2021): 1890 ("However, the doctrine and practice of labor and employment law have produced the view within labor law—and thus labor organizing—that disability accommodations involve only individual rights that threaten collective representation.").

77. Julia Carmel, "Before the A.D.A., There Was Section 504," *New York Times*, July 22, 2020, https://www.nytimes.com/2020/07/22/us/504-sit-in-disability-rights.html; Eileen AJ Connelly, "Overlooked No More: Brad Lomax, a Bridge Between Civil Rights

Movements," *New York Times*, July 8, 2020, https://www.nytimes.com/2020/07/08/obituaries/brad-lomax-overlooked.html.

78. Carmel, "Before the A.D.A., there was Section 504."

79. Leroy Moore, "Black History of 504 Sit-in for Disability," *The Disability Visibility Project*, December 2, 2014, https://disabilityvisibilityproject.com/2014/12/02/guest-blog-post-by-leroy-moore-black-history-of-504-sit-in-for-disability-rights/. I first saw Groves's name in this article of Moore's. I later contacted Moore by email and he referred me to Groves's YouTube archive. See also JG, "Autumn Leaves," *Youtube.com*, November 6, 2006, https://www.youtube.com/watch?v=3HqpOMJnoZY.

80. Phone interview with Janette Rodriguez, November 15, 2022.

81. Steven L. Willborn, "Transparency and Reliance in Antidiscrimination Law," *Catholic University Law Review* 71, no. 3 (2022): 542.

82. Kirsten K. Davis, "The Rhetoric of Accommodation: Considering the Language of Work-Family Discourse," *Saint Thomas Law Journal* 4, no. 3 (2007): 534 (discussing the Americans with Disabilities Act of 1990, the Civil Rights Act of 1964, and the Family and Medical Leave Act of 1993).

83. New York City Administrative Code § 8–107.1. The activists and lawyers Professor Julie Goldscheid, Professor Robin Runge, and Marcellene E. Hearn were foundational in developing and lobbying for the workplace protection of victims of domestic violence. "Civil Rights Law in Transition: The Forty-Fifth Anniversary of the New York City Commission on Human Rights," *Fordham Urban Law Journal* 27, no. 3 (2000): 1135 (statements of Professor Goldscheid); Robin R. Runge and Marcellene E. Hearn, "Employment Rights Advocacy for Battered Women," *Domestic Violence Report* 5, no. 2 (December/January 2000): 18, 26.

84. Lin, "Bargaining for Integration," 1839 (noting the undue hardship defense under the Rehabilitation Act and the Americans with Disabilities Act.). Under laws like the ADA, employers may also undertake "interactive processes" (that is, have conversations) with disabled employees to resolve their need for reasonable accommodation, but these processes have their dangers. Katherine A. Macfarlane, "Disability without Documentation," *Fordham Law Review* 59, no. 1 (October 2021): 66.

85. With thanks to Danni Kie Hart for helping me make this point.

86. Civil Rights Act of 1964, § 703(a)(1), 42 U.S.C.A. § 2000e–2(a)(1); Administrative Code of City of NY § 8–107; N.Y. Exec. Law § 296 (McKinney).

87. Legislation and legal theory that calls for using plain language in consumer contracts, educating workers about their contracts, providing a "cooling off" period before a contract takes effect, implementing workplace mentoring programs, creating pay transparency, and combating harassment all provided direction for creating these workers' rights by contract. With respect to how information about the law guides parties' actions, see Lawrence B. Solum, "Procedural Justice," *Southern California Law Review* 78, no. 1 (November 2004): 187.

88. Art workers in these different classes face a host of specific problems. The oppressions suffered by art handlers, interns, and adjunct art teachers are just beginning to get the attention that they deserve. Daisy Alioto, "Art Handlers, Long Overlooked, Push for Better Wages and Union Representation," *Artsy*, September 25, 2017, https://www.artsy.net/article/artsy-editorial-art-handlers-long-overlooked-push-better-wages-union-representation; William Soule, "Learning through Experience: Borrowing Lessons from Abroad to Understand the Legality of Unpaid Internships in America," *Chicago Unbound*, 29, no. 1 (2017), https://chicagounbound.uchicago.edu/uclf/vol2017/iss1/29/.

89. Katherine Macfarlane, "Accommodation Discrimination," *American University Law Review* 72 (forthcoming), available at SSRN: https://ssrn.com/abstract=4190587 or http://dx.doi.org/10.2139/ssrn.4190587 at page 10.

90. The anti-harassment and bias provision was submitted later than the other asks, in October of 2022.

91. Aruna D'Souza, "What Can We Learn from Institutional Critique?" *Art in America*, October 28, 2019, https://www.artnews.com/art-in-america/features/hans-haacke-new-museum-retrospective-institutional-critique-63666/ (discussing *MoMA Poll* (1970) and other works); Howardena Pindell, "Testimony," 1987, https://pindell.mcachicago.org/art-world-surveys/statistics-testimony-and-supporting-documentation/. In 1997, Pindell updated her report, observing that galleries at the apex of the food chain were still likely to be 100 percent white but that alternative venues had provided increasing opportunities for artists of color. Howardena Pindell, "Commentary and Update of Gallery and Museum Statistics, 1986–1997," 1997, https://pindell.mcachicago.org/art-world-surveys/commentary-and-update-of-gallery-and-museum-statistics-1986-1997/.

92. Dieter Lesage, "Who's Afraid of Artistic Research?" *Art & Research* 2, no. 2 (2009), S. 1–10, http://www.artandresearch.org.uk/v2n2/lesage.html.

93. Imani Jacqueline Brown, *Debt of 500 Artists Largely Owned by Five Non-Governmental Economic Super Powers (after Hans Haacke)*, https://imanijacquelinebrown.net/Debt-of-500-Artists-Largely-Owned-by-Five-Nongovernmental-Economic."

94. Forensic Architecture, "'Environmental Racism in Death Alley, Louisiana/Phase I Investigative Report," July 4, 2021, 2, https://content.forensic-architecture.org/wp-content/uploads/2021/07/Environmental-Racism-in-Death-Alley-Louisiana_Phase-1-Report_Final_2021.07.04.pdf.

95. Sergio Muñoz Sarmiento, "CV/BIO," http://www.sergiomunozsarmiento.com/pagecv; Camilo Cruz, "Bureaucracy Art," https://camilocruzart.com/.

Index

Page numbers in *italics* refer to figures.

Abdur-Rahman, Aliyyah I., 61
Abolish ICE, 107
abortion rights, 84–85
Abramović, Marina, 116, 211n30
activist art. *See* artivism
ACT UP, 8, 24, 31–32
Adastik, María Aldrete, 4, 173–75
adhesion, contracts of, 159–60, 219nn58–59
Adjaye, David, 48
adjunct art professors, 157, 221n88
Adler, Amy, 7
administrators, 157
Agassiz, Louis, 38–41, 50, 54–56, 61–62, 195n5, 195n8
Aguiñiga, Tanya, 9, 37, 89–108, 168, 170–71, 178, 206n2; *Border Quipu, 94,* 94–97, 104–5, 107, 170; *Línea Pak,* 2, 4, 89, 99–107, *100,* 176–77; *Metabolizing the Border,* 1–2, 4, *90, 96,* 97–99, 105–7, 177
A.I.R., 29
Alcantara-Tan, Sabrina Margarita, 191n84
Aldrete-Diaz family, *174*
Alfaro, Luis, 149
Alvarado Arts Workshop, 185n12
AMBOS (Art Made Between Opposite Sides), 93–96, 101, 170
American Federation of Labor, 161
Americans with Disabilities Act (ADA), 2, 4, 82, 99, 101–3, 163, 208n30, 208n37, 221n84
Amézquita, Jackie, 94
anarchy, 65–69, 80, 84
Anderson, Regina M., 78–80
Andry, Katrina, 111, *131*
Andy Warhol Foundation for Visual Arts, Inc. v. Goldsmith, 197n40
Angels of Light (drag ensemble), 21
Antenna (arts organization), 119
antiwar movements, 5, 15, 17–21, 26, 114, 186n33
Anzaldúa, Gloria E., 6, 27

"appearing in public without shame," 8, 13, 15, 21, 71–72, 79, 182n40, 203n39
appropriations art, 40–46, 56
archive building, 11, 183n2
Arendt, Hannah, 58
Aristotle, 9
Arkansas Game & Fishing Commission v. United States, 128–29, 135, 213n55
Armstrong, Sarah Gail, 88
Army Corps of Engineers, 112–13, 117, 121, 124–25, 127–29
art: challenges to definitions of, 171–72; commodified and monetized, 93, 122; emotional responses to, 9, 32, 98, 107; institutions (*see* art world); law and, 3–4 (*see also* artivism)
Art and Housing Collaborative, 81
art handlers, 147–48, 151, 157, 161, 167, 170, 215n4, 221n88
Art Institute of Chicago, 60, 71
artist-audience divide, 65, 68–69, 77
Artist Protest Committee, 5
Artists Alliance, Inc. (AAI), 140, 152, 165–68, 171–72, 177
artists' collectives, non-union, 161. *See also* collaboration
Artist's Reserved Rights Transfer and Sale Agreement (1971), 149
Artists Space, 29
Artists Union, 161, 180n17. *See also* unions
artivism: 1930s–40s, 13–15, 184n4; 1960s–70s, 15–27; 1980s–90s, 27–36; 2000s–present day, 36–37; critiques of law and, 6–10, 177–78; defined, 4–6, 173–76; social movements and, 13; transnational, 9; US-based, 10. *See also* direct action; disabled artists of color; queer of color artivists; women of color artivists
arts-activism, use of term, 4–5
Arts & Labor working group, 149
Art Strike Against War, Racism, Fascism, Sexism, and Repression, 5, 161

INDEX

Art Workers Coalition, 149
art world: exclusion from, 20, 27–30, 36, 44, 96, 147, 149, 170, 191n90, 192n102, 217n26, 222n91; spaces in, 67, 73–75, 83–84 (*see also* safer spaces); working conditions, 139–49 (*see also* contracts). *See also individual artists; specific institutions*
Asawa, Ruth, 185n12, 185n20
Asian Art Museum (San Francisco), 215n8
Astorga, Marvin, 71–72, 75
asylum, 5, 32, 97–99, 102, 180n21
Ater, Renée, 5–6, 15
Atlanta Braves, 35
Ayinde, Dove, 88

Baca, Judy, 5–6, 11, 24–27, *25*, 58, 87, 176; *The Great Wall of Los Angeles*, 25, *25*, 36, 80, 101, 133, 170
Baker, Josephine, 40, 43
Balkin, Jack, 7, 58
Barbash, Ilisa, 51, 198n67
Barboza, Anthony, 42
Barnard College, 150
Barnett, Sydney, 94
Batman Gallery, 148
Bautista, Ernesto, 4
Bearden, Romare, 148, 215n7
beauty, 9, 72–75, 77–78, 80
Bechet, Ron, 111
Bell, Derrick, 7
Bellecourt v. City of Cleveland, 35, 45, 194n130
Benítez, Luz Esther, 185n20
Bentley, Gladys, *12*, 13–15, 27, 36, 44, 60, 79, 169, 178
Berger, Maurice, 30
Beuys, Joseph, 4, 24, 185n12, 189n66
Biesenbach, Klaus, 116, 211n30
Bing, Bernice, 148
Binion, McArthur, 148
Bird, John, 184n12
"bird's eye view," 119, 121, 123, 129, 136
Bishop, Claire, 5
Black Code (1806), 124
Black Emergency Cultural Coalition (BECC), 5, 29–30, 149, 161
Black futurity, 79, 81, 85–86, 151, 205n68
Black Liberation movement, 183n42
Black Lives Matter, 3, 8, 21, 26
Black-owned property: beauty salons, 78; in New Orleans, 109–38
Black Panther Party, 5, 21, 23, 29, 162, 192n95
Black Photographers Annual, 42
Black Rock (residency in Dakar), 79

BlackRock, Inc., 119
Black@TED, 75, 88
Blair, Ezell, Jr., 17–18
Blanco, Kathleen, 126
Blights Out (arts collective), 37, 111, 113–14, 116, 119, 126–27, 130, 138
Bluestockings Cooperative, 202n27
Blum, H. Steven, 126
Boone, Mary, 29
Border Art Workshop/Taller de Arte Fronterízo (BAW), 91–92, 206n3
border crossing: deaths during, 93, 99, 107; elderly and disabled immigrants, 101–5, 108; mutual aid and, 91, 94, 99–102; performance-protests and outreach at, 89 (*see also* Aguiñiga, Tanya). *See also* immigration policy
Bostock v. Clayton County, 24
Boston Museum School, 148
Bourriaud, Nicolas, 5
Bowers v. Hardwick, 32
Braden, Susan, 112–13, 123–25, 127–29, 134, 136
Brawley, Cecilia, 94
breach of contract, 157, 176; as civil disobedience, 44–45, 52, 56–58, 64, 80; safer spaces and, 84, 87
Brinshore Development, 79
Brissette, James, 126
Broad Museum, "Non-Object(ive) Happening," 65, 67–70, 75–77, 80, 82–84, 88, 178
Brooklyn Museum, 30, 150, 161
Brown, Imani Jacqueline, 3, 37, 109–38, *110*, 169–70, 176–78; "Death Alley" report, 120–21, 123, 130, 136–38, 170; *Debtfair*, 110, *118*, 119, 123, 130, 134, 138, 149; *Debt of 500 Artists Largely Owned by Five Non-Governmental Economic Super Powers (after Hans Haacke)*, 170; *Fossil Free Fest*, 119, 123, 130, 134, 138; *Home Court Crawl*, 111, 116; *Live Action Painting*, 111–13, 116–17, 119, 122–23, 127, 130–38, *131–32*, 178; *The Remote Sensation of Disintegration*, 121, 123, 130, 134–38; *What Remains at the Ends of the Earth?*, 113, *121*, 122–23, 130, 134–38. *See also* Blights Out (arts collective)
Brown, Kimberley Juanita, 61
Brown Berets, 25
Bryant, Amy, 111
Buick, Kirsten Pai, 30, 192n99
Burns, A. K., 149
Bush, George, 126, 136

Cage, John, 42
Califano, Joe, 163
Campbell v. Acuff-Rose Music, 45–46
canon formation, 11, 30, 181n30, 183n2
capitalism, 122; art production and, 140; "disaster capitalism," 116, 127, 211n29; rejection of, 133
Carens, Joseph, 107
Carmichael, Mary, 55
Carrier, Toni, 54
Castelli, Leo, 29
catharsis, 9, 98, 107
Catlett, Elizabeth, 13–15, *14,* 23, 27, 36, 44, 98, 177
causation analysis, 128–29, 134, 213n54, 213n61
caveat emptor ("let the buyer beware"), 159, 219n54
Center for Afrofuturist Studies, 79, 81, 151
Center for International Environmental Law, 120, 170
Cha, San, 75
Chao, Maia, 139–48, *142,* 150–53, 157, 169, 171
chattels, 47
Chávez, César, 161
Chechen asylum seekers, 5, 180n21
Chicago, Judy, 67
Chicago Housing Authority, 79
Chicano Blowouts, 8, 25
Chicanx education-rights artivism, 24–26
childcare, 147, 167, 171
Childs, Chris, 54
China, 9, 183n47
Chisholm, Linda, 131
Chon, Margaret, 46
Chung, Young, 70
civil disobedience, 8, 32, 176; breach of contract as, 44–45, 52, 56–58, 64, 80. *See also* protests
Civil Rights Act (1964), 16, 29–30, 81, 185n17
civil rights movement, 3, 8, 15–18, 61, 182n37
class status, 67, 69–70, 80–82, 156. *See also* poverty
Cleveland Indians, 35
climate change, 214n74
Clinton, Bill, 32
Club sCum, 73
Clyne, Gina, 94
collaboration, 58–61, 80, 114, 122, 133, 154. *See also* community-based arts practices; *Drawn Together*
collective bargaining, 161–62

Collins, Lisa Gail, 5–6, 15
Columbia University, 110
Commission on the Status of Women, 59
commissions contracts, 156
Commonwealth and Council (gallery), 70, 76
community-based arts practices, 5; legal aspects, 88; in Los Angeles, 93; near US-Mexican border, 91–92; queer POC safe spaces, 72–77, 79–80
complicity, 63, 119, 123, 139
conceptual art, 3, 184n12
Cone, Kitty, 162–63
Congress of the Dialects of Liberation, 66, 69
consciousness-raising (CR), 67, 78, 81, 85
consent, 18, 26, 189n68
consignment contracts, 156
Constitution, 10; Fifth Amendment, 37, 112, 127–30, 135, 138, 211n23; First Amendment, 26, 35–36, 83, 194n130, 204n52 (*see also* free speech rights); Fourteenth Amendment, 59; Thirteenth Amendment, 50, 123; values of, 84–87
contracts, 37, 88, 139–72; accommodation rights and, 162–68; cancellation of, 160; contract law defenses, 157–61, 219n64; language of, 151–52, 221n87; negotiation of, 145–47; surveys on, 153–54; types of, 156–57; unfair, 139–51, 156–61; unions and, 161–62. *See also* breach of contract
Cooday, Jesse, 215n11
Cooks, Bridget R., 5–6, 15
Cooper, Paula, 29
Cooper Do-Nuts riot, 15, 23
Copyright Act, 42, 44–46
copyright law, 37, 40–42, 196nn28–29; fair use doctrine, 44–47, 196n35, 197n40; race and, 45–47, 61; transformation of works, 46, 197n35
Corcoran Gallery of Art, 15, 30, 44
Cortez, Beatriz, 3
courage, 64, 81, 178
Court of Appeals for the Federal Circuit, 112, 128–30
Court of Federal Claims, 112–13
COVID-19 pandemic, 89, 98, 105; Delta variant, 99–101
Cowans, Adger, 42
craft-work, *34,* 35–36, 92–97, 108, 173–76
Crenshaw, Kimberlé, 106, 181n29
Crimp, Douglas, 29
Critical Race Theory (CRT), 7, 85–86, 213n65
Crump, Ben, 58
Cruz, Camilo, 171

INDEX

Cuchifritos Gallery & Artists Space, 139–41, 151, 153–54
Cullen, Countee, 78
Cunningham, Merce, 42
Customs and Border Protection Agency (CBP), 103–7
Cypher, Elspeth B., 61–62, 64

dance, 3, 20, 31, 33, 42, 65, 72, 86, 152, 169, 173, 175
Darwin, Charles, 39
data collection, 95–96, 104, 107–8, 170, 177
Daughters of Bilitis, 24, 189n67
Davis, Adrienne, 7
Davis, Angela, 20
Davis, Peggy Cooper, 130
Dayal, Mira, 139–48, *141,* 150, 168–69, 171
DeCarava, Roy, 42
Decolonize This Place, 30, 149–50, 167
Defund the Police, 10
dehumanization, 63, 72
Delaney, Beauford, 148
DeLarverie, Stormé, 24, 189n67
Delgado, Richard, 7
Delgado Art Museum, 13–14, 98
demosprudence, 7, 181n31
Descendant/Lanier daguerreotypes, 36–64, 170, 199nn67–68
Devanbu, Josephine, 151
Devezin, Jer'Lisa, 111
Dia Foundation, 149, 161, 216n20
Dinner, Deborah, 82
direct action, 8, 138, 176–77, 182n38, 184n4; art practice and, 11–13, 15 (*see also* artivism). *See also* breach of contract; civil disobedience; lawbreaking; petitions to US government; protests; rule-breaking
disability rights law, 37; on accommodations, 103, 108, 163–65, 208n31, 220n76, 221n84. *See also* Americans with Disabilities Act (ADA); Rehabilitation Act
disability rights social movement, 3, 108, 162–68, 171
disabled artists of color, 6, 11, 156. *See also* artivism; Groves, Brigardo
disaster capitalism, 116, 127, 211n29
discrimination: in employment, 145, 148, 158; laws against, 20, 81–82, 168, 185n17, 204n44; protected classes, 218n52. *See also* gendered injustice; racism and racial injustice
Dobbs v. Jackson Women's Health Organization, 10, 83, 205n64

Doerfler, Ryan D., 10
domestic violence, 21, 81, 163, 165–67, 218n52, 221n83
Dorchester Art and Housing Collaborative, 79
Douglas, Emory, 5
drag, 21–24, 71, 188n52, 188n54
Drawn Together (collaborative project), 139–72, *140–44, 153–55,* 176–78
Dred Scott v. Sandford, 124
dress and grooming rituals, 73–75, 87
Duchamp, Marcel, 43, 169
Due Process Clause, 123
Duncan, Keith, 111, *132*
Duplan, Anaïs ("An"), 79, 81, 87, 139–48, *143,* 150–52, 169–71, 177; *Concrete Poem, 155*
duress, 157–58
Duvalier, François, 32
Dyk, Timothy, 112–13, 123–24, 128–30, 134, 136–38, 212n51

Eastwood, Mary, 7
education, 25–26
Eleventh Circuit, 46
emotions and feelings, 9, 63–64, 98–99, 101, 107, 155, 162, 165
energy companies, 117–23, 135
English house portraiture, 131–33, 138
Enlightenment philosophy, 130–33, 138
enslaved people: daguerreotypes of, 36–64, 199nn67–68; in Louisiana, 124; sexual assault against, 18, 186n28; unmarked graves of, 120–21. *See also* reparations for slavery
environmentalism, 119, 123–25, 135
environmental racism, 120–21, 123, 130, 136–38, 170
Equal Protection Clause, 3, 7–8, 123
Equal Rights Amendment (ERA), 3, 183n42
esparza, rafa, 3
European art traditions, 130–33, 138
exploitation, 17, 55, 57, 78, 123–24, 130, 147, 149, 159
extractivism, 117–23, 135

fabric arts, 92–93, 95, 173
failure, 56, 68, 71–72, 81, 101; endurance failure art, 2, 98; fear of, 171; governmental takings and, 112–13, 123, 128, 133–36; "racial failure," 108, 168; unconscionability and, 160
fair use doctrine, 44–47, 196n35, 197n40
Farmer, James, 8
Faust, Drew Gilpin, 56, 62–63

FEMA, 126, 136
female genital cutting, 9
femicide, 9, 97, 105, 107
feminist legal theory, 85–86
feminist movement, 3, 8, 15–17, 60, 179n10; consciousness-raising, 67, 78, 81, 85
Ferrer, Elizabeth, 183n2
Fifth Amendment, Takings Clause, 37, 112, 127–30, 135, 138, 211n23, 211n26
Firestone, Shulamith, 60
First Amendment, 26, 35–36, 83, 194n130, 204n52. *See also* free speech rights
Fish and Wildlife Service, 124–25
"504 sit-ins", 162–65
flag burning, 3, 20–21, 36, 187n41
Forensic Architecture (FA), 120, 123
Formosa (petrochemical company), 120–21
fossil fuel industry, 117–23
Fourteenth Amendment, 59
freedom, 65–69; rights and, 86; temporary spaces of, 75, 77, 83–84. *See also* liberty
Freedom Summer, 7
Free Migration Project, 107
Free Renty: Lanier v. Harvard (film), 62
free speech rights, 83, 192n102, 194n130. *See also* First Amendment
Fryd, Vivien Green, 67
Fugitive Slave Law (1850), 124
fundamental rights, 23, 26, 37, 81, 84–87

Galton, Francis, 43
Gandhi, Mohandas, 8, 17–18
Garcia, Rudy "Bleu," 73
Garth Greenan Gallery, 28
Gates, Henry Louis, Jr., 49, 51, 56
Gates, Theaster, 79, 81, 87, 177
Gay Liberation Day March, 24
Gay Liberation Front, 23
gendered injustice, 1–10, 43, 59, 75, 85, 216n18, 217n26; in art institutions, 156, 160, 162, 166 (*see also* art world; contracts); intersectional, 26, 50 (*see also* intersectionality); laws against, 82; responses to (*see* feminist movement; queer rights movement; womanism; women of color artists); slavery and, 18, 50. *See also* power dynamics
Getty Museum, 43
Gibbes, Robert W., 38
Ginsburg, Ruth Bader, 7, 183n42
Godinez, Natalie, 94
Gold, Victor, 217n33
Goldscheid, Julie, 221n83

Gompers, Samuel, 161
Grady, Lorraine, 191n84
Gray, Fred, 7, 59, 183n42
Greenhouse, Carol, 83
"Greensboro Four," 18
grief, 32, 94, 105, 134, 158
Griswold v. Connecticut, 84, 86
Groves, Brigardo, 6, 163–66, *164,* 168, 171, 177
Grubin, David, 62
Guantanamo Bay, 32–33, 106
Guerrilla Art Action Group, 5
Guerrilla Girls, 149, 216n14
guest curator contracts, 156–57
Guggenheim Museum, 29, 149, 161, 216n20
Guinea, 9
Guinier, Lani, 7, 58–59
Guyot, Arnold, 38

Haacke, Hans, 95–96, 119, 170
Haiti, 31–33, 36
Halberstam, Jack, 13, 101
Hamer, Fannie Lou, 3, 7, 10, 183n42
Hammer Museum, 70, 76
Hammons, David, 24, 101
Hampton, Mabel, 185n20
Handbag, Dynasty, 101
handcrafted items. *See* craft-work
happenings, 65–69, 77, 87. *See also* Mutant Salon
Harding, Sarah, 83
Hardy, K8, 149
Haring, Keith, 5
Harkins, Elisa, 72, 75
Hartocollis, Anemona, 62
Harvard University: daguerreotypes of enslaved people in Peabody Museum, 38–64, 170, 199nn67–68; Legacy of Slavery Fund, 62; Vision and Justice conference, 48–50, 52
Health, Education and Welfare Department (HEW), 162–63
Hearn, Marcellene E., 221n83
Hendricks, Jon, 20, 187n40
Hernández, Robb, 6
heteronormativity, 21, 71, 74–75, 84, 86, 150
Heumann, Judith, 162–63
Hickman, Heidi, 111
Hidden Witness (Getty Museum), 43
Hijas de su Maquilera Madre (Daughters of the Maquiladora Mothers), 9
HIV/AIDS crisis, 27, 31–33, 36
homophobia, 13, 32, 73

228 INDEX

hooks, bell, 27
hope, 142, 165–67, 171, 178
Hormona, Jackie, 188n55
Hot Peaches (musical troupe), 21, 188n54
housing: artists' contracts and, 171; Hurricane Katrina and, 109–17, 121, 124–38; landlord-and-tenant law, 83, 87; as a right, 203n41; safe spaces and, 23, 79–81
Hughes, Langston, 78
humanity, 24, 55, 99, 155, 161–62, 166
human rights, 3, 8–10, 27, 30, 86, 192n102; asylum seekers, 102; queer and trans rights, 21, 24. *See also* fundamental rights
Human Rights Law (District of Columbia), 82
Human Rights Law (New York City), 82, 163–65
Humble, Horton, 111
Hurricane Katrina: blight caused by, 109–38; court decisions on property claims (*see Saint Bernard Parish Government v. United States*); ecological and environmental factors, 117–23; evacuees, 109, 115, 163, 211n27, 214n78; history of, 124–27
Hurricane Rita, 127–28
Hurricane Sandy, 115–16
Hurston, Zora Neale, 78

identities, 92, 95, 156, 162, 165–66, 172, 216n18; intersectional, 6–10, 15, 162, 165, 172, 177, 181n29, 184n4
immigrants: fair contracts and, 146–47, 156. *See also* border crossing; immigration policy
Immigration and Naturalization Service, 91
immigration policy, 1–2, 4, 37, 207n28; child detention camps, 97, 102, 105; disability rights and, 2, 4, 82, 99, 101–8; open borders, 107–8
incapacity defense, 219n64
inclusivity, 20, 26, 30, 73, 86, 95, 149, 163–65
independent contractors, 29, 192n102, 205n59
Indigenous artists, 3, 18, 27, 33–35, 62, 72, 92, 95, 215n11. *See also* Teters, Charlene
Indigenous land occupation, 150, 167
inequality, 27, 36, 64, 116, 123–24, 142, 148
Institute of American Indian Arts, 34
institutional critique, 15, 185n12
insurance, 83–84, 87; health, 145, 147, 159, 171; liability, 74
intellectual property law, 45–47, 52, 60

interconnectivity, 117, 123, 134
interns, 148, 157, 221n88
intersectionality, 6–10, 15, 162, 165, 172, 177, 181n29, 184n4

Jacobs, Harriet Ann, 18, 186n28
Jazz & Heritage Festival, 119, 212n36
Jim Crow laws, 15, 28. *See also* segregation
Johnson, Georgia Douglas, 78–81, 83
Johnson, Kevin, 107
Johnson, Marsha P., 3, 21–24, 22, 36, 44, 58, 68, 79, 87, 98, 133, 148, 168, 170, 176–78, 188n50, 188n55
Johnson, Ray, 67, 69, 87
Johnson, Sterling, Jr., 33
Johnson v. United States, 104–5, 208n29
Jones, Lois Mailou, 15, 30, 44, 148–49
Jovanovich, Alex, 2–3
"Judson Three," 20

Kaltenbach, Stephen, 24
Kansas City Chiefs, 35
Kaprow, Allan, 65–67, 69, 77, 87
Kapur, Ratna, 86
Kaqjay Moloj collective, 4
Katyal, Sonia K., 7, 46
Kee, Joan, 7
Keller, Deidré A., 46
Kennedy, Anthony, 24, 84–86
Kennedy, John F., 59
Kim, Eunsong, 61
King, Martin Luther, Jr., 8, 44, 56, 59–60, 200n85
Kootz, Sam, 148, 215n7
Korematsu v. United States, 18
Koskoff, Josh, 58, 62
Kozachenko, Kathy, 24, 189n67
Krauss, Rosalind, 29
Kwak, Young Joon, 3, 37, 66, 69–88, 170, 176–78

labor movements, 161–62, 220n76. *See also* unions
LaBouvier, Chaédria, 150
LACE (Los Angeles Contemporary Exhibitions), 1–4, 76–77, 89, 176; *Cavernous* (Mutant Salon), 77, 87–88; *Intergalactix,* 2–4, 87, 102
Lacy, Suzanne, 4, 67, 69, 78, 81, 85, 87, 170
landlord-and-tenant law, 83, 87
Lanier, Tamara K., 41, 49–50, 52–58, 53, 54–64, 177–78, 195n15, 198n57, 198n61

INDEX 229

Lanier v. Harvard, 61
Latinx artivists, 6, 149. *See also* Aguiñiga, Tanya
Latorre, Guisela, 4–6, 11, 15, 25
Laurent, Varion, 111
Lavigne, Sharon, 120
law: art and, 3–4 (*see also* artivism); rights critique, 86; skepticism about, 86, 178. *See also* contracts; copyright law; disability rights law; fundamental rights; human rights; property law
lawbreaking, 13–15, 20–21, 27, 35–36. *See also* civil disobedience; rule-breaking; vandalism
Law for Black Lives, 183n42
Lawler, Louise, 43–44
Lawrence v. Texas, 24, 84–86, 189n68
law studies, 7
lawsuits, 8; for emotional distress, 63–64; Harvard against Weems, 40–41, 44–45, 56, 60–61, 64; Lanier against Harvard, 49–64; for negligence, 63; social movements and, 58–59
Lee, Stephen, 208n38
Lennon, John, 60, 200n83
Levine, Sherrie, 43
Lewis, Sarah Elizabeth, 7, 48–49
LGBTQI movement. *See* queer rights movement
liability, 74, 88, 212n48, 213n55
liberty: ordered, 84–85; safer spaces and, 77–78 (*see also* freedom)
Lieja Quintanar, Daniela, 4, 87–88
life artists, 24
Lindsey v. Normet, 81
Linzy, Kalup, 79, 81, 87, 170
Lippard, Lucy, 5, 29
litigation, 8. *See also* lawsuits
Lloyd, Tom, 19
Lomax, Brad, 162–63
Long, Charles, 71–72
Lorde, Audre, 24, 27
Lori-Parks, Suzan, 111
Loyola Law School, Los Angeles, 151
Loyola University New Orleans College of Law, 120, 170
Lozano, Lee, 24

Macfarlane, Katherine, 104
MacKinnon, Catharine, 85, 106
MacPherson, William D., 195n11
Madison, Ronald, 126

Madison Museum of Contemporary Art, 149
Magraff, Craig, 111
Mahajani, Usha, 186n33
marriage laws, 13, 15
masculinity: Black female, 13; toxic, 73
Massachusetts Supreme Judicial Court, 41–42, 54, 61–62
mass incarceration, 26, 190n79
MASS MoCA, 149, 161, 216n20
materials arts, 95, 97, 177
Matsuda, Mari, 7
Mattachine Society, 24
Mayeri, Serena, 7, 58
McCain, Franklin, 17–18
McNeil, Joseph, 17–18
Mendieta, Ana, 185n20
mental health, 146–47, 156, 162
Meredith, James, 20, 187n41
Meredith March Against Fear (1966), 3
Metlitsky, Anton, 61
Metropolitan Museum of Art, 29, 149
Mexico, 9, 107. *See also* border crossing
Middlesex County Superior Court, 49–50, 54, 61
Milk, Harvey, 24, 189n67
misrepresentation, 158–59, 218n50, 219n55
Mitchell, Margaret, 46
MoMA (Museum of Modern Art), 17, 28–30, 95, 116, 150, 161, 170
Monroe, Marilyn, 43–44
Montano, Linda, 24
Montgomery Bus Boycott, 7, 59, 183n42
Montgomery Improvement Association, 59
Moon, Jennifer, 24, 75
Moore, Leroy, 163
Moraga, Cherríe, 27
Moreno, Mike, 149
Morton, Samuel George, 38
Mouffe, Chantal, 5, 7
Moyn, Samuel, 10
Mtima, Lateef, 46
Munch, Edvard, 148
mural painting, 24–26, 91
Murray, Pauli, 7, 20, 59, 183n42
Murray, Yxta Maya, *144, 153*
Museum of Art of the National University of Colombia, 70
Museum of Contemporary Art (Chicago), 30
Museum of Modern Art. *See* MoMA
Mustache Mondays (venue), 73

INDEX

Mutant Salon (queer arts collective), 37, 68–70, 73–88, 170, 177–78
mutual aid, 175–77; arts contracts and, 147; for immigrants, 91, 94, 99–102; safer spaces and, 78–79; theater and, 107

National Black Feminist Organization (NBFO), 20
National Coalition on Racism in Sports and the Media (NCRSM), 34
Native Americans. *See* Indigenous artists; Indigenous land occupation
Nava, Nacho, 73
necropolitics, 108
negative rights, 83, 204n52
NeJaime, Douglas, 7, 183n54
Nelson, Stanley, 192n95
Newman, Donald, 29
Newman, Michael, 184n12
New Museum, 149, 161
New Orleans: constitutional property rights, 37, 109–38; gentrification, 111–13, 127, 133–35; Housing Authority, 127; Lower Ninth Ward, 112–13, 124–25, 127–28, 134, 137; Mid-City district, 109–11, 116, 130, 134; Road Home program, 109, 116, 135; Saint Bernard Parish, 109, 112–13, 124–25, 127–28, 134, 137; satellite images of, 119–21, 123; Tremé neighborhood, 110–11, 116; Upper Ninth Ward, 116. *See also* Hurricane Katrina
New Orleans Redevelopment Authority (NORA), 116
New-York Historical Society, 149, 161
New York Pay Equity Law, 159
New York Radical Women, 3, 16, 60
Nogales, 96
noise ordinances, 83, 87
nonviolence, 17–18. *See also* Ono, Yoko
Noriega, Chon, 6
Nova, Zazu, 188n55
Nussbaum, Martha, 7

Obama, Barack, 36
Obergefell v. Hodges, 24, 85–86, 190n68
Occupy Wall Street, 110, 115, 119, 149
O'Connor, Sandra Day, 84
Ogletree, Charles, 56
Okediji, Ruth L., 46
omission/commission distinction, 113, 128–30, 133–38, 213n55
Ono, Yoko, 16, 23, 176, 178, 186n24, 200n83; *Cut Piece*, 16–18, 26–27, 36, 60, 98

open borders, 107–8
Open Borders Project, 107
Orbison, Roy, 44–45
otherness, 70–71
outreach, public, 89, 95, 108, 177. *See also* Aguiñiga, Tanya
Owens, Craig, 29

Pace/MacGill gallery, 29
Padilla, Laura, 85
painters, 20, 27–30
Palencia, Roland, 149
Parks, Rosa, 8, 18, 44
parol evidence rule, 217n33
patriarchal norms, 66, 93, 150
pay rates, 145, 157–60, 167
Peabody Museum. *See* Harvard University
Peñalver, Eduardo Moisés, 46
Perez Setright, Gabriel Yarince, 94
petitions to US government, 2, 4, 8, 89, 99, 101–5, 170, 177
petrochemical companies, 117–23, 135
photography, 42. *See also* Descendant/Lanier daguerreotypes
Pierson v. Post, 47
Pilchuck Glass School, 98
Pindell, Howardena, 6, 27–30, *28*, 35–36, 96, 149, 170, 177, 191n84, 191n90, 192n99, 207n15, 222n91; *Art Crow/Jim Crow*, 28; *Free, White and 21*, 28
Piper, Adrian, 5, 30
Planned Parenthood of Southeastern Pennsylvania v. Casey, 84–86, 205n64
plein air painting, 131, 138
Poblado Maclovio Rojas, 92
police: movements to defund, 10, 26, 183n51; surveillance and discipline, 88, 111
police brutality, 106, 184n3; against Black people, 29, 124, 126, 136, 192n95; against queer and trans people, 21, 26, 188nn51–52, 190n82
political art, 3–5, 180n17. *See also* artivism
Pollock, Jackson, 180n17
Pope.L, William, 98, 101
positive rights, 83
Posner, Richard, 7
Post, Robert, 7, 58
poverty, 82, 148, 191n83
power dynamics: in contracts, 157–61; in galleries and museums, 142–48, 151; happenings and, 65–69; jurisprudence and, 129–30; race and copyright laws, 45–47
Pozen, David E., 58, 196n31

prison abolition, 205n68, 213n66
prison population, 26, 190n79
procedural unconscionability, 160
Projansky, Robert, 149
property law: copyright and (*see* copyright law); forfeiture, 62; governmental takings, 109–13, 116–17, 127–38, 213nn55–56; real property, 47, 60; redistributive property ownership, 49, 52; regulatory takings, 211n26; safer spaces and, 87; slavery and, 59, 64
Prospect.3 (arts center), 116
protests, 5, 26, *34*, 35, 89, 111, 114, 176–77; risk of arrest and, 8. *See also* civil disobedience; direct action
public accommodations, access to, 81–82
Purnell, Derecka, 10

queer legal theory, 85–86
queer of color artivists, 6, 10, 13–15, 21–24, 31–33; complexities of, 59; otherness and, 70–71; safe spaces, 37, 69, 73–88. *See also* artivism; Kwak, Young Joon
queer rights movement, 3, 36, 85–87, 189n67, 189nn67–68; in China, 9, 183n47; Stonewall riots, 16, 21–24, 36, 188n55. *See also* "appearing in public without shame"
queer studies, 71
queer temporality, 67, 77, 83
queer utopianism, 85–87, 171, 205n68
quipu, 95–96

racism and racial injustice, 1–10, 156, 191n83, 192n102, 213n68, 217n26, 222n91; anti-Asian, 18, 186n33; anti-miscegenation laws, 13; in art world, 20, 27–30, 36, 44, 96, 147, 149–50, 170, 191n90, 192n102, 207n15, 217n26, 222n91; copyright laws and, 45–47; responses to (*see* women of color artivists); in science, 38–39, 43, 55, 57, 61–62, 64, 131, 133, 195n5; in sports mascot culture, 33–35; union membership and, 162; verbal harassment, 73. *See also* power dynamics; segregation; slavery
Radich, Stephen, 20
Rainer, Yvonne, 187n42
Randall, Alice, 46
Rankine, Claudia, 150
rape: anti-rape politics, 18, 186n30; rape law, 18, 26, 106
Rauh, Joseph, 7, 183n42
Ray, Ethel, 78–79
Reagan, Ronald, 27, 35, 191n83

real property, 47, 60
Rechy, John, 15, 23, 177
Reclaim the Streets movement, 5
REDCAT theater, 75–76, 83
redistributive property ownership, 49, 52
Redstockings, 186n30
Reeder, Eskew, Jr., 15, 79
Rehabilitation Act (1973), 103–7, 162–65, 168, 208n34, 208n37, 221n84
Reichlin, Elinor, 39
Reminder Day, 24, 189n67
reparations for slavery, 45, 47, 61, 196n30
representation contracts, 156
research artists, 170
resources, 85; rights to, 83
Rhode Island School of Design (RISD), 92
Richmond, David, 17–18
Ringgold, Faith, 3, 5, *19*, 23, 29–30, 44, 58, 95, 133, 149, 170, 177, 187n40; *People's Flag Show*, 19–21, 26–27, 35–36, 80, 98, 101, 187n42
Rivera, Sylvia, 23, 79, 170
Roberts, Charles, 60
Roberts, Dorothy E., 7, 10, 130
Rodriguez, Janette, 163
Roe v. Wade, 10
Rogers, Molly, 49–51, 198n61, 198n68
Rothko, Mark, 180n17
Royall, Isaac, Jr., 39
rule-breaking, 8, 15, 30, 35–36, 176; appropriations art and, 44. *See also* lawbreaking
Runge, Robin, 221n83
Ryoo, Diana, 94

Saar, Betye, 148
safer spaces, 69, 73; law and, 76, 81–87; policies on, 202n27; roots of, 77–80; thriving in, 76, 80, 82–86; use of term, 78
Saint, Assotto, 27, *31*, 31–33, 35–36, 44, 177
Saint Bernard Parish Government v. United States, 112–13, 117, 123, 127–30, 134–38
SALAAM: Student Activists of Louisiana Against Aggressive Militarism, 114
same-sex marriage, 85. *See also* queer rights movement
Sanches, Ray, 73
Sandoval, Chela, 4–6, 11, 15, 25
San Francisco, 162–63
Santi, Linda, 136–37
San Ysidro border, 1–2, 89, 97, 99, 171
Sarmiento, Sergio Muñoz, 171
Sarrouf, Camille F., 54

Schmidt-Reitwein, Jörg, 185n12
Schneemann, Carolee, 69, 87; *Round House,* 66, 78
Schnorr, Michael, 91–94, 105, 206n3
Scruggs, Dana, 150
Segal, George, 65, 83
segregation, 7, 13–15, 28, 59, 124
self-care, 79–80, 84–86, 176
Self Help Graphics, 182n38
Sen, Amartya K., 79, 182n40, 203n39
Senegal, 9
Sepper, Elizabeth, 82
Serkin, Christopher, 135, 211n26
sexual assault, 18, 67. *See also* rape
Shell Oil, 119, 212n36
Siegel, Reva, 7, 10, 58, 130, 181n32
Siegelaub, Seth, 149
Sierra, Santiago, 5, 180n21
Sigal, Lisa, 111, 116
Simon, Carolyn, 24
Siqueiros, David, 180n17
Sister Fa, 9
Sixth Circuit Court of Appeals, 44
SLAAAP!!! (Sexually Liberated Asian Artist Activist People), 191n84
slavery: crime of, 45–46; legacy of, 64; reparations for, 45, 47, 61, 196n30. *See also* enslaved people
slow violence, 208n38
Smith, Barbara, 27
Smith, Roberta, 29
social movements, 5–7, 15, 177; artivism and, 13; law and, 3, 7. *See also* antiwar movements; civil rights movement; disability rights social movement; feminist movement; queer rights movement
Society of Human Rights, 24
Society of Washington Artists, 149
¡Somos Presente! (website), 2, 102–3
Soskolne, Lise, 149
Souter, David, 84
Spade, Dean, 10, 86, 205n69
spatial analysis, 120–23
Spitzweg, Carl, 184n12
Steinem, Gloria, 60
Steiner, A. L., 75–76, 82–83, 149
Stone, Irving, 148
Stonewall riots, 16, 21–24, 36, 188n55
Stony Brook University, 29
Strada, Alex, 149, 167, 171, 216n18
Street, Sidney, 20, 187n41
Street Transvestite Action Revolutionaries (STAR), 23, 79, 170
"streetworks" (New York), 5

Strike MoMA, 30, 150, 167
Studio Watts Workshop Garage Gallery, 67, 78, 81
substantive unconscionability, 160
suffering, 2, 33, 48, 63; of artists and art workers, 147–48, 150, 158, 221n88; Hurricane Katrina and, 110, 126; of migrants at border crossings, 91, 97, 102–7, 208n38. *See also* trauma
Sunder, Madhavi, 46
Suntrust Bank v. Houghton Mifflin, 46, 197n40
Supreme Court: on copyright, 44–45; on fundamental rights, 23, 26, 84–87; omission/commission distinctions, 128; on property law, 47; on slavery, 124. *See also specific cases*
surveillance, 29, 68, 76, 82, 84, 88
survival, 76, 93, 97, 99, 123, 126–27, 175–76

take-it-or-leave it contracts, 157–59
Takings Clause (Fifth Amendment), 37, 112, 127–30, 135, 138, 211n23, 211n26. *See also* property law
Taylor, Breonna, 184n3
Taylor, Mrs. Recy, 18
Taylor, Paul, 42
temporariness, 75, 77, 83–84
Tenement Museum, 161
Teters, Charlene, 3, 27, 33–36, 44–45, 58, 95, 98, 133, 168, 177–78
Texas v. Johnson, 21
textile art, 92–93, 95, 173
theater performances, 26. *See also* Ono, Yoko
Third World Women's Alliance, 20
Thirteenth Amendment, 50, 123
time: natural, 65, 77; queer, 67, 77, 83; unnatural, 68
Toche, Jean, 20
To Make Their Own Way in the World, 49–52, 54, 57, 59
Torres, Gerald, 7, 58
transgender rights movement, 3, 205n69. *See also* Johnson, Marsha P.; safer spaces; Stonewall riots
trauma, 147–48; of Hurricane Katrina, 110, 126–27, 136–37. *See also* suffering
trespass, 14, 84, 165, 205n57
Troche, Jean, 187n40
Trump, Donald, 7, 10, 36, 93, 96
Tucker, Louella, 78–79
Tucker Act, 212n48
Tulsa Queen Rose Art House, 79, 81
Tute Bianche movement, 5
2 Live Crew, 44–45

Ulay, 184n12
unconscionability, 159–60, 219nn58–59, 219nn62–63, 219n65
underground performance spaces, 73
undue influence, 157–58
undue pressure, 158
undue susceptibility, 158
unions, 161–62, 171, 180n17, 216n20
United Auto Workers (UAW), 149
United States v. Eichman, 21
United States v. O'Brien, 35
University of Illinois, "Chief Illiniwek" mascot, 33–35
Unruh Act (California), 82
USC Roski School of Fine Arts, 72–76, 82–84, 202n22
utopianism, 85–87, 171, 205n68

vandalism, 24–26, 190n72
van Gogh, Vincent, 148
Vats, Anjali, 46
Venice Biennale, 20
verbal contracts, 156
Vietnam War, 18. *See also* antiwar movements
violence, 73, 82; after Hurricane Katrina, 126, 136, 214n77; anti-Asian, 18; borders as sites of, 107; immigration and, 98; in private spheres, 81; against queer and trans people, 76, 208n41; safer spaces and, 78; slow, 208n38. *See also* domestic violence
Viva! (artists' collective), 149
Voon, Claire, 97
voting rights, 3, 7
Voting Rights Act (1965), 16, 185n17

W.A.G.E. (Working Artists and the Greater Economy), 149, 161, 167
wage theft, 157. *See also* pay rates
Wales Padlock Law, 13, 178
Walker, Alice, 187n37
Wallace, Barbara, 19–20
Wallace, Michele, 19–20, 187n40
Warhol, Andy, 43–44
Washington Redskins, 35
Washington v. Glucksberg, 84
Watkins, Peter, 148
Waynberg, Jodi, 152–53, 167–68, 171
Weber, Mark, 106
Weems, Carrie Mae, 36–64, *39,* 80, 131, 176–78, 198n57; *And 22 Million Very Tired and Very Angry People,* 47; *American Monuments,* 48; *Art in the 21st Century (Art 21),* 40, 45–46, 48, 59; *Colored People,* 42–43, 64; *From Here I Saw What Happened and I Cried,* 40, 43, 45, 47, 50, 56–59, 64, 170, 178; *Kitchen Table Series,* 42; *Museums,* 48; *Roaming,* 48; *While Sitting upon the Ruins of Your Remains, I Pondered the Course of History,* 50, 57
Weizman, Eyal, 120
Wendlandt, Dalila Argaez, 61
West, Robin, 7
Westley, Robert, 196n30
white supremacy, 28, 52, 61, 73–74, 149–50, 213n65
Whitney Museum, 148–50, 161, 216n20
Wiley, Kehinde, 79, 170
Williams, Carl Joe, 111, 116, 127, 137
Williams, Patricia, 7
Willis, Deborah, 51
Wilson, Jackie Napoleon, 43
Winnemucca, Sarah, 18
Wisconsin Triennial, 30, 149
womanism, 20, 187n37
women of color artivists, 4–10. *See also* Aguiñiga, Tanya; artivism; Brown, Imani Jacqueline; *Drawn Together;* Indigenous artists; Kwak, Young Joon; Latinx artivists; queer of color artivists; Weems, Carrie Mae
Women Students and Artists for Black Art Liberation (WSABAL), 19–20, 26, 29, 36, 149, 161, 170, 187n40
workers' rights, 161, 221n87. *See also* contracts; disability rights law; human rights; unions
Works Progress Administration, 161
written contracts, 156
Wu, Simon, 139–48, *140,* 147, 150–51, 171

X, Malcolm, 47, 49, 52, 60–61, 200n85
Xina Xurner (musical duo), 66, 71–73, 77, 81, 86

Yams Collective, 149
Young, Margot, 86
Young Lords, 23

Zapatista revolution, 5
Zealy, J. T., 38–39, 41
Zhang, Shawn, 9

www.ingramcontent.com/pod-product-compliance
Lightning Source LLC
Chambersburg PA
CBHW071411170526
45165CB00001B/241